D0765419

Frederic Remington

Frederic Remington–
Selected Letters

The following pages contain
people who Know us.

Yours faithfully
Frederic Remington.

Frederic Remington-
Selected
Letters

By Allen P. Splete and
Marilyn D. Splete

Abbeville Press • Publishers • New York

To our parents for their love and
guidance and to our children, Heidi
and Michael, for their patience
and understanding.

Editor: Walton Rawls
Art Director: Howard Morris
Layouts: Joe Freedman
Copy Chief: Robin James
Copy Editor: Don Goddard
Production Manager: Dana Cole

Library of Congress Cataloging-in-Publication Data

Remington, Frederic, 1861–1909.
Frederic Remington, selected letters.

Bibliography: p.
Includes index.
1. Remington, Frederic, 1861–1909—Correspondence.
2. Artists—United States—Correspondence.
I. Splete, Allen. II. Splete, Marilyn. III. Title.
N6537.R4A3 1987 709'.2'4 [B] 86-28786
ISBN 0-89659-694-X

Contents

5.

Visible at Last 1894–1902 235

6.

Fame 1902–1907 305

7.

A Brief Last Hurrah 1907–1909 364

Foreword

I N THE SUMMER OF 1906, Father settled my mother, my sister
Elaine, and myself—age twelve—in a little summer hotel on
Cedar Island for a two-week vacation. Cedar is one of the
larger islands in the Chippewa Bay archipelago, that last large
bulge in the Thousand Islands area along the downriver stretch of
the St. Lawrence. The upper end of Cedar Island is shaped some-
what like a fishhook, with a lagoonlike bay separating Cedar from
its smaller neighbor, "Remington's place," as I heard the island re-
ferred to. I was permitted to fish for perch from a skiff out in that
small lagoon, and I had full view of the boathouse and dock over at
"Remington's place."

My interest centered more on the perch than on the fat man who
nearly every afternoon came down to that dock, settled himself
well-amidship in a beautiful Rushton cedar canoe and then pushed
off, out through the open gut into the St. Lawrence for his daily
constitutional. I inquired of my mother who that huge, florid-faced
man was.

"That," Mother replied, "is Mr. Remington, the famous artist,
who paints all of those wonderful pictures of Indians, cowboys, and
horses. Many years ago his father sold the *St. Lawrence Plaindealer*
over in Canton to your grandfather Manley. That is how your fa-
ther became the publisher of that newspaper."

The perch were biting, so I had no time for more. However, I
began taking a livelier interest in that big fat man. Fifty-five years
later, I unexpectedly found myself engrossed in writing a mono-
graph, *Frederic Remington, In the Land of His Youth,* for the 100th
anniversary celebration of the birth in Canton of Frederic Sack-
rider Remington.

There have been certain advantages to living out one's entire life
in the same North Country village. It was my privilege to know
members of the Remington "tribe." When I approached the early
stages of manhood, my dad took me up to Remington's Corner
Clothing Store where I was measured for my first suit with long
trousers. The store's proprietor was none other than William Reese

Remington, Fred's beloved "Uncle Bill." His daughter was the beautiful Ella, whom Fred referred to as "my old maid cousin"—only in mid-life Ella up and married. Her brother, George, and Fred were as alike as two peas in a pod. They were companions throughout their all-too-short lives. Then there was "Len" Caten, my St. Lawrence University classmate and fraternity brother, who was a nephew of Frederic and Eva Caten Remington.

Of course there were many other local associations of like character, so it was a privilege to be asked to head the Canton Centennial Committee. No time was lost in broadcasting to the public that October 4, 1961, would mark the 100th anniversary of Remington's birth. In 1940, Remington's portrait had appeared on the 10-cent postage stamp in the Artists Series of the Famous Americans stamps, and the Canton Post Office was accorded official First Day of Issue cancellation honors. Therefore, our committee lost no time in suggesting to the Post Office Department that a Remington commemorative stamp would be a fitting recognition. Two months later, a Washington dispatch announced that inasmuch as the centennial of Remington's birth was in the offing, the Post Office Department would issue on October 4th a commemorative stamp with the interesting departure that the design would not feature his portrait but one of his famous paintings, *The Smoke Signal.* However, this time First Day of Issue cancellation honors would be in the nation's capital, with special ceremonies held at the National Gallery of Art. The Remington commemorative was later judged the most beautiful U.S. stamp of the year, becoming the first in a most excellent series of the so-called Art Commemorative stamps.

Of especial significance to our total centennial program was a ceremony held in the Owen D. Young Library on the St. Lawrence campus where members of the Cox family who were related to the late Poultney Bigelow—Remington's friend at Yale and later collaborator—presented the university with the Bigelow–Remington Letters. This collection, with a small album containing the Herbert F. Gunnison–Remington Letters, formed the basis of what now constitutes the largest and finest collection of correspondence pertaining to Canton's favorite son. To the above have been added the Poste–Remington Letters, the John C. Howard–Remington Letters, and the Sackrider–Remington Letters, over three hundred originals in all. Also included are copies of the following collections: the President Theodore Roosevelt–Remington Letters from the Library of Congress; the massive amount of correspondence with the Fairmount Park Association of Philadelphia in connection with Remington's life-sized equestrian bronze *The Cowboy;* and the Lieutenant Powhatan H. Clarke–Remington Letters at the Missouri Historical Society.

In 1960 a northern New York youth named Allen P. Splete was graduated from St. Lawrence University. Eleven years later, with

both a master's and a doctorate degree, he returned to join his alma mater's administration as vice president in charge of academic planning and special programs. As a North Country product, Dr. Splete soon became interested in the university's growing Remington collections, eventually teaching a mid-term, one-month special course about Frederic Remington, his life and art. By then he had become deeply engrossed in that massive accumulation of letters; he had also acquired a considerable collection of Remington memorabilia of his own. While serving as president of Westminster College in Pennsylvania and now as president of the Council of Independent Colleges in Washington, D.C., Dr. Splete and his wife still found time to complete the research and writing pertinent to this excellent new Remington book. All who are Remington disciples are deeply in debt to Allen and Marilyn Splete for this volume, with its profusion of pen-and-ink and pencil sketches done by the artist, many seen here through the generosity of the Frederic Remington Art Museum in Ogdensburg, New York, and other institutions. So much for how this most recent adventure in Remingtonia came about; now to the book.

Atwood Manley
Canton, New York

Acknowledgments

THE AUTHORS ARE INDEBTED to the John Ben Snow Foundation of Syracuse, New York, for support in making this book possible. We would like to recognize Vernon F. Snow, president of that foundation, for his encouragement through the years of research and writing necessary to complete the work. Inspiration to commence the Remington research came from G. Atwood Manley, a Remington scholar from Canton, New York, who shared his many insights into Frederic Remington's life. Many hours of delightful conversation with Atwood and his late wife Alice added incentive to the quest and provided the spirit of curiosity so important in unraveling important connections among people, places, and things. Richard Meyers, also of Canton and another Remington booster, discussed many aspects of the man and was helpful by responding to our questions. We would like to recognize Betsey Deuval of Governeur, New York, a relative of Frederic Remington, for her assistance and comments. The late Ed Blankman, revered Canton historian, graciously shared his Remington research and was an enthusiastic supporter of our project.

A special note of gratitude is due the Owen D. Young Library at St. Lawrence University in Canton, New York, for the assistance of its staff throughout the project. The cooperation of Mahlon Peterson and Lynn Case Ekfelt went far beyond the call of duty. The staff of the Frederic Remington Art Museum in Ogdensburg, New York, deserves our heartfelt thanks for their generosity in responding to requests for information and in giving permission to use many items from their outstanding collection. Mildred Dillenbeck, Bruce Eldridge, Melody Ward, and Lowell McAllister, current director of the museum, were most helpful. Susan Danehy and Judith Gibson of the Benton Board of the Canton Free Library in Canton, New York, were ardent supporters of the research undertaken. Frank P. Piskor, president emeritus of St. Lawrence University, was instrumental in securing several original Remington letters for the university collection, which became a base for the extensive letter searching necessary to complete the book. His personal en-

couragement and recognition of the importance of the undertaking helped the authors maintain their diligence and commitment.

Rudy Wunderlich, formerly of the Kennedy Galleries of New York City, was a helpful source of information, as was the late Harold McCracken of the Buffalo Bill Historical Center in Cody, Wyoming. We wish to note with appreciation the support of his wife, Angie. Peter H. Hassrick, director of the Buffalo Bill Historical Center in Cody, Wyoming, and Shari Small of his staff were marvelous in providing additional materials for the book. Eleanor Gehres and Bonnie Harwick of the Western History Department of the Denver Public Library of Denver, Colorado, gave prompt and thorough replies to our inquiries. Stephanie Klein and the staff of the Missouri Historical Association in St. Louis, Missouri, were most helpful. Jerry Bloomer of the R. W. Norton Gallery in Shreveport, Louisiana, was a source of encouragement and great assistance in compiling materials. Hillary Cummings, curator of manuscripts, special collections, at the University of Oregon in Eugene, Oregon, deserves our thanks. Barbara Simmons, Linda Stanley, and Karl Polch of the Fairmount Park Art Association in Philadelphia, Pennsylvania, were very helpful in sharing pertinent information about the Remington statue that is a part of that city. George Miles of the Yale University Library, and Judith Schiff, chief research archivist there, should be mentioned here along with those in the Western American Collection in the Beinecke Rare Book and Manuscript Library in New Haven, Connecticut.

The often forgotten but essential people behind the scenes who spent countless hours typing and copying drafts of transcribed letters and edited materials are cited for special praise. Gail Colvin, Sheila Smilgin, and Madeline Zimmer of St. Lawrence University made many rough letters take a finished form. Nancy Wright, Virginia Williams, and Ida Taylor at Westminister College, New Wilmington, Pennsylvania, typed manuscripts in various stages of completion and expedited completion of the finished manuscript. George Bleasby, professor emeritus at Westminster College, read an unedited copy of the manuscript and offered constructive suggestions. We wish to recognize Walton Rawls for his editorial assistance and attention to publishing details. The quality of the book has been enhanced by his involvement.

There were countless other individuals who through responding to a question, providing a letter, sketch, or catalogue were important in helping us fill in missing pieces or in pointing us the right direction as we tried to validate our facts. To those of you in that category, our gratitude.

Introduction

I T WAS NOT UNTIL 1947, thirty-eight years after Frederic Remington's death, that the first fairly comprehensive book about his life and work was published. That Harold McCracken completed *Frederic Remington: Artist of the Old West* was due in large part to the efforts of Emma Caten of Ogdensburg, New York, the sister of Remington's wife. Frederic and Eva Remington had no children, and Remington himself had been an only child, so after his death in 1909 it was Eva and, later, Emma who, with the help of Remington's friend John Howard, took responsibility for the collection of unsold paintings, sketches, and western paraphernalia in the house in Ridgefield, Connecticut, where the Remingtons were living when he died. When Eva died in 1918, she bequeathed the collection, as well as a copy of each of Remington's bronzes, to the Ogdensburg Public Library. When the library suffered a fire, the collection was transferred to the Parish Mansion in Ogdensburg, overlooking the St. Lawrence River, and it was remodeled and renamed the Remington Art Memorial. Still housed in the same building (including an addition) and now called the Frederic Remington Art Museum, the collection contains a comprehensive trove of Remington works and personal effects, including many letters. Another large collection of letters is found in the Owen D. Young Library at St. Lawrence University in Canton, New York. These two sources in the North Country of New York, where Remington spent his boyhood and visited at least yearly throughout his life, provided the inspiration for our undertaking the task of making Remington the man as accessible to his admirers as Remington the artist.

Our book builds on the work of other Remington scholars, but, to our knowledge, it is the most complete compendium of Remington letters in existence. In addition to the two sources mentioned above, there are other repositories around the country of Remington correspondence, and copies of their letters were generously lent to us. A few of these letters have been used by other authors, and Remington has often been quoted, but ours is the first attempt to

transcribe the letters in their entirety and to organize them. Our goal was to write a book that would inform, entertain, and provide useful paths for future scholars.

The book is organized chronologically, and each chapter begins with a historical section that sets the time and place. The letters follow generally in time sequence, but this was difficult to determine since Remington often noted just the day of the week or month and date and usually did not bother to include the year. Transitional bridges occur regularly between groups of letters, to set the stage for the letters that follow or to introduce a new correspondent. The letters themselves are footnoted to identify people, places, or events with which the reader may be unfamiliar. The footnotes also clarify references by Remington to his own works in progress and give the reader a unique view of the business end of being an artist at the turn of the century. Each letter is printed as it originally was written, with grammar, word usage, sentence structure, and spelling for the most part untouched. In this regard, we caution the reader that seemingly racist, sexist, or ethnic comments or unusual figures of speech (and they are relatively few) must be viewed in the context of the time, with awareness that this was private correspondence and not public statements.

Remington often added a doodle or sketch to a letter to illustrate a point. Many not previously published, these appear throughout the book with the letters they originally enlivened. We looked at more than a thousand mostly handwritten letters from and to Remington, from places all across the country and from well-known and lesser-known people who were acquainted with Remington in a variety of ways. Many are short and business-related. Somewhat more than half the letters examined appear in this book. Several anecdotes and vignettes supplement the letters, among them poems and longer accounts written by Remington's friends, including a eulogy delivered by Almon Gunnison in Canton, New York.

What makes this compilation appealing and different is the amount of new information in Remington's own words about his personal habits and interests. This includes examples of his uncanny wit and humor, insights into his "work hard–play hard" lifestyle, and a revelation of his mental block for learning foreign languages. The letters also give the reader insights into Remington's way of doing business. As an illustrator and artist he was often his own agent, and many letters make reference to his methods of advertising, marketing, and actual sale of his pieces. The file of letters concerning the Cowboy statue in Philadelphia's Fairmount Park follows the development of that piece from its inception to its completion. In addition, new light is shed on Remington's standing among the country's military leaders even though he never served in the armed services himself. Through friendships with military officers he sought to gain material for his work and was prompted

to suggest to Washington changes in military uniforms and equipment. He was politically astute in working with high-ranking officers, for this paved the way for good opportunities to depict the military life of his day. So respected was Remington that he unabashedly tried to persuade government officials to take actions that often helped advance his career interests. There is also much evidence in the letters that Remington's time in northern New York had a great deal of influence on his work. "Ingleneuk," his summer retreat on the St. Lawrence River, was more than a haven and respite, it was a place of tremendous inspiration. Much of the adventure in Remington's life and the periods of greatest productivity had their roots there. Finally, there are many statements in individual letters that give a picture of his philosophy and beliefs regarding art, politics, and the American people.

Remington's impact on the literary and art world of the late nineteenth century has yet to be fully described. His works, which include sketches, drawings, paintings, bronzes, illustrations, articles, short stories, and books preserve for us the American West as it was in Remington's lifetime. He was so prolific that there are those who would argue that much of our conception of the Old West is the result of his interpretation of it. His photographic mind, enhanced by the many artifacts in his Western collection, made time stand still long enough for him to reproduce it for us. His reflections, histories, and accounts have provided us with detailed portraits of the cowboy, soldier, and American Indian. He is perhaps best remembered for those legacies and his characterizations of the West. With the publication of his letters we now have a better appreciation of the man.

<div style="text-align: right">

Allen and Marilyn Splete
Damascus, Maryland
October, 1987

</div>

Frederic Remington-
Selected
Letters

Chapter 1
The Formative Years
1861–1884

THE AMERICAN WEST that Frederic Remington came to know as a young man was heir to the era of "Manifest Destiny." This apt phrase, coined by a newspaper editor, describes the national mood of the 1840s, when westward expansion was finally unleashed. During the administration of James Polk (1845–1849), more than a million square miles of new territory came under American control. The western boundaries of the United States, established by the Louisiana Purchase in present-day Colorado and Wyoming, advanced all the way to the Pacific Ocean to open up immense resources and possibilities of national development almost beyond imagination.

In January 1848 gold was discovered in the Sacramento Valley in California, and the "gold rush" began. Eighty thousand people poured into California alone in 1849. Although it was possible to get to California by ship around Cape Horn or by the dangerous, difficult shortcut across the Isthmus of Panama, by far the most popular route was across the plains by covered wagon. Gold and silver were the minerals that brought the first colonists to this last frontier, and the settlement followed a pattern. Individual miners were followed by the commercial mining corporations. Then the farmers and ranchers moved in to establish a more permanent economy. As the miners, cowmen, and farmers sifted in, they came face to face with the indigenous Indians whose determined and sustained resistance was to last well into the 1880s. Westward expansion was also slowed by the onset of the Civil War.

When Frederic Remington was born in Canton, New York, on October 4, 1861, the Civil War had just begun. Union forces had been routed at the first battle of Bull Run, shattering Northern complacency about the newly forming Confederacy. Even in Rem-

ington's birthplace, far from the scene of that or any other battle, emotions ran high. Local men enlisted, encouraged others to enlist, or took the lead in forming regiments. Seth Pierre Remington, Frederic's father, was one such man. A businessman, he had founded in 1856, along with William Goodrich, Canton's only weekly newspaper, the *St. Lawrence Plaindealer.* He became sole owner at the end of the first year.

In July 1861, President Lincoln had received Congressional authorization to enlist 500,000 volunteers for three-year service in the Union Army. Seth Remington signed up in December 1861 and at first was given the job of recruiting more men in his home territory of St. Lawrence County in New York State. On March 13, 1862, in Washington, D.C., he was mustered in as captain. Seth Remington was made a major in Colonel Swain's 11th New York Cavalry, also called "Scott's 900." He and seventy-eight troopers are credited with slowing Gen. Jeb Stuart's advance to join Lee at Gettysburg by charging madly into Stuart's ranks on June 27, 1863.

Undoubtedly his heroic deeds and awards earned him the approbation of the community. Known as the "Colonel" and treated with respect, he bought back the *Plaindealer* in 1867 and settled down to earn a living, pursue Republican politics, and enjoy his wife and young son.

The Republican Party, the Grand Old Party of Lincoln and the victorious Union Army, was the dominant party in the North after the Civil War. In 1870, Seth Remington's political activity paid a major dividend as he was appointed U.S. Customs Collector for the Port of Ogdensburg, New York. It was not until 1873 that he sold his newspaper to Gilbert Manley and established permanent residence in Ogdensburg.[1]

Canton in the 1860s and 1870s was a rugged outdoor community. Hunting, fishing, and horseracing were common pursuits. Young boys grew up in close acquaintanceship with the local rivers, mountains, lakes, and streams. For Frederic, there was also a connection with the military, especially the cavalry. The returning soldiers, his father and his friends, found many opportunities to relive their Civil War experience in stories. For young boys with keen imaginations it was an armchair journey into military excitement, and they reveled in it.

There were many opportunities, too, to observe horses in action—on the streets and in the backyards of Canton, on the farms, and at the St. Lawrence County fairgrounds.

Seth Remington became associated with a young harness driver, Walter Van Valkenburg ("Van") of Hermon, New York, in 1867, and a working relationship evolved. In 1873, Van joined the Colo-

1. Atwood Manley, *Frederic Remington: In the Land of His Youth* (Ogdensburg, N.Y.: Northern New York Publishing Company, 1961). This is the best resource on Remington North Country associations and family history.

nel in Ogdensburg to train the horses the Colonel purchased. This partnership in harness-racing continued until the Colonel's death in 1880. There was pride and public acclaim in the winner's circle. Both men enjoyed being there. Small wonder then that Fred Remington was a horse buff and knew the ins and outs of breeding, training, and racing. Observing horses and actually taking the reins gave him unusual insights into what made these animals tick. It is not surprising, therefore, that the young man's earliest sketches are of horses and, later, of cavalry and soldiers.

Westward migration continued even during the war years and political organization followed on the heels of settlement, but conflict with the Indian tribes on the plains continued. In 1867, the Indian Peace Commission was established by Congress to recommend a permanent Indian policy. After 1870, broad outlines of this policy began to take shape. The tribes were concentrated in two large reserves, one in Dakota Territory and the other in Indian Territory (later Oklahoma). Although this limited the Indians' ability to make war, their resistance was far from ended. Constant skirmishes with the Sioux on the Northern plains were evidence of smoldering resentment. In 1875, gold was discovered in the Black Hills on the Sioux reservation. Threatened by the influx of miners, between 2,000 and 4,000 Indians left the reservation to form, under the leadership of Chiefs Sitting Bull and Crazy Horse, the largest Indian army ever. The United States Army, led by Generals Crook, Terry, and Gibbon, was sent to round them up. The most famous battle took place near the Little Big Horn River in Montana on June 25, 1876. Lt. Col. George A. Custer's regiment under Comm. Gen. Alfred H. Terry was sent ahead to locate the enemy. Not realizing the overwhelming numerical superiority of the Indians, he divided his regiment into three parts, sending Maj. Marcus A. Reno and Capt. Frederick W. Benteen further upstream while he took a third route with over 200 men. Custer's band was overwhelmed and annihilated by the Indians. Punishment was swift; the Sioux were scattered and both Sitting Bull and Crazy Horse were later killed by reservation police. But millions of American children have gotten their notions of Indians from the tales of this bloody massacre and a Currier and Ives lithograph of it.

Custer's defeat at the Battle of the Little Big Horn (Remington was fifteen years old at the time) was an event that moved the young artist. An early sketch found in one of the ledgers he used at Highland Military Academy shows his interpretation of "Custer's Last Fight." Many years later, his painting *The Last Stand,* which appeared as the frontispiece in *Pony Tracks,* a collection of Remington stories published in 1895, portrayed the scene in a strikingly similar fashion. His romantic kinship with the dashing cavalry exploits of the military was firmly ingrained. A visit to the Little Big Horn battlefield on his first trip west to Montana in 1881, five years after the event, confirms his special affinity for this place and event.

At the age of fourteen, Remington was sent away to school, first to the Vermont Episcopal Institute in Burlington, Vermont (1875–76) and later to Highland Military Academy in Worcester, Massachusetts (1876–78). Letters and sketches from this period speak to his good soldiering instincts and knack for capturing on paper the details of what he saw and did. A natural talent is evident in his drawings of student cadet companies on parade and in his descriptions of military drills. The budding magic of his crude pen and ink renderings foreshadows the liveliness that emerges in his later works of art.

Boyhood inclinations and individual traits that were to be part of Remington's character throughout his life show in early family communications. His difficulty, for instance, in keeping his weight down and his need, if not craving, for physical exercise (along with his belief in its virtue) appear in Frederic's letters from school. His penchant for humor and his tendency to underscore a thought with a flourish of a pen or a pencil drawing are evident early.

From the beginning, Frederic Remington felt obliged to report on how hard he worked and to express his constant yearning for a vacation, which usually meant a retreat to nature. A protective mother and a father with significant literary credentials and political acumen reared a rugged individual who was yet sensitive to life's expectations. Remington had an uncanny ability to record details of specific events in his sketches, and he took pride in the fact that they were recognized by his peers as being good representations. He drew his personal experiences as if compelled. His letters are filled with pictorial delights—some humorous, some businesslike, some somber, but all faithful to the occasions and circumstances.

The correspondence from his days at Highland Military Academy reveals an adventuresome boy whose mind was more on fun than on his studies. The sketches from this period, however, reveal a developing eye for line and form. After Remington left the Academy, he enrolled in the art school at Yale University for the fall of 1878. During the summer of 1879 he returned home to northern New York. It is coincidental, though fitting, that a horserace at the St. Lawrence County Fair in the early fall of 1879 was probably the setting for his first meeting with Eva Caten, his future wife. Atwood Manley, a North Country Remington scholar, has speculated, with the aid of newspaper accounts, that both of them would have been at the fair on September 17. Eva had registered, with her brother William, to attend St. Lawrence University in Canton, New York, that fall as a special student. Remington had not yet left for his second year at Yale.

The fall semester would have begun at St. Lawrence on the Wednesday before the first Sunday in September; that is, two weeks before fair time. So Eva was definitely in Canton. At that time, the

university had no facilities for housing nonresident undergraduates, so students found room and board in village homes. Eva had become a "Caldwell" girl, taking up residence at the Pine Street home of Theodore and Sarah Caldwell, an old Canton family. The four of them, Mr. and Mrs. Caldwell and the two Catens, attended the fair on September 17. So also did Frederic Remington. Mars, a bay stallion jointly owned by Seth Remington and the trainer Van Valkenburg, was entered to race that day. The Remington family had come over from Ogdensburg to watch. Eva Caten Remington was to say much later, in her widowhood, that the introduction went like this. The Caldwell party and the Remington party were sitting together in the stands. Mrs. Caldwell said to young Remington, "Fred, I would like to have you meet our new friends Eva Caten and her brother, William, who have just entered St. Lawrence. Eva is living with us."[2] One can only wonder at this time how many visits, letters, or meetings transpired between the two from this early encounter until their marriage on October 1, 1884. We do know that courtship of some variety occurred during these five years and that Gloversville, New York, home of Eva Caten, was not an impossible distance from either Ogdensburg, New York, or New Haven, Connecticut.

The years from 1879 to 1884 were transitional for Remington. Seth Remington, his father, died on February 18, 1880. Frederic had completed a year and a half at Yale and did not return to finish the school year. The death of his father left a void that was only somewhat filled by his uncles, Horace and Robert ("Unkie Yob") Sackrider, his mother's older and younger brothers, respectively. They had been close to him in his younger years and continued to provide advice and encouragement. "Uncle Mart," Lamartine Remington, his father's younger brother, acted as his guardian and also provided counsel. Between 1880 and 1883, Remington held several different clerking and desk jobs in Albany, New York, which his uncles helped find for him. His family hoped he would go into business, and the efforts of his uncles to secure various jobs for him in Albany were meant to help him toward that goal. Remington, it appears, was not at all sure that this was the direction he wanted for his life. In August 1880, he asked Mr. Lawton Caten for Eva's hand in marriage and was refused. In the summer of 1881, as a youth of nineteen, he went west, for the first time, and spent a month or two on the plains of Montana.

Twenty-four years later, in an article for *Collier's Weekly* (March 18, 1905), he was to write, "I had brought more than ordinary schoolboy enthusiasm to Catlin, Irving, Gregg, Lewis and Clark, and others on their shelf, and youth found me sweating along their tracks. . . . Evening overtook me one night in Montana, and I by

2. Atwood Manley, "When Boy Met Girl," unpublished manuscript, pp. 6–9.

good luck made the campfire of an old wagon freighter who shared his bacon and coffee with me. I was nineteen years of age and he was a very old man."[3]

Thus began Frederic Remington's own account of how he became the pictorial historian of the American West. Fired by the stories of the old freighter, he realized that here was a fast-vanishing phase of our history that no one had attempted to illustrate. He added, "Without knowing exactly how to do it, I began to try to record some facts around me, and the more I looked the more the panorama unfolded."[4]

A number of sketches resulted from this trip, and the seeds of his love affair with the vanishing West were planted. He sold one of the sketches from this trip to *Harper's Weekly*. Intrigued by the drawing's freshness and realism but not by its finished quality, *Harper's* gave the sketch to W. A. Rogers to be redrawn. It appeared as "Cow-boys of Arizona: Roused by a Scout" in the February 25, 1882, issue.

Remington received his patrimony from his father's estate on October 4, 1882—something over $9,000. Around this time, he became interested in sheep-ranching in south central Kansas as a result of his correspondence with an old friend from Yale, Robert Camp.[5] Camp had established himself in the Peabody, Kansas, area and owned 900 sheep.

Before the Civil War, Vermont had been the leading sheep-raising state of the Union. After the war some sheep-raising developed on the plains but there was always competition if not outright warfare with cattlemen, who were convinced that sheep would ruin the grass by close cropping. Probably as a result of Camp's enthusiastic description of life on the ranch, Remington used his inheritance to buy a small 160-acre sheep ranch next to his friend's and left for Kansas early in 1883.

Living on his own during the next year, his only one on the plains, Remington matured. This interlude fulfilled his restlessness for open space and his desire to sketch what he saw, unencumbered by too many responsibilities. He became acquainted with Western

3. "A Few Words from Mr. Remington," *Collier's Weekly*, Mar. 18, 1905.
4. *Ibid.*
5. The best account of Remington's years in Kansas is found in Robert Taft, *Artists and Illustrators of the Old West: 1850–1900* (New York: Scribner's, 1953, pp. 114–211). Other excellent accounts of Remington's days in Kansas are David Davy, "Frederic Remington in Kansas," in *The Prairie Scout* (Abilene, Kans.: The Kansas Corral of Westerners, 1973, pp. 79–84; the same material also appears in "Frederic Remington in Kansas," *Persimmon Hill*, vol. 6, no. 1, pp. 30–35, undated); and Brian W. Dippie, "Frederic Remington's Wild West," *American Heritage*, Apr. 1975, vol. XXVI, no. 3, pp. 7–23. This same article appears as an introduction in the 1979 exhibition catalogue *Frederic Remington (1861–1909): Paintings, Drawings and Sculpture* (Shreveport, La.: R. W. Norton Art Gallery).

types and cowboy habits, gaining firsthand information that would be invaluable for his later work.

Sketching cowboys would have been easy for Remington to do in the early 1880s. The period from 1865 to 1885 was the heyday of the Great Plains cattlemen. The "long drives" of cattle began in Texas, moved north along such trails as the Chisholm, and terminated in such railroad towns as Abilene, Kansas. The long drive itself was a spectacular episode that began with the spring roundup of cattle. Cows and calves were then turned out to pasture while the steers were branded and readied for the drive north. The combined herds of several owners would usually number between 2,000 and 5,000 head. They were attended by cowboys or "cowpunchers" from each outfit. With their forty-pound saddles, twenty-foot lariats, "six-shooter" revolvers, chaps, and sombreros these men were an impressive sight. Though they were romanticized even at the time, their work was more often dull and outright dangerous. The fact that such figures attained the stature they did in folklore is partly due to the artistic skills of Frederic Remington.

Poor wool prices and an embarrassing trial that resulted from a thoughtless prank helped Remington decide to sell his Kansas ranch in late spring 1884. He left Kansas and took a trip through the Southwest sometime during the spring, sketching voluminously as he went. He saw Cheyennes and Comanches in Indian Territory and Apaches in Arizona Territory. He went farther south into Mexico as well, and spent a good deal of time and money purchasing or trading for articles such as beaded buckskin garments, ceremonial Indian dance paraphernalia, and silver decorated horse trappings that were to become the nucleus of an extensive collection of Western items in his studio.

After returning from his trip, Remington, as a silent partner, put money into the Bishop and Christie Saloon in Kansas City. He made a down payment on a small house and returned to Canton, New York.

On October 1, 1884, Frederic Remington and Eva Caten were married in Gloversville, New York. They left immediately for Kansas City, Missouri. During that time, Remington was buying his art supplies from W. W. Findlay's art store on North Main Street in Kansas City. Sometime late in that year, Mr. Findlay apparently either asked Remington or was asked by Remington if he might try selling some of the young artist's paintings. In any case, Mr. Findlay took the paintings and they sold. Also during this period Remington sold a second drawing to *Harper's Weekly*. This time it was redrawn by Thure de Thulstrup and appeared as "Ejecting an Oklahoma Boomer" on the front cover of the March 28, 1885, issue.

Generally, however, things were not going well for Remington in the spring of 1885. Eva did not like Kansas City and had returned to live with her parents in Gloversville, New York, for a while. He

had lost the money he invested in Bishop and Christie's Saloon. In August 1885 he left again for the Southwest, following a somewhat different trail from the previous trip. He went to Arizona Territory, where Geronimo and the Apaches were known to be active. From there he wandered through the San Carlos Reservation, which had been set aside as a place for the Apaches to be resettled. He sketched continuously. Moving on to the grassy Texas ranges, he struck up a friendship with a Texas cowboy and rode northward into Indian Territory. Eventually they reached Fort Sill, one of the principal military strongholds of Indian Territory and also the center of the Comanche reservation. He returned to Kansas City at the end of the summer, his portfolio jammed with sketches. He was financially destitute but determined to go to New York in the hope of selling some of his pictures.

It was the right decision. He would learn that his art had a magic appeal for the Easterner who was curious about the rough and tumble life of cowpunchers, the ways of the "savage" Indians, and the general topography of the West.

Someone who could enlighten through words and illustrations was going to be very much in demand. The time in Kansas was a period of contemplation and decision-making. The die had been cast in favor of an art career. Art would be his means of expression. He was to say later, "Art is a she-devil of a mistress, and if at times in earlier days she would not stoop to my way of thinking, I have persevered and will continue. Some day, who knows, she may let me tell you some of my secrets."[6]

The following letters and sketches give the flavor of those early years when Remington first became intimately acquainted with Western styles and ranch life. Whether roping horses or chasing rabbits, from the loneliness and hard work of eking out an existence on the plains to the joys of freedom while traveling and sketching, Frederic Remington was learning about the West in a very personal way.

6. "A Few Words from Mr. Remington," Collier's Weekly, Mar. 18, 1905.

One of the earliest letters to Remington is from his father, written when Seth Remington was in Illinois on business. Frederic was nine years old. It reveals a father-son relationship that was probably typical for its time: somewhat businesslike and including fatherly advice. The letter contains commentary on soldiering and discipline—two values that this distinguished Civil War veteran was bound to pass on to his only child.

☐ **SETH REMINGTON TO FREDERIC REMINGTON**

Sherman House
Chicago, March 9, 1871

My dear little Fred— I write this letter with a pencil because I can not get a pen except in the office and your mother wants I should write in her room so she can see what I say to her old darling.

We arrived in Chicago last evening at 8 o'clock. It was 9 by my watch there being an hours difference between the time here and in Canton. Your Uncle Mart[1] will explain to you how that queer state of things arises. Your mother behaved liked a veteran all the way but Mrs. Cheney was quite miserable. She went directly home without stopping. This morning your mother and myself took a stroll about the city and called into Mr. Orville Page's store, and there met Mr. Allen. We afterwards called on Mrs. Allen. They leave for home this afternoon. Your mother has bought you some soldiers, and they are no little "pea nuts" but regular "square-toed" veterans. We leave on the 5:30 train this afternoon for Bloomington. Your mother says, every little while, that she would like to know what her little Freddie is doing, and if he is well. You must say your lessons regularly and be a nice boy so that when she gets home there will be nothing to mar the pleasure of your meeting. Your mother is well and I hope will enjoy her trip almost as well as seeing you on her return, which will be a regular pleasure.

From your
"Venerable Papa"

In addition to his family, a boyhood friend with whom he kept in touch most of his life was John Howard. Howard later became the president of the Hall Coal Company in Ogdensburg and an investor in banks, the railroad, and manufacturing companies in the local area. Remington visited with him on his trips north and in later years invited him along on trips when he needed to "blow off steam." Howard's role was one of confidante and protector of Remington from his own excesses. The two complemented each other well, and their corre-

1. Lamartine Remington, Seth's brother.

spondence even in early years sheds light on Remington's private
side. When Remington, age fifteen, was away at Vermont Episcopal
Institute in Burlington, Vermont, for the school year 1875–76, he
wrote home to Howard about his experiences.

☐ *FREDERIC REMINGTON TO JOHN HOWARD*

Burlington, Vermont
Tuesday [1875]

You Farmer, I received your letter to day and you can't lose me.
John I will take one of those papers, any one you want to give me,
you are kind in giving me my pick.

I received a letter from Chot and he don't like Latin. I am just
beginning to like it, are you. I am going to read Caesar pretty
soon, and I am going to take up Geometry.

We have raised the duce here, in the last few days. Today it
snowed like sin, you could not see 4 rods and on our exercise, we
snowballed the teacher and he laid 300 tax-marks on the school.
I have got 30,000 min to stand up tomorrow.

Hopkins[1] is giving lectures on American History every day.
Excuse hurry and oblig.

Your very affec.
Fred S. Remington

John,
 All I want is room.

76 cent horse
the best time on record

Our Skipper
From the St

A number of early sketches by Remington
survive. Some were on odd scraps of paper.

1. Theodore Austin Hopkins, a teacher at Vermont Episcopal Institute.

☐ *FREDERIC REMINGTON TO JOHN HOWARD*

Burlington
June 13 [1875]

Dear John: I received your very short letter this morning and am going to answer it now, and do wish you would follow my example.

Only fifteen more days now before you see my blooming count-inence again. On the 23rd of this month we drill on the square in Burlington and our examinations begin. We are reviewing now.

I got out of drilling this after-noon on pretense of a sore foot, in order to see the drill a fellow cant see nothing while in ranks.

I am glad you like my colt, and I hope she will prove a success.

Monday was Founders-Day and we had an excursion down the Lake[1] on the steamer Vermont and I have been in the ruins of Fort Ticonderoga and Crown Point, the scene of Ethen Allen's[2] fame. I picked up a stone in the magazine as a memorial.

John I am getting my mucle up and I can circle the bar five times with out touching the ground, and chin myself ten times, and numerous other things Oh! I'm some.

We have some splendid swimming in the Lake, has the St. Lawrence got warm yet and do the boys go in. We can only stay in fifteen minutes. There are some splendid swimmers here.

There was a durned "country kidd" came here some time ago and the fellows raise H—with him they call him "Golic"

Saturday three fellows came home drunk, one was dead drunk and the fellows put him in the barn, answered his roll-calls for him, and Ham never missed him at prayers. The fellows extinguished the lights and he stayed out all night, he was sober in the morning.

There was a little fellow sick from smoking. Oh! We aint no By G__ boys here. Though I never will drink, I have been asked a good deal but you need not be afraid of me.

It takes my time now. When a fellow wants to get away to school, he wants to get home again, sooner, but every one has to find this out.

Frederic

1. Lake Champlain.
2. On May 10, 1775, Ethan Allen captured Fort Ticonderoga, New York, from the British.

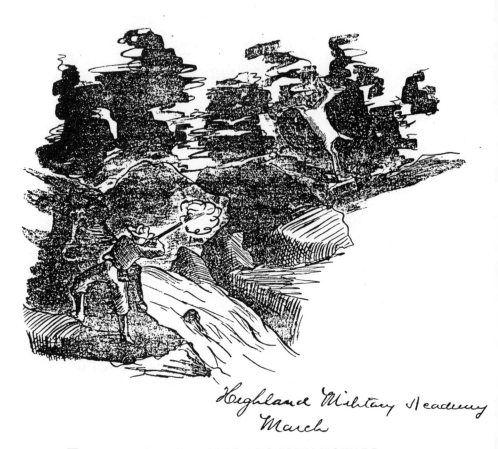

Highland Military Academy
March

☐ *FREDERIC REMINGTON TO JOHN HOWARD*

Rock Point
Friday [1876]
Dear Old Boy: Excuse me for not writing before, but I all most
forgot you, but here goes now any way. How are things getting
along in Old Ogd. I would like to be there now, you may bet.
We had about three inches of snow, snow, beautiful snow, here a
day or two ago. We are to have a boss old fight here next Satur-
day, between a fellow from Ill. and one from Mass. I am to be Ill.
second. Ill. has licked him before. Its only about 40 more days
and then I'll leave this "blot on civilization" for three weeks at
home. What fun do you fellows have now. We had a lot of chick-
ens and turkey and some cake in no. 3 the other night, we had
some fun about 12 o'clock. We've got a staving old Latin lesson
today, about 6 lines to translate to English and 13 to translate to
Latin. I've got about three hours to stand up on Saturday. I would
like to see the fellows now, bad, I had a fight a day or so ago, I
licked, retreaving the reputation of Ogd. I've got a black-eye, play-
ing football. Its a nice thing to have, why don't you get on. Do you
have fun hunting now. We have to write a sermon every Sunday,
an essay every Wednesday, and a page of Daily Writing every day,

a letter every three days. I wear a blue shirt, top boots, and a slouch hat, taken from a Tenn. chap. But I must close now. Write soon.

Yours,

F.S. Remington

Remington attended Highland Military Academy, Worcester, Massachusetts, from 1876 to 1878. An unnamed friend compiled this description of young Remington at the Academy. It was in the possession of Ella Remington Mills, Remington's cousin.[1]

☐ *TO ELLA REMINGTON MILLS FROM UNNAMED FRIEND*

School life at Highland Military Academy in 1876–77 was one of hard work and long hours with strict military discipline maintained by cadet officers. A new cadet got his first instruction in the "Awkward Squad" under a cadet Lieutenant or Sargeant, who lost no opportunity to impress his superiority upon the new comer. Here he got his first lessons in the "setting up" drill, in marching and later the "manual of arms."

Frederick Remington was in my "Awkward Squad" and I well remember that his cheerful interest in mastering the details of military drill soon brought him many friends. Out of a boy rather stout of build and rather careless and easy in his ways, was soon developed a good soldier and popular cadet.

He had a breezy way, a happy and generous disposition with a willingness to do things that the boys liked. We soon found that he had a talent for drawing which made him in demand at all gatherings of the cadets, who delighted in his caricatures of cadet officers and the teachers. He would draw pictures of the cadet corp on parade "noble colour guard," and his sketches of the companies in various maneuvers were the wonder of the school, so correct were they in detail, so true to life, and so spirited.

On April 20, 1877, he wrote his name in my autograph album and decorated the page with a sketch of the school on parade and two character sketches entitled "5:20 AM" (the hour of morning roll-call) and "5:20 PM" (the hour of dress parade). All of these were sure indication of the brilliant career in store for one who as a boy had so many attractive qualities.

1. A copy is in the Remington Collection at the Kansas State Historical Society, Topeka, Kansas.

Julian Wilder, a cadet and fellow classmate at Highland Military Academy, spoke of Remington's strength from the experience of injuries received in a wrestling match with him. Another student recalled him as vital, aggressive, and full of good humor. This same Wilder had a friend in Augusta, Maine, named Scott Turner, who shared Remington's passion for drawing. Turner's letters to Wilder contained sketches that Remington saw. This led to an exchange of letters between Turner and Remington, although they never met.[1]

☐ *FREDERIC REMINGTON TO SCOTT TURNER*

Highland Military Academy
March 3, 1877

Friend Scott— Having seen some of your drawings which you sent Wilder, I am desirous of opening a correspondence with you. I hope you will honor me with your sanction. I am the fortunate possessor of one of your drawings, entitled "Where is the Cap't?" You draw splendidly, and I admire your mode of shading, which I cannot get the "hang" of. Your favorite subject is soldiers. So is mine; but, mind you, I do not pretend to compare my drawings with yours. I can draw almost as good as Wilder. If you will please to send me a sheet of pictures such as you sent Wilder, I will do my best to draw a little cadet life at the Highland Military Academy.

Yours truly,
F. S. Remington

☐ *FREDERIC REMINGTON TO SCOTT TURNER*

[Highland Military Academy]
[1877]

I don't amount to anything in particular. I can spoil an immense amount of good grub at any time in the day. I am almost as bad as Wilder, who is acknowledged to be the "baddest" man in school in that line. I go a good man on muscle. My hair is short and stiff, and I am about five feet eight inches and weigh one hundred and eighty pounds. There is nothing poetical about me. I live in Ogdensburg, New York, on the banks of the St. Lawrence. I went to school in Burlington, Vermont last year. I lived in Bloomington, Illinois once in my life and never want to live there any more. I

1. The letters appear in Crooker, Orin Edson, "A Page from the Boyhood of Frederic Remington," *Collier's Weekly*, September 17, 1910, p. 28.

am well instructed in Upton's Infantry Tactics and have just come off from an hour's drill.

Wilder and myself have been under arrest for the last few days. We marched into the armory—I with the saber that David killed Goliath with and Wilder with an old rusty musket. I don't swear much, although it is my weak point, and I have to look my letters over carefully to see if there is any cussing in them. I never smoke— only when I can get treated—and I never condescent to the friendly offer of "Take something old hoss?"

☐ *FREDERIC REMINGTON TO SCOTT TURNER*

[Highland Military Academy]
[1877]

. . . Hearing you wanted a picture of me, I send you this "misfortune." I don't see what you want of such a looking thing as this. You probably would not have wanted it if you had known what it was going to look like. You can burn it up, but don't throw it into the backyard or it may scare some wandering hen to death, and if perchance a small boy should find it he would exhibit it for two cents a look as the Grand Duke Alexis or "A What Is It!" There is nothing about that picture which shows me off to advantage. They all say I am handsome. (I don't think so.) But you wouldn't get that idea from that photo. No! And in fact I never had a picture taken which showed my fine points. Besides, it costs like sin for me to have my "fiz" got inside of a camera, as they have to put a coal sieve in front of the box to keep it from cracking the glass. . . .

☐ *FREDERIC REMINGTON TO SCOTT TURNER*

[Highland Military Academy]
[1877]

. . . I hope you will excuse the blots I got on the upper end of this sheet. They don't mean anything in particular, but I wish you would make some similar ones on your return letter. Draw me a good picture, only one, and I'll be your slave forever. Give us battle between the Russians and Turks, or Indians and soldiers . . .

. . . Don't send me any more women or any more dudes. Send me Indians, cowboys, villans or toughs. These are what I want. . . .

"Unkie Yob" was Remington's Uncle Robert Sackrider, his mother's younger brother. He was one of the executors of Remington's father's estate. The two men were good friends.

☐ *FREDERIC REMINGTON TO ROBERT SACKRIDER*

Highland Military Academy
Worcester, Mass.
November 13 [1877]

Dear "Unkie Yob," Rob, I am so sick and have been so for the past few days that I can hardly find time to write. The cause of this is, upon receiving a letter from home I read a certain passage in it, that you will surmise that passage I have no doubt, and I imediately had an epelectic fit, and ruptured myself in the bargan. Now Rob I do feel so sorry for you but then it cant be helped. Dont let it happen again. By jove, I picture to myself O horrors! What a sight it will be, when that sweet little picture of sequestered inocence arrives at the age of 18 years and applies to

his emaciated paternal for a $5 william, in order that he may take his girl to a sleigh ride.

Now if you are at a loss to find a name for this prodigy just take the advice of somebody who has had some experience in naming babies. Give him a good substancial name, such as will take poets eyes or break a girls heart to look at. For instance "Bret," "Lionel," "Chester," "Terril," or something similar. Dont be harsh or a helpless elf and apply any such epithet as "John, Bill, Horace, Hardie," or any name like these who have been borne by notorious characters around Canton. Now I always liked Grandpa[1] and would do anything for him or let him do anything for me, but name a baby. He might name it after "Obadiah, or Zacharias" which worthy gentlemen were pasionately fond of attending church, according to Bibalictic story.

It all very nice when he is contented with such things as these but when he demands these articles and interests the Gov.[2] to put on the "mitts" with him, it is another affair.

No fooling "Yob" I congratulate you

1. Henry Sackrider, Robert's father, Remington's grandfather.
2. Henry Sackrider was also called "the Governor."

and Emma[3] on the happiness which this
occasion must needs afford. Now Rob,
be shure that this aspirate never
touches tobacco.

When he get old enough
I'll learn him to "box." I
have the job engaged
with Mart's infant.

Yours affec.
Fred c.

Head Quarters H. Military Aca.
This 13 day of Nov. In the year
of our Lord 1877

(Postscript to November 13th [1877] Letter)

I am studying real hard now, no fooling. Haint studied so much
since I was a boy. I dont waste no more time on that nonsensical
Geometry but am progressing "right-bully" in the "Roman gab"

This country looks like the banks of New England. A fog has
been hanging over here so that you have to ring a bell or you'l
run over some one.

We are having the artillery drill now and it beats the bayonet
and saber all hollow. I am "No 2 on the 2nd gun." The feller what
puts the ammunition into the bore of the piece. (it is generally a
"chaw of tobbacar") We dont fire now but are going to soon.

I am reading "Great Expectations" (Dickens) now and its im-
mense. If he hadn't started off with something bout soldiers I
never would have read it.

Don't you forget to send me some postage stamps.
 Yours all over,
 "Younk"

3. Emma Sackrider, Robert's wife.

A number of early sketches by Remington are found in the margins of pages in his early textbooks.

Passage by Boat.

Poem about Highland Military Academy found in Remington's Autograph book:[1]

There a land where they don't have fun
There a land where they play poker none
There a land when they don't have rum
I'll be d—n if I want to go there

In that land you must sit up plumb
And the giddiest dissipations chewing gum
If you substitute tobacco you'l be run
 Out by old Peter with a gun
New young fellow if for Congress
 you would run

PAY DAX

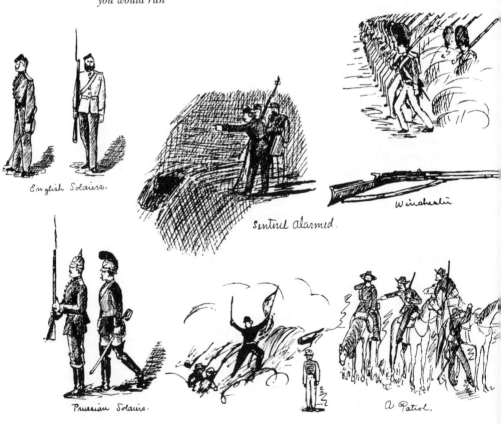

English Soldiers.

Sentrul Alarmed.

Winchester

Prussian Soldier.

a Patrol.

1. Frederic Remington Art Museum, Ogdensburg, New York.

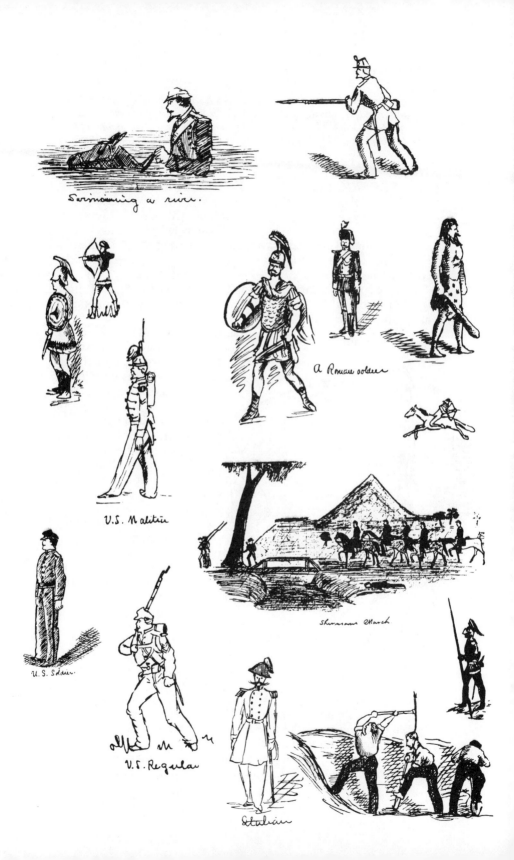

Swimming a river.

A Roman soldier

U.S. Militia

U.S. Soldier.

U.S. Regular

Sherman's March

Italian

Early letters to his family while he was a student at Highland Military Academy reveal a curious mix of the mischievous and the serious in Remington. There is one to his mother, Clara Remington, one to his friend John Howard of Ogdensburg, and one to his mother's older brother, Horace Sackrider.

☐ FREDERIC REMINGTON TO CLARA REMINGTON

Highland Military Academy
Wednesday [1878]

Dear Mother, I can hardly find time to write to you. Must'nt expect any (6) page letters this summer. It is just (8) weeks till I come home.

I wrote a good composition on "Chivalry" to day. One of those I tried on and not one of those where I spit some ink on my paper and rub it around with a brush.

Tell the Col. to take lots of physical exercise and no mental. You are a good man pa, only you are one sided. Like this picture in next page. Brains overbalances muscle.

You are a nice man and a kind father but you dont know when who are licked. You would stick by your old desk until some disease had done the "biz" for you. Do you miss my "gab," on martial subjects. Guess if I hadn't come home you would have died, but my pleasant company and smiling "phiz" kind'er revived your drooping spirits.

I have been trying to diet this week but have eaten enough to kill Goliah. Wats the use of dieting when you are as well as I am.
[unsigned]

☐ FREDERIC REMINGTON TO JOHN HOWARD

Highland Military Academy
April 14, 1878

Dear "John," I thought I would write you a few lines. Last Sunday about ten fellers took it into their heads tat a half holiday would be a good thing and so they slid of limits and went into the country. Every thing went merry as a marrage bell until the sun began to sink and their stomachs went back on them when they turned their languid steps towards, "Hell's blighted hope," as the

boys term the H.M.A. When we struck home the Commandant
and a detail were in waiting and three fellows (myself among
them) were filed off to the "pocketts" where a gloomy period of
three days awaited us. Solitary confinement; dont seem much.
Shut yourself up in your ash-house for three days and nights,
by that means you may test an apoligy for it. I have come to the
conclusion as they most all of them do, that this "skimming" off
limits dont shine on both sides of the shield. There a bright side
and a dark side to such escapades, as I have tested both and find
that they wont ballance.

I suppose you are enjoying your life in Ogd. while I am lan-
guishing in this miserable hole. But "every dog has his day," and
mine is'nt far distand (21st of June) I am coming home Easter for
about a week. I cannot but dream of the days when I can call my
soul my own but they are few and far between, as you will find if
you look over our catalogue of terms and vacations.

Love to the boys, keep some for yourself, It ain't very sweet but
whats that got to do with "Tattoo." Lights out, a general scramble
to divest yourself of uniform.

Good night. Write to me. I'm alone.

Fred Remington

☐ *FREDERIC REMINGTON TO HORACE SACKRIDER*

Highland Military Academy
May 27, 1878

Dear Horace, I thought I would drop you a line, in the dubious
hope that by some freak on natures part, you might respond.

As you might be interested in such a thing I would say, that I
have just finished a complete course in book-keeping both single
and double entry. I am of quite to much of a speculative mind to
ever make a success at the solem reality of a book-keeper. No sir,
I will never burn any mid-night oil in squaring accounts. The
Lord made me, and after a turn of mind which would never per-
mit me to run my life from the point of a pen. He never gifted
me with enough of that peculiarity which characterized Job. I
never intend to do any great amount of labor. I have but one
short life and do not aspire to wealth nor fame in a degree which
could only be obtained by an extraordinary effort on my part.

"The pathes of glory lead but to the grave." As book-keeping
would not tend to extend my chances in the one direction (fame)
and seeing that he seldom reaches further in the other direction
I have concluded not to hire out in that capasity. Therefore my
stock of knowledge in that point is superfluious but if Rob wants
a few points, why apply to the little "snip" who used to supplicate

for the donation of a jack-knife and thanks to the several partners of Sackrider & Sons[1] generally gained his point.

No, I am going to try and get into Cornell College this coming June and if I succeed will be a Journalist. I mean to study for an artist anyhow whether I ever make a success at it or not.

There is just one obstruction between me and prosperity, that is, if Uncle Sam ever gets into any delicate controversy I will leave my bones where thousands of patriotic Americans have deposited theirs within the past fifteen years.

Don't calculate there will be much trouble about Fenians[2] and Communists this coming summer. In the first place the United States never bred enough Irish Nationalists to get over the Canadian line; and second America is an un-wholesome soil for a transplan-tation of such a foreign idea.

Next Wednesday we start on our annual excampment. Well, its hard with the marching, etc., but its different from barrack life. I am an acting Corporal now and dont have any more sentinel duty to do, which is the bug-bear of a soldier's life.

I have not seen you Canton people or at least I wont see you

until a year shall have passed. I gues the Col. is going up in the woods with me this year. It will do the old boy good. Lord I fix him. I fill those pants up so full of fleash that cast iron buttons wont hold and I'll put a tan on his "phiz" that would lead you into a dialema as to what part of the South Sea Islands he came from. Darn him, I'm disgusted so is Mama. We have concluded that the old boy dont know enough to take care of his precious corpse and we are going to do it for him. Ma snatched him out of his office and I'm going to cast him off

"Good night."

1. A Canton, New York, hardware firm started by Henry Sackrider, Frederic's grandfather.

2. Members of an Irish revolutionary society. Fenians in the United States attempted raids into Canada between 1866 and 1871. Their avowed purpose was to seize Canada and hold it as a hostage for Irish freedom. At least one of the raids took place from Malone, New York, not far from Ogdensburg.

somewhere where a tooth-brush and a newspaper will be as difficult to find as "Rat" Warner at church.

The drum for "tatoo" has beat and I must to the court of Morpheus. Good by, much love, millions of imaginary kisses to the branch of the Sackrider trible so he gos,

Yours all over,
Fred Remington

After leaving Highland Military Academy, Remington attended the Art School at Yale University from the fall of 1878 to mid-1879. He became friends with Poultney Bigelow, who was the editor of the Yale Courant *when the decision was made to illustrate the magazine. Remington was asked to submit a sketch. It was used on November 2, 1879, as number four in a series called "College Riff Raff." His depiction of a battered football player (some say a self-portrait) was his first published piece of art.*

"Good gracious, old fellow, what have you been doing with yourself?"

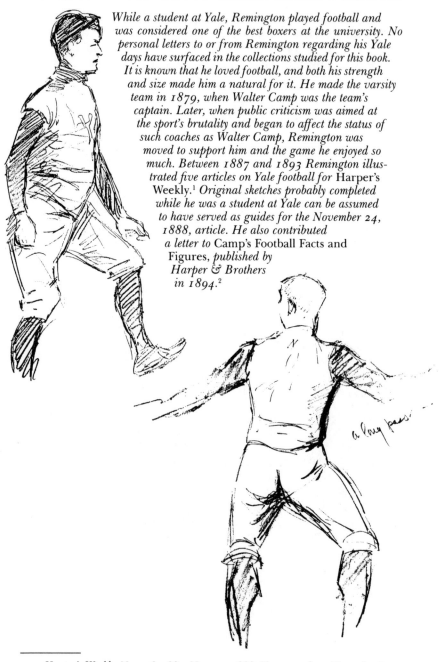

While a student at Yale, Remington played football and was considered one of the best boxers at the university. No personal letters to or from Remington regarding his Yale days have surfaced in the collections studied for this book. It is known that he loved football, and both his strength and size made him a natural for it. He made the varsity team in 1879, when Walter Camp was the team's captain. Later, when public criticism was aimed at the sport's brutality and began to affect the status of such coaches as Walter Camp, Remington was moved to support him and the game he enjoyed so much. Between 1887 and 1893 Remington illustrated five articles on Yale football for Harper's Weekly.[1] Original sketches probably completed while he was a student at Yale can be assumed to have served as guides for the November 24, 1888, article. He also contributed a letter to Camp's Football Facts and Figures, published by Harper & Brothers in 1894.[2]

a long pass

1. *Harper's Weekly*, Nov. 26, 1887; Nov. 24, 1888; Nov. 29, 1890; Nov. 18, 1893; and Dec. 2, 1893.

2. Walter Camp, *Football Facts and Figures* (New York: Harper & Brothers, 1894).

Remington returned home from Yale for Christmas vacation in 1879 to find his father gravely ill. After his father died on February 18, 1880, he did not return to Yale but instead took a series of clerking jobs in Albany, New York, arranged for him by his uncles. The first was as executive clerk in the chambers of Gov. Alonzo B. Cornell. Aunt Marcia Sackrider was the wife of Horace Sackrider, his mother's older brother.

☐ **FREDERIC REMINGTON TO MARCIA SACKRIDER**

Insurance Department
State of New York
Monday [1879]

Dear Aunt Marcia, I received your kind letter so much against the principles of secrecy fostered by the Xmass god, St. Nocholas. Well I don't think so much of Santa Clause as I used to—as the saying goes somewhere in sacred or profane literature—"when I became a man I put away childish things:—but then I aint very stoical as yet and if I should see old S. Clause coming down the chimney I should step up and remove the land irons so that he would not hurt his feet. You want to give me something just once more hey—and you want to know what I want too. Well, lets see now that I think of it I want every bit of personal property in the world, but like every feller I want some things more than I want others. I would rather have a box of bon-bons than a whole gross of Downe's Elexir. I want a brown-stone front, a foot man on a closed cab—and two black horses on the same principle as Horaces farm team but not afflicted with as much age as they are. I want a saddle horse. I want a situation as son in law in first class family—no objections to going a few miles in the country. I want an English walking Jacket—fur collar & cuffs. I want "La Art"[1] for a year. I want De Neuvilles[2] last autotype. I want some half hundred books. I want about 1,000,000 Henry Clay cigars. I want a smoking set—not the common kind but the uncommon kind. I want a board bill paid in advance for 4 weeks at Fire Island. Oh laws I want everthing—anything and nothing at all. Guess I would'nt buy anything for such a feller as I am. I want to ride a horse Christmas—I want to see Mother and you all—I want something to eat—I want to get away from here and Albany—all of which I hate + I am happy.

I saw some Egyptian hieroglyshics on the bottom of your letter. They were very interesting. I made out "box-stall" and "Turk"—

1. A weekly art magazine published in Paris between 1875 and 1883.
2. Alphonse Marie De Neuville, a French artist who portrayed horses and men in action in the Franco-Prussian War.

I inferred that the Turk was in the box-stall. The only Turk in Canton is Jerry Weston and if he is in a box stall he's in luck this winter. Chop his straw for him and if he don't choke to death this winter leave the window open and he'l blow out. Humanity is getting better and better and the future of the commonwealth is assured.

<div style="text-align: right">
Yours as ever

Fred
</div>

During the summer of 1880, while he was in Albany, Remington asked for Eva Caten's hand in marriage from her father, Lawton, and was refused.

☐ FREDERIC REMINGTON TO LAWTON CATEN

<div style="text-align: center">
Albany

August 25, 1880
</div>

Mr. L. Caten,

Dear Sir: I pen these lines to you on a most delicate subject and hope they will at least receive your consideration. For a year I have known your daughter Eva, and during that time have contracted a deep affection for her. I have received encouragement in all propriety, and with her permission and the fact of your countenencing my association, I feel warranted now in asking whether or not you will consent to an engagement between us. If you need time to consider or data on which to formulate I will of course be glad to accede either.

Hoping this will not be distasteful, allow me to sign.

<div style="text-align: right">
Your Obd. Servt.

Fred'c Remington

Ex. Chamber

Albany, N.Y.
</div>

Remington worked at several jobs in Albany between August 1880 and the summer of 1881. He spent five months as a reporter for the Albany Morning Express *(partly owned by his uncle Lamartine, "Uncle Mart," Remington) and worked for a time with his Uncle Mart in the Department of Public Instruction. During this period he continued to write humorous letters to his Aunt Marcia Sackrider.*

☐ *FREDERIC REMINGTON TO MARCIA SACKRIDER*

"Come Hal lets have no more of this."
 Fal.

> State of New York
> Department of Public
> Instruction
> Superintendent's Office
> Albany, Sunday,—[1880]

Dear Aunt, I shipped a box of imported Havanna Henry Clay,
Govt. stamped, superfine, smoothe wrapper, grain filled $3.50
segars to your address and if any son-of-a gun says they are not
the "daisy thing" he never breathed the fumes that are foreign to
his primeval duny heap, and we hereby proscribe his judgement
as an imbecilic voponug. Do we not?

I am thrown on an ungenerous world when I write to you. I am
subjected to the fastidious scruples of Webster and if I am ever an
unknown quantity it is where I venture into the domain of that
monopolist. Its mean to twit a lame man or remark on poverty in
the shape of revised clothing and I loose all sympathy for anyone
who makes it a point to sit down with one of my episltes and a
Websters unabridged and seek to verify a well authenticated
fact—namely that I disagree with Webster. And still I consider it
no disgrace but knowing the conservative spirit that adores that
many authority I am nervous when at varience. It seems to signify
that I am not up to demands of the public by an unaequantence
with Webster. Still Webster didn't know me and were not "all men
created free and equal." Aint Webster dead? Aint you going to
have any more words cause he's dead? I would have you know
that I hold myself a man endowed with a faculty of reason and if
any one will show me any reason for putting in two "g's" I put em
in otherwise I sign myself.

> Yours Emphatically
> Frederic the Great word juggler

(To His Websterian Aunt)

☐ *FREDERIC REMINGTON TO MARCIA SACKRIDER*

> State of New York
> Department of Public Instruction
> Superintendent's Office
> Albany, Friday—[1880]

Dear Aunt, I am right glad you liked the segars 'cause that bears
my judgement out in a matter that I really pride myself on. It is
said to be one of the qualifications of a gentleman that he "pass

creditable comments on the wine" now you see I lay out for a
gentleman although at wine I am so incompetant that I take the
"cue" from any fellow with a rubicond nose and side as he does.
But on segars I am par-excellence as I have inherited from both
ancesters a love for the "filthy weed," so when ever anyone wants
to know the quality of a box of imported stubs they have but to
call me around and ante up one and I can judge to their
satisfaction.

The adjutant General officially stated that we would be retained
until the 30 of April. I will be home about that time and there we
will try and have some fun.

Give my love to them all and dont you smoke many of those
segars in your present weak condition. Tell Horace that he can
give me one or two of those if he dont smoke 'em all up before
I get there and now.

<div align="right">
I hush to murmer

Fred R.
</div>

☐ *FREDERIC REMINGTON TO MARCIA SACKRIDER*

<div align="right">
State of New York

Department of Public Instruction

Superintendent's Office

Albany, Wednesday—[1880]
</div>

My Dear Aunt, I was gratified at receiving your letter and am
sorry your mind is not at peace concerning my "viciated ideas."
Permit me to subjoin that I have never put myself on record as an
infidel, materialist, or anything in fact. I shall be what my reason
inclinations point out as the right thing and whatever my religion
shall be. I mean that morality shall not suffer. I fain would follow,
as a conservative Englishman should, in the footsteps of my fa-
thers but it is a fact that my fathers have erred in many things and
if any traditions and custom of theirs will not stand the test of
investigation then it will require the demoralizing taint of hypoc-
racy for me to follow where I cannot see. But as I have said dont
trouble yourself as I am not professing anything at present and
do you know that persecution or intolerance never made a con-
vert that was sincere. That is a thing a man must work out by
himself and the fewer prejudices that are intermixed the better &
easier. Never hypocritical, sometimes religious and always
moral—thats the idea.

Ma is enjoying herself and has it will write you.
Good by and peace be with you. Love to all—

<div align="right">
Yours lovingly

Fred
</div>

☐ *FREDERIC REMINGTON TO MARCIA SACKRIDER*

> State of New York
> Department of Public Instruction
> Superintendent's Office
> Albany, Friday—[1880]

Dear Aunt: I received your kind hearted Easter greeting and I now lay out to refute and uncalled for proposition that you stated. "My letters is stupid"—it is hey?—well it aint. Your letter is the outpouring of a generous nature—written to an undeserving wretch—therefore generous. Your letter framed in the most approved high ritulistic, double leaded English rhetoric and bearing a poetry deeper, more real than any labored contortion of a Prof. Poet. that has been paid for at the rate of a quarter a line, brings that faith back to a sinking spirit who doubts the exhistence of any Edenarric virtues in human nature.

It is a strong trestlework that a man stands in when he knows that a good and well ordered member of the Episcopal faith in the feminine gender offers him her support. Letters contain such refined expressions of sympathetic esteem as yours are not to be found in every mail and it aint an illogical visitation whose only usefulness is to impress the virtue of forbearance on unrighteous humanity. Oh I'm in luck. But if I insist on boarding with you let me remind you that Yob would think a cross section bedlam had lit down him if I gathered in his festive board. Any Christian woman who can gaze with serene resignation on the never ending channel of distruction (my worth) with out sighs of regret is a good one. This may seem sytrical—it is—but of course I don't mean it. Anything for fun. Yours. Fred

A letter is seldom taken in the spirit it is offered.

Between August and October 1881 Remington traveled west to Montana on his own and returned with a number of sketches. He then started a new job in Albany in the State Insurance Department. The meeting with George William Curtis, editor of Harper's Weekly, *referred to in the following letter probably did take place.*

A quiet evening on the Ranch.

☐ *FREDERIC REMINGTON TO HORACE SACKRIDER*

Insurance Department
State of New York
Albany [1881]

Dear Uncle, I am in the Actuary Department of the above office.
It is all figure work and a good scheme for me. I have had no
trouble so far. The business consists in calculating the worth of
policies. I shall expect a permanent appointment soon and per-
haps a transfer to some other branch of work, such as engrossing.

This is a great year for hay and potatoes. A man in the office
just paid $2.62½ per bushel for good potatoes. They have been
worth $3.00 bush. It might be a good investment for you to ship
some—but do it later—

I have an appointment to go to New York soon to see George
William Curtis of Harpers Weekly in order to see if that Co. will
publish some work of mine. It would be a good scheme if I could
get something in there.

There is not much hope in political circles of the State Ticket.
Jamie Husted[1] will be "cut to hell" and so will some of the [illeg-
ible] There is the usual row in the country. We are going to be
close on the Senate this year.

Has my saddle come?

Yours truly,
Fred Remington

☐ *FREDERIC REMINGTON TO MARCIA SACKRIDER*

Insurance Department
State of New York
Albany, Thursday—[1882]

Dear Aunt, I received your letter last week. Well—do you seek
to draw out the peculiarities of our last years corrospondence
again? If so I will take my regular dose of Hosletters bitters and

1. A New York State politician.

now you see him

and pretty shortly you dont.

proceed to grind out "the gull and bitterness of debate." I tell you
we are not built—either of us—for lying on daisies and indulging
in idle phrases—we are both of us diameterically opposed to each
other that we can never agree. I dont bank much of the Episcopal
church and you cant convince yourself that you are a mammal
and a simple improvement on a protoplasm. Then again you are
inclined to take some stock in Democracy while I dont lay in a
cent on that hand. But to diversify—those photographs of mother
are the finest things in existence—well taken and a good subject—
I just tell you that the old girl is a good looker if she aint anything
else. I take a good deal of pride in her.

So Horace has got another Pegasus has he—say would'nt
Horace have taken a satanic delight in trading horses with Don
Quixote. Canton is positively alive with news now—the Caldwell[1]
failure—the Hodkins[2] kid and numerous smaller things are what
go to make up the fever of human existence.

Well good day—cant write anymore—spose you saw the Har-
pers Weekly picture[3]—got three or four more drawings coming
out in Lippincotts Monthly on the St. Regis.[4]

Well—so long—write me often, I like to hear from you.
 Yours truly,
 Frederic the Great
Tell Horace to pull down his vest and also tell him not to let
mother take on about the Journal.

1. A Canton family.
2. Another Canton family.
3. "Cowboys of Arizona: Roused by a Scout," redrawn by W. A. Rogers from a
sketch of Frederic Remington, *Harper's Weekly*, February 25, 1882.
4. These drawings were never published in *Lippincott's Monthly*.

Remington received a little over $9,000 from his father's estate in October 1882. In February 1883, he bought a sheep ranch near Peabody, Kansas, where he learned first-hand of the vicissitudes of such a life. On February 23, 1884, he sold the property. There is little correspondence from this period other than with his uncle Horace Sackrider when he needed additional money to develop his sheep ranch.

☐ *FREDERIC REMINGTON TO HORACE SACKRIDER*

Peabody Bank
Peabody, Kansas
May 16, 1883

Horace D. Sackrider

Dear Uncle:— My account with this Bank is within a hundred dollars or so of drawn up and I have this day made a draft through them on the St. Law. Co. Bk. for one thousand dollars. My sheep sheds are going up and I want the money. Have no delay as I would not have my draft dishonored for the world.

The Mo. Land papers came duly to hand and I sent them on.

Yours
Frederic Remington

"write to me."

☐ *FREDERIC REMINGTON TO HORACE SACKRIDER*

Peabody, Kansas
August 23, 1883

Dear Horace:— I have waited in vain for the statement of my affairs as they stand in your hands.

The one thousand dol's I just drew I wanted for expenses—I now want one thousand dollars more to make my final payment

on my sheep—due the 1 of August. I wish you would telegraph whether I can draw that amount now. Otherwise I shall be compelled to borrow at 2⁺ per cent a year.

Please have a settlement with me immediately.

Yours truly,
Frederic Remington

☐ *FREDERIC REMINGTON TO ARTHUR F. MERKLEY*

Ranch—Henry Creek.
But.[ler] Co.
P.O. Peabody—Kansas
December 29, 1883

My dear Arthur:— Your letter at hand. As I am about to sell out here and go somewhere else it is needless to say anything about the subject to which your questions apply. I shall not get away from here very soon and can be found at the above address so you had better stop over here as you come East. I shall be delighted to see you. When I get my money out of this scheme I am going further West—I do not like Kansas and then tackle some business.

I dont care whether it is stock, mercantile, either hardware or whisky—or anything else. I should like nothing better in the world than to find a partner, whom I had confidence in and who had a little money. You are acquainted with the hardware biz. I believe. Why not start a hardware ranch out West?

Write to me and tell me when I can look for you in person. If you want to do any business with me you must "talk"—I cant write. Come on.

Hows your health?

Yours truly,
Frederic Remington

Chapter 2
Visions of the West
1884–1889

WHEN REMINGTON DECIDED TO RETURN TO NEW YORK in the fall of 1885 to seek a career as an illustrator, he probably did not realize at first how much he was the right man at the right time. The period following the Civil War had witnessed a rapid movement of the American people westward, and a great deal of pressure was being exerted on the Indian tribes of the Great Plains and Rocky Mountain regions. Up until the 1860s the Indians of the plains had been relatively peaceful, but the advance of white settlers along the upper Mississippi and Missouri frontier and the Indians' dissatisfaction at their treatment by the government combined to increase the occasions for hostilities.

By the 1870s there was great interest among easterners in the West. Abundant opportunities for farming, mining, ranching, and lumbering on a large scale were available, but the area had to be made safe and accessible for settlement first.

It is estimated that 225,000 Indians inhabited the plains in the 1860s. Mounted on swift horses and relying in many ways on buffalo that roamed the open range in the millions, these nomadic tribes were skilled fighters who resisted the encroachment of the white man. There were the Crow, Arapaho, Blackfeet, Cheyenne, and Sioux in the North, and Kiowa, southern Arapaho, southern Cheyenne, Comanche, Ute, and Apache in the South who were determined to halt the advance of settlers. Skirmishes erupted all over the West between Indians and U.S. troops in the field to protect settlers moving west along the Missouri River and other well-traveled trails. Eventually, the encroachment of these settlers, the movement of miners into the mountains, the invasion of the grassland by cattlemen, and the completion of the Transcontinental Railroad in

1869 made inevitable the end of nomadic life for the Indians. The extermination of the buffalo, however, was one of the most important factors in the decline of the militant resistance of the plains Indian. Hides, sinew, and buffalo meat were necessary for Indian survival as hunters. Although there were perhaps 15,000,000 buffalo on the plains in 1865, by 1885 only a few straggling herds remained. These survived under government protection and could no longer provide subsistence for the Indian.

During the last half of the nineteenth century, the American people were trying to sort out their ideas about the army, the West, and Indians in particular. A consensus was developing that an enlightened national policy was going to be necessary to bring an end to needless wars and massacres, to the fraudulent seizure of Indian lands, and to dishonest speculation by Indian agents. The result was a system that aimed to assimilate the Indians into a farm economy by settling them on large tracts of land. This met with mixed public reaction as well as mixed Indian reaction. There was sharp division between those who wanted to preserve tribal customs and those who wanted to "Americanize" the Indian. By 1885, however, 171 "reservations" had been established for Indians in more than twenty states and territories.

The public's interest in news about clashes between Indians and the cavalry, especially in the activities of Geronimo and the Apache tribes in the Southwest, was being spurred by the revolution taking place in American journalism. In the 1860s and '70s, New York City had been the newspaper center of the nation. Great New York dailies such as the *Tribune* under Horace Greeley were models for smaller papers across the country. Greeley was a social reformer who used the editorial page of his paper to exert considerable influence on public opinion. Smaller papers followed suit. Gradually, during the 1870s and '80s, politics was subordinated to "news," and a highly efficient machinery developed for reporting and news gathering. The importance of editorial opinion and the editorial page consequently declined. Encouraged by low postal rates and rural free delivery, newspapers rivaled each other in the effort to increase readership. Between 1870 and 1900, the number of daily newspapers in the country rose from 574 to 1,611. Circulation in the same period rose from 2,800,000 to 24,200,000. The result was that newsworthy events such as clashes between the Indians and the Army quickly reached a growing American reading public.

Newspapers alone were not able to satisfy the public's hunger for information. The gap was filled by magazines. These, too, were changing. For the twenty years following the Civil War, the principal magazines had been respectable family monthly journals such as *Harper's Monthly, Scribner's*, and *The Century Illustrated Monthly Magazine*. Printed on good stock and well illustrated, they enjoyed modest circulations and published some of the best fiction and po-

etry being produced by American writers, catering to middle-class American readers whose tastes were primarily literary. Similar in nature but more current in their content were such weeklies as *The Nation, The Independent,* and *Harper's Weekly.* They were still family magazines, well illustrated and well written but more timely, dealing with issues and political opinion as well as entertainment.

The foremost targets of criticism were the post–Civil War administrations of the Republican party, which were marred by factional quarrels, political scandals, and lack of constructive leadership. The election of 1884 brought a political upheaval that enabled the Democrats to secure the presidency for the first time since the war. Dissatisfaction within the Republican party led to the nomination of James G. Blaine, former secretary of state, rather than the incumbent Chester A. Arthur. The Democrats nominated Grover Cleveland, the courageous and efficient governor of New York, who won.

In 1888, the major issue was President Cleveland's call for downward revision of the tariff. Cleveland was renominated by the Democrats. His Republican opponent was Benjamin Harrison of Indiana, nominated after Blaine declined to become a candidate again. Harrison was elected.

In the decade of the 1880s, magazine readership grew rapidly, and a number of new magazines, designed to appeal to the mass market, appeared on the newsstands. In 1865 about 700 magazines were published in America; by 1885 there were 3,300. Toward the end of the decade, publishers would be using new techniques of mass production and marketing—cheap but attractive printing and low prices to increase circulation, and lavish advertising to increase revenues. A constant flow of articles and illustrations was needed to meet the demands of a readership increasingly aware of news events far from home.

This was the state of publishing when Remington took a portfolio of his best sketches to J. Henry Harper of *Harper's Weekly* in the fall of 1885. The quality and immediacy of these fresh new drawings, straight from the field, appealed to Harper, and he purchased two. The first was "The Apache War: Indian Scouts on Geronimo's Trail," which appeared as a full-page cover for the January 9, 1886, *Harper's Weekly.* The second was "The Apaches Are Coming," showing a horse being reined in at a gallop. It appeared on January 30, 1886.

The transition that began for Remington that fall was sudden and stunning. From an uncertain career that included ranching, business, and clerking, he moved full ahead into illustrating and art. Eva joined him again, and they took up residence in an apartment at 165 Ross Street in Brooklyn.

Harper's Weekly published a few sketches in the spring of 1886, one redrawn by de Thulstrup again. As there was no immediate

next assignment from *Harper's Weekly,* Remington entered the Art Students League of New York for the spring term beginning March 1, 1886. He was to keep in touch with some of his fellow students later, including Edward Kemble, who became a close friend and neighbor. He also kept in touch with his instructor, Julian Alden Weir, younger brother of Yale art professor John Weir. His term at the Art Students League ended in May 1886.

By that time *Harper's Weekly* was looking for someone to go west and report on the Indian wars, especially the skirmishes between Geronimo and Gen. Nelson Miles in Arizona. The die was cast. In the summer of 1886, *Harper's* chose Frederic Remington for the job. In the course of his career he would make many such trips on commission from his publishers. *Harper's Weekly* published illustrations from this trip beginning on July 17, 1886, with "Signalling the Main Command." On August 7, 1886, "Mexican Troops in Sonora" appeared along with five sketches taken from photographs. On August 21, 1886, "Soldiering in the Southwest: The Rescue of Corporal Scott" appeared with its dramatic frontispiece.

Although Remington never caught up with Geronimo, he came away from his fourth trip west with a mind full of images and two new friends. One of the friends was Gen. Nelson Miles himself, who had been sent to Arizona just weeks before Remington arrived to continue the Army's attempts to contain Geronimo. The other was Lt. Powhatan H. Clarke,[1] with whom Remington kept a regular correspondence through the summer of 1893, when Clarke accidentally drowned while on duty in Custer, Montana. For Remington, Clarke was a rich source of information about the details of army life in the Southwest. A keen observer and good writer, Clarke, in fact, had literary aspirations of his own. From his point of view, Remington might have helped open doors to publishers in New York.

Remington's interest in the American West is thoroughly chronicled in his correspondence with Clarke. Their friendship answered Remington's incessant desire for first-hand accounts of military life and equipment, and Indian battles and tribal ways. The letters reveal that Remington used Clarke as a primary source for material to illustrate articles. On several occasions he told the young lieutenant that there were dollars to be made if he would send copious notes on everything he saw and did, along with photographs. In return, Remington offered fatherly advice on how to get promoted, his impressions of Army brass, and his opinions about national military policy. Remington always put in a good word with his editors on Clarke's behalf, or said he did, and to key military leaders, Gen. Nelson Miles in particular.

1. Clarke's name is spelled Clark by many. Remington often dropped the "e."

In the fall of 1886, Remington also began to seek out other publishers for his work. *St. Nicholas,* a magazine for young people that featured the best artists and writers of the time, published an article entitled "Juan and Juanita" by Frances Baylor in its November 1886 issue. It was illustrated by Remington. In October 1886 he called on his old friend from Yale, Poultney Bigelow, who was now the editor of *Outing Magazine.* Bigelow commissioned him to do some pen-and-ink sketches for a series of articles called "After Geronimo." They appeared in December 1886 and from January to April 1887.

There is no doubt that by the end of 1886 Remington was an established illustrator, an occupation that remained his major means of livelihood. For the May 1887 issue of *Outing* he both wrote and illustrated "Coursing Rabbits on the Plains." His illustrations continued to appear regularly in *Harper's Weekly.*

But in February 1887, for the first time, he entered a watercolor in the 20th Annual Exhibition of the American Water-Color Society. He also entered a watercolor in the 62nd Annual Exhibition of the National Academy of Design, a juried show in which the best artists hung their work. While the works won no prizes, they were accepted for exhibition; they were Remington's first steps away from illustrating into the world of fine art.

In April 1887, Remington accepted a commission from *Harper's Weekly* to make a sketching trip to the Canadian Northwest. Full-page reproductions of drawings from this trip appeared in the magazine soon after his return and continued through early 1888. The subjects were mainly Indians, Blackfeet and Crows, and the Canadian Mounties.

Thus Remington continued to travel west whenever the opportunity presented itself. His wife Eva, hampered by "ovaritis" and other chronic complaints, did not often accompany him. Though a big man, Remington was still fit enough to ride with the cavalry, or hike on the trails. The West was tamer than it once had been, but in his illustrations, his stories and articles, and his paintings, Remington made it seem wild and romantic at the same time.

The drawings in *Outing Magazine* and the earlier ones in *Harper's Weekly* brought him to the attention of Theodore Roosevelt in the fall of 1887. Roosevelt had written *Ranch Life and the Hunting Trail,* which was to be serialized in *The Century Illustrated Monthly Magazine* and then released as a hardcover book. He was looking for an illustrator and suggested Remington to the *Century* editors. The articles appeared in the February, March, April, May, June, and October 1888 issues, each accompanied by between eight and twelve Remington drawings. Subsequently, both the articles and the book were well received and brought Remington a good deal of national attention. From that point on, commissions flooded his way.

Though Remington won the Hallgarten and Clarke Prizes for a

large oil he entered in the 63rd Annual Exhibition of the National Academy, titled *Return of a Blackfoot War Party,* the bulk of his work was still in illustrating. He began a series of drawings to accompany stories that were to appear in twenty-three different issues of *Youth's Companion Magazine* between February 1888 and December 1889. At the same time, *Century* sent him west during the summer of 1888 to gather material for a series of illustrated articles, which then appeared in the January, April, July, and August 1889 issues.

On his trips, Remington is known to have carried a camera (the lightweight Kodak camera was introduced in 1889). Like the artifacts and Western paraphernalia he collected along the way, Remington used the pictures he took as an aid in accurately reproducing details for his illustrations. Several of the letters to his wife make reference to items he was acquiring and shipping back to her. Many of these were used to furnish their early homes. As Remington grew more affluent he was able to set aside an entire room as his studio, and this he furnished from his great treasure chest of Western items.

By the end of 1888, Remington was doing well both as an illustrator and as a painter. Fifty-nine drawings had appeared in *Harper's Weekly,* ninety-three in *Outing,* nineteen in *Youth's Companion,* and sixty-three in *Century.* There were also five in *St. Nicholas Magazine,* one in *Harper's Bazaar,* one in *Harper's Young People,* and eight in *London Graphic.* He was well enough off financially to move from Brooklyn to a flat in the Marlborough House at 360 West 58th Street in Manhattan. But he was working hard, and the letters to Clarke reflect that. Later in 1888, he moved again, this time to a house on Mott Avenue in upper New York City, near 140th Street. For the first time he had his own studio, and his old friend Kemble was a next-door neighbor.

The year 1889 was an important one for Remington. Early in the year he submitted a big oil, *Last Lull in the Fight,* to the American jury for the 1889 Paris International Exposition. In July he learned that it had won a second-place medal. Meanwhile, he had gone to Mexico on commission from *Harper's Weekly* to illustrate a series of articles by Thomas Janvier. "Aztec Treasure House" appeared between December 21, 1889, and April 26, 1890, with illustrations by Remington. Janvier also wrote "The Mexican Army" for the more prestigious *Harper's Monthly;* it appeared in November 1889 with Remington's illustrations.

After his return from Mexico, Remington and Eva went to Canton to relax with family and friends. Remington also began work there on a large commission for Houghton Mifflin, the first illustrated edition of Henry Wadsworth Longfellow's *Song of Hiawatha.* Twenty-two paintings were to be used as full-page plates and 379 pen-and-ink sketches for the margins. Remington spent a great

deal of time that summer of 1889 at Cranberry Lake in the Adirondacks. Senator Dolph Lynde and his family were there also. Lynde family diaries recount that Remington would set up his easel on the shore or sit in the stern of a skiff on Witch Bay, whistling and "diddling his foot," resting his sketchbook on the side. It was typical of Remington that he was able to draw any sort of scene from his mind's eye while relaxing at one of his favorite northern New York haunts. He returned almost every summer for years.

Atwood Manley described the anticipation of Remington's many visits to Cranberry Lake:

> "Remington is on the way in." From 1889 to 1899 the message was almost perennial. Sometime during the summer or fall word would come up the line from Canton to Clifton to Cranberry Lake that Fred Remington was on the way. At the foot of the lake, this was always good news. . . . At the lake he would turn out a considerable portfolio of pictures where the great horned owl looked down on his camp fire at night or the buck went whistling and crashing through brush.[2]

Manley's source of information was the diary of Adirondack guide Bill Rasbeck. Remington hunted and fished avidly, and tales recounted in the diary refer not only to those activities but to his good humor, his appetite, and his strong thirst. Occasionally an illustration or an Adirondack tale would make its way into print. "Spring Trout Fishing in the Adirondacks" appeared as a double-page in *Harper's Weekly* on May 24, 1890, and "A Good Day's Hunting in the Adirondacks" appeared as a double-page in the same magazine on January 16, 1892. The inspiration for the second illustration came from a fall 1891 hunting trip with guides Has and Bill Rasbeck and hunting companions John Keeler and Robert Sackrider. All are identifiable in the illustration. Another Cranberry Lake visit in July and August 1892 provided the setting for "Black Water and Shallows," which appeared in *Harper's Monthly* in August 1893. The story was based on a canoe trip he took with guide Has Rasbeck. Equipped with a Canadian style cedar canoe called "Necooche" (the name is clearly visible on the canoe's side in the illustration "Hung Up"), built by J. Henry Rushton of Canton, they followed the Oswegatchie River from its outlet at Cranberry Lake to its mouth on the St. Lawrence River.

Remington felt at home on both the lake and the river. In 1900, he would buy an island in Chippewa Bay not far upriver from Ogdensburg, New York, and spend part of every summer there until 1908. Although he traveled west at least once almost every year, he

2. Fowler, Albert, ed., *Cranberry Lake from Wilderness to Adirondack Park* (Syracuse, N.Y.: Syracuse University Press, 1968), Chapter 5, "Frederic Remington," by Atwood Manley, p. 61.

still seemed to need and crave the inspiration that came from time
spent at one with nature in the North Country of New York State.

A second major painting was completed by Remington in 1889.
It was *A Dash for Timber,* done on commission for wealthy indus-
trialist Edmund Cogswell Converse. Remington was continuing to
be well received by the public and the art community. In December
1889, he and Eva moved again, this time to a large house built to
their specifications in New Rochelle, New York. They would live
there until early 1909. As a painter and as an illustrator Remington
had "arrived." From now on his fame was assured.

*The summer after they met, Remington wrote to Powhatan Clarke
from Small Oaks Island in the Thousand Islands region of the St.
Lawrence River on the United States–Canada border. The sketch in
the letter was used later as the basis for an oil painting. Remington
would address Clarke as "Clark."*

☐ FREDERIC REMINGTON TO LT. POWHATAN CLARKE

In camp—Chippeway Bay
"Small Oaks Island"
Thousand Islands
August 6, 1887

My dear Clark —I am here—that is a forma-
dable heading—I endevour to describe where
I am but that hardly does it—well its to you some-
where on the St. Law. River—I am having a
good time—doing a little "pot boiling"—
sketching a little—trying to catch *muskalongue*—eating more than
is good for me—rowing getting up a muscle and in the evening
I fight mosquitoes—I shall leave here on the 20th—will be in
New York city for a day or so about the 1st of Sept. Shall be near
Albany N.Y. for the month of Sept. and in my own house on the
Hudson from thence on. If I knew just where to find you I would
go to N.Y. then—I have a business appointment there on or about
the 1st of Sept.—should be right glad to meet you once more. But
on your winter furlough you will come and visit me perhaps.

This is a devil of a rough draft of our present quarters.—a
friend of mind owns the Island and has a small cottage but we
"are in camp"—camp is the only thing in summer—if I had
money enough I would live in a bark camp the year round—got
a great trip for next year—canoe up the Ottawa river—moose
September—month & half thereabouts.

Well so long old top—get up a muscle—get well you are no good if your health is poor—pough—an invilid soldier I'll none of thee—

<div align="right">
Your friend
Remington
</div>

Canton St. Law. Co. N.Y.
 Please forward

☐ *FREDERIC REMINGTON TO LT. POWHATAN CLARKE*

<div align="right">
360 West 58th Street
New York City
Wednesday
November 3, 1887
</div>

My dear Clark: Yours at hand—in summing up its contents the only advice I have to offer, is, be sure and "qualify"—a soldier who cannot shoot in these days is worse than a "cut" minister at a camp meeting. Say old top when you write me write sort of descriptive like—all that you see and do down there while it is stale matter to you is of great interest to the undersigned—tell me what you do and what U.S. soldiers do these days—write any observations you may make or hear relative to Indians or Mexicans—who knows but you might inspire me to make an illustration for which I would get $75—but alack—I do not reason well, you would not get anything out of that—I hear you say but then to proceed with the argument I have a clincher—you are a soldier and a soldier has nothing in the world to do in time of peace except make himself and others (with empathus) happy.

You are a brick—that Indian *curio* business has absolute possession of the right ventrical of my heart and when the mama is gratified why I exhault—do you remember that big straw mexican sombrero I wore when you last saw me—well that hangs here in my room—I often laugh when I think what an odd figure I must cut down there—I suppose you always remember me as a kind of quasi tramp and always will until your esthetic sense is appaled by view of my realy beatic proportions clothed in the vestments allound to be proper in Gods country—I know I can never disassociate you from "niggers" and "greasers" and a uniform not gaudy but neat. But then I revert to my philosophy which says "trust not to appearances" and do not doubt but my young indian chasing friend would grace the uniform of a Kings body guard. By the way—that reminds me, that by the way—my letters are all *by the way*—they do not hang together—but to resume the jumble—I expect a lot of indian clothes from the agent of the Blackfeet soon—*did you ever see an Apache with a lance*—I suppose they are obsetic now—I got a coup stick this summer and they are

harder to find than the devil—*By the way here* is
the type of a Blackfoot. They are realy magnificent
reds more *elan* than even the Sioux the tuft
of hair & feather give them a dash—all wear a
medal of Queen Vic[1]—look more like Cooper[2]
than anything have seen—hair more like a
Mohawk you know. I am to illustrate a U.S. history.[3]

[letter ends]

☐ *FREDERIC REMINGTON TO LT. POWHATAN CLARKE*

360 West 58th Street
New York City
Thursday [Fall 1887]

My dear Clark—. I am here at last—located for the winter—
your letter did not reach me being forwarded, until to late to
meet you in this city. Cant you come up to New York and visit me
for a day or so at least—I want to see you before you go back.

Does this reach you as the Irishman said?—write.

Yours
Frederic R.

P.S.
I want you to take my "camera" back with you.

☐ *FREDERIC REMINGTON TO LT. POWHATAN CLARKE*

send me your Arizona address.—

360 West 58th Street
New York City
10th [1887]

Clark Old Son— As the Cornish miners say—was glad to hear
from you—sorry you didn't look me up when you were East—
better luck next time—I am permanantly situated now—bar
server—gas and kindred no calcuble city nuisances. I have just
pulled 700 strokes on my rowing machine and my hand feels a bit
stiff. How long before you will be East again—I so much wanted
to give you my "Detective"[1] to take back with you—didnt know
but you would like to try amateur photography and I might avail

1. Queen Victoria of England.
2. James Fenimore Cooper.
3. *The Household History of the United States* by Edward Eggleston, published in
1889 by D. Appleton and Co., New York.

1. The new lighter cameras were called "detective" cameras.

myself of the benefit and then I wanted you to get me a buckskin Indian shirt without sleeves—big neck & short skirt—if you go to Tucson look up one at that dealer in Indian curios store—If you find me such a one and send it on I will pay you by return mail and look with distrust one the adding list of my obligations to you.

I am very pleasantly situated now—keeping house in one of the Marlborough Flats[2]—I have a good little studio all fixed up and begin to live—since I "broke up" my home in Kansas City three years ago I have been knocking about from pillar to post but we'll do for the present until I have my home somewhere in the country where I can have a large and worthless collection of dogs & horses—I would like to entertain you some time for a—well indefinate time.—I am going up the Ottawa river way back into virgin forest in Canada next year and kill some moose—next Fall—may be that might strike you—'45 Winchester shooting not bad 1100 lb moose—most as good as Apaches.

So you saw Mrs. C.—well if they dont nominate Blaine[3] I am for Mrs. Cleveland for President—Grover[4] is no good—he wouldn't fight and if the govt. got into a war—the first batch of detail would overwhelm the clerk President and then what—why eat less, physic more or bust Grover—oh you and I would quarrel on politics I guess—I dont mind taking you and Redwood[5] one at a time but if you should combine one might out flank me. I am a sort of *crank* on politics—got some of the god d—— idiotic notions some of my friends suggest that any man who has a fear of asylum bars ought to cherish. But now speaking of politics, I struck a young English squid up on the Mounted Police and you just ought to have seen how nicely I gutted him. The thick necked pup began to make claims on the heritage of some hundreds of years of anglo saxon deeds and virtues—just as though so far as that went I was not entitled to as much credit as he was—there aint a drop of anything but English blood in my veins—pure Saxon at that—no Norman—bred on the soil and Every Remington that a herildric fiend can trace was a British soldier—and the only blot on an English record is that the ancestor of all American Remingtons deserted from the British army and settled on a farm in Vermont when that state was all woods.—since then I have had a direct paternal ancestor in every campaign that Uncle Sam ever undertook except the Mexican War—but of course that part did not appeal to the English sub.—but suffice it to say that I did him up but he was a perfect revelation of a d—— fool and his ignorance of everything was miraculous therefore no

2. The Remingtons' apartment in Marlborough House on West 58th Street.
3. James G. Blaine—Republican presidential nominee who lost to Grover Cleveland in 1884 and declined to run against him a second time in 1888.
4. Grover Cleveland, Democratic presidential candidate.
5. Allen C. Redwood, a New York illustrator.

general principal was involved. Where is Bigelow[6] to digress—
Bigelow of "Outing" has "thrown up his tail"—quit the literary
venture—gone to Europe with his rich wife—thereby proving a
well known axiom that a young fellow no matter how brainey with
lots of money is a wart on the face of the Earth.

Well I expect old man Redwood back on every train—he is a
refreshing individual—perfectly odd—no neves—very little of a
crank and possessed of the logical mental quality on every thing
except politics—in which he was ruined while young. You should
have met him—but then you are long for this earth and you cant
do it all in a minute—you I observe have a gallant appreciation of
a pretty girl—I expect some of these dimpled beauties will give
you a tierce thrust some day—and then—well we will see whether
I get an invitation or not—but every young chap I know usually
costs me $10. before I have the pleasure of attending his funeral.

Write again—dont quit—d——it Clark you and I will "brace a
racket" before we wear angel plumage—

Yours very truly
Frederic Remington

P.S.

Keep it dark—I am illustrating a new book for Mrs. Custer[7]—
its good—shes bright I met her recently—

Dont forget the indian shirt—you can get me some indian stuff
easily I recon and d—— me I know you will do it—

R

☐ *FREDERIC REMINGTON TO LT. POWHATAN CLARKE*

360 West 58th Street
New York City
January 3, 1888

My dear Clark— Your letter and the buckskin shirt are here—
to say that I am pleased is nothing I am so tickled as a boy with a
pair of long pants. I will send you the money as soon as I go down
to the bank where I do business which is in Chambers Street. The
thing is a little new but I can fix that by having it smoked.

With regard to you "running jacks"[1] that gives me an idea—I

6. Poultney Bigelow, editor of *Outing Magazine*.

7. Mrs. Elizabeth Custer, widow of Maj. Gen. George Custer.
Tenting on the Plains, Chas. Webster and Sons, 1887.

1. "Running jacks" refers to the pastime of chasing jackrabbits. In May 1887,
an article had appeared in *The Century Illustrated Monthly Magazine*, written
and illustrated by Remington, called "Coursing Rabbits on the Plains."

will illustrate it. I have been there myself on many occassions and you say figuratively "you talk about your English fox hunting" but understand I dont talk or I wont let anyone else talk either. The desease of Anglo fobia is very marked in my case. Running jacks lays over any sport going—the only thing that approaches it is "stalking antelope on a good open rolling plains country. Of course it should be remembered that the process of landing a 2½ lb. small mouth black bass of the St. Law. river on a 5 ounce rod is a scheme with "no flies on it" to speak in Irish. Oh the great error of our civilization is that I want boon with a bank account which allowed me to be as much of a d—— savage as my instincts dictate. I would be a "lolly"—but why harrow ourselvs with such vain regrets. We are fortunate to be hard working men and not tramps.

I went over the other day to the Central Park Riding Ring and joined in a musical ride. I have ridden a great deal in my life— riden for a living etc. and my ideas of how to do it are very pronounced—These New Yorkers have their scheme and I was forced to do likewise as they hang the stirrups just forward of the horses ears.

This illustrates the scheme—Aint it hell. These people are a pack of hopeless idiots—Oh how I long for a d—— roach back, watch eyed four year old bucking broncho which has never been saddled. I would break him to stand under a saddle and then get one of these on him.

Exhibit I Exhibit II

Of course it would be expensive as I should have to pay for the hole in the roof of the riding school where the tenderfoot went heavenward.

I leave here the 1st of May for a summer in the North[2] and then about the last of Sept. I shall go to your country for three months![3] I want to do "US soldiers"—some Pueblo Indians—

2. Canton, New York, and the St. Lawrence River area.
3. On commission from *Century* to get material for a series of articles.

some Apaches—and then Mexico—I am not going to fool with any d—— illustrating but make finished oil studies for painting. I wish you could get a few days off to go to San Carlos with me. I want to make a "negro cavalry picture."

At present I am hard at work—"getting there" so to speak, one at a time. Thats a pretty good break for an ex cow-puncher to come to New York with $30 and catch on in "art." Jesus it makes some of these old barnacles tired. Well write you dont have anything else to do.

<div align="right">Remington</div>

Remington and his wife moved from their Marlborough flat on 58th Street to 561 Mott Avenue on the edge of the city in 1888—far from Mott Street in Chinatown. His address in the first letter is undoubtedly a joke. He was working on plans for a return trip west.

☐ FREDERIC REMINGTON TO LT. POWHATAN CLARKE

Mott Street—Chinese Quarter
New York
Day after Election
March 13 [1888]

My dear friend Clark:— "Grover's[1] in the soup"—"no. no—no free trade"[2]—whose in the soup? "Grover" Harrisons[3] all right— whose all right. Why Harrison hes all right. Grover is the only man in America who can take his shirt off without unbottoning

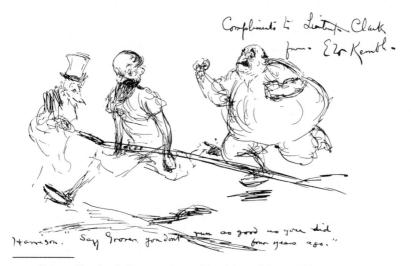

1. Grover Cleveland, Democratic presidential candidate, 1888.
2. Tariffs vs. free trade was a major issue in the campaign.
3. Benjamin Harrison, Republican presidential candidate, 1888. He was elected.

the collar.—he's going to buy two new trunks and a railroad ticket.
He's going to do stunts in Europe—they say his head aint swelling
so fast as his feet. And Sherman[4] lets see, he owned a red snot-
rag-no. no red bandana to take the place of the star-spangled-
banner. Everybody get drunk. Shes great—I dont like to rub it
in but just listen while I jump on you. Poor Francis[5]—Grovers
a chump—

Well boy I like to get amongst ye—going to go down and
smoke old

☐ *FREDERIC REMINGTON TO LT. POWHATAN CLARKE*

561 Mott Avenue
Mott Haven
New York City
Saturday—April 3, 1888

My dear Cleark— Your last was at hand some time since. I have
been moving—am now beautifully situated in a house all by our-
selvs up here on the edge of the city with the green fields near at
hand. "Kemble"[1] the nigger artist is my next door neighbor and
we have good times together.

Great thanks for Mac's invitation and yours too. I am now try-
ing to convince these d—— publishers that they should send me
out on summer raid in your direction and if so be it why I shall
descend on you "horse foot and dragoons."

I have reason to know that a man is liable to prespire under his
arms in Arizona during the summer but a man can sweat and still
enjoy himself—just how I can ever ride a horse again is raising
the duce with my grand tactics but I have read that a troop horse
is often burdened with more than 220 lbs so there is still hope
that I will not have to do the "dough-boy" act. I had lots of sport
last evening. My friend "Kemble" was shortly ago an honored
member of the Manhattan Athletic Club and has numerous 100 yd.
trophies and some startling tales appertaining thereto. He is light
and willowey still. Time was when the undersigned had somewhat
of a local reputation in "Yale" but also the reputation has vanished
until there scarcely lurks a semblance under the heaving mass of

4. It is not clear whether the reference is to William Tecumseh Sherman, Union
general in the Civil War, or his brother John Sherman, a leading Republican
senator.

5. Frances Folsom Cleveland, Grover's wife.

1. E. W. Kemble, who specialized in illustrations of blacks, was his next-door
neighbor.

the aforesaid 220 pounds. Some banter ensued between us on our walk yesterday and the proposition was advanced that the road was perfectly level ahead and that talking would never settle it, where at we fell to running—at the end of about 75 yds. Mr. Kemble had learned not to trust always to appearances and yours truly fell inspired to "brag" in a manner that none but an utterly crushed audience would have endured. There is now a cautious exchange of opinions as to who knows the most about the "manly "art"—I suppose that will end in a "bout" in one of our back yards which will greatly edify the Irish help and create consterna- tion amoung our wives. The great questions must all be settled before two people can proceed to perfectly understand each other. I should be willing to give ten years off from my life for a trip into Arizona this Spring—although you must tell your friend that an artist is nothing short of a d—— informal nusiance on a pleasure trip for where "sane" men are supposed to enjoy them- sevs they are constantly beset with the enthusiastic and benignly put request to "just keep that position a moment" while the fool artist goes hunting about for his sketch book and pencil.

I am hard at work now and greatly behind so you must excuse this brevity of mine.

All I want is one good crack at your nigger cavalrymen and d—— your eyes I'll make you all famous! Do you know I think there is the biggest kind of an artistic pudding lurking in the vacinity of Camp Grant.[2]—

Well write—be gracious. I have about made up my mind that you are a corospondent worthy of any ones steel—I know it is not labor for you to scratch therefore apologies will not be accepted.

<div style="text-align:center">Yours
Frederic Remington</div>

☐ FREDERIC REMINGTON TO LT. POWHATAN CLARKE

<div style="text-align:center">561 Mott Avenue
New York City
April 11, 1888</div>

My dear Clark: "The die is cast, "I'll plunge I'll cross," or in a more prosy diction I will go on and explain that I have beguiled a certain distinguished publisher[1] into sending me on an atistic and litterary tour through the Indian Territory and into Arizona.

2. Military post in the Arizona Territory where Clarke was stationed.

1. *The Century Illustrated Monthly Magazine.*

I can not say where—but I will either start on the 1st of June or 1st July at about which time I will come to Grant.[2] I am going to do the "Black Buffaloes"[3]—This information you will please keep private as I do not want to be anticipated. I shall then return by the way of Texas and the Territory. I shall get letters from the Secty. of the Interior and can get them from the Secty. of War. I rely on your good nature largely for the facilities for working up my material.

Now tell me candidly—can I have men to "pose" for me at your post and how can I get *bed and board* there. I have no desire to impose myself on your good nature on this a purely business venture of mine—of course you can lend me a helping hand and make my road smoothe—that I know you will do. As to the "hunting trip" I can not decide—the work I have in hand will be enough to keep me "hustling" all the time I have but may be a few days may be filched if that would be enough—however that is a small matter easily arranged.

Will you also enquire among your soldier friends and find if any of them have recently served in the Indian Territory—if so ask them where the "Kiowa Commanche Arrapahoe & Cheyanne" indian agencies[4] are—how far apart and how I can most conveniently reach them.

Well Clark—all this is "shop talk" and I trust you will excuse the whole thing. Write soon and explain just whats what and whose who.

Will you be there at the above date—at Grant—that is!

I am

Very truly yours
Frederic Remington

I am doing some stuff now for the London Graphic[5]—

2. Camp Grant, Arizona Territory.

3. The black cavalrymen were called "buffalo soldiers" by the Indians because their curly hair was thought to resemble the fur of the buffalo. The second of Remington's four illustrated articles for *Century* was "A Scout with the Buffalo Soldiers" in the April 1889 issue.

4. Illustrations of Kiowa, Comanche, Arapahoe, and Cheyenne Indians appeared in the third and fourth articles for *Century*, "On the Indian Reservations" (July 1889) and "Artist Wanderings Among the Cheyennes" (August 1889).

5. A drawing by Remington appeared in *London Graphic* in the March 30, 1889, issue and another in the June 28, 1889, issue.

☐ *FREDERIC REMINGTON TO LT. POWHATAN CLARKE*

561 Mott Avenue
New York City
May 18 [1888]

My dear Clark:— Your letter at hand—so you are banished as it were—well I hope you are like Cataline[1] in spirit—but go slow my boy—there are a heap of people who need murdering in this world but the job of "taking hence" of such of those who are unworthy is not for our hands—It has often occurred to me that if I were Czar of all the Americas, I would reduce the population some to begin with. Bathe your head in cold water and wait like Clovis[2] and we may yet avenge the "vase of Soissons"—

I trust the powers may relent before I visit your summer home— the school teacher and the genereal environment of your detachment are well worth 3000 miles to see through—I shall see you bar accident.

I have yet quires and reams of work to do—I am "dead stale" and hate to do it but the gods must be propitiated so I will "sweat" a little yet and by the 1st of June I hope to start my pilgrimage.— That reminds me that I am to day undergoing the tortures of the d——, I donig a penance which would be a theme for Poe. I had "too many blood of the grape" ensconced in my system last evening and well you have probably been there—I take it you have been before now initiated into the ancient and honorable order of drunkards. We elected Gilder[3] of the "Century" President of the Fellowcraft[4] last evening and the thing was hot.—many bottles were broken—we all make a frantic attempt to lead the procession—by two AM the dead were thickly strewn about and as the ancient Arabs said "God only knows how many men were perished in that war."—

Of course I realize that we are all d—— fools but the creator should have altered his plan of construction when he made *man* or he should have designed "the straight & narrow way" so that it would have covered more ground. Well I will save the time by working in order that it may be spent with you in the flesh instead of the spirit.—

Yours
Frederic Remington

1. Catiline was a Roman politician who could endure any amount of labor, fatigue, and hardship. He led unsuccessful conspiracies to overthrow elected consuls in Rome and he died in 62 B.C.
2. Clovis I was the founder of the real French monarchy. He succeeded Childeric in A.D. 481. The victory of Soissons which he gained over Syagrius in A.D. 486 rendered him master of all Roman possessions in the center of Gaul.
3. Richard Watson Gilder, editor of *The Century Illustrated Monthly Magazine*.
4. A New York City club.

Remington went west in the summer of 1888 under a commission from The Century Illustrated Monthly Magazine. *He spent time in Arizona, Texas, New Mexico, and Indian Territory. He visited Fort Grant and took a tour of the San Carlos Reservation with Powhatan Clarke. Eva stayed home. His letters to Eva while traveling show how Remington conducted his Western "business" and gathered material for illustrations.*

☐ *FREDERIC REMINGTON TO EVA REMINGTON*

> The Grand Pacific Hotel
> Drake Parker and Co.
> Proprietors
> Chicago, Wednesday
> June 6 [1888]

My dear girl:- I got down to the Des Crosses St. ferry all right— found I had forgotten my check for trunk—by a little diplomacy and a half dollar I made out to fix that all right. To my utter disgust—I found that I could have taken the fast express instead of the Limited and made connections equally well as I now have to wait from 9 AM until 4:30 PM for the R. Island RR. to K.C.[1]

I came to the above hotel and went to see Stevens and also O Brien the Art Dealers—Stevens is a magnificant ass and O Brien is the absolute stuff. I have made an arrangement with O Brien and he will handle some stuff for me—

I wonder how you and "Snip"[2] alias "Toto" got along—I imagine Kembles[3] magesty rose superior to carrying a dog and I suppose Toto had rather "Pot luck"—I trust no one laid a trunk on him or stepped on him.—Well that is all—

I am regarded as wintry of look here by nearly all I meet. One fellow at the train insisted on his taking me for an English Lord but I convinced him that I was the plainest sort of an American. Well treat yourself well—write Kemble for a check book if you need one.

> Yours,
> Fred

1. Kansas City, Missouri.
2. Snip, Remington's dog, also known as Toto.
3. E. W. Kemble, Remington's next-door neighbor, took him to the station the day he left.

☐ *FREDERIC REMINGTON TO EVA REMINGTON*

> Franklin B. Hough and Co.
> Bankers and Financial Agents
> New Journal Building
> Kansas City, Missouri, Friday
> June 8 [1888]

My dear Eva— I arrived here all right—met Hough[1] drove about with his magnificent squaw—went home with him—met the people—they enquired about you going to Colorado this summer—Hough going to Colorado with me this afternoon, thinks he will meet at Fort Worth Tex and go in territory—K. City has had a most "extraordinary development—you would hardly know it— my excursion ticket must be carried to Los Angelos[2] to be signed there for return passage—smart aint I—I am trying to have the matter adjusted. Went up with friends and saw Judge McCrane of the Santa Fe[3]—got letters to Gen. Pas. Agt. at Topeka where will stop for a lunch—hope to fix it up—met Terry[4] am going to lunch with him

> Yours
> Fred—

Hough is the best fellow in the world.

☐ *FREDERIC REMINGTON TO EVA REMINGTON*

> "Santa Fe Rante" Eating Houses
> Depot Hotel
> La Hunta[1]—Colorado—Sunday
> June 10 [1888]

My dear girl:— I got here this morning on the Denver Express from Topeka where I had my ticket changed. Hough came with me and has gone onto Colorado Springs—I take the Southern train in an hour and a half—will get to Grant Tuesday some time— the Ferrys—whom I called on in K.C. wanted to know why I did not bring you out here—they said they were going to send for you—if they do you can make some excuse for not coming. As

1. Franklin B. Hough was an acquaintance from days when Remington first lived in Kansas City in 1884.
2. Los Angeles, California.
3. Santa Fe Railroad.
4. Gen. Alfred Terry had recently retired from the U.S. Army and spent considerable time in the West.

1. La Junta, Colorado.

a summer resort K.C. will never be great—they all are mighty impressed with my importance there.

The old sun shines hot and the bloody town is dull and devoid of all interest—a few drunkards loll about the saloons are all open and the only evidence of Sunday is the question on the calendar— well we are right up to date.—I am getting tired of travelling but its business—Ide like to hear from you and suppose I will at Grant.

Well adios—love and kisses little girl—keep a stiff upper lip

Fred—

☐ *FREDERIC REMINGTON TO EVA REMINGTON*

Postmarked Geneseo
Sun. 11
Tuesday 1888
Depot Hotel
Deming, N.M.

My dear girl— One week ago to day and only Deming[1]—missed our Western connections yesterday by one hour and have to lay over here 23 hours. Its a d——shame—just wait till I get to be in Grover's place—I'll condemn all railroads and make the people walk or ride a burro.

Am dying to hear from you. Tell the Governor[2] that all the mineral in New Mex & Arizona lays in pockets and that for general mining the upper country is best if the ore is low grade—

I may take a sort of exploring trip to the Grand Quevera an old town (Astec) way out in the desert between the Rio Grande and the Pecos[3] but dont know.

Yours lovingly
Fred R

Indian

1. Deming, New Mexico.
2. He is probably referring to his grandfather, Henry Sackrider, who was commonly called "the Governor."
3. Rio Grande and Pecos rivers.

Remington recorded impressions from his trips in a diary as well as his letters. The following entry is probably from the trip made to the West in 1888.

Staid in Deming over-night—Got a room—gave it up gallantly to a lady when her big fat relative gave a grunt of satisfaction and never even looked pleasantly at your much abused servant. Oh its a great satisfaction to feel that one is chivalrous, there appears to be no other benefit derived in this country. I slip in my clothes on a cot and am badly in need of a bath. Late train on S.P. so did not get off till 1 o'clock P.M. following. Ther are a lot of infantry recruits going to the front and a batch of negro cavalry came in on S.P. Good style men. I met incidentally a Capt. Allaine (Scotch) of 1st Inft. here—a very good style of a man. Appeared cordial etc. not always the case with that distinct species an Army Officer. It is getting warm now but not uncomfortably so.

Fronter

Talk with Texas friend. The old Texas cowmen had very hard times—were perfectly uncivilized—lived in stake and mud huts—dresses nearly same as modern cowboy—no buckskin business. He told of exposures suffered on the plains of Arkansas turning cattle back in. . . . Said Mexican horses better than Texas bretheren—high boned coarser but better the bulk of Arizona horses are Mexican. The Pecos valley all cattlized. Told about "loco' a plant peculiar to N.M. Amaro. I S. Col. its effect on horses

c (olor) notes

The distance mountains are [illegible] and the non-dis are [illegible] and the near hills eventful and yellow red with blue depression the far masa is cloud streaked. P.G. red brown yellow light and dirt color. This is on the flat masa—the atmosphere is exceedingly clear but apparent. At times on certain grounds the glare is beyond belief of the casual picture observer. Flake white would express it best but it would be a dangerous effect to attempt.

Fronter

The cowboys of whome I meet—many are quiet, determined and very courteous and pleasant to talk to. There is none of your Dodge city stock here. Their persons show wear and exposure and all together they look more as though they followed cattle than the persuit of pleasure. Such lined and grizzled and sun scorched faces are really quite unique. The climate theory of Buckle is suggested very strongly to the observer.

☐ *FREDERIC REMINGTON TO EVA REMINGTON*

Tenth US Cavalry
Fort Grant, Arizona
Thursday
[June 14, 1888]

My dear girl: I arrived at Willcox[1] all right the following morning I was driven to the Post in a 6 mule ambulance.[2] Met Clark—Had the warmest imaginable reception. We never can do enough for Clark should he come East. Last evening we went out with Keyes and Baker companies on their move to Thomas[3]—the baggage wagons did not get in until 10 'clock and as I was tired I went supperless to bed—

not at all unpleasant however I have a fine horse—

Tonight I sleep in an infantry camp and go on the trail with them until tomorrow noon. The day following I start on a scout with Clark up through the San Carlos way to Apache (Fort)[4] I will be gone two or three weeks and you will not hear from me very often. Am well take good care of yourself.

Yours Respt
Frederic Remington

Excuse the yours Respt it was a slip—love—don't loose Snip

☐ *FREDERIC REMINGTON TO EVA REMINGTON*

Tenth U.S. Cavalry
Fort Grant
June 22 [1888]

My dear girl:— We just returned this afternoon from a two weeks scout up as far as the Perial Mountains. The particulars are so numerous as to furnish me material for many pictures. We "pulled out" of Grant with four men, a Sergeant—Clark—two

1. Willcox, Arizona Territory.
2. Ambulance, an army passenger wagon.
3. Fort Thomas, Arizona Territory.
4. Fort Apache, Arizona Territory.

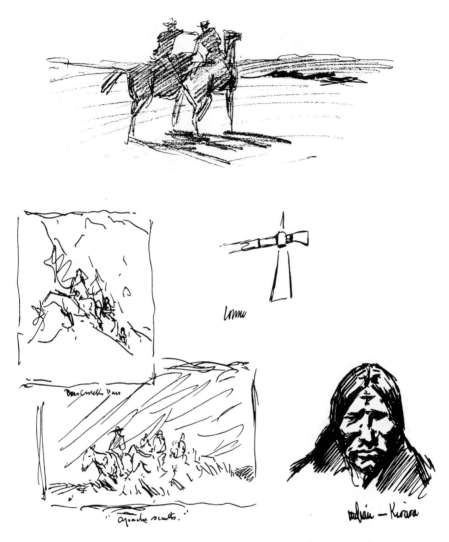

packers and 4 pack mules—myself on a company hourse—the
first days march was through the Taylor canon of the Sierra Bo-
nitos—it was tough—the toughest thing I ever went through ex-
cept our passage of the Mescal range later on—the climb was like
going continually up stairs only often steeper—the rocks gave bad
footing—we dismounted and led our horses. The air was rare
and grew rarer as we ascended—I puffed like a tug boat.—I felt
like dropping in my tracks at times—We got off the trail—Clark
& 2 men—on the Knife like ridge of the divide we could look
over the Sulphur Spring valley & the Gila valley at the same

soldier soldier.—

point—with the blue mass of the mountains towering on every
side. It was grand but it did not repay the torture of the ascent.
Well we camped—saw a wild bull fight—the next day I was very
sore—we marched about 30 miles across sand wastes, cactus and
alkali—the water nearly boiled in the canteen if it had not have
been for my helmet I could not have stood it.—Well I see I can
not describe it all but we made Fort Thomas and on to the San
Carlos Agency. There I saw the ration day Apaches by the thou-
sand and black soldiers until you cant rest.—a Chinnaman ran
the officers mess—four races of people in one group—quite a
commentary on America—it is awfully hot in the Gila valley—
the water is all luke warm that we drink.

We then went on to the Perial range under the guidance
of Lieut. Watson[1] of the "10th Nubian Horse"[2]—we here saw
mountain scenery which was too grand to describe—we came
back there over another trail lost it and made plumb over the tip
top of the Mescal range—that day and the next—ride through
the Gila valley—with the sun scorching and the dust rising in a
solid column clear out of sight in the sky made an experience
which I will never forget. I have lost 20 pounds at least—feel well
and am perfectly blistered in the face—the skin is coming off but
I will soon be all right to give you an idea of how hot the first Gila
valley day was I will say that three grey hounds that Clark took
gave out laid down and were abandoned—I took lots of instanta-
neous shots—dont know what they will be—

You must not write here any more—I leave here Tuesday for
Fort Sill Indian Territory. I dont know how long I will be there or
where I will go so that I dont see as you can write anywhere until
you hear from me again. I will certainly be home before the 1st
August and will probably come before—I am very anxious to see
you in fact I can not stay away as long as I should—

It is a very successful trip and will help me professionally very

1. Lt. James M. Watson.
2. Tenth (Negro) Cavalry.
3. Fort Sill, in Indian Territory, later called Oklahoma Territory. Oklahoma
became a state in 1907.

greatly—the photo of you and the baby was very good especially the three quarter length.

Well good bye little girl when I come home we will put up a job and have some fun—I am tired have been in the saddle all day and cant keep awake any longer. Do not pay 24 on the London drawing—I dont want it—it should come through for nothing— or have it destroyed—I presume Kemble can fix that—if he cant let it lay—

<div style="text-align: center;">
Love & kisses from

Your

Fred
</div>

☐ FREDERIC REMINGTON TO EVA REMINGTON

<div style="text-align: center;">
The Grand Central

El Paso, Texas

June 25, 1888
</div>

My dear girl:— I left Grant yesterday evening by ambulance— I shipped a large box of Apache and Soldier bric a brac by freight—consigned to Lawton Caten[1]—I enclose receipt—New York or Albany being a "common point it will go there—then I could not ship it to Gloversville from here (they could not give me a rate) or to 561 Mott.—I nearly died before the train came into Willcox of lack of sleep but finally got off and landed here where I lay over for a day.—I bought a nice lott $20 worth of Mexican and Indian pottery here and 1 Mex. zerape—which I have consigned to you—collect.—It will make us some unique decoration. Much rarer than anything we could buy in New York no matter how nice.

I am getting tired—want to go home—will start on tomorrow and will surely be home by the 1st of Aug. if not before—It is hotter than the devil here—you can ferm no idea—The sweat drains from me as I write.

I enclose receipt. Give it to the old gent and if he goes away look out for the freight but I expect to be home before it arrives—El Paso is a nice town—quite Americanized—I am going over to El Paso del Neste or the Mex side as soon as the Sun gets down a little.—

I expect to see Lieut. Johnson 10th Cav.—a nice fellow—at our house this winter.—

I have $380 out of 600 when I left the house—I'll get through. Love Missie—I'm *dying* to see you—

<div style="text-align: center;">
Yours lovingly,

Fred
</div>

1. Lawton Caten, Eva Remington's father, who lived in Gloversville, New York.

☐ *FREDERIC REMINGTON TO EVA REMINGTON*

Office of Commercial House
Louis Lacoste, Proprietor
Henrietta, Texas
Sunday
July 1, 1888

My dear Girl, Here I am at last—leaving in the morning by
stage for Fort Sill—spent a day in Fort Worth with Hough—had
a devil of a time—the mosquitoes like to have eaten me up—there
is not a square inch on my body that is not bitten—and oh oh oh
how hot it is here—I have sweat and sweat my clothes full—I can
fairly smell myself—I am dirty and look like the devil and feel
worse and there is no help for me. Well you can bet I am going
to make the dust fly and get through as soon as I can—This is a
miserable little frontier town with a little hen coop of a hotel—I
am nearly starved to death—this Texas grub is something fright-
ful and my room—I wish you could see it. You would smile—I
full agree with Phil Sheridan[1] "If I owned Texas and hell, I would
rent Texas and live in Hell."—Well all this is very discouraging
but its an artist life. I have no idea how long this thing will take
for these Indians are scattered all over the earth but I "touch and
go" and you can bet I wont spend the evening with them—still I
came to do the wild tribes and I do it.

Love missie—
Your old boy
Fred

*After his return from the West, Frederic and Eva visited family in
Canton. It was his first visit since his mother's marriage to Orris S.
Levis in May. Remington did not approve of the marriage and had
little subsequent contact with his mother.*

☐ *FREDERIC REMINGTON TO ROBERT SACKRIDER*

Gloversville
Sunday [July 1888]

My dear Rob— Your telegram at hand—you had better send
another immediately unless you are prepared to entertain me for
a few days, as it is now my intention to start with Eva for Canton
on Wednesday morning. I don't propose to "bully myself"—I will
face the music. I have had my say and now I don't care a d——
for anyone. I want Mrs. Levis to know that she is nothing to me.

1. Gen. Philip Henry Sheridan, the Civil War hero.

She has got that to find out and she might as well take her medicine. I am perfectly calm—nothing can influence me one way or another now—the thing is done and I dont propose to skulk before the good people of Canton. I go to the Islands in a few days from Canton.

<div align="center">Yours Fred R</div>

[Postscript by Mrs. Remington:]

You see the landlord feels like talking. We think it best to give you the first dose as Grandma is not well and Uncle Wm's[1] people expect the Gunnisons[2] so soon. We go to the Islands soon after Aug. 1st. Mr. and Mrs. A. W. Harriman[3] have invited us there for a few days on our way to the island.

<div align="center">Lots of love
Eva</div>

We want to see the Gunnisons and we want to see George and you all & why should we not come there and do the way the rest of you are doing. Fred feels anything but desperate and you need have no fear of him. Am anxious to get your letter.

In the fall of 1888, Remington picked up again on his correspondence with Powhatan Clarke.

□ **FREDERIC REMINGTON TO LT. POWHATAN CLARKE**

<div align="center">561 Mott Avenue
New York City
Saturday
September 11, 1888</div>

My dear Clark. Well old boy I have treated you shabbily in not writing but I have been so busy having a good time and now I am so tarnally taken up with being miserable that damn it I couldnt. I'm going to tell you the news & then go to breakfast.

—I get up in the morning now-a-days

—I am at work.—HARD

—I am writing up the 10 Nubian Horse

I am going to make some illustrations for it before which the world will stand in a grim and terrible awe.

—I am going to put a small study of 10th Trooper in the N.A. this Fall.

—also a Cheyenne

When are you coming East. When is Johnson coming East.

1. William Reese Remington, Frederic's father's brother.

2. The Herbert Gunnison family were old Canton friends. Fred Gunnison and Fred Remington were peers.

3. The Harrimans were family friends living in Ogdensburg, New York.

When is Mac sacrifised? I have bought a beautiful lot in a residence Park in New Rochelle up on the Sound and am hopelessly in debt now but if I can get there Im going to build next year. If "Posa Granda" goes up you know.

Send my revolver sheath etc. I dont know but that you are out in the field.—

<div align="right">Yours lovingly
Frederic R.—</div>

P.S. Im going to give old Jim Watson hell in this article for marching me so.

☐ *FREDERIC REMINGTON TO LT. POWHATAN CLARKE*

<div align="right">561 Mott Avenue
New York City
October 25 [1888]</div>

My dear Clark.— Your welcome letter at hand, also the broncho with the fine saddle and the photo of yourself. I can't say that it flatters you and yet it is a remarkably good looking sort of chap— do you catch the delicacy and grace of this compliment.—I wont do so any more—let this pass—but really several women have seen it and for the sake of the grand simplicity of your nature I am glad you were spared the remarks.—its hell when a young fellow discovers that he is good looking—not that you are ever liable to—"aint" this kind of mean—gad—I'm guying you Clark—but you know me well enough, so that I take the liberty—I presume some of the "fair" ones to whome you will present it will gush but you must have a sort of counter-irritant and here it is! On the dead—Clark, I have it at the place of honor.—I feel called on to take up with my fat friend of the infantry whome you "cuss out" you know I am a dough boy and I wont stand it to have you long legged horse soldiers putting slights on us, Still "may be so" he dont do us credit—kill the sun of a—— If you use him the way you did me I think you can do it. Did the big chump have my old "Snoozer"?

I think on the whole I will buy me a horse soon—I must have exercise—It gives me a pain to see these "bobbing chappies" who go about these streets making a frame of their ass and the saddle for a landscape which happens to be beyond. I will buy a Whitman saddle I think and try and do as a man who has taken out naturization papers should.

Well Clark—its all politics here—I wish it were over—I think we can do you up but we have no picnic in the process.

I am rushed to death—Got two M.S.[1]—25 Century illustra-

1. Manuscripts.

tions—4 chromos—a Harper page & an oil painting to make be-
fore the end of next month and that wont give me much time
"monkey."—

I have sent an oil of a "10th Cav. Trooper"[2] to the Fall Ex.
Academy,[3] I intended to do you up in a water color with my
compliments but dont know when I will get at it—before the
year ends though.

Tell Johnson he must come and see me when he is here or I will
enclose a formal note which you will hand him. These soldiers are
hell for documents conveying authority.

Well Clark you must let me off now—I have the will to write
more but absolutely no time. However I will write often and that
will make an average—

<div style="text-align:center">Yours

Fred Remington</div>

P.S. By the way Clark when do you come on leave—Regards to
the gentleman whom I met.

□ *FREDERIC REMINGTON TO LT. POWHATAN CLARKE*

<div style="text-align:center">561 Mott Avenue

New York City

October 31, 1888</div>

My dear soldier Your letter very enjoyable—discription of the
cook fires at night great. Would give my coins to see such a thing.
You chaps keep up that sort of thing—never heard as much army
and navy agditation as now—something

got to come of it.

Am full of work—just finished my
"Mexican Major"[1]—great. This Falls ex-
hibitions will tell whether there is still a
God for Israel. Had heap or flatterring
things said about the large canvas. It has
gone to Boston to be photogravred. Will
see that you get one—'bout size of Tel el
Keber. The Boston people got a process that
beats Gonpil. Does the subjoined drawing con-
vey any idea to you.—If it does you put her in
your note book and send me the bill. The

2. Probably the small study of "10th Trooper" referred to in the letter to Clarke
of September 11.

3. Annual fall exhibition of the National Academy of Design.

1. "A Mexican Major" appeared as a full-page illustration in *Harper's Weekly*,
September 27, 1890.

old lady[2] and I are going to Zuni[3] in the spring. say last of February and to do some landscape also. We will probably stop at Wingate.[4] Have you any friends there.

I sent your portrait to your people down towne. I suppose they got it all right. I am going to take my portrait of you and a d—— Mexican soldier and frame them to gather. You can stand it if the Mex. can. You are altogather the tougher looking of the two but everything goes.—

I am so stupid as the devil to day. Been working pretty hard and going to rest for a few days. We are having indian summer— would go to country only cant. This great social problem keeps an artist guessing—Harper[5] took your stuff. You will get 8 dollars in the course of 30 or 40 years. They are going to bilk you on the grounds that you are a rich gentleman but I wont let them. It is rather unfortunate I also find to be so d—— distinguished in personal appearance—hotel clerks etc. Always run the limit on you.

I like my horse better every day. Its only a question of time befor I will have to stop riding and buy a flying road wagon Its a great consolation to fat gentleman to know that he looks solid whether he is or not. Sleeping in ash barrells and missing meals dont put lining under a mans vest.

Well we enjoyed your short stop here very much and I hope you will indicate your appreciation by coming back some day. Missie says "that Clark is a funny fellow—I did not feel I knew him until he went away and then I could see how funny he was—he was always thinking of his old war business when he ought to be thinking of something else." These are the exact words of the lady—She would tear this up if she could see it—there is an implied compliment in the observation as you may discover. You keep pounding away and we'll get up a row for you some day.—

2. Eva Remington.

3. Indian tribe of the Southwest located on the western boundary of New Mexico. Remington spent about six weeks on the Mexican trip. Eva did not go along.

4. Fort Wingate, New Mexico Territory.

5. Probably refers to J. Henry Harper, editor of *Harper's Weekly.*

I enclose you some ideas for a new U.S.A. uniform—think em over and dont get out of patience with a d—— citizen—ha-ha- if I didnt know any more than you do about war I'de keep a grocery store.—

Your friend
Remington

Infantry full dress. cobalt over belts.- brass helmet.
dark coat.- pants aubinings blue - very bright. –

cavalry full dress –

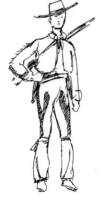

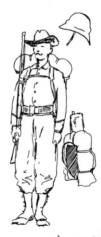

Irregular cavalry.- no sabre.-
blue coat- mexican leg rig.- –

Campaign infantry. Canteen on knapsack.
no haversack.-
entrenching tool on back of knapsack.-
Thin leggins.- short blouse + big pantaloons.-

☐ FREDERIC REMINGTON TO LT. POWHATAN CLARKE

561 Mott Avenue
New York City
Monday
[December 27 1888]

My dear Clark:— Xmas is merry with you I know—I go north
with Madam for a few days and hope it will be merry with me.

Saw paragraph in paper Corporal shot a Sergt. at Grant.

Glad you liked the "deserter" picture.[1] Saw a scene like it
years ago at Fort Ellis. Mont. Was there a military error in it—
presume so.

I sent Johnson[2] a lot of papers—also one to you—I gave him
just as good a send off as I could. I sent a paper to Gen. Miles.
Was that a good scheme?

The "10th Cavalryman" was sold in the Academy—also "A
Cheyanne"[3]—I am doing a water color of the "bugler"[4] which
I made in your back yard for the Water Col. Society. Also an
"Apache scout."[5]

Am at work on a big oil—Spring Academy[6] or "Paris Ex"[7]—
dont know yet. "Lull in the Fight"[8]—sand hill—hot as devil—big
plain—mesquit indians around in far distance. 4 old time Tex.
cow punchers—one dead—two wounded—damdibly interested—
tough looking chaps—four dead horses—saddles canteens old
guns buckskin etc.—one man bandaging a damaged leg—critics
will give it hell—brutal etc.—two characters.

Have got big job for this year—take half the year illustrate
Hiawatha—Houghton Mifflin of Boston.

You ought to see Vertschaqui's collections of paintings now
here—priest blessing a field field full of dead and plundered sol-
diers—white marble forms of dead—dry grass—spots of blood—
thousands of em—awful—good.

1. "Bringing in a Deserter," *Harper's Weekly*, December 8, 1888.

2. A drawing, "Lt. Carter P. Johnson," appeared in "Lt. Johnson and the 10th
Cavalry," *Harper's Weekly*, December 22, 1888. Remington probably sent Johnson
several copies.

3. "A Cheyenne," an illustration in "Artist Wanderings Among Cheyennes," *The
Century Illustrated Monthly Magazine*, August 1889.

4. "The Bugler," an illustration in "Skirmish Drill of the New York State
National Guard," *Harper's Weekly*, August 4, 1888.

5. "Apache Scout," an illustration in "On the Indian Reservations," *The Century
Illustrated Monthly Magazine*, July 1889.

6. National Academy of Design show.

7. Paris International Exhibition.

8. "Last Lull in the Fight," *Harper's Weekly*, March 30, 1889, double page
244–45. The painting won second-place honors at the Paris International
Exhibition.

Just illustrated Kentucky racing article for Scribners[9]—theroughbred horses—out of my line.—

Clark I promised to do some work for you this year but I have got a mass of stuff to wade through which I can not see the end of and I am afraid I wont get around but be of good heart—Ill get there some time if death dont intervene.

About your writing that thing up—its a dead gamble—if its Christmas it wont go for a year—see—it could only go as a story in a magazine. Write "Garrison Life in the South West"—write it way up—racy—real—unconventional—and Ill see what I can do with it.—

<div style="text-align:center">

Yours
Frederic Remington

</div>

This is "more" ink—its "most" ink too.—

William A. Poste was an old friend of Remington's from Canton, and his personal attorney. He had served as first deputy attorney general of New York State, and later as a partner in the law firm of Russell, Poste and Percy.

☐ **FREDERIC REMINGTON TO WILLIAM A. POSTE**

<div style="text-align:center">

360 West 58th Street
Marlborough *Tenement*
New York City
[1887]

</div>

Mine Host:— That dress coat proposition is one of the most low down tricks which a white man could resort to. Of course it is plain enough that you want to economize well knowing that I have outgrown my dress suit which is now so tight that I cannot

9. "How the Derby Was Won," Harrison Robertson, *Scribner's*, July 1889.

take breath, let alone eat in it. But I patiently take my medicine. Order a French Chop and an after dinner coffee—that will be all right if I let out the top button.

>Freezingly yours,
>Fred Remington

21st

☐ *FREDERIC REMINGTON TO WILLIAM A. POSTE*

>Marlborough House or Manor—
> anything you like
>Second Sunday after Trinity
>Amen—pass the pears—
>Gotham [1888]

My esteemed Contemporary— I am thus formal that I may impress upon you that my address is 561 Mott Avenue—two blocks from the 138th St. station of the N.Y. Central or Harlem road— 9 minutes from the G. Central Depot and dont you forget it and it aint a d—— sight nearer Boston than it is New York as a friend of mine suggested just before he put feathers on his back and got out his harp. This no bloody railroad guide book M.S. either but a plain unvarnished tale. I want to be "put on the list" of your calling places here and remember that there is no latch on the door and the pantry is always full of pie.

>Yours
>Frederic the Great.—

P.S. I was out late last night. Banquet at Canadian club but I have gone back to whiskey—no more beer since King William died from the effects of drinking it at the tender age of 497 years. I want to live for ever.

☐ *FREDERIC REMINGTON TO WILLIAM A. POSTE*

>561 Mott Avenue
>New York City
>November 11 [1888]

My dear Poste— Your letter at hand—in reply would say—that you are d——est queerest critter that I ever jumped—little sensative—too d—— sensative—because I didn't answer your last letter—well aint that a h——l of a way to look at it—you know me Pete—I dont go in much on the formalities—I would write you thirty thousand letters if I had anything to say and wouldn't give a durn whether you answered or not—you just go ahead and write me letters and come up here and smoke my cigars and pipes and

drink my rum and eat my grub and your always welcome and if I have got to pass formalities with you I just switch. I'll give you a dréss coat—9 course dinner—I will say "Mr. Poste if you happen to desire a little of this Kentucy Burbon I trust you will help yourself even if I do not drink"—I will have all cards printed—"I will request the pleasure of your company, from 8 until 10 PM" etc. etc. etc. etc. etc.—now then you just come off the grass—you churn up my soul—I'm tired.—

After you got around to it I very much enjoyed your letter— Ive been debating whether to send it to Wright[1] or not—Wright's weakness is constitutional and I do not think he could be regemented by simple argument satire or advice. If we licked him we would simply increase our own degeneracy—if I painted him people would cry "caricature" I tell you that when a chap gets on the moral plain of Wright and J.K. Hamilton Willcox they are beyond the reach of ordinary human endeavors.

As to Roosevelt[2]_____

my opinion is that he is a g—— d_____

And that is all I have got to say about it in public.—

If you will come and see me I will fill *your* mind with patented ideas transcendental theory—glairing English usage of the new regime—and also I will not neglect the creature comfort—if that is not an inducement I will declare a dividend—now then

Here I am
Frederic Remington

In the spring of 1889, Remington went to Mexico by train on a commission from Harper's Weekly *to gather material for illustrations that would accompany a series of articles by Thomas Janvier. "The Aztec Treasure House" appeared in seventeen installments between December 21, 1889, and April 26, 1890, each with one or two Remington drawings. In November 1889, an article by Janvier appeared in* Harper's Monthly *with fourteen illustrations by Remington, including the frontispiece and several full-page drawings. It was Remington's first appearance in this prestigious magazine.*

1. George M. Wright, New York lawyer and friend.
2. Theodore Roosevelt. The occasion for the outburst against him was probably the pressure Remington was feeling from *Century* to get the illustrations done for their serialization of Roosevelt's *Ranch Life and the Hunting Trail,* which would appear in that magazine prior to publication.

☐ *FREDERIC REMINGTON TO POWHATAN CLARKE*

561 Mott Avenue
New York City
March 14, 1889

My dear Clark. I am just home from the city of Mexico where I
have been doing the army. They are immensly picturesque and I
have some good subjects. In your next letter write me all the facts
you know concerning the operation of Mex. regular troops in
Sonora—their methods—their marching and fighting. I may
use it in connection with an article.

Our article comes out the 1st of April.—[1]

If you get a leave come and see me. We will have a great little
time here—I am full of work but a "loafer" dont bother me.

"*Missie*" thats my wife says tell "Mr. Clark to come on East and
see us." I presume Mr. C. would like to come but I know he dont
have his own say so—hows that.

Was sorry to be as near as El Paso and not see you but "*tempes
est duieros*"

Well I am not caught up in my bus. letters so I cant wast time
on my friends.—More soon

Yours
Fred R

P.S.

My big picture "The Last Lull in the Fight" has gone to Paris.—

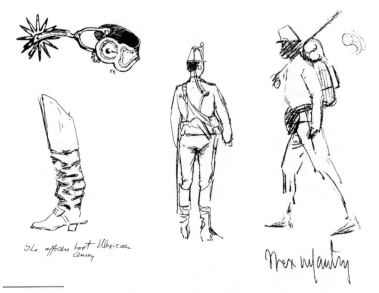

The officers boot Mexican army

Mex infantry

1. "A Scout with the Buffalo Soldiers," written and illustrated by Frederic
Remington, *The Century Illustrated Monthly Magazine*, April 1889.

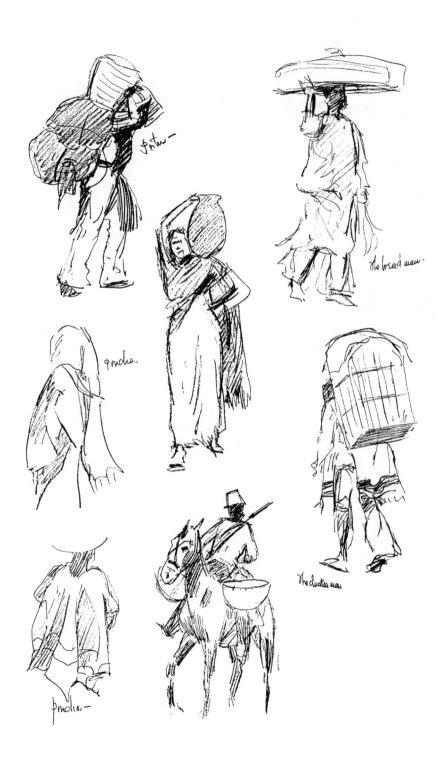

The bread man.

The chicken man

☐ *FREDERIC REMINGTON TO LT. POWHATAN CLARKE*

561 Mott Avenue
New York City
April 2, 1889

My dear Clark. I think the rabbit photo is great—will use it presently for an illustration. By the time this reaches you, you will have read my article in the "Century"—There is a great deal in that article which *reads well* and has nothing else to recommend it. A friend of mine charged a reporter once with writing what was not so but the reporter meekly querried "dont it read well"—"oh yes—but its a d—— lie"—replied my friend "then its all right" perorated the reporter.

Sorry about your eyes but I hope they may bring you East. Clark, I mightly would like a visit from you—it would not be a high carnival for you but then little things make life.

I have a big order for a cow-boy picture[1] and I want a lot of *"chapperras"* —say two or three pairs—and if you will buy them of some of the cow-boys there and ship them to me by express C.O.D. I will be your slave. I want *old ones*—and they should all be different in shape. One pair like the drawing would be very desirable—big flaps uncut for fringe—you have seen them. I have four pairs now and want some more and as soon as I can get them will begin the picture. There are a lot of cowboys in your country and you ought to be able to pick them up with out much trouble—also that pistol holster which I left down there. Write if you are not able to procure them and I will try elsewhere.

If you come East I hope you will come before the 1st of July as I go North then.

Your old pard
Remington

Richard Watson Gilder was editor in chief of The Century Illustrated Monthly Magazine. *Remington wrote and illustrated four articles for the magazine in 1889: January ("Horses of the Plains"),*

1. He was commissioned by Edmund Cogswell Converse to do *A Dash for the Timber,* a four-by-seven-foot oil painting.

*April ("A Scout with the Buffalo Soldiers"), July ("On the Indian
Reservations"), and August ("Artist Wanderings Among the Chey-
ennes"). He had illustrated several of Theodore Roosevelt's articles
for the magazine prior to that and continued to illustrate articles
for Century through 1904, but these were his only attempts at
authorship for them.*

☐ *FREDERIC REMINGTON TO RICHARD WATSON GILDER*

561 Mott Avenue
New York City
April 6, 1889

Mr. Gilder—Editor Century My dear sir:—At your convenience
I trust you will have the goodness to conclude the business trans-
action regarding the two Indian articles which I wrote for your
magazine. I was paid $100 on account for the two articles as you
had not had time there, in the office, to look the matter up thor-
oughly. If there is any more coming to me I should like to know it
and if not, the determination of that fact will have a soothing
effect on my mind. I have not inquired into this matter in so long
a time that I thought I would remind your people of it. I am

Very Respt. yours
Frederic Remington

☐ *FREDERIC REMINGTON TO LT. POWHATAN CLARKE*

561 Mott Avenue
New York City
April 15 [1889]

Dear Old Boy: I d—— glad you are coming East. I am in a sweat
of a hurry but I'll tell you you just keep me posted and I'll see that
we meet this trip.—You have got to eat my porridge this time or
bust a flue.

—Poor old Jim.[1]—I told him I'de get *hunk* with him—d——
him, he s square with me—I consider that he gave me the awful-
est racket that a tenderfoot runs accoss often. There will be no
second dose you can bet.

I'm going to do the hounds for a "double"[2] soon.

Yours
Remington

1. Lt. James M. Watson, Clarke's fellow officer in Tenth Cavalry.
2. "Double" refers to double-page illustration. "Running a Coyote with the
Hounds in Southern California" appeared in *Harper's Weekly*, October 25, 1890,
but as a full-page not double-page illustration.

☐ *FREDERIC REMINGTON TO LT. POWHATAN CLARKE*

561 Mott Avenue
New York City
December 1, 1889

My dear old man— Well Im going to write you—nothing in particular to say but this.

I have signed the contract for the purchase of an estate[1]—estate is the proper term—three acres—brick house—large stable—trees—granite gates—everything all hunk—lawn tennis in the front yard—garden—hen house—am going to try and pay $13,000 cold bones for it—located on the "quality hill" of New Rochelle—30 minutes from 42nd with two horses—both good ones on the place—duck shooting on the bay in the Fall—good society—sailing & the finest country 'bout you ever saw—what more does one want. I wouldn't trade it for a chance at a Mohamedan paradise. The next time you come to see me you will have better care than the last. We are only living on probation now—I had no capital and was trying to accumulate some but now I'm going to branch out and since we only go through this life but once I propose to go easy—Dont be discouraged at your last reception just try me in New Rochelle and if I dont make you glad—Il be a d——.

My picture "Dash for the Timber" in the Academy[2] has got a *grand* puff in the papers.—They all had a good word to say—I have had it photogravied—Am doing, "Questionable Companionship"[3]—"Past all Surgery" and "In a Timber Slash" new—all orders—What did you think of My Mexican Army[4] in Harpers Magazine.

1. Remington bought land and built a house in New Rochelle, New York.
2. *Dash for Timber*, done in 1889, a large oil on canvas, was entered in the Autumn Exhibition of the National Academy of Design.
3. "Questionable Companionship" appeared as a full-page drawing in the August 9, 1890, *Harper's Weekly*.
4. "The Mexican Army" by Thomas Janvier, illustrated by Remington, *Harper's Monthly*, November 1889.

We are having delightful weather here—no snow—bright not cold etc. this is the best all round climate in the world.

I see they are razing h——l with the army—I think Gen. Lew Wallace[5] is right—democracise the army—make the best American youth enlist—I wonder what prejudice Gen. L. Wall—recommendations will meet with among you chaps.—some one no doubt but no *great* reform was ever instituted that did not have to wade knee deep in the blood of a prejudice.—

When do you have your next "leave"?

I hope you are not still "in the field."—I wish you could see my house—

My wild horse is doing well had a nice long ride to day—but I wish you could only see my house—my head is getting large on account of it.—The proportion is as this—which is as you remember to— to this and if I can only keep it down to this size I am all hunk.—

That photographe from Apache sends me $150 worth of photos—which I will remit.—

"Missie" sends you her love and wants to know if you still pace the floor with your hands in your pockets and talk war.—I know you do and still I love you

As Ever
Frederic Remington

[On margin of first page Missie writes:]

"Darlin" is dieting & is losing some, not so much however but what you would know him.

[At the end of the letter she adds:]
My Dear Lieut.

Our new home is perfectly charming and we are the happiest people you ever saw & just I'm in anticipation of the good times we are to have there. We have a view of the sound & country around & in fact we are lucky in possessing it. which is the *best* girl now? You ought to leave the army, get married & come & live next to us if you want perfect enjoyment.

Excuse pencil You must come east soon & see us. "Missie"

5. Lewis Wallace was a general in the Union army during the Civil War and rose to the rank of major general. He was governor of New Mexico from 1878 and United States minister to Turkey from 1881 to 1885. He was also the author of the novel *Ben Hur* (1880).

Chapter 3
The Recognized
Illustrator and Beyond
1889–1894

B Y 1889, Remington was commonly thought of as "the Western artist." His work was appearing regularly in some of the most widely read magazines of the time—*Harper's Weekly, The Century Illustrated Monthly Magazine,* and *Outing.* His pictures of soldiers, cowboys, and Indians, of horses and buffalo on the plains, were done with a realism that attracted those who knew the West. Remington's approach was that of a participator. Not one to sit on the sidelines once he had arrived at his destination, he rode along with scouting parties, slept in their tents, and shared their grub. He did not hesitate to take advantage of an opportunity to join the action if one was offered, and was lucky enough never to have been seriously harmed.

Beginning in the late 1880s and at least once every year until well after the turn of the century, Remington made at least one trip west, and occasionally to Canada or Mexico. These were no longer the wandering journeys of his youth. Now he was sought out by editors and publishers and given letters of introduction. His drawings were awaited eagerly by the readership of the magazines he worked for because they felt he was giving them an honest portrayal of the scenes and people he saw.

In December 1889 he went to Canada with Julian Ralph, a widely published and popular travel writer who practiced an older, more chatty style. The two men had become good friends through their mutual association with Harper's publishing house and had spent time together socializing with the actors, writers, and artists who

congregated at the Players Club in New York. Their collaboration in Canada resulted in "Antoine's Moose Yard," which appeared in *Harper's Monthly* in October 1890.

Another opportunity arose in January 1890. Gen. Nelson A. Miles, whom Remington had met on the 1886 trip west, invited him to tour California as a guest of the Army. Harper's extended the assignment to include the Northwest as well, commissioning him and Julian Ralph to do a series of illustrated articles on western Canada. This time, Eva Remington accompanied her husband. The trip produced a flurry of articles about British Columbia, featuring a total of 49 illustrations by Remington, in *Harper's Monthly*. "Dan Dunn's Outfit" ran in the November 1891 issue, "Chartering a Nation" in December 1891, "Canada's El Dorado" in January 1892, "A Skin for a Skin" in February 1892, and "Talking Musquash" in March 1892. In 1892, *Harper's* reprinted these articles, along with several by Ralph about other parts of Canada, in a book titled *On Canada's Frontier*. Remington illustrated two other books for Ralph between 1890 and 1895, as well as two articles for *Harper's Monthly:* "Brother of the Sea" (April 1892) and "Where Time Has Slumbered" (September 1894).

Ralph even wrote about Remington and his eccentricities for *Harper's*, augmenting the artist's celebrity. As a result, Remington operated at a high level of self-assuredness in his relationship with the publisher. His letters reveal a confident illustrator who not only accepted commissions but also submitted work he was sure would be accepted and paid for, even if it were not used immediately. This is evident in his sometimes curt or high-handed notes to Fred B. Schell, his editor at *Harper's*.

Later in 1890, disturbances on the Indian reservations in southwestern South Dakota, especially the Pine Ridge Indian Reservation, took Remington west again. General Miles had, in the spring of 1890, been promoted to major general in command of the Division of the Missouri, which encompassed old Sioux hunting grounds that were now part of reservations such as Pine Ridge. To assess the problems that seemed to be arising from conflicts between the Indians and the government's agents, Miles planned a trip to the area in October and invited Remington to join him. On his return Remington wrote and illustrated two articles: "Chasing a Major General" appeared in *Harper's Weekly* on December 6, 1890, and "Indians as Irregular Cavalry" on December 27, 1890. That was not the end of Remington's involvement with the Sioux, however. Miles's orders from President Harrison were to avoid hostilities, but a detail of men sent to "arrest" the Sioux leader Sitting Bull killed him instead on December 15, 1890. When news arrived in the East about the uprising that followed, Remington immediately got Fred Schell's permission to cover the story for Harper's. Once in South Dakota, Remington left General Miles and joined

Lt. E. W. Casey and a group of Cheyenne scouts in the hope of seeing some action. When nothing seemed to be happening, he left Casey and joined H. C. Thompson, an interpreter, and several other Indian scouts, including Red Bear, on their way to the Pine Ridge Agency. When they encountered some unfriendly Sioux Indians and, simultaneously, some friendly cowboys, a few shots were fired. Remington later credited Red Bear with saving his life and sent him a rifle to express his appreciation.

Meanwhile, Remington missed the real (and only) battle of the war, the Wounded Knee massacre, which took place on December 29 not far from the Pine Ridge Agency while Remington was returning there. In this infamous battle, the Seventh Cavalry under Col. James Forsyth surrounded and attacked a camp of Sioux, including women and children. Remington left for home on January 5, 1891, and learned on the train that Lieutenant Casey had been shot to death by the Sioux.

Articles written and illustrated by Remington about these experiences appeared in *Harper's Weekly* as "The Sioux Outbreak in South Dakota" on January 24, 1891; "Lt. Casey's Last Scout" on January 31, 1891; and "The Sioux War: Final Review of Gen. Miles's Army at Pine Ridge" on February 7, 1891.

During this period, Remington began to make an effort to broaden his experience beyond the West. In March 1891, General Miles invited him and Eva to Mexico. Eva was thrilled at meeting the Mexican president and with everything she saw, as she wrote in detail to Lt. Powhatan Clarke.

Remington's own correspondence with Clarke reflects his satisfaction with the way his work was being received. He comments on the scope of his work and his ever-improving style of life, epitomized by his large new house in New Rochelle. First named "Coseyo," the house was later called "Endion," an Indian term meaning "the place where I live," which Remington had heard on one of his trips with Julian Ralph.

More than ever, Remington writes in short phrases and incomplete sentences, separated by dashes and filled with unfinished thoughts and misspelled words. They are the letters of a man on the run, a man so busy with assignments and his preparation for them that he barely has time to catch his breath.

Harper's Weekly published three articles related to Remington's trip to Mexico. "General Miles's Review of the Mexican Army" appeared on July 4, 1891, and "Coolies Loading a Ward Liner" appeared on November 7, 1891, both written and illustrated by Remington. "El Cinco de Mayo," written by Maurice Kingsley with illustrations by Remington, appeared on May 7, 1892.

In June 1891, Remington was elected an Associate of the National Academy of Design, the second highest honor his artist peers could bestow. Much to his disappointment, he never achieved the

Academy's highest designation, that of Academician. He was reaching a decision point in his career. Should he continue as an illustrator of the West or pursue a more purely artistic direction? When Clarke went to Europe in 1891, Remington went to Canton and Cranberry Lake in the Adirondacks. His correspondence indicates that he too was considering a trip to Europe, both for the sake of his artistic development and as an opportunity to see European military men and arms at close range. When an opportunity came to go with Poultney Bigelow in 1892, he took it.

There is some dispute about the trip's itinerary. It is known that Remington left New York on May 19, 1892, and returned July 9, 1892, and that he and Bigelow spent time together in Berlin, in Russia, and at Trakehnen, the German emperor's horse farm. Their original plan included a canoe trip on the Volga River, for which they needed permission from the Russian government. They had purchased two Rob Roy sailing canoes fitted with hatches and sleeping quarters, tents, sails, and all that was needed for a long journey. Unfortunately, the trip was perceived as an espionage mission by Russian officials, and the two travelers were unceremoniously ejected from the country and only later compensated for damage to their canoes.

There is some indication that they touched down in North Africa after leaving Trakehnen and before returning to Paris.[1] The fact that Remington illustrated an article for *Harper's Monthly* called "Slavery and the Slave Trade in Africa" by Henry M. Stanley, which appeared in March 1893, would tend to support that theory. It is possible that Remington and Bigelow went to Oran, Algeria, first and had the experiences that Bigelow later described in "An Arabian Day and Night," published in *Harper's Monthly* in December 1894.[2] The article may derive, however, from a second trip by the two friends between February 21 and April 1, 1894, during which Bigelow gathered information for a series of articles commissioned by *Harper's* on military posts in France's North African colonies.[3]

Nevertheless, three other articles by Bigelow related to the 1892 European trip did appear in *Harper's Monthly* within the year, all illustrated by Remington. They were "Why We Left Russia" in January 1893, "In the Barracks of the Czar" in April 1893, and "Sidelights on the German Soldier" in July 1893. Bigelow also produced a book, *Borderland of Czar and Kaiser*.

Bigelow later commented on Remington's phenomenal photographic memory. The two men were trailed by Russian officers

1. Peter Hassrick, *Frederic Remington* (New York: Harry N. Abrams, 1973).
2. Harold McCracken, *Frederic Remington—Artist of the Old West* (New York: J. B. Lippincott, 1947).
3. Peggy and Harold Samuels, *Frederic Remington: A Biography* (Garden City, New York: Doubleday, 1982).

during the days they waited for their passports to be validated. Finally, when they were on a steamer on their way out of Russia, Remington thought he was comparatively safe from observation and pulled out his sketchbook. An officer came up to him and politely warned him, "as a friend," to put it away. Remington, not wanting to be held in a Russian jail, folded the book, weighted it, and slipped it into the water. But it didn't matter, said Bigelow. When they were safely across the border, Remington perfectly recalled his impressions in a rapid-fire succession of sketches that later appeared as illustrations for the articles and book related to the trip.

Remington left Bigelow in Europe and stopped in London before returning home. He went to see William F. "Buffalo Bill" Cody's Wild West Show and visited with the British military at Aldershot. On his return, *Harper's Weekly* published sketches from these two side trips. Ten drawings entitled "Buffalo Bill's Wild West Show in London" appeared in the issue of September 3, 1892, and eight entitled "An Athletic Tournament of the British Army at Aldershot" in the issue of September 10, 1892.

Commissions related to this trip continued for several years. When an article by Powhatan Clarke—"Characteristic Sketches of the German Army"—appeared in *Harper's Weekly* on May 20, 1893, there were thirteen Remington sketches accompanying it. Thirteen more Remington drawings appeared with Poultney Bigelow's article "Emperor William's Stud Farm and Hunting Forest" in the April 1894 *Harper's Monthly*.

The question of art versus illustration was still an unresolved one for Remington. In January 1893, he took a step in the direction of art by holding a one-man show and sale at the American Art Galleries in New York instead of simply participating in the 1893 exhibition of the National Academy of Design. Remington spent a great deal of time preparing for the show, which received national publicity and brought in over $7,000. He was ecstatic but exhausted. On January 29, 1893, he and Eva left for a trip west and south. Eva stopped in Chicago, Detroit, Dayton, and Kansas City before going on to join her husband, who had gone ahead to Chihuahua, Mexico, and Jack Follansbee's ranch at Bavicora, a few hundred miles to the north. Remington returned home with his portfolio filled. Over the next few years, articles appeared in both *Harper's Weekly* and *Monthly* on topics related to Mexico. The three in the *Monthly*, "An Outpost of Civilization" (December 1893), "In the Sierra Madre with the Punchers" (February 1894), and "A Rodeo at Los Ojos" (March 1894), were written and illustrated by Remington. Illustrations appeared in the December 9 and 30, 1893, issues of the *Weekly*, and an illustrated article—"Coaching in Chihuahua"—appeared in the April 13, 1895, issue.

Remington would continue to illustrate, accepting commissions

for magazine articles as well as books. He would also continue to refine his paintings and within a few years would discover the joy of working in bronze.

A poem by William Poste, Canton attorney and long-time family friend, introduces the Frederic Remington of 1889.

☐ **POEM BY WILLIAM A. POSTE TO FREDERIC REMINGTON**

F. R.

He paints the Injun all greased up for gore—
This brainy, burly, obstinate, blonde crank.
He limns the broncho, humped, rat-tailed and lank;
And e'en depicts the punched bull's frenzied roar.
He writes us English that doth never bore,
And speaks the tongue with many a vigorous *blank.*
The rarest host is he in th' evening's shank,
And hates the sound of good-night closing door.
His pictures draw us as with lasso's strain
To Western scenes—we hunt the grizzly bear;
The redskins circling ride the hopeless plain,
Round leaguered troopers grim though in despair;
The cowboys mock the tenderfoot's weak pain;
The bellowing round-up shakes the dusty air.

W. A. Poste
January 8, 1889

☐ **FREDERIC REMINGTON TO WILLIAM A. POSTE**

Bloomingdale Asylum
Feast of St. Peter's Chair
at Rome, 1889

My dear Post— Owing to inebriety and over work I have neglected to respond to the poem. I have been intending to do so.

It was somewhat out of your usual vein and down here we are inclined to be a trifle sensative on the thing—that is the friends of Mr. Wright.

I interviewed Mr. W. the other day on the subject—he is very sore and I think not without reason. Of course none of us object to real fun but when it comes to speaking right out boldly of certain truths such as that poem contained Mr. W.—and his friends sort of are inclined to resent it. Of course if I were Wright, I

should send *my friend* to *your friend* but W—will simply suffer in silence. There is a grave difference between fun and brutal reminders of infirmities.

Yours indignantly,
Frederic the Kalsominer

☐ *FREDERIC REMINGTON TO A MR. McCORMACK*

301 Webster Avenue
New Rochelle, New York
December 10 [1890]

My dear McCormack, Thank you for your appreciation and good words.

You see there is a wide fundamental split between myself and the school which holds that subject matter is of no importance in painting. I believe it is. I was born wanting to do certain phases of life and I am going to die doing them. This school ought to forgive me for wanting to do man and horses and landscapes of the West and hold it of no importance. The school considers only my paint. I am willing to be judged from their small standpoint.

If I were condemned to do fret-work—knit or crochet birds and second growth timber and babbling brooks I should cease to paint. I simply disagree with them in toto—and I am perfectly willing to be judged by posterity; it don't matter what we think now. I wish sometime you would just say this— say that I don't agree with this idea so prevalent now and shall die fighting.

Yours truly,
Frederic Remington

Regards of both to Mrs. McC-

William Carey was an assistant editor at Scribner's, which published The Century Illustrated Monthly Magazine. *Fred B. Schell was Remington's editor at* Harper's. *Although the telephone had been patented by Alexander Graham Bell in 1876, much business continued to be conducted by both carefully constructed letters and hastily dashed notes.*

☐ *FREDERIC REMINGTON TO WILLIAM CAREY*

561 Mott Avenue
New York City
October 3, 1888

Mr. William Carey. My dear sir:—I have corrected one or two words in M.S. I send something to add relating to wolves—The mountain man referred to once or twice—The cut "A Sire of the

Race" should be tipped over to the left—he is coming down hill
and the action is ruined by wrong placing of the picture—(plate).

Yours very Respect.

Frederic Remington

P.S. insert the "writing" about wolves in * page 335.

P.S. The present title is an improvement.

R

☐ FREDERIC REMINGTON TO FRED B. SCHELL

561 Mott Avenue
New York City
January 8, 1890

My dear Mr. Schell The double page this week is immense in
the matter of reproduction. It comes nearly as well as in the proof.
It has all the qualities of the original. It is one of those things that
makes an illustrators life worth living. These engravers are all
right when they do great good work but they need a good deal of
special dispensation to purge their sins—process is the coming
thing—the purpose of reproduction is the point and if a reproduc-
tion cost $25 or $300 it does not matter—the fittest will survive.

The point of this letter is to let you know that I am happy—&
there is no charge for all this information, meanwhile I am

Yours very truly
Frederic Remington

☐ FREDERIC REMINGTON TO J. HENRY HARPER

561 Mott Avenue
New York City
January 21, 1890

Mr. J. Henry Harper My dear sir—I read the enclosure of the
gentleman who saw discrepancies in my "Carabou hunting"[1] with
interest but find that he is talking about New Brunswick while my
picture is located on the north shore of Lake Superior among the
Chippeways. You might mail him this and he might then be more
lenient. I am

Yours truly,
Frederic Remington

1. "Hunting the Caribou"—'Shoot! Shoot!'" was a double-page illustration
in the January 11, 1890, *Harper's Weekly*.

☐ *FREDERIC REMINGTON TO FRED B. SCHELL*

561 Mott Avenue
New York City
February 15 [1890]

My dear Mr. Schell— Here is a drawing—"Spring Trout Fishing in the Adirondacks"[1] —an odious comparison of weights—or any like title which you may think of if this does not best express the idea. I did this Kurtz[2] process and would like a "double page" on it—I am

Yours truly,
Frederic Remington

Remington's letter to Mr. Sparhawk indicates that he has made a choice about direction in his illustrating; that is, he will do Western scenes, not Civil War scenes.

☐ *FREDERIC REMINGTON TO MR. SPARHAWK*

301 Webster Avenue
New Rochelle, New York
November 26 [1890]

My dear Mr. Sparhawk— I have your very agreeable note asking for the war drawings but I am not going to send them for the reason that I am not satisfied with them myself. The fact is that I do not do the Civil War period because I do not know enough about it. It is a mistake to think I can handle that subject. I am weak enough at times to attempt things which I know little or nothing about but if I ever give it a second thought I withdraw.

Mr. de Thulstrup or Allen C. Redwood of Bergen Point New Jersey have a good knowledge of the period and lots of "stage property" concerning it. I would advise that you go to them.

I am apt to get the character of the war 10 years out of period and moreover am afflicted with a lack of care concerning such subjects.

All the objections against my drawings were quite true no

1. Appeared in *Harper's Weekly* on May 27, 1890.

2. Kurtz was a photoengraver who was using a new process to reproduce art for use in magazines. Remington was excited about the method because he felt his drawings could be more exactly reproduced by this method than by the woodblock method then in common use. He often worked closely with Kurtz and acted as an advocate for the process with his own editors.

doubt, only I should have been furnished with the knowledge, photos etc. before and not after the work.

It is quite my fault and so we will give it all up. Sorry to have delayed you in your publication and thank you for your unfailing courtesy in the matter.

Yours faithfully,
Frederic Remington

This is a diagram of Ralph's mouth while he is sleeping—The Human Caliope

One evening in December 1889 at the Players Club in New York City, Julian Ralph and Remington, both tired from overwork, concocted a moose-hunting trip to Canada. It was not unlike either Remington or Ralph to make such spur-of-the-moment plans.

☐ FREDERIC REMINGTON TO JULIAN RALPH

301 Webster Avenue
New Rochelle, New York [1889]
My dear Julian— What do you want to go to Canada for?
What is the matter with little old New York.
Yours truly,

☐ FREDERIC REMINGTON TO JULIAN RALPH

Endion
New Rochelle [1889]
My dear Ralph— The receipt of your letter was like "three fingers" on me. Of course Ill' go. I have some work to do and then within about ten days we will go to where there is eight feet of snow.

I will meet you at the Sun office (Paddocks)[1] at 9.45 (exact) on Saturday morning. We will then arrange the details of our assault on the Scribners and go at them. That will leave time enough for negotiations. Ohval & Burdick[2] and Van Horne will chalk our lists and we will have a good time and get rich. You say a book—oh well—if you can make it. Four articles will do though. The boys say the present art manager of Scribners is no good— but—guess we can go over him, Doubleday[3]

The Yellowstone Park in winter has never been done.

Yours truly,
Frederic Remington

Pencil sketch of a moose possibly made on hunting trip to Canada with Ralph Dec. 1889

Sketch used as basis for illustration "The Hotel—Last Sign of Civilization" in Julian Ralph's "Antoine's Mooseyard," Harper's Monthly, Oct. 1890, vol. 81, p. 653.

1. *The New York Sun,* a newspaper.
2. Joel Burdick worked for the Delaware and Hudson Railroad. He was a friend of Remington's and an avid outdoorsman.
3. Frank Nelson Doubleday was manager of *Scribner's Magazine* at this time. Later he become president of Doubleday, Page and Company.

☐ *FREDERIC REMINGTON TO JULIAN RALPH*

New Rochelle
May 22, 1891

My dear Ralph How glad I am that we did not shoot a moose—
lots of common place people do that—we do not but we set the
world agog about whether we did or not and private investigation
will always be fragmentary and not serious. We will always be
credited as either great hunters or great liars and either is good
enough to satisfy the ambition of modest men.

I'll see you one day. Don't ever forget to say "Well I've got my
head and that's d—— good documents.

Yours, Fred Remington

*After Remington and Julian Ralph returned from their winter trip to
Canada, Remington received an invitation from Gen. Nelson A.
Miles to tour California as a guest of the Army.*

☐ *FREDERIC REMINGTON TO LT. POWHATAN CLARKE*

New Rochelle
January 9, 1890

My dear Clark Ten days before Xmas another man who was also
insane and I started to make a dash for the North Pole—we got as
far as Matawa Canada and then concluded to hunt the "festive
moose" as you would say. We got three degenerate Algonquins
who had been doing the "flowing bowl act" for some days & then
started—we had grub which was tough enough for an Arizona
prospector. We slept in a log camp with half the roof off and as
the Western man said "d—— us we like it too"—we killed to moose
& we have "done the thing" as the newspaper men say—of course
we will jolt Christendom when they find out what fly hunters
we are.

Gen Miles sent me a nice little note—wanted all my work—I
gasped—he would if I had made him pay for it—but the Kings
request is a demand so I upset N.Y. got the plunder to gather sent
it to him with note all about how happy I was & he replied by a
very graceful letter missive which is now pasted in my scrap book—
but seriously it was good of the Gen. to like my stuff and I was
duly honored etc. he asked me to come out next summer—would
like to you can bet—I recen you & I could get a pack train if we
wanted it. But no—Selkirks—better mountain scenery, more
game—good hotel for the old lady at Banffe

Am at work on that big cavalry picture you say—got smoke and
blood a foot thick on it—think it will get there.

Met Edwin A. Abbey[1] to day—first time—rather nice little fellow—stuck on England—can talk American though—most people manage to forget it in two or three years.

These sketches were made on the spot and show just how Antonie and I looked when we were getting ready to do the following.

You will observe the great attention to detail—the vast knowledge of situation—the play of human emotion—the character of the moose aforesaid & you must realize that it was made by our special artist on the spot.

Clark this is a d—— poor apology for a letter but I am a mental rag and like the little boy who made an error in the seat of his pants—"Ill do different next time."—Yours

Frederic Remington

Early in 1890, Remington entered two paintings in the Brooklyn Art Club exhibition. Inexplicably, the labels on the two pictures were switched. Frank Squires was the official in charge of the show.

☐ *FREDERIC REMINGTON TO FRANK SQUIRES*

561 Mott Avenue
New York City
January 30, 1890

Mr. Frank Squires My dear sir: I have not had time to go over to the Brooklyn Art Club Ex and I am somewhat amused and greatly concerned upon reading the press criticisms to find that the critics are describing a picture of mine called the "Indian Trapper" (scene laid in Selkirk Mountains—far North West) under a heading of another picture called the "Mexican Major." (scene laid about 5000 miles from there). If you will kindly look and see which of these pictures is in the Club and write me I will be under obligation. Also please see that the "salesman" is made aware of the error.

My little sketches are inexcusably bad but I rely on your trained mind to appreciate that they are not alike. You may possibly hand this to some other person to answer—in any case I will be very much obliged to you and remain

Yours truly
Frederic Remington

1. Edwin A. Abbey, American artist and contemporary of Remington's who achieved great fame as an illustrator of Shakespeare.

myself my algonquin (as Longfellow

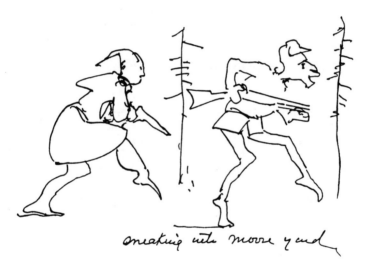

sneaking into moose yard

☐ *FREDERIC REMINGTON TO FRANK SQUIRES*

561 Mott Avenue
New York City
February 1, 1890

Mr. Frank Squires My dear sir—your considerate letter at hand.
I saw the Wadsworth at the Water Color Reception last night and
he advises me that the Indian Trapper is sold.

I yet have the "Mexican Major" which is the more important
picture of the two and possibly your people will consider that.
The picture is at present in Wilmurt's framing store 13th St. or
the American Art Association on 23rd Street and is soon to be
sent away. You might write me if you desire me to hold it for a
time. Thanking you for your kindness and congratulating you
on the success of the Art Club. I am

Yours truly
Frederic Remington

☐ *FREDERIC REMINGTON TO LT. POWHATAN CLARKE*

1–30–1890

My dear Lootinint- Your last letter is here—I will take the Cav-
alry Journal—where do you get it.—d—— the future—soldiers
by proffession deal with the future—artists deal with the past
though. I dont care a d —— what you cavalryman are going to
do—its what you have done. You tell me I dont know anything
about the pursuit of arms and I belive you now why in thunder
should I freight my pail brain with the wrangling of a lot of chaps
who cant agree among themselves?

If you want to have your soul harrowed up—just tell me when
U.S. soldiers discontinued to wear the black slouch hat like this.—
There is an idea. When was the Springfield carbine in use after
the Spencer[1]—did Custer's men carry sabers in the "Washita"
fight.[2]—Custer's orders were "not to"— Sergeant Kennedy kiled
several indians with a saber before he was killed.—now then great
head worry over these problems—their artistic. My big "cavalry
fight" is going to be a "corker"—I tell you boy I've got 'em to fight-
ing—blood by the bucket full—smoke
enough for Chicago in '70.

Where can I get that record of the
U.S. Army engagements since '68 by
Sheridan?[3]

1. Spencer rifle.
2. Custer routed Black Kettle's Cheyennes on the Washita River in Indian
Territory (later Oklahoma) in 1868–69.
3. Gen. Philip Henry Sheridan.

Your views on the reorganization of the army—"socilistic & general equality racket" etc. Are not rare—they are not progressive—I see that if I tackle you seriously I have got a large undertaking to convince you that you are a man who ought to steer clear of the *ruts*—you would be better off in a new deal—this scheme of the man who has the best vital organization and who takes the most

care of himself eventually getting to be General of the Army is tough.

As to the Cavalry Association will say I have joined every d—— association in America in the last 6 months but that I have bought a house—have got to buy another horse—two wagons—everything I am hopelessly bankrupt.—but if I can have six months I will get my second wind and then I'll join the C.A.[4] & run for Congress; or scuttle a ship; anything.—

I have not had the "grip"—hope you escape.—

Am "slicking" your portrait up for the Ex. of the Society of Am. Artists[5] this Spring. —it was a rather good bit of painting. You remember it.—something like this.—

We move up to New Rochelle 15 April. —Missie sends love & I send photographs which prey pardon.—I am

Yours Remington

P.S. Hope the Pussian General takes hold of you. You'd make a good watchman.

☐ *FREDERIC REMINGTON TO LT. POWHATAN CLARKE*

561 Mott Avenue
New York City
March 25, 1890

My dear Clark— Your letter notifying me that I have been elected to a life membership of the Cavalry Association at hand— I accept the favor with avidity and the greatest pleasure—I will be

4. Cavalry Association.
5. He is probably referring to his first one-man show, which was held at the American Art Galleries in New York beginning April 7, 1890.

glad to "cough up" the dues, initiation fees, real and personal taxes, insurance gas and water rates and would even be glad to enrich a post trader for a basket if I could do so. How will I find out this item—suppose you will let me know.

I suppose there must be some perquisites for an member of the Cav. Ass'tion. I'll be blowed if you can ever make me walk up hill like a dough boy, now that I am a cavalryman. Of course my acceptance of this honor is conditioned on the understanding that I am not to go to war. My business in life, as a painter and illustrator is to give other fellows the credit that is due for gallantry—I desire no honors of this kind myself. In the public judgement of to day I am accorded the benefit of a doubt as to the heroism of my moral nature and I never want to get up very close to an evily disposed person with a gun for fear that the doubt might be dissapated.

You can make it known that I accept the election and can thank the fellows for the honor—I am

Yours gratefully
Frederic Remington

☐ *FREDERIC REMINGTON TO LT. POWHATAN CLARKE*

561 Mott Avenue
New York City

Personal & Private [March 1890]
My dear boy— Gen. Miles has been here for a week. He invited me down the Bay[1]—could not go. I had him up to ride and dine with me—he feels very kindly disposed toward me—he liked the article [2] just published in Harpers. He spoke very highly of you & also Watson.[3] He inquired about you in many ways and I made remarks calculated to do you good. You just be good to Gen. Miles and your day will come—he is disposed to treat you with consideration—bide your time dont ask small favors but wait until he is in shape and then you can bet a favor that you want and that is of importance.

Old boy we'll get you to that d——— French Cav. School or to Washington one these days if we have to burn New York City.

I move to New Rochelle.Westchester Co. N.Y. in three days!— What officers do you know at Wingate[4]—What are the hotel

1. To Governor's Island, New York.
2. "Two Gallant Young Cavalrymen," *Harper's Weekly*, March 22, 1890.
3. Lt. James M. Watson, one of the two men featured in the article. Clarke himself was the other.
4. Fort Wingate, New Mexico Territory.

accomodations there—ask John Norton!

I am coming down this Fall and I don't anticipate any trouble about having a show.

When does the summer camp break up?—

Yours
Frederic Remington

Awful hurry—excuse brevity.

☐ *FREDERIC REMINGTON TO LT. POWHATAN CLARKE*

New Rochelle
April 9, 1890

My dear Clark— Your letter at hand—dont mention it old man—you chaps deserve that sort of thing and I propose to do it as much as I find occassion for.—

I'll read your old cavalry journal even if "I dont know anything about military matters" as you alledge.

We are up here —three acres—three horses—three wagons— 2 dogs —10 hens—a good house—elegant barn & a whole lot of the d—— meanest weather you ever heard of perfectly happy— oh I forgot a tennis court. You ought to see me girate around.

There aint any little boys to say "git on to his waist band" Clark your picture is in the American Art Association Galleries and is admired by thousands—they think you are a d—— tough looking cuss but you can stand it—got you between a d—— greaser and a bad cow boy and they dont suffer by comparison. I have made a hit on the Exhibition I think.

Haven't got much to write—I simply work away—go out and "curry a hoss" before breakfast and otherwise go in for a great life.—

Missie would write you— & tell you all about it.

I hope we can entertain you here some day soon—

Sorry you couldn't give the French dough-boy a "whirl"—he enjoy it—Ask "Jim" when he's going to the "moon"—

Yours
Remington

☐ *EVA REMINGTON TO LT. POWHATAN CLARKE*

Coseyo
New Rochelle
May 24, 1890

My dear Lieut: I only wish you were here to day to see our small
farm & eat roast beef with us instead of my writing to you for then
you would see what a paradise this place is. We just returned from
a trip in the Adirondacks yesterday where we have been for ten
days fishing, hunting, sketching, *eating* & sleeping. I think "Dar-
lin" gained some 5 lbs. in that time and now he is out riding try-
ing to reduce himself. We had a very delightful time and "Darlin"
got many valuable sketches. We however found "there was no
place like home" as this place did look so beautiful to us. We have
a lawn in front of the house about 200 ft. deep by nearly 200 ft.
broad with many beautiful elm trees. Our home is old in style but
so delightful. We have an *immense* piazza in front with vines run-
ning all over it, just the place for hammocks, big chairs, a table &
luncheon if you like. The house homey and so bright. I will draw
a little plan of it. Darlin has a studio 13 by 22 ft. and a smaller
room out of that where he simply keeps his saddles, costumes etc.
We also have the walls of his studio full of his things. I hardly
know how we got so many things into that small room on Mott
Ave. We have a delightful room up stairs about 13 by 22 that we
are going to make a little art gallery of. The ceilings are very high
and is just the kind of a room for his pictures.

Our stable is large & the gray team are beauties and I do take
so much pleasure with them. We have an immense garden with all
of the good things in it you can imagine of. Our strawberries will
soon be ripe and they are very large & of a fine variety. We have
10 plymouth rocks hens & soon will have some chickens. I take all
the care of them and find it great fun. We both dig in the garden
& take all the pleasure we can out of this place and I can assure
you it is a great deal. We are just as happy as we can be and per-
fectly satisfied with our home. I am in hopes of going to Zuni with
"Darlin." This fall of course we will see you. I am so glad Gen
Miles is such a great admirer of yours and I told him all the good
things of you I could think of. He is awfully nice and I very much
admire him. The drives around this country are beautiful being
lined with tall trees & stone fences covered with ivy. This we find
in all directions. We have our grounds full of beautiful trees.

"Darlin" has just returned and says to tell you he will write you
soon but just now is very busy. Well I must stop & see about our
luncheon. When are you coming to see us? We both send lots of love.

As ever
"Missie"

What do you think of the name we have given this place?

*A letter to Maj. George W. Baird about his manuscript and a few to
Mr. Schell at Harper's as well as those to Clarke give an indication
of Remington's workload in this period of his life.*

☐ *FREDERIC REMINGTON TO MAJ. G. W. BAIRD*

New Rochelle.
June 2, 1890

My dear Maj. Baird[1]— You are doubtless in receipt of my tele-
gram of yesterday—Mr. Gilder the editor of the "Century" says
that your M.S. will be read immediately and of course accepted
if it is all right. Now my dear Major I hope this will be a go—as
I very much desire to illustrate what you must describe.[2]

You had best write Mr. Gilder an explanatory letter in full—
I tried to explain the import of the "stuff" but do not have the
comprehension of the subject necessary. I rather think that the
Century will take it. You might suggest in your letter that if your
"stuff" seems to be decidedly professional in its aspect that you
can eleminate that phase by going over it—remembering that the
Century is read by women children—idiots and every other class
of people who wouldnt know the sidorial movement of the earth
from a government wagon you will see the necessity of this—I am
<div align="right">Yours,
Frederic Remington</div>

☐ *FREDERIC REMINGTON TO LT. POWHATAN CLARKE*

New Rochelle
June 5 [1890]

My dear Clark— I have a suspicion that I owe you a letter in
fact my obligations to you are beyond paying but you understand
that its the weak flesh that is at the bottom of it.

We went away for 10 days fishing—like all fishing excursions it
was pleasant but no fish. I dont go fishing in order to catch fish.
"Going fishing" is now a days a mere formula—a sort of function.

Gratified to know from Lieut. Jim's letter that I wont have to
fight a duel with him next time I come down there.

I hope now to come this September. Got lots of things to tell

1. George W. Baird was an army officer who served with Gen. Nelson Miles
and was wounded in the Nez Perce Campaign of 1877.

2. Material referred to was accepted by *The Century Illustrated Monthly
Magazine* and appeared in July 1891 under the title "General Miles's Indian
Campaign" by G. W. Baird.

you when I come. Too long winded to write. Dont go to Grand
Canōn till I get there. "I *want to go* too as the small boy's say.—
 Had one of my little team die the other day—hard luck —
bronchitis—bought a lulu mare from Kentucky they dont have
horses any where else but Kentucky. Never buy a horse again
except in Kentucky. Got the G—— d—— breeding—you see.—
 Got 3 horse now—wish you were here we would give you
a mount.
 Things look beautiful here—trees and grass—warm as hades—
150 yards long revolver shot—don't think I be very much afraid
of you at that range.

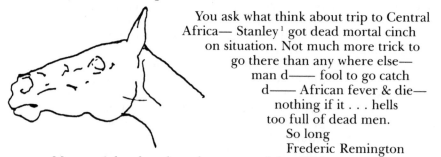

You ask what think about trip to Central
Africa— Stanley[1] got dead mortal cinch
on situation. Not much more trick to
go there than any where else—
man d—— fool to go catch
d—— African fever & die—
nothing if it . . . hells
too full of dead men.
So long
Frederic Remington

My mare's head—whats the matter of that Eli.[2]

☐ *FREDERIC REMINGTON TO LT. POWHATAN CLARKE*

New Rochelle
August 7, 1890

My dear Clark:— I find two letters on my return from the North
West.—you don't know how sorry I am that it will be impossible
for me to come down there this Fall but I am up to my neck in
work and "can't with an elaborate C."
 I wrote whats his name of the Cav. Ass.—Saw your article on
"pistol" biz in Journal. Solid as the devil. You take it off as hard
and sound as a vetran of 1000 fields! I agree with you. The trouble
with six-shooters is that the soldiers often do not use them well—
if a six shooter is well used its a d—— unhealthy scheme.
 Your experience with these Apache scouts is great. Now old
top I tell you *"hold your dish up when it rains pouridge"*—Make

1. Sir Henry Stanley, African explorer. Stanley made several trips to Central
Africa, the last one between 1887 and 1890. Remington later illustrated Stanley's
"Slavery and the Slave Trade in Africa," which appeared in the March 1893
Harper's Monthly.
 2. Yale University.

notes—observations and when this cruel war is over you write
some magazine articles which I will have published & will illus-
trate. You have rare opportunities to do a good thing which will
compensate you for the hard times you are having. Missie and
Julian Ralph (writer) & myself went to Montreal and thence to
Victoria British Columbia. We had a nice trip and got some good
stuff. I had the old lady packed over the mountains on a "cayuse"
and she stood the racket like a little man. Ralph is a large fat man
& he had a little runt of a pinto—it was his first experiance in the
saddle and with a funny hat with a piece of cheese cloth on his
pants worked up to his knees he did an act which made one think
of Mark Twain's Doctor in the Holy Land.

We saw a "pony dance" at the Blackfoot reserve and it was
tremendous. They are a fine outfit those Blackfeet.

Never mind the Apache for "large grassy lawn," dont risk your
reputation with the heathen—"Endion"—whats the matter with
that—sounds like Greek dont it—well its Ojibawa for *The* place
where I live."

I hope you get the "Kid" but please do not let the devil kill you—
it would be a rather tough final for a career which might get a
better chance to go *over the range.* However you will get a proper
obituary—bet on that. But how little
an obituary interests a dead man.

You are sensable in riding a pony
they are better than a big hoss for
that work and dont cost as much.
Poor Turner—he will have more
trouble with his monthly drunk
now that his base of retreat is cut
off.

Well good bye old chap! Luck
with the "Kid" and when you come East
headquarter here—"with the whisky in
the heel of your hand sir—here's to the
health of the scout—standing up."

Blackfoot.
Calgary, N W J.

Yours
Frederic Remington

☐ *FREDERIC REMINGTON TO LT. POWHATAN CLARKE*

Endion
New Rochelle
September 1, 1890

My dear Lieut— The last letter had balls and fringe on it—
you are a word painter from the *old house.*

Your portrait "by ME" has the place of honor in our large en-

trance hall and I hand that letter to people and say "I did that (the painting) and I am forced to admit it is a d—— fine piece of painting but he did this (the letter) and it is the greatest"—here my bosom swells with pride "d—— litterary touch since Carlislie's letters in Ireland."

If you dont do the "mighty act" with that old cheese knife of yours you can do the "mightier act" with that pen you wield. And right here I am forced to say, much as I dislike to, a realizing all the possibilities of mortal offence between us and the duel which must follow that if you do not make copious notes of your present experiances in the vein in which you write letters to me, that— you—and I hesitate—but I must say you are a thrice d—— fool, truant to your trust, despised of men and d—— of God. A half dozen litterary ducks have run over your letter and say that it is plumb full of guts—I am going to let Harper read it and I will put up a job for some magazine stuff to be written some time

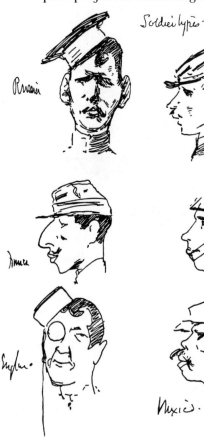

hence. The articles should be *"The Hunting of Men"* and *"Service with troops of Four nationalities"* or *"races."*—I am working on Capt. Banks M.S. & Maj. Baird and in fact all the time have M.S. by Army people and why should not you augment your income and increase your fame by litterary effort. Of course you know that you cant make a running horse trot and that all art comes right from the human character not—in short it must be yourself—untinctured by other peoples ideas— you certainly have a well defined personal view now be true to it—I know you will but I want to make it clear to you that you might write some charming reading while you could not have written "Butter Anatomy of

Melencoly". You have the facility of not taking people or life seriously and that's at the heart throb of modern litterary men. Thats what makes me such a d—— fool—I'm too serious. When the doctors get this trepaning[1] down a little finer I'm going to have the top of my skull lifted off and two or three bumps sawed off—then I think I can be quite a feller. When do you come on leave—I very much want to see you. We can give you a good time up here—so much better situated than in that accursed hole of a Mott Haven.

I trust you have the *camera* by this time—get some good single figures in the foreground—have yourself taken—

I am working on an enormous canvas now, "The War Path."—a vast mass of rushing ponies and ferocious naked figures. Im going to take it over to London with me next winter. Made a painting for the Fall Ex "The Arrival of a Courier" [2]—got you in the foreground—an adaptation of the target photograph pub. in Weekly. I would send it only suppose you will see it. What do you think of it? Artillery fellows East have said it was good as far as they are concerned. I would hitch my saber to the saddle and put carbine on back—you approve of that I judge by your article in Cav. Jour. The Mex. do it with good results.—The Infantry outfit is the trump card.—

Well take care of yourslf—MAKE NOTES—MAKE NOTES—MAKE NOTES!

> Yours truly
> Frederic Remington

1. Trepanning is a surgical process using a small circular saw (trephine) to remove circular disks of bone from the skull.

2. *Arrival of a Courier*, an oil on canvas, was originally painted to be used as an illustration for Capt. John Bourke's story "General Crook in Indian Country," which appeared in *The Century Illustrated Monthly Magazine*, March 1891. Clarke is one of five men in the picture and easily identified.

☐ *FREDERIC REMINGTON TO LT. POWHATAN CLARKE*

Endion
New Rochelle
September 13, 1890

My dear Clark— Your nice long letter at hand—you a just having great "doins" along with those savage Indians and half savage "Congoes." Photograph the whole outfit till they just lay down and kick with one foot. I bet I wish I was along. We can get up a great article on that affair. Send your plates to me and I'll have them developed by Kurtz or Notman. I want just one more whack at Arizona before I die. But got to do Hungary and Algiers before I come again.

Are you reading any of the stories of Rudyard Kipling about British India. He is a second Brete Harte.

Do I understand that you will be East after Thanksgiving?

Sat up all night yesterday and am a physical wreck. Dinner at the "Fellowcraft" Club. They are a d—— sight worse than your scouts. I have made some "lolla" water colors of U.S. soldiers. Century will publish them.[1]

There is a big civil war going on down at Harpers—An editor is trying to procure the scalp of a litterary friend of mine and we are going to ruin his reputation in the process of the argument so you see that infantry Post Com—are not the only enemy young men have in this vale of tears.

When are you going to Europe!

You want a long letter from me I gather in your note —long letters are a thing that I can not write. I have nothing to tell you except a few little facts like for instance the Whitman saddle is the best on earth and "I told you so" about those half bred California horses some years since and you told me I did not know a d—— thing about War with a delicate hint to pay more attention to my painting. The moral of this is that kind thoughts and gentle action will turn the hardest natures. I want an Apache saddle so bad that I cant eat till I get

This or Cheyenne.—

This or Sioux. —

a very unluduy subject.

1. Probably refers to John G. Bourke's article cited earlier.

one—Got a Blacfoot one last trip. Made of buckskin & beads.

Saw birch bark canoe up in British Columbia Like this.—
Queer—

Got letter from Finley from Apache[2] gave me a going over for
that suggestion for a cavalry uniform.

The old lady says give my regards to the Lieut. and tell him to
come East soon as I want to talk war with him.

Write often—you have lots of interesting stuff to tell and make
notes for future use.

<div align="center">

Yours

Frederic Remington

</div>

[Around the edges of the pages Eva Remington added the
following:]

Have some more pictures taken I will send you one if you would
like it. I think they are better than the others. I am anxious to see
Arizona. Our trip was very interesting to me & I took it all in.
I never tired of looking at the Blackfoot Indian. I believe they
are the most picturesque people in the world. There is something
very interesting about those wild savages. I must run now & see
what is to be cooked for dinner. Lots of love *"Missie"*

My "Darlin" tells you a *fib* when he says I want to discuss war
with you. I am for peace *always* and will not talk war. Why don't
you come here now while it is such lovely weather and see our
lovely drive. I will take you all over the country. Also will tell you
of my experience traveling with
two fellow across this country.
Lots of funny things happened.
Come & see us soon. I do not
envy you your rides through that
country with those drunken In-
dians. You have lots of pluck.
[Added to letter is another
note by Frederic:]

a paper plate.

a glass plate.

Since writing have a strange
incoherent telegram from you
to go buy a camera. I am not
going to trifle with your soldier
nature by disobeying my or-
ders—I shall buy a camera. I
will not buy you a roll holder
unless you write and insist be-
cause they are no good—it is
only at rare intervals that any-
thing like good results come

2. Lt. Finley from Fort Apache, Arizona Territory.

from paper plates and for one with quite an extended experiance
with paper plates I say that it is no manner of use to waste oppor-
tunities time and money by monkeying with them. I have a roll
holder with my camera but did not send it to you. I sent my
camera to Fort Bowie—I wonder if you have gotten it—what in
thunder do you want of two cameras? I will give you mine or I
could have given it to you for 40 cents but it to late now —your
camera will be purchased as desired. Glass plates are the only
thing—a little more trouble but whats the use of shooting a cam-
era for a week and getting two good pictures and lot of fog. With
care all your glass exposures will be of use and photography is
like love, one success is better than a thousand failures.

<div align="right">Your Res

Frederic Remington</div>

☐ *LT. POWHATAN CLARKE TO FREDERIC REMINGTON*

<div align="right">John H. Norton & Co.

General Merchandise

Wilcox, Arizona Territory

September 13, 1890</div>

My dear Remington Got yours of 20—well you will ruin me yet
and I wont be able to descend into the valley only "on high places
will I touch." I hope by this time the camera is on its way to me.
Sorry to worry you *but* left Bowie[1] on 8th camped here on 9th
sent outfit to Dragoon Pass while I spent the day in a dark room
trying to get right diaphram and speed on shutter my first two
attempts were "time" and came out splendidly but I could get
nothing on the snap until I put in larger diaphrams and got very
indistinct images—bought some chemicals intending to keep on
but I got things O.K. took train to Dragoon with two Indians &
joined outfit they were tickled to death over the ride in the "Soou
wagon." Got Indians and saddles off train started said to Brakeman
"put my camera and lantern off in Tucson "all right" said he I'll
put her off at Benson, next station. To cut story short the camera
has been traced to Oakland, Cal. and traces lost but little chance
of turning up so that I will send you the one I have ordered to
replace it and any balance that may be due in difference of price
business is business. Well now I hope to see that brakeman—
Imagine; I wired Benson before train got in also Los Angeles—
such are the ways of the S.P.R.R.[2] I enclose cheque for $100.
Camera to be about $90. Always tell me when you pay any ex-

1. Fort Bowie, Arizona Territory.
2. Southern Pacific Railroad.

penses as these fellows charge at both ends & when are let. Well I have got the gosple or something like it—tomorrow I go to Bowie and thence to Rucker Canon and now I must herd Injuns—With love to both of you. Adious— Well you bet I'll get notes keep a diary that is like cutting nicks in the memory bumps—Guess you are right—life is too short to be taken seriously but wait till I *sic* my nigger on that brakeman—

<div align="right">Yours
Powhatan H. Clarke</div>

☐ *FREDERIC REMINGTON TO LT. POWHATAN CLARKE*

<div align="center">New Rochelle
October 1, 1890</div>

My dear Lieut. Your letter and check at hand—I will pay your bill of $71.55 and send you the balance with bill from Scovill—I trust you have got your camera. It is a good one with lots of plates. Remember that you always over-expose in Arizona.

So my camera has gone astray. Well its of no consequence. The camera was not just what I wanted—and as for your buying a camera to give to me—nonsense—I would not take it for a million dollars or from fear of certain death—is that strong enough language to convey my idea. No the camera is yours and that settles it and if you ever send it East it will go back by the next

my frend Clark breaks the goverment horse—

train. Save the expense of the compliment. Trace it through if you can—get hunk with that bloody brakeman if you have to draw on me to do it. We will get hunk with him if we have to tackle old Stanford or Huntington.[1]

If you did not want a camera what in the h—— did you go and buy one for—you know less every day—its only a question of time before your brain will dry up and blow away. If you did want one you are all right.

This is our sixth anniversary[2] and we are having a mild disipation. I am going to celebrate by doing a d—— hard days work.

When do you come East!

<div align="right">Yours resp
Frederic Remington</div>

1. Leland Stanford and Collis Huntington founded the Central Pacific and Southern Pacific railroads in California.
2. Wedding anniversary.

☐ *LT. POWHATAN CLARKE TO FREDERIC REMINGTON*

Bowie
October 24 [1890]

My Dear Remington Check came yesterday with short letter.
Rode up from Mexico yesterday 40 miles in ten hours and have
to sit in this court room to oversee my interpreter who is trying
to come Ganiony [illegible] on me and clear the man who tried to
shoot my corporal all the same I am stiff in the shoulders. Oh my
pride! or conceit! Our new general (McCook) "Gutsy" was here
with his aide de camp and son in law of his —McCook[1] says who
is this young man Clarke—he seems to be pretty independent and
guess we will have to saw his horns or words to that effect then he
tells one of these 25 Cavalry 1st lieutenants that he was going to
put him in charge of the line "You can write direct to Mr. 'Baker'"
the aforesaid son in law—this particular man is one I despise
from a military point of view and consider very inefficient—the
1st lieutenant—his idea is to give him half of my outfit and have
me also dependent on the tenderfoot for orders. The first lieuten-
ant told me this yesterday and I informed him that I would be
d—— if I would serve under him or any other 1st lieutenant and
would apply to be relieved the minute his order came of course if
they wont relieve me I will do my duty but damn these family
headquarters—"tela est la vie." McCook is now at Apache and I
have work "Carter" to get the old gentleman to leave me alone or
send me back to my troop—I sent two oz [illegible] plates but I
have not got the shutter or stop right on them but I think that I
have it all right now—tell photographer to let me know when
mistakes are—I have been developing plates to find out how I
was getting on but as soon as I think exposure is ok I will let the
chemical business alone. Will you let me know how to arrange the
finances with the photographer as I expect to have them work
right along on the plates—Tell me exactly about these prints and
if you object to my distributing any of them—except in the case of
Lieut. Stocker who has been helping me I do not care to give any
of the prints. Well this court is determining to adjourn for a new
interpreter and I must get out and rustle some things for camp.
 Love and Adios

Yours
Powhatan L. Clarke

1. Brig. Gen. Alexander McDowell McCook graduated from West Point.
Routed in the Chattanooga Campaign during the Civil War (1862–63), he was
relieved of command in October 1863 but later exonerated.

When Nelson Miles was promoted to major general on March 21, 1890, he was given command over the Division of the Missouri, which included the old Sioux hunting grounds in the Northwest. In the early fall of that year, Miles invited Remington to accompany him on a trip to that area. Remington wrote two articles for Harper's Weekly *on his return ("Chasing a Major General" and "Indians as Irregular Cavalry"). The concept of "irregular cavalry" was being used in the field by Lt. Samuel Churchill Robertson and Lt. E. W. Casey, who were attempting to train braves for that purpose in the vicinity of Fort Custer, Montana. It was felt that since the Indians had been herded onto reservations, they needed something to do. This would give them a purpose. Alvin Sydenham was camped on the Tongue River when Remington passed there with Miles on his way to Lame Deer.*

☐ *FREDERIC REMINGTON TO LT. POWHATAN CLARKE*

Endion
New Rochelle
November 12, 1890

My dear Clark— Got your letters—Have been with Miles through the North West.—Rode 248 miles in 38½ hours—relays of cavalry horses.— He is an awful marcher.—Saw Vale—of the 1st Plungers— nice lot of chaps in the 1st cavalry.—Dont think they are a fighting crowd lot of old gentlemen on the upper story—good kids though. Eight Cavalry are all hunk—good regiment.—

West over Custers' Battle ground—he would have licked Sitting Bull if Reno[1] hadn't been a d—— coward.

Got some dandy Indian scout-coups up there—Crow & Cheyanne.—

Will take your plates down to-morrow —dont know what it will cost.—

I am keeping all your letters—some day am going to have them published—you will edit them or I will or some one will.—

I bought a Kodac before I went and will see how it works. D——paper plates—no good.—

Keep out of row with old McCook—those old devils are the curse of the army. Old story—youngsters full of enthusiasm—old chaps full of whisky—cant get along—but Death is around and

1. Maj. Marcus A. Reno of the Seventh Cavalry, who was with Custer at the Little Big Horn.

hes got his eye on the fellows of that kind—In case of war they would all go on the retired list.—

Gen Miles spoke very nicely of you 10th Cavalry Kids—says you are fightin.—He dont love these old "coffee coolers" as he call 'em.

When are you coming East.—? You just keep easy you young broncho and I tell you your day will come.—

<div style="text-align:right">

Yours
Frederic
Remington
</div>

P.S.

Got some bully indian plunder—I will have the boss indian collection some day.—

jils on camd marshall—

☐ FREDERIC REMINGTON TO FRED B. SCHELL

<div style="text-align:center">

New Rochelle
October 11, 1890
</div>

Mr. Fred B. Schell My dear sir:—I should very much like to do a picture of the Horse show[1] if I was at all sure I could get a subject which I like in advance. Can you not make them give you a programme and send it to me. I will look it over and report on what I think a good scheme.

I have a M.S. "Chartering a Nation"[2]—Magazine with a limit of four pages. That is as prime article. There is more good pictures in that M.S. for me than any I have had in a good bit, why not let me do more. The other two M.S.[3] for May are not great in an illustrative point of view but this is.

I will illustrate the M.S. Weekly "The Post Chaplain."

<div style="text-align:right">

Yours very truly
Frederic Remington
</div>

1. "Sketches from the Horse Show at the Madison Square Garden" appeared November 15, 1890, in *Harper's Weekly*.

2. "Chartering a Nation" by Julian Ralph appeared in the December 1891 *Harper's Monthly*.

3. He is probably referring to a four-part series of articles by Col. Theodore A. Dodge titled "Some American Riders," which appeared in *Harper's Monthly*, May–August 1891.

☐ *FREDERIC REMINGTON TO FRED B. SCHELL*

Endion
New Rochelle
[November 1890]

My dear Schell,

Send herewith the "Chasing a Major General" [1]——double [2]
in weekly [3] my M.S. in your hands:

It arranges like this.——
ambulances Cheynne
 Scout
Maj. G. Miles and escort
Soldiers around fire I'll give you a proof
 in a week or so.——
 Yours very truly,
 Frederic Remington

P.S. Tell Mr. Harper that we are going to have an Indian War [4]—
I think—Miles wouldn't order troops from Arizona unless he
thought so.

F.R.

1. "Chasing a Major General" was published in *Harper's Weekly* on December 6,
1890.
2. Double page.
3. *Harper's Weekly*.
4. Remington foresaw the outbreak of hostilities with the Sioux Indians, which
actually occurred in December 1890.

☐ *FREDERIC REMINGTON TO FRED B. SCHELL*

New Rochelle
December 10 [1890]

My dear Schell— Here are the illustrations for my article which will come down Saturday on "Indians as Irregular Cavalry"—you can use them as you see fit.

Please do not make pencil marks on the front side of the watercolors and return them to me as soon as you are through with them.

You might make a print of the Cheyenne Scout—[1]
Casey and Robertson[2] are the high priests of the new regime.

I am
Yours Truly
Frederic Remington

☐ *LT. S.C. ROBERTSON TO FREDERIC REMINGTON*

Ft. Custer
December 31 [1890]

My dear Remington: When, fifty or sixty years hence you depart from mind [illegible] and affairs. You, in the happy hunting grounds, the spirits of the Indians your clever pencil has created *I'll* see that the U.S. Army—Scouts included—Keeps your grave green. In addition, you shall have a head stone at my private expense on which will be traced a grateful tribute to your efforts on behalf of the service. It is not too much to say that I believe your pencil has done more for us than any other single influence I know of. Personally I am grateful to you for your last dissertation in *Harper's Weekly*[1] about Indian Scouts. Your article, if I know aught about the subject myself is masterly in its conception of the whole matter. It is a matter of profound interest. I like yourself should be able to go right at the root of the question in so

1. "One of the Fort Keough Cheyenne Scout Corps" (also known as "The Cheyenne Scout") appeared on the cover of the December 27, 1890, *Harper's Weekly*.

2. Lt. E. W. Casey commanded the Cheyenne Scout Corps and Lt. S. C. Robertson commanded the Crow Scout Corps at Fort Keough, Montana. Pictures of both men appear in the article. Lt. Casey was killed January 7, 1891. An article about him, written and illustrated by Remington, appeared in *Harper's Weekly* on January 31, 1891—"Lt. Casey's Last Scout."

1. *Harper's Weekly*, December 27, 1890. Lt. Robertson's picture appears on page 1004 of the article. On February 13, 1892, an article by Robertson, "Our Indian Contingent," appeared in *Harper's Weekly*, illustrated by Remington.

comprehensive a way—My experience with Indians has induced me to believe that there is some truth in every line of that article—not only where you point out the effects of disease in the Indian Bureau's management of the Indian & their causes, but also in the remedies you prescribe for them. I only hope the seed of that article may produce sometime.

I hear you are again making your "Headquarters" in N.Y. So under such circumstances it would be too poor a jest to wish you a Happy New Year, but if you've *not* had a pat would say be as happy as you can—allow me to congratulate you upon your facility with the pen as well as pencil—a fact which I didn't realize until lately and say very sincerest good wishes.

> Faithfully yours,
> S. C. Robertson

☐ *FREDERIC REMINGTON TO LT. ALVIN SYNDENHAM*

> Endion
> New Rochelle
> October 31 [1890]

My dear Syndenham:— I have your kind note and would not hesitate to crawl into your Sibley[1] if occasion offered.

So you are a "bloomin" artillery man—a red leg —as old Capt. Corlis 8th Infantry used to say "one of those d—— artillerymen—who wouldn't know a government wagon if he saw one."

I am puffing away at my drawing and painting—Hope to do Europe next year.

I suppose you know old "Cheyanne Struthers" 1st Infantry. Give him my regards and tel him I think he is more or less of a "chump" not to write to me once in a while.

Well so long—I like to hear from you.

> Yours very cordially
> Frederic Remington

1. Army tent.

☐ *FREDERIC REMINGTON TO J. HENRY HARPER*

New Rochelle
Grand Pacific Chicago—
December 17 [1890]
I leave here tonight for Rapid City—near Deadwood. There is
going to be a row— that's settled—it was good judgment to come
I think.[1]

Yours
Frederic R.

excuse postal

☐ *FREDERIC REMINGTON TO FRED B. SCHELL*

New Rochelle
February 20, 1891
Mr Fred B. Schell Here are receipts signed. The page drawing
of "Genl Carr receiving a report of a scout" and the page of smaller
stuff was material accumulated while on my Sioux outbreak trip
and in my opinion should come under the $100 a page contract—
it is now paid for at $60. Please let me know your impressions
as to this. I do not understand why that material should be $60 a
page when you pay me $75 for other material which if not of the
same real value to say nothing of an exceptional contract. Possibly
I am wrong and if so I wish you would have the goodness to tell
me how—I am

Yours very truly
Frederic Remington

☐ *EVA REMINGTON TO LT. POWHATAN CLARKE*

New Rochelle
January 20, 1891
My dear Lieut: By the enclosed clipping you will see that you
are getting famous, notorious or whatever you wish to term it. I
do not envy you chasing those savages over those mountains and
am glad you have not a little wife at the Post in a state of anxiety
for you. There is no fun having your better half fighting Indians.
My Fred came home one week ago last Friday and he has come to
the conclusion that Winter campaigning is not all together the
pleasantest thing in the world. He came home with a *horrible* cold
& is just getting so he can speak loud.

1. Remington sent a telegram to Fred B. Schell at Harper's from Chicago,
saying he was on his way to cover the "Sioux Uprising" in South Dakota.

He just escaped being captured by these *horrible* hostiles, had he been dressed like a Western man instead of his riding habit guess he would not have escaped but he was a queer looking man & bad medicine. Too bad about Lieut. Casey.[1] "My Fred" became very fond of him. I hope Gen. Miles will get the upper hands of those wretches I guess he will if the higher powers at Washington will let him have his way. It is rather miraculous, how small a man Harrison[2] is. Well Adieu, Frederic will give you a few lines now. Had a *very nice letter* from your Mother. So nice of her to think of me when I was so worried. With love from us both.

<div align="center">Eva A. Remington</div>

Old Top—I want to write you a good long letter but God bless you the publishers fairly scream for M.S. and I have to just hump myself but the first minute I get will be yours.

<div align="center">Fred R—</div>

Remington when General Miles recovered his stolen sketches from a band of Crow Indians. Drawn by Kemble

☐ *FREDERIC REMINGTON TO LT. POWHATAN CLARKE*

<div align="center">New Rochelle
January 27, 1891</div>

Dear Old Chap— Well I have gotten my second wind. I have felt guilty in not answering your very interesting letters but the old lady has sent in the apologies.

Had letter from your mother and a letter from you enclosed—

1. Lt. E. W. Casey was shot in the back of the head by an Indian on patrol near the end of the Sioux outbreak in January 1891. The case attracted a lot of attention because the Indian (Plenty Horses) had attended the Carlisle Indian School in Carlisle, Pennsylvania, and was supposed to have been "civilized." Plenty Horses said his motive for the killing was to overcome the alienation from his people that had been caused by his white education. He was tried for murder and acquitted. The verdict was that "he had acted in a time of war against a scout who could have been called a spy" (Samuels, page 153).

2. President Benjamin Harrison's orders to Miles had been not to take aggressive action toward the Indians but to exercise patience and diplomacy. The Sioux were to be controlled without resorting to open hostilities. James W. Forsyth's 7th Cavalry attack on the Indians at Wounded Knee on December 29, 1890, without Miles's authorization, ended the uneasy truce.

I kept that against his orders. When you come East we will put up a job to edit them. I have all your recent letters.

I spent a month in the Sioux outbreak and had a very interesting experiance—I have done the whole thing in Harpers Weekly and you will save me the trouble of writing it by reading said illustrated paper. 4 per year in advance and d—— a soldier who wont take it—its the only unofficial friend the soldier has in this boomin peaceful *countrie*.

I saw soldiers till you cant rest. The 7th is a d—— fine outfit—soldiers are all over the room—got the knee action—no funny work and a burning desire to fight—well named—Think their recruits are best— think men like the Regt.—The best company of soldiers in the service—Capt. Fountain's of the 8th—Old Brook[1] is no good with a big G—Miles is the biggest man in America — every soldier ought to be proud of him. He had brains to start with and he has cultivated what he had—As Senator Voorhis says "he has a man's face on him." Saw the Leavenworth Battalion—

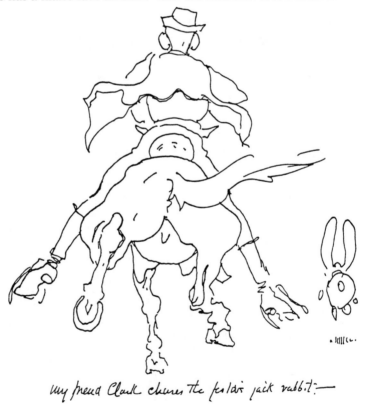

my friend Clark chases the polar jack rabbit—

1. Gen. John R. Brooke, who called for Col. Forsyth to come to Wounded Knee.

Casey—kept them from stampeding—to much soft time—good stuff but bad lot officers—incompetent—mostly drunkards & dudes—The 9th is a great Regt.[2] Bette lot of "nigs" than the 10th.— Lots old 10th men in it. Henry[3] gallant fellow—Some of these infantry chaps not slow—1st Inft. good—as result of experiance 10th Cav. has best lot line officers I have ever seen. Dont forget to paste Lieut. Casey's name on your hat—he was a soldier —from the ground up and for 7 miles on every side. Oh Lord Clark, come East. I write for a living and detest nothing as much as writing letters— come and see me and I'll tell you all about it.

Yours truly
Frederic Remington

Notman
 Photographer
 42nd St. and Madison Ave.
 New York City
 no bills from F. Remington

Remington and Eva were invited on a trip to Mexico with General Miles in March 1891. They met Miles in Chicago and traveled south in his private railway car. In Mexico they met President Diaz and attended a dance at the American ministry. Remington wrote and illustrated an article for Harper's Weekly *on his return. "General Miles's Review of the Mexican Army" appeared on July 4, 1891. Clarke at that time was in Germany. They returned by way of Havana, taking a steamer to New York. Remington's illustrated article for* Harper's Weekly *on November 7, 1891, "Coolies Coaling a Ward Liner," recounted this experience.*

□ *EVA REMINGTON TO LT. POWHATAN CLARKE*

Endion
New Rochelle
June 1, 1891

My dear Lieut:— Your very good letter was received by Frederic yesterday and we were so very glad to hear from you & of the charming times you are having. We envy you. I only wish we were there to see the beautiful Rhine the picturesque castles and hear some of those interesting legends. You certainly are in clover. Fully as interesting to me would be the soldiers & especially some cavalry. I did so enjoy the "review" in Mexico but they need more discipline & ought to keep the beggers off of the grounds during a review, *at least I think so.* There certainly is something most

2. The 9th Cavalry was a regiment of black soldiers.
3. Lt. Col. Guy Henry commanded the 9th Cavalry.

attractive about a uniform & so much more so when worn by a bright man mounted on a beautiful horse. You are getting to be famous and I can assure you we very much enjoying seeing all of these good things said of you. Frederic is your devoted admirer as you well know. Now to come down to every day things I will say that I am quite myself again or will be soon and hope that I will not have to go through such an illness again. Had the doctor here when I first called in understood my case & not been a perfect fool, I would not have been so ill. My young sister is with me and we all have some very jolly times. Frederic has just been made a member of the New York Jockey Club and Mount Morris Park race course is just below here. They have a magnificent club house where we can go at any time & as the races commence to-day I hope to go down some afternoon & take dinner. Too bad you have not wings so you could fly over here & go with us & then return. The papers state that you have met the Emperor etc. etc. Do tell us about him & what you think of him. You know probably that we met Pres. Diaz & Madam also that the American Minister gave a reception & dance for the General & Mrs. Miles & that we saw every one & everything of any account in Mexico. Frederic did not enjoy any too much the social part of it but I did. I went wild over their music, especially "LaPoloma." We had several serenades by the different bands.

I very much enjoyed the picturesque town of Orizoba—it was so clean and the place so old & every one looked so happy. I could have spent many days there. The ride from Mexico to Vera Cruz is most interesting & wonderful at times as you wind around the top of the mountains & see a beautiful valley & town a mile below you & wonder how you will ever get there. We were at Havana two days & it is *vile*. very nasty, not the least picturesque & made of dead cats, chickens etc. lying in the streets. Excuse me from living in such a country. The United States can not be beaten & especially this lovely old state of New York. The English war ship "Canada" was at Vera Cruz & the officers came up to the city. They were very delightful. When an Englishman is bright you cannot help but like them but when stupid they make one so very tired.

I have given you a great dose so will stop. Will let Frederic tell you about the paintings he is at work on. They are *immense*. He will write you soon. With love from us both—

<div style="text-align:center">Very Sincerely
"Missie"</div>

P.S. Was so very sorry not to have seen your mother while in New York but of course my illness prevented.

☐ *FREDERIC REMINGTON TO LT. POWHATAN CLARKE*

New Rochelle
June 3, 1891

My dear Clark This is a purely business letter.

Lieut. Smith of "Ours" sent me some horse jumping photos taken by you and himself. I have made a page of horses and call it "Training cavalry horses to jump obsticles. We can get no one to write it up and the "house" instructed me to write immediately and ask if you would not have the goodness to do column and a half for *Harpers Weekly* at your very earliest convenience, send it to me and sign your name. Do it old man, it will be a good thing for you. I send a diagram of my page of sketches. [1]

The Editor of the Magazine says they would very much like to look at an article by you on your scouting business—racy—picturesque & characteristic. Ill make her go and will do an A-1 job of illustrating. It will do you good and bring in dollars to your "*kick.*"

Now is your time to get in your work.

Immediately write me if you will do this. I am yours

Frederic Remington

Training Cavalry Horses to Stand Fire.

1	*"The completed thing"*	*2*	*is yourself*
3	*"Hit him again"*	*7*	*"Make him go"*
4	*Refusing a cut bank*	*8*	*Squad drill over logs*
5	*"Good boy"*	*9*	*Rather awkward*
6	*"Short"*	*10*	*Over a dead steer*

1. The article "Training Cavalry Horses to Jump Obstacles" appeared in *Harper's Weekly* on September 19, 1891, written by Remington, not Clarke, and including nine drawings. Clarke later wrote an article, "The Military Riding School of Germany," which *Harper's Weekly* published on November 14, 1891. Remington illustrated it.

☐ *FREDERIC REMINGTON TO CAPT. CHARLES PENNY*

<div align="center">

New Rochelle
June 13, 1891
</div>

Capt. Chas. G. Penny My dear sir:—I am advised that the Winchester Arms Co. have shipped a rifle express prepaid to you at Pine Ridge[1] and of course you know it is for the scout "Red Bear." [2]

Will you kindly write me when he has received it and please explain to him that I am not an utterly depraved person because I waited to long before keeping my word but that I was very busy and simply neglected it when I ought not to. I also have some business relations with the Winchester Arms people and the time was not ripe for me to make a good trade until of late. I do their advertising cards and calendars and you see I get consideration in return. I do not suppose Red Bear will appreciate all this but now that he has a good rifle I hope he will warm up. Give him my regards and tell him I often think of him and hope some time to meet him again. As a matter of fact I think I might have had poor old Casey's luck if it had not been for him.

Thanking for your trouble in this matter I am

<div align="right">

Yours very truly,
Frederic Remington
</div>

Powhatan Clarke went to Germany in late 1891 to observe cavalry training, and while there continued his correspondence with both Frederic and Eva Remington. Responding to Remington's desire to travel in Europe, Clarke suggested that Poultney Bigelow, Remington's friend from Yale, might need an illustrator for the trip he was planning to make. Although Remington was not sure that he and Bigelow would do well together, he asked for Bigelow's address.

☐ *FREDERIC REMINGTON TO LT. POWHATAN CLARKE*

<div align="center">

New Rochelle
[1891]
</div>

My dear Clark When they made a soldier out of you they spoiled a d—— good literary man at any rate—your letters come like dew from heaven—

1. Pine Ridge Agency, South Dakota, was the Indian reservation where Remington spent time with Gen. Miles during the Sioux uprising in December 1890.

2. Red Bear was one of the Indian scouts with Gen. Nelson Miles and the 7th Cavalry during the Sioux uprising in 1890. He was the one Remington credited with saving his life.

I want you to write me some stuff from Arizona and I want you to do all the polishing. It takes a heap of polish to make the thing go now. Mind what I say—write some good stuff— it will do you a heap of good. You play your cards right and you have got the world by the rear elevation.

Nice article on you in the "Sun" last Sunday—I always play a "short horse to win" and its seldom I get them but I got one winner in you.

My better half is very sick—she is dangerously so in fact and the house is crowded with doctors and nurses— Poor little soul I hope she pulls all right because I wouldn't be of any more use than an old shoe if she weren't around to kind of "luff me off when the wind's too breezy."

Was awful sorry not to have seen you.

Had a good time but now have got to peg away or the bank act will go to the [illegible] bow-wows.

Well get up the bloody old war which is so long in coming — you ought to see it and I will start immediately. Wouldn't it be lovely—no d—— little ragged ghost shirts going scampering off over the hills but real blood letting and everyone willing to have the thing go on.

Cant write anymore —no news havent been out of the house in 10 days.

Do you see how old Proctor[1] has monkeyed this Indian soldier business. Strange aint it.—he's been told time and again how the thing should be done but he had to do it some other way and it wont work.—Damn a marble merchant anyway—artists are bad enough.

Brace up cultivate your intellect write articles and being just from Arizona dont let the German girls get all your sustance.

Frederic Remington

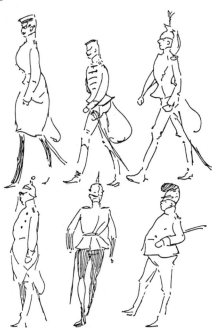

The German Army - Frederic Remington.

1. Redfield Proctor from Vermont was U.S. secretary of war.

☐ *FREDERIC REMINGTON TO LT. POWHATAN CLARKE*

New Rochelle
June 20 [1891]

My dear Lieut:— Your letter came—sorry for you old man
homesick—what is the matter of those Germans. Why do they
let you get homesick—I expect they are stiff—formal—no milk
of human kindness—no emotion— lack our naturalness—you
are used to the quintenesence of the American idea and I suspect
the thing is maybe so another extreme. Well d—— em if they
dont treat you right.

I am up a stump in the "Teaching cavalry horse to jump ob-
sticles" I made a page & cant get letter press—so then to Smith
belongs all the credit—well I'll write up a lot of nonsense about
the 10th cavalry and really Smith deserves all the credit— dont
give me away—& it dont much matter if you do—Ill say they do it
and if they dont they ought to & that lets me out. I am not going
to patronize a "slow" regiment. I begin doing things about the 1st
Dudes on the 1st Plungers as Viebe calls 'em.

I am doing a big painting and I aint sure of my tactics. Its this.

You see they are coming like hell & I want to get the title "Right
front into line, come on!"[1] The "Come on" is all in the expression
of the officer & the bugler is blowing the charge—I am going to
have the men with carbines instead of sabers—the dead horse or
pony tells of the trouble in front as does the faces of the men.
I thought I would call it "The Relief Column etc. the above you
see." The men are large on the right & trotting while as they go

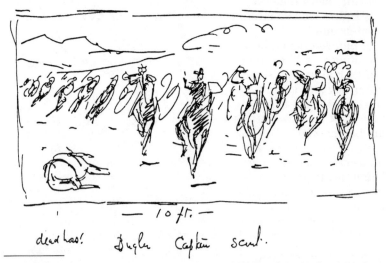

— 10 ft. —

dead hos! Bugler Captin scut.

1. The painting was entered in the autumn exhibition of the National Academy
of Design in 1891.

away they begin to go faster & faster until on the far left they are
turning double back handsprings—now is this right.

"The Relief Column—"Right front into line, come on."

Of course all I want is to say a little and then have my tactics
right. You cant give the whole of Upton in a title.

I dont know where Pack is but will find out. I'll stand him off
& if he wont stand I'll pay him—Are you getting hard up over
there—I expect the expenses are hell—If I want right in the
throes of a financial panic I'de go a thousand on you. Maybe so
I'll be rich this winter. D—— it I ought to I made $200 a day—
some bloddy commercial work—A Winchester Arms Co. cal-
endar[2] & I jump em *"plenty"* as old Casey used to say.

Did a "hoss race" recently. Aint dry yet—going some—every-
body has to do a "hoss race" & I've done mine & glad its over.
I like cow-punchers & dogers & other things are irksome. I am
doing "The Advance Guard or the Military Sacrifice"[3]—The Bad
Lands—a soldier with the bullets striking the sand—hoss hit—
scared—the man 100 yds. behind him waving hand—the little
bunch begining to run & consternation way down the canōn or
coulie to the main column far away on the flat. Got the idea in
Sioux outbreak.

How long are you going to stay over there?

Do you wear a German uniform?

Could I paint those fellows or are they commonplace & without
life—are they all frills?

Are you glad you are there?

Tell Smith to call on me when he comes back.—Gen'l Order
No. 1—

Are the German Military painters any good—from art stand
point not soldier?

Can you ride better than those men—Honest!

Are horses cheap or dear there—as I understand?

What good would the average German under officer be in the
Sierra Matra?

And soldier?—

& Why the devil dont you write me an article while you are a
hell of a fellow which will be pub. in Harpers & make you immor-
tal.—Answer me that—old man thats business—three days &
its done. Take my word as a fellow who knows a little something
about the advertising business & do that save it you miss a drill.

Good bye—
Yours
Fred Remington

2. Remington did illustrations for their company calendars.

3. "The Advance Guard or the Military Sacrifice" was a double-page illustration
for *Harper's Weekly,* September 16, 1893.

☐ *LT. POWHATAN CLARKE TO EVA REMINGTON*

Borgsdorf Westphalia
August 31 [1891]
Address the same—Dusseldorf
My dear Missie Your cheerful letter was a treat, how you would
like the quaint old towns and picturesque villages. We have been
in the manuvers since last Tuesday, in the heart of Westphalia.
Last night as we sat in front of an old inn under a great aquan
church steeple in the market place of a quiet medaeval town I felt
as though I was in a play and that the curtain would rise, the land
is like a fairy tale, everybody goes to church, the girls are all good,
every cross road has a great crucifix in stone, all morning we march
along well kept pikes under shady trees, through dark cool for-
ests, by huts and castles and then with music through the narrow
streets of the villages. Sometimes we are twenty officers, to day
I am alone. We are quartered about in the villages and farms,
having a rendezvous in the evening, one day in a chateau with
obsequious servants, another in a peasants home when you are
treated like a prince. Our men are nearly all the sons of these well
to do farmers. Yesterday we followed the Colonel in white gloves
and sabres to take dinner with Prulam [illegible] Hinterman [il-
legible] who used to be a major in *our* regiment, a splendid din-
ner, a dull afternoon too rigid—but we danced with the bar maids
on our return in the hotel, shocking, and had a nice quiet eve-
ning, the Germans never get ill natured or noisey. We are only
marching up to the maneveres. Tell Fred—dear that we need an
awful lot of change in our service—but I bet it will come if we can
get the People who rule (big P.) to look into it.
 We will get nothing out of our superiors, but the "papers" "the
press" must be got to leap on them every Sunday, our Cavalry
Journal ed. does not go far enough and those of us who tackle the
"machine" must be "harmonical" among ourselves. I believe we
need a *little* Army but an awfully *good* little Army then some good
untitled laws with lots of assistance and instruction from our Uncle
Sam without giving him too much pull. I am waiting to hear from
Guty [illegible] about my "articles" I hope his eyes will not say "he
must get them typewritten." I have all the photos for "Hanover"
tell him to keep them for me or return the large ones from my
albums unless he wants them and then I will duplicate. I only
send a few that came yesterday the others and the uniform is in
Dusseldorf. He will have to bring you over some day but we will
talk all of that over. That Adriondack scheme is good you will get
lots of health and fun out of it but dont sink too much coin in it
put your money on "Endion." There is no place like home. I have
none so I can talk. These Dutchmen are good fellows on a "scout"
real jolly good natured fellows. For generations they have been

soaked in the finest flavoured wines and you cant make elegant pickles in beer. Well, give my love to the "old man" take some for yourself, be good and write promptly and excuse a man who must study maps.

Ever your friend,
Powhatan S. Clarke

□ **FREDERIC REMINGTON TO LT. POWHATAN CLARKE**

New Rochelle
September 8, 1891

My dear Clark I have the M.S. on "A hot Trail"[1] & gave it to Harper—who said "very well if he writes as well as he does in your letters it should be very good"—I have not since heard from it.

The Cavalry School MS"[2] came duly but the photographs are not here yet and I have delayed an acknowledgement on that a/c —I hope no misfortune has overtaken them.—

I am going to have an ex—and sale this winter and am devoting myself almost exclusively to American & Mex. military subjects.

"Right Front in line— Come On."[3]

"A critical case"—wounded infantryman

"The Advance Guard or the Military Sacrifice"

an ambushed [illegible] cav. in the Bad Lands

my friend Clark licks a drunk.

R——

1. This is the first of several attempts by Remington to convince Harper's to publish Clarke's manuscript "A Hot Trail."

2. "The Military Riding School of Germany" by Powhatan Clarke appeared in *Harper's Weekly* on November 14, 1891.

3. *Right Front into Line—Come On* had been Remington's entry in the fall 1891 exhibition of the National Academy of Design.

"A shot on the picket Line"
"Scout in the Snowstorm"
"The cavalryman's breakfast"[4]
are part of them.

I have done *horror*—"The Mex. Sheapherder in Apache Land"—dead withered body hanging by one leg over a cliff— I heard about it—years ago in Arizona. Its a regual "ladies faint" of a picture. I am going to sell you[5] —d—— it you are more or less public property—Ill call you—"A cav officer" and the result of the sale may determine your popularity. Well turn your MS on Cav. School into Magazine.

Well—tell me if there is going to be a war in Europe pretty soon or if not soon *When!* I want to be in on the ground floor when she "goes up"—and you are my only *"tout."*

I am dying to see you— when you return to America I want a week

Yours—
Frederic Remington

☐ *FREDERIC REMINGTON TO LT. POWHATAN CLARKE*

New Rochelle
October 14 [1891]
My dear Clark. The book of uniforms and the photos came duly to day. The book of uniforms is very valuable if one were to do German soldiers— the Seydlits is a good thing—a little stilted—sort of old school—not our modern notion of fidelity—natur- lism etc.

The soldiers in the photographs appear to be good looking intelli- gent and what might be called high class men. They may be selected types.

I have finished the draw- ings on the German Cav. School.

Sho [t. studies. —

4. *A Cavalry Man's Breakfast on the Plains* would be Remington's entry in the 1892 exhibition of the Society of American Artists. The Society was made up of younger French- and German-trained artists who were involved in the Impressionist movement. Although Remington would later adopt impressionist modes in his painting, this oil represented Remington's Western realism at its best.

5. Remington had painted a portrait of Clarke in his cavalry uniform. At this point he was planning to have a one-man show and sale at a private gallery.

Spoke to Harper about the Hot Trail and will get a report today.

I go down this morning to New York to meet Gen'l Miles on appointment.

Got a letter from Carter Johnson [1] the other day and he says "I see Clark is keeping Europe stirred up." Thats a compliment—go it old man, just you handle the biggest spoon you can lift.

If you will send me a bill of the charges on this material I will remit.

I hope to strike Europe next year—

> Well adios
> Yours
> Frederic Remington

☐ *FREDERIC REMINGTON TO LT. POWHATAN CLARKE*

New Rochelle
October 27, 1891

Me dear Clark "Woe is me"—we have shot our wad—to my surprise and chagrin old man Alden [1] of Harpers has handed me back your Hot Trail. [2] I stood on my head and talked and ex-postulated and explained and then grew cold and sarcastic—I did all the acts but it want any good. They said "Very interesting material, but unavailable" and then it was quietly intimated that "The Lieut has slighted the thing—he writes better as we know from his letters" and that I could not deny. They had read your letters and the verve and snap of them had gotten them raised to a point where the M.S. seemed dry.

The [l]. Kids L—and of the artist.

Tell me what to do with it. I shall read it again and while I am not—"in with" the Century now I may try them —or the Herald or Sun Sunday editions as a last chance.

I mean as soon as you get back to edit your letters—that is the thing to do.

Well I am having my portrait painted—to consumate my Academy election.

1. Lt. Carter P. Johnson of the 10th Cavalry.

1. Henry Mills Alden, an editor at *Harper's*.

2. Clarke's manuscript. *Harper's* never did publish "A Hot Trail." After Clarke's death on July 21, 1893, Remington sold the article to *Cosmopolitan Magazine*, where it appeared in October 1894 illustrated by Remington.

It looks a little like a row with Chili[3]—I dont think we will have one—it would be naval and of no interest to me—the 10th Nubian[4] wouldn't be in it.

I did "A Merry Xmas in a Sibley Tepee" for Harpers Weekly Xmas number.

Well old man this world turns up a sharp edge once in a while in spite of our plans —and even praying and swearing are of no avail but we can beat the game for our board and clothes which ought to satisfy us.

Write and tell me all about it.

Yours
Frederic Remington

☐ *FREDERIC REMINGTON TO LT. POWHATAN CLARKE*

New Rochelle
November 2, 1891

My dear Clark:— Your note at hand—"There aint going to be no war with Chili" as the boy said about the core of the apple. Sad-sad!

As to your bloody old Europe—I'm loosing faith—but I hope to see the thing when it comes off. Of course a man who cant talk French is a d—— fungus growth on this Earth —I have just read Von Mollks[1] memoirs—he was a dish pan of brains—and the Germans out-fought the French everytime according to his version. The French were demoralized & disheartened I imagine because they used to do better—however Russia and France are the natural allies of the U.S.—all the traditions and all the present interests are that way—My sympathies are with them—of course I like Tommy Atkins[2] but he wont be in it— you say.

Do you think I could get in with the Russians—

You say go in six years—God—do you expect to live six years— you'l be married—two babies and fat in six years.

P—— Bigelow and I are all right only he is a natural chump and I dont recon we would pull double very well. Get me Poultney Bigelow's address and Ill see if he'll pull me in out of the wet. I'll give you a letter to him if you want it?

3. Chile.
4. A reference to the 10th Cavalry—Clarke's unit.

1. Count Von Moltke, Prussian general.
2. A British soldier. Lt. Alvin H. Sydenham wrote an article, "Tommy Atkins in the American Army," for *Harper's Weekly,* August 13, 1892, illustrated by Remington.

Going on a long ride this afternoon with the Harpers.[3]
If you come over in Spring just rememb to call here—
<div align="center">
Nothing new—

Yours

Frederic Remington
</div>

P.S.
Hussars[4] never talk politics—thats funny but best I suppose—
do they think or have they gotten disciplines to a point where dont
<div align="center">R ————</div>

☐ *FREDERIC REMINGTON TO LT. POWHATAN CLARKE*

<div align="center">
New Rochelle

November 20, 1891
</div>

My dear Lieut— The photos came—they are the swell of the
Swell too awfully too tooooo to to—you are however a great big
North American stuff—a lump of inanity, a wart on the face of
the Earth as you would have sent them before and I would have
published one with your article but as you say "what does a d——
artist know about war"—again it occurs, that one can expect noth-
ing from a d—— soldier—you ought to have a guardian—a
manager—

And so had I—do you know that I went off the other night and
met about 11 million folks all "to once" and got a "jag on" which
will not become eradicated except by time and lots of it. I met the
gay and festive Henry Watterson of Louisville and I have no use
for a Kentucky gentleman—they know how to handle their own
rum. I am now a strickly temperate man and am going to walk in
the "big road" as the cowboys say. There are a class of d ——
fools in this world who dont know enough to drink whiskey and
I'm one of them—I had always cherished a fond delusion that
I was one of the men who could but I aint and henceforth "no
thank you a little Appollusan's please." This is no drunkards
afterclap but a square deal if I have to join the "Bicloride of
Gold Club."

I have sent your d—— Hot trail to Harper again and I'm going
to make someone publish it if I have to pay for it. As Bill Neye's
old father said of his dead soldier boys grave "I'll keep it green
if I have to paint it."

Have got a set of fine photos from L. Troop Crow Inguns—

3. Harry and Will Harper of *Harper's* were family friends as well as business
associates.
4. Hungarian light horsemen.

Lieut S.C. Robertson to work up.[1] It's stunning—you talk about Cavalry—"dose Angun" as ol Lareux Blackfoot interpeter used to say "are the way up stuff"—nothing like em on the Earth—they could take a Cossack and milk his d—— mare on the run.

Did a page on Hunting—Bye day with Westchester Hounds— Do you see Harpers? The article on Ger. Cav. School was great; [2] it has been much talked about. Dutch may not like it but United States folks think is great. Am going to hunt canvas backs Chespeake Fitch Ballwin—will call on your folks if I have time.

Did the West Point riding school—whole detachment took 5 ft. hurdle bareback [3]—dont beat that much anywhere as I knows of.

My "Right Front into Line" is in Academy and must go down and see it today.

Going to paint picture with Old Casey as central interest—give it to West Point Mess if dont sell right off.—

Well adios—dying to see you—may go abroad next year—
Yours
Frederic Remington

☐ *FREDERIC REMINGTON TO LT. POWHATAN CLARKE*

New Rochelle
December 10, 1891

My dear Clark— The editer Harpers has again sent your "Hot Trail" back. They say it has much good but they have no time to edit it. They say "you do not take them seriously" & "that it is hurried" etc. I will keep the M.S. and anytime you want to rewrite it—when you have conquered Germany I will send it you. Its too good to be lost and all it needs is some good honest work by yourself.—

I was in Baltimore the other day—went down to do the "duck shooting." I called on your people. Your sister is a smashing girl— looks something like you, only your faults are corrected in her. The old gent and I sat out the evening in a club and ate raw oysters and fought the Civil War over again but we concluded Peace ere we parted.

I may come over in the Spring and we must do a trip togather. Lets go down into the Balkan Stats as Hungary—or Algiers.—

1. Appeared in *Harper's Weekly*, February 13, 1892, as "Our Indian Contingent" by Lt. S. C. Robertson, illustrated by Remington.

2. "The Military Riding School of Germany" by Powhatan Clarke, illustrated by Remington, *Harper's Weekly*, November 14, 1891.

3. One of Remington's illustrations for George I. Putnam's "The American Cavalry School" in *Harper's Weekly* on June 4, 1892, was titled "Five-Foot Hurdle Bareback."

Lets do a Scout with Buffalo soldiers in Algiers—wouldnt that
be a world beater—

> Yours—
> Frederic Remington

☐ *FREDERIC REMINGTON TO LT. POWHATAN CLARKE*

> Endion
> New Rochelle [1892]

My dear Clark— I suppose as a matter of fact that as the hour
approaches the time draws near and that it would be unchivalric
and wanting in a just appreciation of a delicate situation if I even
questioned myself not for a moment to suggest to one who must
be expected to have had his thoughts diverted to channels where
the ebb and flow are easy as the changing fancies of a lover loved
but a man like yourself must be able to realize that even the crisis
which is greater than death does not absolve a man from certain
obligations which though gross and trivial are yet solemn through
the binding things of that convention, called friendship. It is in
sorrow and not in anger that I indite this missive. I had thought
that through the years of trust and mutual endevor and kindly
effort that I had minted the good feeling as my friend Clark but
I see that —well now I suppose I should look at this thing differ-
ently—more as a doctor of medicine—like one who knows that it
is contagious & not epidemic and that like all fevers it runs its
course—infants have it worse than grown people though its very
bad when old people catch it. I might still look at it another way—
the young woman is getting the whole bloomin benefit of your
correspondence and when the bit is on you, you are a regular case
of diahorreha in written words!

I am to be in Berlin by the first of June SURE—and
if you are not there—and then knowing that
you will not write to me anymore I suppose
we are no longer friends.

A d—— sub lootenant of dragoons
roasted me in the Army & Navy Journal[1]
—its a long story and its a great scheme—
I'll tell you when I meet.—

> Yours
> Frederic Remington

1. Gen. Eugene A. Carr took offense at the way he had been characterized in
an article written and illustrated by Remington that appeared as "The Galloping
Sixty" in *Harper's Weekly* on January 16, 1892. Carr's second lieutenant, Alonzo
Gray, struck back at Remington in a letter to the editor of the *Army and Navy
Journal* on February 6, 1892. In response to that, Richard Harding Davis, then
editor of *Harper's Weekly,* spoke out in Remington's behalf.

☐ *FREDERIC REMINGTON TO LT. POWHATAN CLARKE*

Endion
New Rochelle
March 19, 1892

My dear old Clark— You are a sad dog—I have your letter and
a full set of your "blues"—you took what I had intended as a lot
of nonsence seriously and I am sad too. Why old man I wouldn't
jump on your coins for a whole planet with two moons—not for
oceans—I only ment to stir you up but I made you growl—well I
must be more diplomatic but I had no idea that you would think
of it—

I am sorry you are so depressed but it wont last—the cool air of
Montana will put some red-blood in you—you are getting that
Dutch idea of committing suicide—Brace up—this little Uncle
Sam's tract of land is just spoiling for a fight look at Harrisons
Chili[1] & Beherings' Sea deal[2]—we'll have it inside of three years
and you'l be a Maj. Genl. or a corpse—Besides you can make a lot
of dollars writing about the things you have seen—I'll see to that
and then Genl Miles will be tele'd arrive in three years and he'll
make you head of the bug-department of the Smithsonian or you
invent a new saddle & Ill get it introduced with a 3rd party to run
the business end— stock company—sell out—get immensely rich.

Bah—dont you get down east—you are all hunk—marry the

1. Civil war in Chile had led to an incident in San Diego harbor, where the crew
of a detained Chilean steamer had overpowered the American guard and set sail
for Chile. The fugitive ship eventually surrendered without bloodshed. A second
incident occurred in October 1891, when a riot caused by a Chilean spitting in
the face of an unarmed American sailor on shore leave caused the deaths of two
United States sailors. Public sentiment saw the incident as an insult to the United
States Navy. War feeling ran high in both countries. The Chilean foreign minister
submitted an apology, but many felt that President Benjamin Harrison's (and
Secretary of State James Blaine's) handling of the situation was heavy-handed.

2. Harrison and Blaine were criticized again for their handling of the Bering
Sea crisis. With the purchase of Alaska in 1867, the United States acquired the
Pribilof Islands in the Bering Sea, home to a magnificent herd of some four
million seals. Although the United States could control what happened to the
seals within three miles of shore, Canadians continued to harpoon both male
and female seals as they swam the open seas to and from their breeding grounds.
Despite the demand for sealskin coats and muffs, United States public opinion
reacted violently to this wanton destruction. Congress authorized President
Benjamin Harrison in March 1889 to seize vessels encroaching on American rights
in the Bering Sea, even those outside accepted territorial limits. In February 1892,
after a lengthy diplomatic exchange, Secretary of State Blaine and his counterpart
in London, British Foreign Secretary Lord Salisbury, signed an arbitration treaty
that went mostly against the United States. Damages were to be paid to seized
Canadian vessels. Restrictions placed on further seal hunting slowed but did
not stop the process of extermination. In the press, Blaine was referred to as
a "bombastic bungler," although he was not altogether at fault, and Harrison's
entire administration was tainted by the affair.

girl and come and see us next Sept. I dont expect to sell—Will miss you as I said on the 19th May—sorry but cant help it. I am afraid I wont like Europe—I was born in the woods and the higher they get the buildings the worse I like them—Im afraid those Europeans are too well set up in their minds for me—but you cant tell. Well write when you can—and I wont provoke you to fight a duel unless you will agree to do it with lances mounted on burros.

I suppose Bigelow can fix me all right over there.—

Missie send Love and says I ought to be more careful what I write—& I agree.

<div style="text-align:center">Yours
Frederic Remington</div>

Early in 1892, Remington began to make plans with Poultney Bigelow for a trip to Europe. A year earlier, Bigelow had made a canoe trip down the Danube with the artist Francis David Millet. Now Bigelow was interested in a similar trip on the Volga River. Not knowing if Harper's would sponsor the trip, he wrote Remington that he would con-tact Pall Mall Magazine *in London.*

☐ *FREDERIC REMINGTON TO POULTNEY BIGELOW*

<div style="text-align:center">New Rochelle
January 5, 1892</div>

My dear Bigelow— Yours Dec. 22 at hand.

Well I hope to come over and would be glad to do work for the Pall Mall Magazine.

Would they give us six articles and give me 5 or 6 pages at $125 a page?

When would you start for the Continent? I would not care to stay in London long. I will bring your canoe if I come.

I would rather go in some other fashion than by canoe but we could arrange that.

Well, put up the job—make arrangements and then give me full particulars.

I have heard many people say that the Millet, Bigelow affair hurt Millet.[1]

1. Francis David Millet was an American painter and illustrator who had canoed down the Danube with Bigelow in 1891, sponsored by *Harper's Monthly*. After illustrating Bigelow's article, he wrote and illustrated one of his own for another publication. This led to a quarrel between Bigelow and Millet and was one of the reasons Bigelow was seeking a new illustrator for this trip.

Things are badly out of joint in the U.S. The West and South and the East are fighting each other in Congress.

This sectional difference is inevitable and will increase. It has danger in it to the Republic. The Republican and Democratic parties are disintegrating. [2]

Hope to hear from you soon and if everything is straight "I'm wid ye."

<div style="text-align:right">

Yours

Frederic Remington

</div>

☐ *FREDERIC REMINGTON TO POULTNEY BIGELOW*

New Rochelle,
January 8 [1892]
My dear Bigelow: I have the note from the Pall Mall Art Manager. That is very nice and I am pleased to accept it. I will come over when necessary. I have some work as yet unfinished.

Do they want me to do any American work— if so—I must do it here!

When do we go on our raid into Bulgaria, Bassalonia, Hertzo ME a Chiche and other parts unknown to me beyond the fact that the people should look thus.

Get an article on the Hungarian cavalry.

Put up the job—do your best for me and then give me all particulars and I'm your meat.

<div style="text-align:right">

Yours faithfully

Frederic Remington

</div>

☐ *FREDERIC REMINGTON TO POULTNEY BIGELOW*

<div style="text-align:center">

New Rochelle

[1892]

</div>

Dear Bigelow: Just have note saying "got pictures." Glad they arrived in good shape.

That is an inspiration of yours concerning buying bronchos in Hungary. That positively shows that your nature is spiritual—that you are exalted—it's Divine. We will buy horse's and a couple of pack animals.

2. In 1890 the Populists succeeded in capturing control of the Democratic party in a number of Southern states and in establishing a working alliance with Democrats in the West. The Populist party formally organized in 1891 and presented a full ticket in the elections of 1892, with James B. Weaver its candidate for president.

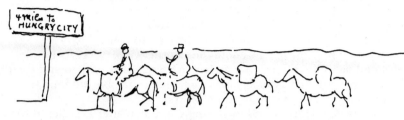

No one but a d—— Trinkit digger goes in a canoe.

Mrs. R. thanks you for your kind invitation but I do not know whether to bring her or not. We will be in such an outlandish place and she can't go and I don't like to leave her alone. We will see.

"Com O see Doitch"

"Not on your natural life."

Frederic Re

☐ *FREDERIC REMINGTON TO POULTNEY BIGELOW*

Endion
New Rochelle
January 11, 1892

My dear Bigelow:— Your note at hand— The plot thickens— Well if Harper puts it up that way I'll go to Russia or hell or any undeveloped country with you.—I'll jump Harper a little and report.

Yours very truly
Frederic Remington

☐ *FREDERIC REMINGTON TO POULTNEY BIGELOW*

New Rochelle
January 21, 1892

My dear Bigelow— I went down the other day and talked with Harper about your trip and they finally showed me your letter — I mean their letter to you and it seems that I am not in it. I hope to be in Europe in time to see the Fall maneuvers and in case of war we are all right but they say that what you are to write is not to be illustrated.

I am in hopes Chili will not back down, but am afraid they may. Give me your London address so that I may communicate with you in case I desire.

Yours truly
Frederic Remington

☐ *FREDERIC REMINGTON TO POULTNEY BIGELOW*

New Rochelle
February 10, 1892

My dear Bigelow— I went to the Century Club twice. As I understood we were to meet at 4.30. I was there as late as 5.20 and then thought you had probably been detained as the boy told me you had only been gone an hour.

I saw Mr. Harper and in speaking of our matter I gathered that it would go through all right. I told him I would go.

Can I meet you at the Century Club at 5 o'clock tomorrow afternoon. If Y can, telegraph me and if I get no word I will know you cannot meet me. We want to arrange some details.—I am

Yours very truly
Frederic Remington

☐ *FREDERIC REMINGTON TO POULTNEY BIGELOW*

New Rochelle
March 8, 1892

My dear Bigelow— I enclose a document which is no better than my word and just as good. Its formal enough for red-tape and a pigeon hole. Don't you worry on that score old man—I ain't half as mean as you think.

Didn't want to go on the 19th but I suppose it goes. Its "bloomin" lucky we get the navy over for nothing. You did not enclose the letter from Scherz. [1]

When you look at the boats—please see that mine is O.K.

Mrs. R. may come over [2] and join me later —our plans are not matured as yet. Mrs. R. would be very much pleased to meet Mrs. B. and we will arrange to have it so—either here or in towns in a very short time. I expect Lieut. Baker, U.S. Navy, to visit me today and to stay awhile and I want to run around with him as he did it for me in Mexico and I feel the obligation. So we will make a day the 1st of next week when you come back from New Haven.

"Allah is great and you are his prophet."

Yours truly
Frederic Remington

1. He is most likely referring to an anticipated letter of introduction from Carl Schurz, a German-born journalist. He was United States Senator from Missouri (1869–75) and editor of the *New York Evening Post* (1881–83), a very prominent figure in American public life.

2. She did not go.

☐ *FREDERIC REMINGTON TO POULTNEY BIGELOW*

Endion
New Rochelle
[1892]

My dear Bigelow— Thats all right about the sails.

Have you seen any Steamer men? I want to engage a passage soon.

I hope you will engage me a room in a London hotel as I understand that is rather a necessary precaution about the last of May.

I see they are having no end of trouble in Berlin. Your Kaiser has got "sand."

I missed you Saturday night but it's of no consequence except I want to see you about the steamer passage and the boat.

Yours
Frederic Remington

P.S. I have your note. I will lunch at 10 P.M.

R.

☐ *FREDERIC REMINGTON TO POULTNEY BIGELOW*

Endion
New Rochelle
March 16, 1892

My dear Bigelow— I was going to say, come up Saturday, but its snowing and we will make it Monday in the hopes that the snow will be gone.

Much obliged to you for jumping the steamboat folks—$132— I fainted dead away—had a regular stroke Jewish heart disease. That's enough to drive a man into the Adirondacks for life. If they don't stop that I'll buy a boat of my own to go over in.

Yours
Frederic Remington

☐ *FREDERIC REMINGTON TO POULTNEY BIGELOW*

New Rochelle
[1892]

My dear Bigelow — I have the solemn compact and will amend it and then subscribe.

I. P.B. shall not be too serious and any man shall be allowed to grin when he sees something funny.

II. P. B. shall wait for F.R. long enough for the latter to make a sketch.

III. P.B. shall have the entire charge of the maps.

IV. We do not sail a canoe when the sea is running high. I to be the judge as to this.

V. If we are fired out of Russia P.B. does business elsewhere.

I did not get your letter in time to meet you at Players.

I will buy a canoe of Everson.[1] Give me his address. Everything seems to be lovely.

You certainly misunderstood me. I am an easy man to get along with when "on the trail." I'm like Von Molke[2] in the respect that the "planning is hard and the execution easy."

Send on your English address—also full particulars of how to get to Germany and then I will communicate with you in England and let you know in time to arrange to meet me there. What line of steamers do I take—Write it.

Will see Everson so that our canoes can be shipped under your directives.

Do I want to do anything in an official way here as regards letters of introduction etc. etc.—If I do tell me what. I suppose I need some sort of letters. But we will discuss this

I can leave my extra baggage in Germany—cameras—six-shooters etc—I suppose.

<div align="center">Yours,
Frederic Remington</div>

Dear B.— P.S. —I want to make a book and have some extra mag. articles and I thought a good title would be "A Mimic War" or something like that—anything to get away from the words "The *German* Army" which title will kill anything.

Harpers strongly protest against treating the thing in a large way—political or tactical. They want little stuff or as Kipling puts it "half lights and little tones."

What do you think—write me.

<div align="center">Yours
Frederic Remington</div>

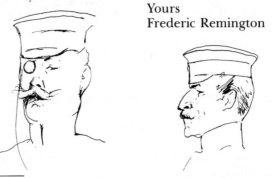

1. James W. Everson, a commercial boat builder in Williamsburg, Long Island.
2. Count Von Moltke, Prussian general.

☐ *FREDERIC REMINGTON TO POULTNEY BIGELOW*

New Rochelle
March 23, 1892
My dear Bigelow— I'll join the Canoe Club.—I sent the informal agreement.—I'll pay Everson in about a month.
Yours
Frederic Remington

☐ *POULTNEY BIGELOW TO FREDERIC REMINGTON*

My dear Remington— There is just one thing your little agreement says nothing about. I want to be distinctly understood as making a canoe trip from Petersburg to Berlin, with incidental excursions, in search of the picturesque —my object being to write a book. Your going with me means equally that we are making a friendly partnership and that you mean to work for the same book as artist and not as scribe. Beyond this I am not particular— all we can make together out of magazines and papers goes to pay expenses and I shall do my best to second you in every way. This covers the case so far as our talks go.

I never propose to use papers of this kind as legal documents and never propose to treat friendly arrangements as basis for wrangles. But Millet came to me yesterday and in cold blood informed me that he had no idea that I had any idea of writing a book!! etc. etc. which simply paralyzed me. So just O.K. this letter, or send me something equally clear.

I have done all I could about the canoes—Rushton's [1] fittings and Kirks' and Squires' [2] are all late and shall have to be forwarded by express to me. Goodbye. I hope nothing will interfere with this grandly outlined course. Au revoir in the Normania. [3]
Faithfully,
PB

[On same letter:]
Best regards to Mrs. Remington
O.K.
Frederic Remington

1. J. Henry Rushton, world-famous canoe builder from Canton, New York.
2. Probably a boat outfitting company.
3. The ocean liner on which Remington sailed.

☐ *FREDERIC REMINGTON TO POULTNEY BIGELOW*

<div align="right">

Endion
New Rochelle
March 27, 1892

</div>

My dear Bigelow: — I O.K. your stuff.—You just rest easy old man—

It looks kind of squally over in our canoe route.

Did you order paddles and where are my bills of expense?

<div align="right">

Yours
Frederic Remington

</div>

Lt. Alvin H. Sydenham was stationed at Fort Keogh, Montana, when Remington accompanied Gen. Nelson A. Miles and the Cheyenne Commission there in October 1890. From their correspondence it appears that Remington was able to help Sydenham break into the publishing world, offering him literary advice and encouraging him to give the public the raw unabridged version of the true soldier life. They also exchanged views regarding their common friend, Powhatan Clarke. Sydenham, obviously a gifted observer of men, and an equally gifted writer, apparently never submitted his manuscript describing Remington for publication. It was finally published in the Bulletin *of the New York Public Library in August 1940 and is one of the most detailed descriptions of Remington ever written.*

☐ *FREDERIC REMINGTON TO LT. ALVIN SYDENHAM*

<div align="right">

Endion
New Rochelle,
[undated]

</div>

My dear Sydenham

I do not think your German story will go but the Tommy Atkins [1] is a likely sketch. The editor of Harpers Weekly will know you and if you send my stuff you like to him you will get an opinion quickly.

I am rushed to death as I go to Europe on the 19th of May for six months.

Old man, you want a heap of d—— formalities from me —I am apt to cut them short but long or short they don't mean anything although I can assure that I am

<div align="right">

Yours till death
Frederic Remington

</div>

P.S.

Do I want the Indian photos—does a duck swim?

1. "Tommy Atkins in the American Army" by Lt. Alvin H. Sydenham appeared in *Harper's Weekly* on August 13, 1892, illustrated by Remington.

☐ *FREDERIC REMINGTON TO LT. ALVIN SYDENHAM*

New Rochelle
April 24 [1892]

My dear Sydenham The photos came duly and they are very
interesting particularly the Scout Corpse of Getty which I served
with during the war that never came.

I have your American Tommy Atkins to illustrate—it was ac-
cepted and is much liked—the Blind Friar they tell me wont go.
Sorry—you do the American soldier—his the stuff and we havent
a man who can do him—everyone has tried and I have always a
watch fire burning for the man to come—the fellow who can put
up the snap—the literary vitality —the picturesque—the wild—
other world sort of background setting for the Trooper of the
Plains. You must get under the regulations—get away from the
inspecting officers views and tell how he acts & talks & eats and
fights and swears and even makes love, and in telling a story
never mind a little lying—God forgives those things even if Gen'l
Carr does not.

Well you old red-leg [1]—become great—you have the receipt—
go ahead the people of the earth await with breathless interest
and *I'm wid ye*

Yours very particularly d——
much
Frederic Remington

P.S.
I sail on the 19th of May for the Fatherland.

☐ *FREDERIC REMINGTON TO JULIAN RALPH*

Tilsot—N.W. Germany
June 11, 1892

My dear Ralph, Here I am at last on German
soil—Thank God—Bigelow and I have
chased all over Russia and finally pried
bodily out of the country [1]—we left St.
Petersburg and instead of crossing at the RR
point we stopped at Kown [2] and took a steamer

1. Another name for an artilleryman.

1. Bigelow and Remington ran into problems with the immigration authorities
in Russia and were asked to leave the country.
2. Kovno, on the Niemen River in East Prussia.

down the Neimen and then a Jew with a funny cart. These Russians are a frightful lot of barbarians and their police espionage is something you cannot imagine. We dodged the police telegrams and got off with our notes and sketches—the canoes are in Russia and God knows whether we will ever get them. You talk about *Inguns*—they aint in it. Fellows disappear in that d—— country and a "lost soul" is doing a regular wholesale and retail business at the old stand beside a man who disappears in Russia.

I have been as lonesome as a toad in a well— can't talk the d——language and its a grand error if one supposes that Russians can talk English. One can't even read the letters of their signs— sort of Greek Russian characters. Well—I suppose you are doing politics—I hope Blaine and Cleveland win—I will have to get you to tell me how to vote.

Two German rail road officials and an old lady who wants to go on the train .—

Some people think they know about vermin—lice and fleas but they don't—no one but the Russians understand.

Well, adios old man—you know that God loves a cheerful son of a gun and he hates me— Yours

— Frederic Remington

☐ *FREDERIC REMINGTON TO POULTNEY BIGELOW*

Hotel Continental—Paris Wed.—
[June 1892]

My dear Bigelow— Got here all right—struck a German from New York—he could talk French and he got me through. A great deal of the French language was fired at me but with the settled gaze of a bull I looked back at them and they let up on me.

Paris is gay and festive—only one trouble—they don't talk English although they talk much more than anywhere else I have been. Every son of a b—— in France is trying to get my money. I have to cough up at every step—Why even in the water closet there is a man who wants to render unto Caesar—I get him to hold my head while I am about—d—— 'em—make 'em earn their money. They are a miserable set of petty thieves—much like Mexico as the old chap said—"The women are all whores, and the men horse theives."

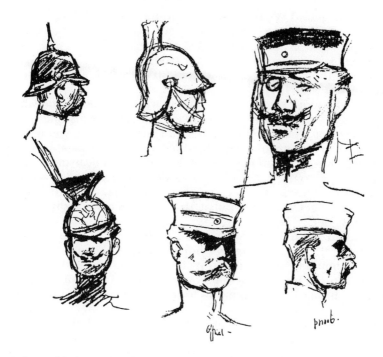

I don't think much of French soldiers. They are no good, physically and I don't think very picturesque. They are not set up and they look as though their clothes were made for someone else— The Prussians could lick 'em and not half try—The officers ain't in with the Prussians—a lot of theatrical chaps—dressed like Bashi Bazoukis[1]—very fierce in the face and very weak in the back—I don't wonder the Prussians licked 'em—I have been through all the galleries—with a general feeling of disappointment although I have learned much.

I go to London today—God bless her—

<div style="text-align:center">Yours cordially
Frederic Remington</div>

☐ *FREDERIC REMINGTON TO POULTNEY BIGELOW*

<div style="text-align:center">Bath Hotel, London—
Monday, June 27, 1892</div>

My dear Bigelow— Got to London without having my cargo lost in the channel although it was a narrow squeak.

1. Bash-Bozouks were mercenary soldiers belonging to the skirmishing or irregular troops of the Turkish army.

Met Davis and White—have been to Buffalo Bills[1]—on the Thames, and today to a Guard Review—I am right in it on the reviews—I have "slummed it" in Whitechapel.

I shall sail on the 2nd of July for God's country.

I don't think we have been written up much although everyone knows you were fired.

Will you write Harper and tell them when (or about) and what you are to write (two articles) so that I can get the illustrating.

I have got some London clothes and am a very nice young man but have great difficulty with the cab drivers whose pronunciation of English is so different from mine. You should hear me tell a cabbie to go to the Bath Hotel—you would think I had two sweatbreads in my throat.

I did not get around to call at Mrs. B.—and assume that now she has gone to Berlin.

I would like to hear from you before I go, so with all your industry in the postal card way I hope you will wake up.

You should hear me talk up William III[2] and abase Bismark. You captured me. It generally conceded by the English Press that despite Bismark's success on his tour it amounts to nothing in his favor.

D—— those stinking Russians.

How's that—does it echo?

Yours faithfully,
Frederic Remington

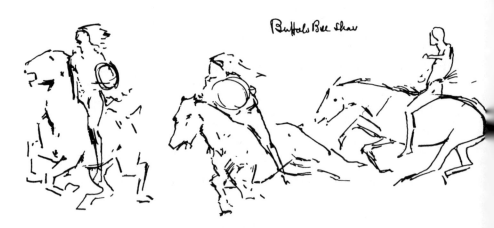

Buffalo Bill Show

1. William F. "Buffalo Bill" Cody's traveling Wild West show was popular in Europe. Remington did ten sketches that appeared in *Harper's Weekly* on September 3, 1892, as "Buffalo Bill's Wild West Show in London." Remington had also provided two illustrations for Cody's *Story of the Wild West,* published in 1888.

2. Remington meant Emperor William II, who brought about Bismarck's dismissal.

☐ *FREDERIC REMINGTON TO POULTNEY BIGELOW*

Bath Hotel
Arlington Street,
Piccadilly, W.
July 1, 1892

My dear Bigelow— "Harper" is burning the ocean cable for the material of "how we were fired." You will probably work that in to the "Russification" stuff. Bear down on the Jews.[1] It is a burning question here. I am compeled to explain to the incredulous how we obliged the Russian police by moving on. To express doubt is to court death.

I missed Mrs. B. and also Lieut. Greerson who has not returned the card.

I have a great scheme—do not do the Germany Army until I get to New York. I want to make a big finely illustrated book in X languages. It's a great idea.

I sail tomorrow Normania, Southhampton.

Yours
Frederic R——

☐ *FREDERIC REMINGTON TO POULTNEY BIGELOW*

New Rochelle
July 12, 1892

My dear Bigelow— Am here all right—had a good passage.

The Harpers asked me why they did not hear from you. I hope soon to have some M.S. from you.

I hope to get you some more articles on the German or Prussian Army. Will communicate.

Very hot here. Crops are good and business booming. We were well advertised.

I hope you are having a good summer. Regards to Mrs. B.

I am going ahead with illustrations for "The Russification of Poland"[1] "The House from Trachanen."[2]

Yours faithfully
Frederic Remington

1. He could be referring to material for "The Russian and His Jew" by Poultney Bigelow, which appeared in the March 1894 *Harper's Monthly.*

1. "Russification: The Polish and German Chapter" did become the last chapter in Bigelow's book, *The Borderland of the Czar and Kaiser* (1895).

2. Trakehnen was a village in East Prussia where a great horse-breeding establishment was located. Poultney Bigelow's article for *Harper's Monthly,* "Emperor William's Stud Farm and Hunting Forest," which appeared in April 1894, included thirteen Remington drawings. "The Emperor's Hunting Lodge" may be the article to which Remington is referring here.

☐ *FREDERIC REMINGTON TO POULTNEY BIGELOW*

New Rochelle
July 19, 1892

My dear Bigelow— I am languishing for the want of material to illustrate. Can you not as soon as you fully determine the titles of your articles send me a list so that I can go on with the illustrations. I am loosing my time. All I want to know is your titles and of course you must stick to them when you give me the tip or I am left.

We had it—
"The Russification of Poland and the Jews"
"Trakenan"
"Military Berlin"
"The Mimic War Maneuvers"
"The Emperor's Hunting Box"
"The Soldiers of Russia and Prussia"[1]

If this is to be otherwise—please let me know. As I say I think I can work in some more German military stuff. I am doing some German soldiers and I'll bet a hat you say its way up in c.

Yours faithfully
Frederic Remington

P.S. My uniforms are now in the Custom House.
P.S. I wonder how I can buy a Cossack uniform and saddle—do you know what was the name of our man at St. P.—the mil. attache?

After Remington and Bigelow left Russia they spent a few days at Trakehnen, the German emperor's estate in East Prussia. This is a pencil sketch of Trakehnen.

☐ *FREDERIC REMINGTON TO LT. POWHATAN CLARKE*

New Rochelle
July 19 [1892]

My dear Clark— I am here—leave for the North in 2 weeks so will be away in Sept. when you come—its rough—have spent all my money and got to get ready a picture for World Fair[1] so cant

1. None of these proposed titles were used for articles in *Harper's Monthly*.

1. Probably the World's Columbian Exposition of 1893 held in Chicago.

make Custer[2]—I can't do anything anymore that I want to and
am thinking seriously of getting off the Earth.

I had a fairish time in Europe—I hate Europe and nothing but
dire necessity will ever drive me there again—of course I'll go
because I'll have to. The German army is the only thing in Europe
that we cant beat—except for the things which were built before
1492 but I dont go much on old churches and palaces so I dont
miss them. The German Army is about as near right as things—
ever get in this world—It is perfection as you know—there is only
one criticism—thats a rather serious one—their cavalry saddle is
an impossible one—& when they try to "ride tight" its one of the
lightest pieces of comic opra I ever saw—they also cant ride a
little bit. The Cossacks [3] are the best light cavalry on the Earth
and they can run over and all around anything the Germans have
got.

I have a Connissier [4] a Hussar [5] (light blue) and a Ulhan [6] uni-
form and am going to paint them.

The Russians are all theives, have bad railway system, are poor
and dont think can maintain 200 000 men in Prussian frontier
(there will be no wars unless the Czar declares it.—Germany
should declare war, its her only salvation). Germany can lick Rus-
sia—it would be a Fall Maneuver for her but with France she may
become exhausted financially. I did not stop long in France—I
dont like France—and they were doing me up in good shape to
the tune of $20 a day (this for the mere right to live and breathe
& have my being) and as I had a contempt for them and was not
very well amused I took my sneak.

I like England—was two days at Aldershot.[7] English Army is
best equipped in Europe. You want to *crusade* against our bit &
and when we get the *bridoon* [8] dont ride on it all the while as the
Germans do.

I put in four days at *Trakenan*, the horse farms —they have
the best horses in Europe.

The French army (what I saw of it) did not seem to be any earthly
good. All very fierce in the face and very weak in the back. Cavalry
cant ride and officers look like a lot of little tin horn gamblers.

The British are a fighting looking lot but I guess the "scheme of

2. Custer, Montana.

3. Light horseman of the Russian army (Turkish origin).

4. A cuirassier was a European horse soldier wearing armor.

5. Light horsemen of Hungarian army.

6. Polish cavalryman or lancer.

7. Aldershot is a municipal borough in Hampshire, south England, the site of
the largest and most complete military training center in the United Kingdom,
established in 1854. Eight sketches entitled "An Athletic Tournament of the
British Army at Aldershot" appeared in *Harper's Weekly* on September 10, 1892.

8. The snaffle and rein of a military bridle, which acts independently of the
bit, at the pleasure of the rider.

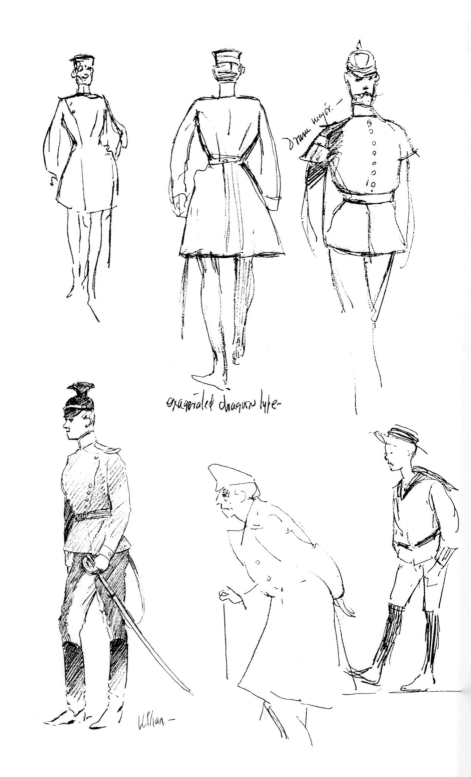

Drum major —

exaggerated dragoon type —

WShan —

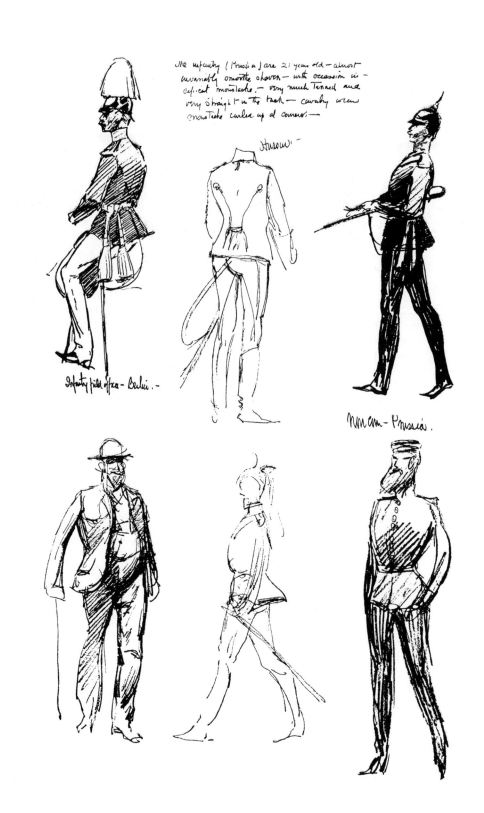

The infantry (Prussia) are 21 years old — almost invariably smoothe shaven — with occasional insignificant moustache. — very much Tanned and very straight in the back — cavalry wear moustache curled up at corners. —

Hussar!

Infantry field officer — Berlin. —

Uhlan — Prussia. —

outdoor relief for the aristrocracy" dont help the discipline. The officers are not skilled soldiers.

I think the Dutch Kaiser is a great man.—

I heard about you in Berlin. They all thought you were a great rider—you sort of cut into Bingham—he likes you but has plenty to say to the effect that you aint much of a feller anyway— or at least he would have said so if I would let him. He treated me well. Should like to have seen the maneuvers but couldn't stay. May go again.— Think will do a picture book on German Army.

Had a very polite invitation to get out of Russia and accepted without hesitation. "*Chased* by the Czar"—how's that. We left them alone with their cholora & fleas—oh—how I hate them. I'll confide in you to the extent that I have discovered that America is the only place on the Earth which is worth the efforts of men or the Grace of God.

They have an Athletic tournament in the British Army—we should have one. We should carry our carbines on our backs & cut 20 or 30 lbs off the cavalry pack. We should have a *straight* saber and *less* boots on the men. We must train our horses better. I guess the German boots for infantry are good. What do you think? We ought to breed our own cavalry horses. Above all we need a war.—

I might run over to [illegible] from Canton for a day—could I get a bed & some grub?

Regards from Missie & yours truly to Madam & the people. These are red-letter days for a soldier I know. It sort of lays over personal intercourse with Apaches & niggers on a sandy desert— hey old man—

Yours Frederic Remington

[Missie wrote a note on the margin of 1st page:]

I have a gun. It is loaded & if you call me *Mrs* again I'll shoot. Give lots of love to Mrs. Clarke. We are both anxious to meet her. I am very happy now that "Freddy" is home & am looking forward for a pleasant time at Canton. Wish we might see you both. With love to your mother, Father & yourself. *Missie* excuse pencil

☐ *FREDERIC REMINGTON TO POULTNEY BIGELOW*

Canton
St. Lawrence County, New York
July 26 [1892]

My dear Bigelow:— Your note at hand—I am just leaving for a little canoe cruise in the woods for two weeks.

It is all right what you have reported to your government and of course you have Warts opening gun. My advice is that you use the incident up to a certain point but to overdo the thing will serve

simply to make us notorious without any particular compensation.

As for me I know so little about what happened in your official relations in Russia that I can say nothing. You can speak for both of us and one cook is better than two. When people ask me about the thing I say "It's copyrighted."—You must anticipate that Warts will try and put you in a hole.

Sorry you came so near being drown—You are a reckless man who will very likely be drowned sooner or later and you may be hanged—it's no sure thing either way.

Am only now beginning to feel good—I got all out of fix—too much work and too little play—

Glad to see you when you "strike the beach" here. America is much maligned and I "tie right up to her." "She's too good for me." I don't want quite such a fine country as this to live in—

Yours
Frederic Remington

☐ *FREDERIC REMINGTON TO LT. ALVIN SYDENHAM*
New Rochelle
August 15 [1892]
Dear Sydenham— You state things which have your imagination for a basis when you say I told you not to send any more stuff to me, but if you want to get something in Harpers you want to tackle a subject that hasn't been done about 635,700,500 times before you tackle it or else you want to do it in a more mulvanesque way. I sent it on to the Youths Companion. Harper would hit me with a Bible if I lugged that in there.

The article is good but its encrusted with the ashes of Pompaie
Yours lovingly,
Rem—

☐ *FREDERIC REMINGTON TO POULTNEY BIGELOW*

New Rochelle
August 24, 1892
My dear Bigelow:— I have your postal saying you have the permission of the Czar to visit Russia. I was surprised and it occurred "well —that takes the wind out of our sails but of course it is now absurd to go."

I went down to Harpers as I am illustrating the why we left Russia [1] and sought advice. They will not hold the M.S. and if it is published you would commit a breach of faith by accepting

1. "Why We Left Russia" by Poultney Bigelow appeared in *Harper's Monthly* in January 1893, illustrated by Remington.

the Czar's permission and yet it is necessary to print the article as an explanation of all the uproar we made. Again you owe it to me to produce the M.S. of our trip so that I can illustrate it.

They have an article on "Farm Life in Russia" —I do not know anything about that.

Do not please make suggestions to Harpers of what illustrations I am to make since it only embarrases me as I can best judge how to use my material.

If you go again to Russia, you can make another series but should at least produce what we agreed on which I know you will—remembering the terrible details of our many "agreements." I will not hurry you of course but if you can expedite your work you will oblige me since I can do nothing until you do.

The White Squadron [2] and the 10. Horse [3] will do nothing for you in Russia. This country will not go to war about 1 citizen or 4 citizens or 1568 citizens and you can put that in your hat.

I hope you are well and the family also. I do not know your present address but hope this will reach you.

Are you coming here this Fall?

> Yours faithfully
> Frederic Remington

☐ FREDERIC REMINGTON TO LT. ALVIN SYDENHAM

> New Rochelle
> August 31 [1892]

I tell you Syndenham we have got to reorganize. The McClellan saddle is all right, cut down a little but some day, about 2000 years from now we will know enough to stop making a pack mule out of a cavalry horse.

What we need is war—you are going to have one I see by your M.S. Have you got an observation which locates it within 10 years or so. I'm getting fat all the while and if it holds off too long I will be forced to write editorials about it instead of "on the spots."

I will return the drawings as I can not use them. Tell the young lady to put a man out of doors to paint him. It is better.

The latch string is lost—and the dogs are tied and while I have little or no use for artillery folks yet I will issue a dispensation in favor of a man who has marched behind a troop.

I am

> Yours faithfully,
> Frederic Remington

2. U.S. Navy.
3. 10th Cavalry of U.S. Army.

☐ *FREDERIC REMINGTON TO LT. ALVIN SYDENHAM*

New Rochelle
September 12 [1892]

My dear Sydenham— I didn't mean to get in an under-cut on your spirit but when you tackle art and literature its like turnips and cabbages so far as the business preliminaries go. The blaze of glory that comes with the publication is all subsequent the real business of life is in cross-countering the editor in the first round. The disapointments of the pursuit of either are as the sharp stones in the road and they are as numerous. To get the advantage of neither needs a man's undivided attention as is generally discovered by those who try.

I thank you for the book and the photos—which have not arrived as yet. Did you read my "Tommy Atkins"[1] at Aldershot last Harpers Weekly.

Very hurry old man—hard at it—pardon haste pen.

Yours truthfully
Frederic Remington

☐ *FREDERIC REMINGTON TO POULTNEY BIGELOW*

New Rochelle
September 27, 1892

My dear Bigelow—I have your "In the Barracks of the Czar."[1] I will make some good illustrations for it. You do not refer to my Krasu Selo' stuff.[2] I want to draw Cossacks and Charlies Guards— etc. Will you not add a page of the sort —and send it to me.

I read your Russification and said I could draw a few pictures for it but have not gotten the article. I read Farm Life and as I know nothing about that I said I could only make a very few drawings—That I have not gotten. They are political articles not calculated for illustration.

How long will it be before I get "Trackanan" or the "Romintes." articles.[3] I am not gettin rich off our trip. Only one article—only

1. Remington did eight sketches titled "An Athletic Tournament of the British Army at Aldershot" that appeared on a full page in *Harper's Weekly* on September 10, 1892.

1. "In the Barracks of the Czar" by Poultney Bigelow appeared in *Harper's Monthly* in April 1893, illustrated by Remington.
2. Krasnoye Selo was a favorite summer resort near St. Petersburg at that time.
3. The article about Emperor William's stud farm did not appear in *Harper's Monthly* until April 1894. "Trakehnen" and "Rominten" appear in it as illustrations.

5 pages since I returned. But you are sick and so I understand it cannot be different but its bread and butter to me old man when you strike your feet.

When you beat up the German army for Heavens sake make it "picturesque" or I'm undone.

Regards to Madam—

Yours truly
Frederic Remington

☐ *FREDERIC REMINGTON TO LT. POWHATAN CLARKE*

New Rochelle
October 14, 1892
My dear Clark— Got your note—glad you are fixed up at last. Everything will run smoothe but you must not kick if the ham is cut too thick at breakfast—you have to be married about three years before you can exercise that priviledge. I note what you say about your "lodge" and would give nine dollars if we could come out but I am full of business and cant come—may go somewhere in February but dont know— Montana is a little cool then.

How do you like the canvas overcoat? and the cap.—it makes a man look like a grizzly bear and feel like one but its the stuff. I see some of the Sioux are talking war.—but they wont want any—not in the winter you tell your folks. Don't you ever go to war in Montana without a Sibley stove—I've tried it and I know. Have you seen the Cheyannes. They are dandies.—The Crows are all right —I dont take any stock in the talk one hears about other indians being better than they. They have fought the whole northwest for ages and held the best land in it against all comers.

I am doing the Russian soldiers now and they are fine—the Cossack gets up in picturesque shape.[1]

Had an awful time this last week getting old Columbus landed. Saw the military parade—the Philadelphia city troop have the dandy cavalry uniform—which we should adopt with modifications. The Pennsylvania militia are away up—look better than regulars and just like them—They have a wrinkle in knap

1. Some Cossacks appeared among the illustrations for Bigelow's "In the Barracks of the Czar," *Harper's Monthly*, April 1893. "The Cossack as a Cowboy, Soldier, and Citizen" by Poultney Bigelow appeared in *Harper's Monthly* in November 1894, with nine illustrations of Cossacks by Remington.

sacks which is smoothe—tell some of your dough boy friends—
per drawing—

Two sticks—which bear on the hind quarters of a man and this
relieves the shoulders. Have never seen it before—it dead right.

Anyone can make one in an
hour. They were the only
people who marched in full
kit—the regulars did not and
infantry who dont are no
good—they look like soldiers
and not like "*doods.*"

Gosh—how I would like to
get some sketches of your
games—it would work up in
great shape. Why cant you send
me some photos and article.

Polo—pick up something at top
speed and send me the photo. Tie a ribbon on one arm and let
others chase you. Pick up another mans by reaching down—he
supposed to be dead—ala Cossack & Indian. It is not yet settled
that you wont write a German book for me—Army of course—
Bigelow is no good—turning in rot.

Merritt[2] well everyone says he's great but I never heard of his
doing anything—the rescue of Thornburg didnt amount to any-
thing—good march though—did a good march in the old Sioux
campaign—got licked in the *War* on various occassions but then
everyone says hes good—cant see it. Miles is the only upper grade
man in our army who is worth the powder to blow him to hell.

Well so long—write when you feel like it.

Yours truly
Frederick R—

☐ *FREDERIC REMINGTON TO POULTNEY BIGELOW*

New Rochelle
October 18, 1892

"*dot and carry one*"[1]

They are of no particular value.—Bye the way I want to send
Maj. Von Frankenburg[2] some books and shall do it shortly. I can

2. Col. Wesley Merritt, who served with Gen. Nelson A. Miles.

1. This is the end of a letter to Bigelow. The first page is missing.

2. Maj. Von Frankenburg-Proschlitz was commandant and governor of the
estate in Trakehnen where Emperor William's stud farm and hunting forest
were located.

make a stagger at the "nice young man," the hussar who weighed more than his hoss—you remember him.

Get in lots about how the colts romped and how we did not know how to eat crawfish and don't ever make the mistake of saying that anyone in Germany knows how to ride a hoss—cause they don't, and I've got the documents.

<div style="text-align: right">Yours
Frederic Remington</div>

□ **FREDERIC REMINGTON TO POULTNEY BIGELOW**

<div style="text-align: center">New Rochelle
October 31, 1892</div>

My dear Bigelow— Haven't gotten your "Sidelights"[1] yet. I want another article on the German army—ought to have two.

Sorry your health is bad— Please convey my congratulations to Mr. Bonsal.[2] I have met him you know.

I want to get away from here by February—rush 'em a little old man.

Regards to Mrs. B. I'll see that you get a Dutch dragoon[3] before the stuff is all gone.

Am going to send some books to Maj. Von Frankenburg.

<div style="text-align: right">Yours
Frederic Remington</div>

1. Remington was waiting for the draft of "Sidelights on the German Soldier" by Poultney Bigelow that appeared in *Harper's Monthly* in July 1893.

2. Stephen Bonsal, an experienced correspondent.

3. A dragoon is a kind of carbine or musket. The term also refers to mounted infantryman with a firearm. It is not clear whether Remington is referring to the weapon, the soldier's uniform, or a picture of one or the other.

☐ *FREDERIC REMINGTON TO POULTNEY BIGELOW*

New Rochelle
November 4, 1892

My dear Bigelow— I send by express—4 books—one is for
you—its my new "Oregon Trail"[1] just out and three others are
indited to King "Bill"[2] in my most effective court style. Will you
kindly send them on to him. You said this was the thing to do
and so I do it. I also sent some to Mrs. Maj. Von Frankenburg
Trakaman.

Send the express account from London to Berlin to me and I
will "repay thee."

Mrs. R. sends regards and I am

Yours as ever
Frederic Remington

☐ *FREDERIC REMINGTON TO POULTNEY BIGELOW*

New Rochelle
November 16 [1892]

My dear Bigelow— I have your note—sorry to hear you are
so long getting back on your feet.

I have just completed eight pages of drawings for "The Bar-
racks of the Czar" and they are as good or better than anything
I have produced yet. Sorry you cannot see them but you will
be an old man before the article appears—a magazine does not
want fresh food but it must be "hung" until it smells with age.
A man must never write anything for a magazine which he will
be ashamed of ten years hence.

The Raged Edge" is good—"Where the battle will be" is better
if you don't mind being a prophet.

I will not go to the place in Russia which you propose. I know
when I have gotten enough.—No Russia in mine—I am not d——
crazy about Europe anyway but I know all I want to about Russia.

I start as soon as I can get this material worked up for the dear
old land—the Rocky Mountains—The Sierra Madra—the Grand
Cañon—The Wind River & Big Horn and the Coast Range—and
through my jaundiced vision Europe ain't a ten cent side show to
that ar' country. It's good for some people but its pisen for me.

1. Remington illustrated a new gilt-top edition of Francis Parkman's *Oregon
Trail* published by Little, Brown and Co. of Boston in 1892.
2. Emperor William II of Germany.

This is my idea of the way we are all going to be when we die.

All the Jews and the Dutch and the Irish will be back in their beloved Europe and once again the cowboy and the trapper and injun will ride the savage uplands and hunt for wood water and grass.

"Missie" send regards to Madam and the *children* and we both join to you. All my photos were no good and I'll have the very devil of a time doing Trakanen—It will be mostly "hosses" since I have a dim recollection of the buildings—but blow the buildings anyway.

Mrs. R. read your "Paddle and Politics" and was tremendously interested—and when I tell her that as a liar you could never become distinguished she is foolish enough to believe everything and—well—you have one admirer at any rate; and I am sorry to say that I find it necessary to keep you in hand or I would say two. With regards to Mrs. B. and just ask her if she remembers how the Normania "lurched" one day and ask her if she won't use me as a highlight in some story—bearing down on the gallantry of my rescue of the very disagreeable old lady from South America.

Well adios —I'll see you if you keep your health and do a smoothe obituary if you die.

Yours truly
Frederic R
P.S. I don't like to send paper like this to a man who spends so much money on stationary but it's all we have ——
F.R.

☐ *FREDERIC REMINGTON TO POULTNEY BIGELOW*

New Rochelle
[undated]

My dear Bigelow:— I have your *"sidelights"*[1]—it is good—it gives the little things which cannot but interest a big people to whome soldiers are brica 'brac like blue jugs from Japan. You *lectured* a very little but that comes of a Puritan ancestry and a fondness for maps—the taint of both are not to be eradicated. It is good and will illustrate.

The Trakeman[2] is all "hunk"—I'll put in that the horses are not deep in the chest—have too little body—and you should have said that the soft boggy ground is bad for hoof development but you didn't and all horsemen will hate you for all time. But you don't care about that.

I have painted a bunch of German soldiers[3] and everyone says they are out of sight but everyone don't know so I will have to wait until someone besides Clark says they are "proper to a degree." He is my friend and like a fellow in love with a girl cannot see the freckles on her nose. I am going to have an exhibition and sale at The American Art Association in January. After that I will have a few dollars or will begin life anew as a tramp—but since my art career was begun as a tramp it will do little harm to revert—I know now how easy the transition can be made from that to a comparative success.

Want very much to go back to the old life "out West" for 3 months —it's the first love and god bless us, they never grow grey.

Did up the "hoss show"[4] today—3 pages—I'm glad it's such a big success—it's good for 200 or 300 dollars a year to your most obedient and why should it not prosper—I cannot see.

I am going to Germany with you someday to "do a maneuver"—am I not, I'll come over *a purpose.*

☐ *FREDERIC REMINGTON TO POULTNEY BIGELOW*

New Rochelle
November 24, 1892

My dear Bigelow— Have yours of the 10th—The $100 frustrates me—its all right only it just this way—I am going to have a

1. The article "Sidelights on the German Soldier" by Bigelow appeared in *Harper's Monthly* in July 1893.

2. Probably Remington meant a "Trakehnener," or horse-wrangler.

3. Remington later illustrated an article by Powhatan Clarke, "Characteristic Sketches of the German Army," for *Harper's Weekly,* May 20, 1893.

4. "The Horse Show of 1892" by Caspar W. Whitney appeared in the November 26, 1892, issue of *Harper's Weekly.*

grand exhibition and sale American Art Ass. in January and I am
working for it—naturally it takes all my money—in loss of time
and some thousands in frames and I cannot indulge in vanities
like Cossacks uniforms but if you do not mind I will let the $100
go until after Jan. but if you do I have a six percent credit system
which I avail myself of at times—*how does it go?*

I can do a Cossack article away up in high C.

You must have my books by this time.

Did Cleveland get there—well I should smile "I am a demo-
crat." I hate Harrison so that I foam at the mouth but we will
have to lick the Demmies next trip.

I am in it—when the war comes.—You and I have lived long
enough, we can afford to die.—I should like to send a few dying
statements to my wife but that could never be done in Germany.

I am crazy with work—excuse haste.—believe me yours etc.
and with regards to Madam I am

<div align="right">Your old pal—</div>

P.S. Millet is a business man, he is not an artist. He is running
the World's Fair. I see the Kaiser is in a hell of a lot of fuss over
his Army Bill.—D—— Dutchmen if they knew as much as I do,
they would all enlist.—

<div align="center">R.</div>

☐ *FREDERIC REMINGTON TO POULTNEY BIGELOW*

<div align="center">New Rochelle
[January 4, 1893]</div>

My dear Bigelow Will see Alden about the "Cossacks." Think
he will take it.

Did you see Harry Harper in London? He was there for a
few days.

The Cossack plunder has not arrived. I will see that you get the
$100 as soon as I "fill my hand."

When I get my stuff back from Harper will send you an
"immortal."

Am digging away at "Sidelights" but it is so "long" ago that I
am not fresh at the subject. Am tired out and want to go West.

Shall go to London with a "Show" someday when I get good
stuff. Will work you for the "rent and lighting."

Amuse myself "breaking a colt."

Regards to Mrs. B—Met Bonsal the other day at the "Play-
ers"—got to know him a little—nice chap—good stuff.

<div align="center">Yours faithfully
Frederic Remington</div>

☐ *FREDERIC REMINGTON TO POULTNEY BIGELOW*

New Rochelle
January 9, 1893

Dear Bigelow: Got letter Alden & you. Do not mind the Cossack uniform.—I am half through with your Cossack article now and it will be of little use to me since, while I can do the illustrations necessary for your stuff, yet as long as my personal relations with the Czar are as strained as at present I will probably never see a cossack again in my life. Recover your money. Time is not money in Russia—

Would like to see you over here but am afraid you will have to tack 3000 more miles on your journey if you catch me.

Next Fall we will talk business. I want to see the Dutch in maneuver. Might tackle the Hun's but not in a canoe if the court knows itself.

Regards to Madam and yourself from Mrs. R.

Keep me posted.

Yours
Frederic Remington

☐ *FREDERIC REMINGTON TO POULTNEY BIGELOW*

New Rochelle
January 29 [1893]

My dear Bigelow— To-morrow—to morrow I start for "my people"—d—— Europe— the Czar—the arts—the conventionalities—the cooks and the dudes and the women—I go to the simple men—men with the bark on—the big mountains—the

great deserts and the scrawny ponies—I'm happy.

Yours
Frederic R——

Miss Grace Bigelow invited us to dinner at 21 club[1] tonight but we were short handed and getting the quartermaster stores together and had to decline. I am sorry—Regards to Madam.

Yours
FR—

1. 21 Gramercy Park address of the Players Club in New York City.

☐ *POULTNEY BIGELOW TO FREDERIC REMINGTON*

98, Oakley St.
Chelsea, London
January 30, 1893

My dear Remington, At this moment I received from our Lega-
tion in Berlin, a communication from the German Foreign Office,
dated January 19th, informing our Government that the Russian
Government offers us the sum of 174 marks and 70 pennyfigs,
representing 86 roubles and 46 kopeks of Russian shin-plaster—
This sum being in the nature of an indemnity for the fine placed
upon our boats. Curiously enough, the returned money does not
come from the American Legation in St. Petersburg but we owe
this magnificent indemnity solely to the German Consul in Kovno,
a fact which does not say very much for the powers of our Ameri-
can Passport. I think it is about time that you made a row about
this matter, because I have done more than my share already.

At the Berlin Palace, the other day, I dined with the Emperor,
and he said he had been reading the January Harpers, and thought
it outrageous that we should have been treated in that manner.
He made no concealment of his opinions, for several in his neigh-
bourhood heard him, and one of those was none other than Wurts,
(but not at the Dinner) who, in this way received such a snub in
Germany as must have made him regret ever having left St. Peters-
burg. He was not invited to the dinner, nor did the Emperor
speak to him or shake hands with him; he stayed with the British
Secretaries all the time, and was presented or rather marched
by the Emperor in single file, along with the English Secretaries.
I am sure he felt more at home there than with his own country-
men, and particularly your humble servant. The Emperor asked
particularly after you, and whether you had enjoyed your visit to
Germany, he asked me to thank you for sending the books, said
he had looked over all your pictures and thought they were splen-
did and proposed getting up a little present for you as a return
compliment, something with an autograph. I gave him to under-
stand that you would make no violent objections to this act of
despotism and he seemed very much pleased.

The Russian Ambassador, Count Schuvaloff, who gave us our
two letters of introduction to St. Petersburg last June, and who
signed our passports for us, came up to me at the Grand Ball in
the Berlin Palace, when I had Miss Phelps on my arm. He smiled
as blandly as the heathen Chinee, and said that he had regretted
infinitely the sad cause of our being fired out of Russia.

Said he "I am going to Chicago this summer, but I hope that
your countrymen will not treat me as badly as mine treated you."

Said I: "Your Excellency need have no apprehension, my fel-
low-countrymen are already civilised."

At this Schuvaloff smiled sweetly, shook hands and went on his path of duplicity.

I have written a letter to President Cleveland, a copy of which I sent you, if you have not received it let me know and I will send you another. In regard to this matter, I should suggest that you write a somewhat corresponding one and give it to the Press as well, for their treatment of you is thoroughly outrageous, for you at least could not have been in Russia suspected of cherishing German sympathies. Cleveland knows your work and Gilder can push your case.

 With best regards to Mrs. Remington from wife and self,

 Poultney Bigelow

After he returned from Europe and illustrated Bigelow's articles for Harper's Monthly, *Remington devoted most of his time to preparations for a one-man show and sale that took place on January 13, 1893, at the American Art Galleries in New York. Remington had decided to do this rather than participate in the 1893 exhibition of the National Academy of Design. The event received nationwide publicity, and Remington made over $7,000.*

☐ **FREDERIC REMINGTON TO LT. POWHATAN CLARKE**

 New Rochelle

 December 7 [1892]

My dear Clark— Am awfully busy and cant write much—sale in January.

Sorry cant come out now to Custer but will be along your way in Spring—going to Mexico[1]—Zuni (do you know anyone at Wingate) California and Northern Pac. R.R. home.—

The man who said I could not make U.S. cav. officers look like duds' is all right. I cant or wont.

The War Dept. be d——. You just wait and we will give you a chance to blow yourself off to the whole blooming American people.

That saddle of which you sent cut is virtually a Whitman—I like it—I *dont* like the cinch—catch—Its no good for two highly important reasons—Would come undone if not cinched too tight—break easily etc.—no good.—

I like your idea of carrying carbine—the gun should be on the man. You want to crusade against the cav. boots. I am going to make a fight for this cav. uniform some day—brown canvas.—

1. He had a commission from *Harper's* to write and illustrate articles on ranching in northern Mexico.

carbine belt accoss chest with carbine hooked to it behind—brown cord trousers, loose English hunting bandage stockings.—brown leather spatter dasers—detachable shoes—spatter dashers thick heavy & stiff and only little over half way to knee—get one?

Saddle like this.—stirrups—like this —made of allumimum three bars—big overcoat no blanket in the field.—nothing on saddle but little bags.—canteen & rope—haversack on man—this idea is largely British—its immortal too.—"It will not down."—

When do you people get the new gun.—I believe in men rising to the trot when marching—do you? I believe in a straight, sword like this.—pretty long.— and the trowel bayonet for infan- try.—

Well—I envy you

your riding.—I am getting crazy to be out in the woods, plains or somewhere, where the air and clouds are and where this pes- tiferous human is not.—

Regards to Mrs. C.—and tell her she must never "jump her husband" Mrs. R. will not agree with this sentiment but it is a good one.—

Yours faithfully
Frederic Remington

☐ *FREDERIC REMINGTON TO LT. POWHATAN CLARKE*

New Rochelle
January 12 [1893]

My dear Clark. Have been very busy with my exhibition now at the American Art Association.[1] It will be Waterloo on Friday night and I will be either Napoleon or Wellington—its toss up which.

Got your long letter the other day—you must keep your self down I hear the same kick from other young men but there is only one way to do the thing and the conditions must be right.

With Miles in—it may be possible with Schofield[2] nothing can be done. If I know more about these things as I hope to I may "jump in and stir things up some day. I think aepathic treatment is what the army needs! A war would do it in 20 minutes but there is the apathy of the people and the big yellow fat Chineese Gods who sit so solemnly in Washington (War Dept) that to get an idea into their heads would be to shatter the whole d—— God.

Keep easy—and if you cant keep easy—etc.

I will see what I can do with the very funny red tape paper you sent to me. I think it could be treated but probably not in the way you desire. A Lieut. cant have an idea without the endorsement of the army [illegible]. It may be right, all that long way round, of doing business—its the conservative way—it has always been so— but its god inspired idocy just the same.

I am tired out and want to quit but cant seem to let go. Want to go West soon and hope to Mexico first. We have got a cow—a daisy—and are living on the fat of the land. It is snowing like the devil—nearly two feet now.

I am doing a Cossack article now. Very interesting—I wish you could see some Dutch I have since done. Think will run over to Germany next fall to manuvers. The Dutch are great.

Some sun—got into my chicken coop and lugged off 8 as fine hens last night as "ever was seen." Ide like a shot at 200 yds. running at the party.

1. Remington's Friday, January 13, 1893, show and sale was actually held at the American Art Galleries on East 23rd St. in New York.

2. Brig. Gen. John M. Schofield.

So you think I dont know anything about equipment—that sounds like you. Well I am not stuck on myself and keep my mind open but I tell you quietly that my scheme is "immortal." I have changed it of late.—over

<div style="text-align: center">Yours lovingly

Frederic R——</div>

Mrs. R. sends regards to Madame & yourself—

☐ *FREDERIC REMINGTON TO LT. POWHATAN CLARKE*

<div style="text-align: center">New Rochelle

January 18 [1893]</div>

Dear Clark Have just read your article in Cav. Journal—Its mountain air to me—I waided along through what "old stuffs" thought and "kids" imagine when suddenly I find a man who says "oh hell—this is the way—you are wrong—" I look and see P.H.C. 10th[1]—and then I know you are right. You talk right at them and you talk sense—and everyone knows it. It makes me sick—I think that all the problems which are delt with in the Cav. Journal are rot—they are not problems at all—any man with sense enough to run a grocery would say immediately when he saw a German saber and our own—Neither is any good."

<div style="text-align: center">Yours truly

Frederic Remington</div>

——"Pardon"

☐ *FREDERIC REMINGTON TO LT. POWHATAN CLARKE*

<div style="text-align: center">New Rochelle

January 24 [1893]</div>

My dear Clark— I made $7300 at my sale. It was a rather good sale—a decided art triumph as people and the papers say and will in its ramifications be of benefit to me. I have since many orders.

I am going to try and get you to write up my German officers.[1] Will know about the order in a few days.

Do not say a word but I heard that Danl. S. Lamont was to be Secty. of War.[2] It is is simply out of sight. He is young, brainy and desirous of distinguishing himself. I know him as well as I do you.

1. Powhatan H. Clarke, 10th Cavalry.

1. "Characteristic Sketches of the German Army" appeared in *Harper's Weekly*, May 20, 1893, written by Clarke, illustrated by Remington.
2. Daniel S. Lamont of New York was appointed secretary of war by President Cleveland in 1893 and served until 1897.

We are in it. Dont say a word—its too good to be true. My man is sick with a little fever and I am detained here—I am tired out and want to go to Mexico but expect to leave by next week. May strike you about last of March if weather is good.

Don't get discouraged about these officers. In case of war they will all go to the wall. There will be a round up some day. You just look out for Clark.

I have not read your article yet —but looked it over. Am afraid it is in need of a blue pencil for publication. Will do what I can. Next year I want some stuff from you of a literary nature. It is hard to get professional stuff in a current magazine. That's an axiom. Richard Harding Davis[3] is going to be an ex-editor pretty soon and then I will be able to do more—he and I dont agree. He tried to kind of suppress me to sort of cover me over with beautiful flowers but I bob up serenely and he aint hunting a row. He leaves for Egypt soon but I shall go away sooner and so dare not tackle him.

It makes me sad to think of you chasing rabbits and coyotes and jumping Johnnie come-lately around on one leg—while I have to bone and bone and fret and stew and I say be—d—— to the whole business. I wish I had never left my native woods.

Do you see all the row the Catholics are having—papers are full of it. The Presbyterians have developed some strong doubts about the existence of hell lately—as Bob Ingersoll says "if they keep on, they will let me into the fold. Am doing some good Cossacks.—

Did you see Tio Juan[4]— last Harpers Magazine? How do you like the anitomical study?

Met a young man of your Regiment in N.Y. going to get married.

Going to see Miles in Chicago. Will find out when we can have full possession of the Earth.

"The Last Stand" was withdrawn from my sale & goes to Chicago.—

Regards to Mrs. C. from Missie and myself.—

Am afraid I will not get a reply to this—I hope to be West. Chihuahua & the Sierra Madre first—

<div style="text-align: right">
Yours truly

Frederic R——
</div>

A few weeks after completing his show and sale, Remington and Eva headed west. Eva stopped in Detroit, Dayton, Chicago, and Kansas City, while Remington headed immediately south. In Mexico, he stayed at Bavicora, the ranch of Jack Follansbee, 225 miles northwest of Chihuahua.

3. American novelist, journalist, war correspondent, and *Harper's* editor.
4. "Tio Juan" by Maurice Kingsley, *Harper's Monthly*, February 1893, illustrated by Remington.

☐ *FREDERIC REMINGTON TO LT. POWHATAN CLARKE*

San Felipe Hotel
Albuquerque, New Mexico
March 21 [1893]

My dear Clark— We are paying $5-a-day—this is a bluff on the part of the Hotel.—

The old *lady* arrived last night from the East and I caught her just as she fell off the car platform.

I had just come in from Mexico. Made the biggest trip since Gen'l Grant went around the world on his stomach. 750 miles from Chihuhua—was at Chihuachupa plain—of course U.S. soldiers dont know where that is, but that was the summer place of "a nice toff old geezer" named Geronimo. At present Mr. Kid is occupying the place but is not generally at home to callers.

Some Mexican folks dropped in one night to take tea with us but we put the 45'es on em and they "rolled their tail."

17 days on venison—coffee & flour—put a 3 gallon coating on my stomach. —

Leave tonight for Los Angelos Will go to San Francisco (Palace Hotel) stopping at Coronado Beach—then Portland—East via Northern Pacific. If you are at Custer siding when the train goes bye—I'll dip my tile.

You tell your folks that if we lick those Mexicans in their own mountains we would sweat plenty for all the glory we got.

Regards to Mrs. C. and the boys!—I want to tell you how thin I have gotten—I could wear your pants.—

Adios—compadre'—muy frejo—hit the flat.—

Yours
Frederic Remington

[On side margin of first page Remington added:]

Dont let on that I dont know it all regarding Germany. Everyone will find that out soon enough—

☐ *FREDERIC REMINGTON TO POULTNEY BIGELOW*

New Rochelle
April 10 [1893]

My dear Bigelow: Just back from 2 months in old Mexico—had a good trip—lots of stuff—You should have waited if possible in coming over—I wanted to see you. You are always in such a d—— rush—I told you I was off for the Wild West.

Well—yes—I want to go with you—but am crowded with work and to go this summer is out of the question. If you will let me breathe a bit I will say when I can go. They will have cholera this

summer and I wouldn't go anyway—you think I want to die—
wrong again old man —

Much obliged for your kind invitation for Madam and myself
to be entertained.

Got a big fine letter from the Imp. Consul Gen'l.[1] to call and get
a portrait of his Majesty. I'll be there with my best bib and tucker.
That's your work old man—well—I don't forget it—and I'm to
do anything you want but I have to make a living and I'm like a
peanut man—if I take in a bad half dollar I will fail.

Going to get rich this year—got a scheme—maybe so it won't
work but if it does I'll be a "great swell."

Regards to Mrs. B. and tell her I am to read the Beaulet
Mrs. Thorndyke.

Yours
Frederic R.

☐ *FREDERIC REMINGTON TO LT. POWHATAN CLARKE*

New Rochelle
April 10, 1893

Dear Clark Just home—9000 miles—tired & lots to do —got
some letters from you and will write at leisure later.

Will see Lamont[1] & the Sun & write—We were much put out
not to come to Custer but business is business and I "rolled my
tail" for the Bowery.

Missie sends love & we hope no 3 Clark will be as good as the
No's. 2 and 1.—

You will get yourself killed with those d—— broncos yet. But
you dont mind that.—

Yours
Frederic R ——

☐ *FREDERIC REMINGTON TO LT. ALVIN SYDENHAM*

New Rochelle
April 12 [1893]

Dear Sydenham:— Just back from a long trip in Mexico—we
went to California, Los Angeles, Colorado & San F. stopped in
Chicago a few days.

My mail is mountain high—and I have so much work that I am

1. Probably German Consul General Fregel in New York.

1. Daniel S. Lamont, secretary of war.

crazy. I find some old letters from you doubtless long forgotten by you. The clipping is good.

I Fear old man that it will be impossible to get you the sketches for the "Overland Monthly." People will not lend pictures, even if I knew where they were and one publisher wont do any *charity* to another you can bet your pants.

Will write at leisure
Yours cordially
Frederic Remington

☐ *FREDERIC REMINGTON TO LT. POWHATAN CLARKE*

New Rochelle
April 13 [1893]

Dear Clark— Got a little out of the woods and want to say—

Now first—tell me all about Lt. Col Hewitt[1] of your old Regt.— now Col. 2nd Cav.—Had letters to him from Miles[2] at Wyngate telegraphed him from Albequerque train arrived 2 o'c in morning, could'nt present letters, wanted to know if there was day accomodations for strangers—old lady with me etc.—wanted to see Zunis. In reply "I *think* there are accomidations at Zuni."

What do *you* think of that?

Is that the kind of sporting blood you have in the Army? I want Col. H.[3] hair—that is I want to know how to take it off if he ever get in a "fight"

I did'nt tell you why I have to hurry home from San. F. but I got a chance to make $40,000 and I "rolled my tail." Thats all — am no end of sorry I couldnt go to Custer.

1. Lt. Col. Hewitt was post commander at Zuni.
2. Maj. Gen. Nelson A. Miles had given him a letter of introduction, but he and Eva were turned away when they arrived at two in the morning.
3. Col. Hewitt.

—Private— personal—dont say a word—I went to Fort Sheridan and had a battery drill organized to get some photos from— It was spiritless— no good—The cap & Lt. drawled—the Sergt. didnt know what to say exactly—Instead of standing up in his stirrups and savegly shreiking "action right" etc he called out pleasantly "do this"—etc—*no way no*—the men were asleep—

Had nice talk with Miles—these d—— old Col's etc. are dead ahead of him but he's good for em & he's good for soldiers but he would make life hell for poops & doods. I told him a cavalry man ought never to get a grade who couldnt take a six rail fence & he said *"good."*

I hope the "kid" is on deck & it ought to be a boy—for the good of the service you know.—

Yours
Frederic R——

☐ *FREDERIC REMINGTON TO POULTNEY BIGELOW*

New Rochelle
April 18, 1893

My dear Bigelow: Got through German Consul Genl Fregel of N.Y. a photo of the Kaiser inscribed in illegible handwriting and a note from the Minister Van Holleben at Wash. It's in the Cenmassieur uniform. I acknowledge the courtesy to the Minister in a letter so formal and cold that you could freeze beef on it. I am proud of the distinction and thank you for I think your fine Italian has manipulated the secret springs.

Am crazy with work but will directly write you at length

Your obedient servant
Frederic I

P.S. Got the picture of the German Emperor—it has a brass frame—Imp. Arnis—a lot of Dutch which I can't read or any German who has yet tried. I suppose there is no insulting language in it— it even may be an expression of good will—but it's lost forever. Some Egyptolotist in 2 or 300 years may go at it with a microscope but alas—Well—I wrote a letter to the German Minister in Washington and said all I dared say—don't want to go into a red-string dove cot in bad form—think I did the Heavy Diplomatic in good form.

May get to Europe this next winter. Will keep the line open anyway.

I still reflect that you could have come to America where *I am in it.*

Yours
F. Remington

☐ *FREDERIC REMINGTON TO POWHATAN CLARKE*

New Rochelle
April 22 [1893]

My dear old Clark— Just got your letter announcing the advent of P.J.H. Clark Esq. [1] Col. of Cavalry—long life to his body and Peace to his soul—"Missie" and I have seen the burning words—we have got on to the fact and we tender our most serious congratulations to Mrs. Clark to whome all the credit is due.

There are men who stand so straight that they bend backwards and I imagine that the enlisted men of K troop say "Get on to his whiskers—is he in it."

Not being a family man— and with a full realization that I will be killed sooner than you I took the old lady to a quiet visit to the jug which contains the "bottled sun-light of 40 summers since," and we had a "ball" and I said "Here is to Mrs. Clark—to Mr. P. J. H. Clark and to Lieut. Clark, 10 Cavalry—with the whiskey in the heel of your hand sir—three fingers—standin up—

Frederic Remington

☐ *FREDERIC REMINGTON TO POWHATAN CLARKE*

New Rochelle
April 29 [1893]

Dear Clark— Hows "Jim"—I mean Jim Clark—or "Pow Junior" —what will the boys call him. And I hope Mrs. C. is well and she must be happy. You I suppose are stretching your hind leg—a little "kickey" as usual and if Cleveland ever gets his supporters in office why we may get a chance to talk with the Powers.

Got a picture of the Kaiser—autograph royal arms on frame— cunusseur uniform etc.—hows that —smoothe?

Jamming away on Cossacks—got to tackle the stinking Russian Jews[1] next and ought then to do dogs —"The Rise and Fall of the Russian Pup"—how would that do— little worse than Jews. How in hell is a man to create an interest in such loathsome coin loving puds as these. It makes me sigh for Hottentots. I am stuck on the Cossack[2]—He's a good game sport in his little unfashionable way—

1. Clarke married a cousin of Mark Twain. He and his wife had a baby while they were stationed at Custer, Montana.

1. "The Russian and His Jew" by Poultney Bigelow appeared in *Harper's Monthly*, March 1894, illustrated by Frederic Remington.
2. Probably his illustrations for Poultney Bigelow's article "The Cossack as a Cowboy, Soldier and Citizen," which would appear in *Harper's Monthly* in November 1894.

The Naval Reserve is all the go here—
havent seen anything though—I dont
mind being shot for my country or
"riding my tail sore" either but this
being drowned for it—not if your
"Uncle Samuel" is "*on*" at the time.

Sorry we could not have come to
Custer—Give my regards to the boys—
and to Madam—

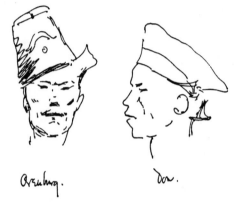

— Aureor.— Arzuhug. Don.

House is full of painters & paperers—fixing up—going to sell
out and make a home where I came from—raise horses—canoe
—be happy—

> Yours faithfully
> Frederic Remington

P.S. A page of "leg pulling" dedicated to you.—

☐ *FREDERIC REMINGTON TO POWHATAN CLARKE*

New Rochelle
May 17 [1893]

Dear Clark— Are these all right—if not why not.—

How can dragoons leave 100 horses when dismounted to fight
on foot—in charge of 10 men. —The Cossacks do it—we should—
by what system would you maneuver these led horses in line or
column—

I am studying this but it really needs experiment to elucidate—
When you tell me I will tell you my theory.—It would make a
good article for you in Cav. Journal. Dragoons mind you and
we dont want anything else.—

What is the matter with heavy stockings or British bandages—
short trousers & brown leather spatter dashers—

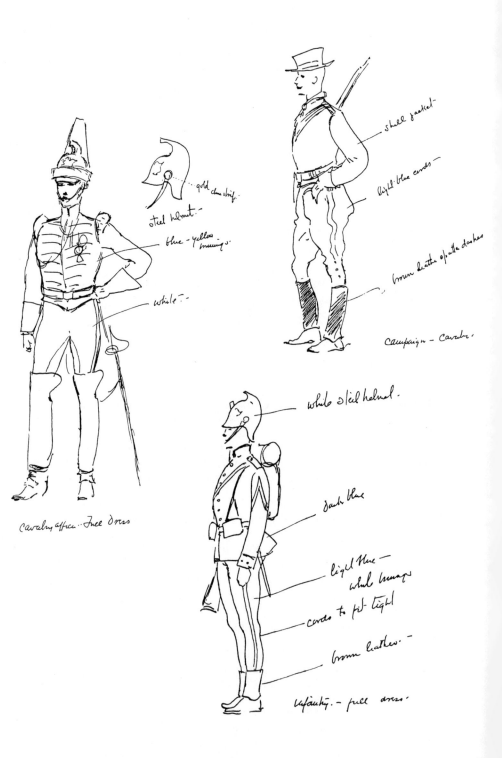

gold chin strap.

steel helmet.

blue - yellow
trimmings.

white.

Cavalry officer. Full Dress

shell jacket.

light blue cords

brown leather of the dashes

Campaign - Cavalry.

white steel helmet.

dark blue

light blue —
white lining
cords to fit tight

brown leather.

infantry. - full dress.

Why would not a silver steel helmet of the Roman pattern be good—too conspicious possibly but would not wear it as a campaigner.

Yours truly
Frederic Remington

☐ *FREDERIC REMINGTON TO POULTNEY BIGELOW*

New Rochelle
[May 1893]

Dear Bigelow: Just gotten your Russian Jews—will do something—it's d—— abstract though—"the dead line" etc. will go. Very interesting and dead right—make all the Moxies crazy and red in the face—but they can't get hunk with a white man 'cept quit lending them money—and we dont want money—hey old man. Never will be able to sell a picture to a Jew again—did sell one once. You can't glorify a Jew. I am a hero worshiper—corie "leving puds"—nasty humans—I've got some Winchesters and when the massacring begins which you speak of, I can get my share of 'em and whats more I will. Jews—injuns—Chinamen— Italians—Huns, the rubbish of the earth I hate—Our race is full of sentiment—we get to thinking so far ahead that we are not always practical and we invite the "Ruisins—the scourins and the Devils lavino" to come to us and be men—something they haven't been most of them—these hundreds of years. I don't care a d—— how a man gets to Heaven—how he takes care of his soul—whether he has one or not—it's all nothing to me but I do care how he votes and lives and fights and as sure as shooting we someday will reap the rewards of our humanitarianism— which is folly.

These Russians have none of that and despite the fact that we don't like them they will "get thar" and with both feet. They are fresh—vital—can stand starvation, cholera, bad govt., war— all the tests—they are conquerors, colonizers—they have abated the Jew and defy the world. I rather admire them. You will when you are 87 years old and if you don't drink more whiskey than you do you will live that long.

Regards to Mrs. B—Mrs. R. called on your people the other day and she is enthusiastic in their behalf. I am

Yours
Frederic Remington

☐ *FREDERIC REMINGTON TO POULTNEY BIGELOW*

New Rochelle
May 27 [1893]

My dear Bigelow: Got note—recon I won't tackle the Bohems—
I don't have any clearer idea of how a Bohem looks than a red
indian would. No doubt though it will be an interesting article.
This country is flooded with that trash. It is no longer the
America of our traditions but it's a good deal of cleaning after all.

I might come over to Europe if they don't have cholera in the
Fall but can't tell now. Have lots of work to do and am considering
a trip to the Flathead country.

How's the war coming on. Are they going to have one. "Side-
lights" comes out in the next Harper.

Yours truly
Frederic Remington

☐ *FREDERIC REMINGTON TO LT. POWHATAN CLARKE*

New Rochelle
June 12 [1893]

My dear Clark— There is at least one redeeming feature about
you—you know more as you get older.

I can see the defect in the Russian system—still they do it —
but with *times* guess we couldn't—and so we wont press that.

You are dead right on the simple uniform—dont want to dress
suit a Penna. malitiaman looks all right.

I am interested to know what you will say about *my Sun* article.[1]
I didn't get a "rise" out of any one. I had hoped I would. I hear a
lot of old tubs growl at me but they dont bark.

Miles is in favor of young blood but he is afraid of a cabal on
the part of the tubs and waits to keep all his portion masked. The
old man is a born fighter and a natural general—he has great
patience, perfect courage and he comprehends a situation—three
things they dont teach in West Point any more than they do in a
young ladies boarding school. He will come out on top and then
if you want anything done, he'll let you or any other man of
capascity.

I am thinking of going to the Kalispel country[2] with Julian

1. Remington wrote an article for the *New York Sun* defending Clarke's article
in the *New York Herald*, which was critical of the Army. Clarke's article was
excerpted in the *Army and Navy Journal* and he received a great deal of criticism
as well as a negative entry in his personal Army file.

2. Kalispell is in northwest Montana, near Glacier National Park.

Ralph this
fall—will stop
over at Custer
a day or two and
take a couple of
Kodacs of you.
Have been two days
yachting on Long
Island Sound—good
fun—fearfully burned
about the head and I wore
one of those d—— low necked
sailor shirts and cold cream set
me on fire. Wouldn't like to be
a sailor—you've got to catch 'em
young to make mariners of them.
Its like cavalrymen & cowboys.
We would like the pictures of
Mrs. C. & the future Commodore.
I expect to go North in August if I
can get through my work and canoe
for a while. Get on to the Dutch in the next Harpers Magazine.
Guess William[3] wont get his men for the army? Sorry 'cause think
he will need them.

Regards to Lieut. Jim while Mrs. R. joins me in best wishes for
Mrs. C. & yourself.

Yours
Frederic R——

☐ *FREDERIC REMINGTON TO LT. POWHATAN CLARKE*

New Rochelle
June 27 [1893]

Dear Clark: Got your documents—Its bold—Its brave—its
"truely bravo" but if you are sure of your ground you will raise
hell with the "tubs." My article[1] has been reprinted and much
commented on.

I wrote a long letter to Secty. Lamont and from what I can
learn he is going "to stir up the military dish with a spoon big
enough to reach the bottom."

As for Robertson—he's a d—— sight better soldier drunk than
any fellow who will come at me, is sober.

3. Emperor William II.

1. In the *New York Sun*.

A chap "Not a very old Fogy" gave me particular hell in the Army & Navy Register.[2] I replied "Anonimity is cowardice and unworthy of a soldier"—Is that a corker—well—I fight a duel with the gent—if he wants it that way. She's got to come. Miles is all right. Schofield is scared to death— he "has got a crack in his cervass" and he dont like to have people poking around it. Dont antagonize Merritt or any other of the "Corinthian class" for they will get it in for you. When you want to apparently be forceful be as foxy as you can—or some "smart fellow" will put twine on you—Pardon advice but its d—— good or I wouldn't give it.

If you go down I'll write you an obituary which will make the blood come right out of the faces of the fellows who jump you.

Got thrown off my big thoroughbred. He unloaded my Irishman & is in command of the situation. He can change ends a d—— sight quicker than a buz—saw and I find that I cant get my old 225 lbs. of tallow to keep up with him.

I'm coming out to see you this summer or Fall—Will your old Col. put me under arrest and telegraph Schofield "I've got him— what will I do with him?"

<div style="text-align: right">

Yours faithfully,
Frederic R

</div>

☐ LT. POWHATAN CLARKE TO FREDERIC REMINGTON

<div style="text-align: center">[undated]</div>

My dear Compadre: You are wasting your life—I am wasting glass plates. I wish you could be down here on the day we got in the fracass had about eight Majdalena Mexicans branding cattle— it was immense—some of the animals were corkers and more than one rope snapped. I never saw such pretty roping in my life—got some pictures but I fear they have foggers an we will get some even at the low "riders" [illegible]. The ponican [illegible] is one long lank "Texican" big rusty spurs, large hat and rusty face—you would give him a shiver [illegible] an hour for a pose and lull but he can swing his rope. I wish I could get his pony catching his cow by the neck with its white teeth to get a move on her the devil seemed to take such huge delight in chewing fresh raw hide but its supreme pleasure is when the critter is on the dead jump whip goes the rope—two turns round the pummel [illegible] and with a horse such the little boy lays back; the leather in the saddle creaks and the cinches moan, the cow stands on one horn but the cigarettes in the old "Tajouoas" mouth never quivers—his names's Jim Potter—the kid and I have been stretch-

2. *Army and Navy Journal.*

ing our eyebrows for an hour listening to Jim and another pictur-
esque old devil tell about the Lincoln County war. "It all started
about a wider 'woman' the the lawyer beat the dame out of ten
thousand insurance on her husband's life—her friends got an at-
tachment for the lawyer's cattle an in return he raised a fighten
party and we was both thar Jim and we" then follows the tales that
would knock the old—chevelier into the swelting pot. Jim is play-
ing hell on a scweekay old fiddle its no wonder he has to to so far
for his horses in the ummis [illegible]. My kid will surely have a
enlightman [illegible] if you dont let up on "Billy the kid" etc. You
ought to have been with us today—went to the Vineteria" —Clear
cool morning everything bright as gold—a springy pony —the
packer—my old sergeant and our Roper who you may recall;
Eleven miles in a hour over the hills and draws to wild pictur-
esque spot hidden in the hills a few miles from the line—then the
little patient burros even trotting in with their immense loads of
mescal plant to the great white piles—a few feet off four Yaquis[1]
are swinging their bright axes cutting and beating the cooked
plant into a pulp—its splendid stuff to eat rather sweet but nicely
flavored—them rows of rawhide vats where fermintation goes on
then a primitive still out of which the clear white liquid is pouring
into kegs then from the kegs to a little brown jug and then Wow!
damn the Fellowcraft Club[2] and Veuve Clifirot—we loaded our
canteens and some bottles then taking a start for our horses we
loaded ourselves *just a little* and struck for home while able—I
think the Adjutant General would have been scandalized to see
my dignified old Sergeant trying to preserve both gravities and
two bottles under each arm getting from his horse to our tent
while the festive scout sat on their hunches and encouraged him.
I fear that I will have to move if my scouts get in communication
with Yaquis for they do love "Tootpar" better than their soles. My
Ethiopeans[3] are having one hell of a pleasant evening and
though it might shock some of this stuff washed second to [letter
ends]

<div style="text-align:center">

Written By
Powhatan Clark

</div>

design for a cane head
10th Cav.-

1. Yaqui Indians of Sonora, Mexico.
2. New York club.
3. 10th (Negro) Cavalry.

*Powhatan Clarke accidentally drowned on July 21, 1893, while on
duty at Fort Custer. Remington wrote to Clarke's mother and father,
and later to Clarke's widow.*

☐ *FREDERIC REMINGTON TO MRS. CLARKE*

New Rochelle
Westchester Co. N.Y.
July 24 [1893]

My dear Mrs. Clark Missie and I were shocked to hear of Pow-
hattan—we cannot believe it—or have it so—It really seems so
improbable and we cannot get used to it.

We feel deeply for you in your bereavement and mourn the
loss of our old friend Clark more than I dare say.

We cannot imagine how it came to pass. Missie and I send love.

Frederic Remington

☐ *FREDERIC REMINGTON TO DR. CLARKE*

New Rochelle
Westchester Co. N.Y.
October 3, 1893

My dear Doctor: I have hardly had the heart to write of your
poor dead Powie before now and only feel impelled to say that as
much as you and your family must feel the loss of your proud
son, yet my wife and I are not yet at all reconciled to the loss
we feel.

I am doing what I can to help erect a memorial of some kind to
him—either at West Point or Leavenworth—I find petty jealousy
in the way but also much encouragement. The thing will be done
some way—some day—or I'll miss my guess.

I have tried to get Harper to publish his "letters to myself" but
hard times &c &c—it is useless—however I expect to serve them
up—second hand—if needs must—some day.

Clark was a fellow who appealed to my imagination—he was
also a good friend to me and I grew to be very very fond of him—
in fact he entered into my life to that extent that I can hardly
make it seem that I have got to get along without him. I know of
no soldier in the U.S.A. who can take his part—who has *verve*
and force and ability to act his part.

What a wonderful reputation he acquired in so short a time. I
have no doubt but if he could only have lived he would have been
a Great Man—and of necessity a great general or at least a great
cavalry leader. He had awful good judgement (to me the leading
attribute) of course perfect courage and was fitted by nature to
lead his favorite arm.—The loss to you is irreparable—seriously

I would give a leg if he could be restored and repeatedly I am assured by officers high in command that the Army can in no way afford the loss of him.

I cannot and never will be used to the idea that my friend Clark is dead—

<div align="center">Yours faithfully,
Frederic Remington</div>

P.S. "Missie" and I send love to Mrs. C.

☐ *FREDERIC REMINGTON TO MRS. POWHATAN CLARKE*

<div align="center">301 Webster Avenue
New Rochelle
Westchester Co. N.Y.
August 4 [1894]</div>

My dear Mrs. Clark, I have sold Powhattan's article—the M.S. of which was in my possession—"A Hot Trail"—to the Cosmopolitan Magazine—for $75—or thereabouts—$15 a thousand words. I am illustrating it for them and I don't know your address but if I can find it by this—I will send you the check as soon as it comes to me.—

I hope you are well and we often think of you. We hope to see you some time again. Poor old Clark—I will never get used to it and often feel as though I did not want any more friends—its so hard to get along without them.

<div align="center">Yours faithfully,
Frederic Remington</div>

☐ *FREDERIC REMINGTON TO MRS. POWHATAN CLARKE*

<div align="center">301 Webster Avenue
August 21 [1894]</div>

My dear Mrs. Clark, I have your reply to my address and we are very glad to hear from you—and the baby. I can't imagine him.

I will try to have the M.S. back but do not know the custom in those matters—it cannot be returned until after publication. I have put a good deal of work into the illustration of it and it will be a good number to keep for the *boy.*

We are well—I am a bad hand for news—but Mrs. R. will tell you how we are doing and I hope we may see you here or some-where in time.

<div align="center">Yours faithfully,
Frederic Remington</div>

P.S. When they send me the check I will forward it.

☐ *FREDERIC REMINGTON TO LT. ALVIN SYDENHAM*

New Rochelle
July 14 [1893]

Dear Sydenham— Fact is—guess your right— I have no business to masquerade as a moose hunter but it was the only photo I had and I was in fear of your wrath unless I did something to ease you off.

Clark is all right. He wont be court martialed and if he is it wont hurt much. He will do them all up yet—he should have the enthusiastic support of all who are not bed-ridden. I will never dare go on a military reservation again. They would lock me in the "clink" and telegraph Schofield "we've got him—what will we do with him." He would reply—"skin him alive—boil him in oil."

Yours faithfully,
Frederic Remington

☐ *FREDERIC REMINGTON TO LT. ALVIN SYDENHAM*

New Rochelle
[August 15, 1893]

Lieut. Alvin H. Sydenham Your note & M.S. & oil sketches are at hand. Will answer the letter—will consign the M.S. to a man who will do what he d—— pleases with them (Ed Har. Weekly) and will say that the young lady Miss Mccrea has every reason to be satisfied with herself. The drawings or studies are very faithful student work. They have a great deal of character and are rather truthful in color sense. They lack finish and subtlety which is like a 30 day note—it will come around in time.

There is a great big aching void in art for a painter who can do the Artillery. I had a nice commission to do some a while back and couldn't because I don't know the difference between a Krupp and a canionade and then to do artillery one must be able to paint nuts and bolts and the artist who can draw a wagon wheel would have to be a person who had no immortal soul.

Still human genius has no limits and a person will some day appear who can put sentiment into a gun carriage and make it look different from an advertisement for a wagon factory.

As to the American soldier— did you ever see a Cossack or a Hussar? Well you know what must become of a man who wear blue clothes. Look at these

[unsigned]

Prussian dragoon. Cossack.

☐ FREDERIC REMINGTON TO LT. ALVIN SYDENHAM

New Rochelle
September 24 [1893]

My dear Sydenham— Your note and the clipping at hand. I read
it and see nothing at all startling in it. There is a certain truth in
what the writer says but it looks as though he had loaded up for
elephants when the prospect was that snipe were abundant. He
lacks humer you know that there are a vast of people who can
never get higher than an agricultural report in their literary ap-
preciation and if a man must write down to them instead of up
to others we would all progress the wrong way.

Yours truly,
Frederic Remington

☐ FREDERIC REMINGTON TO LT. ALVIN SYDENHAM

New Rochelle
October 31 [1893]

My dear Sydenham I have sent your M.S. to Harper Bros. and
will be glad to illustrate it if taken. You see I can do nothing else—
as I never make illustrations unless for accepted M.S. there are
some eleven thousand reasons why this is so. You just fire anything
you write into the Editorial Dept. Harper and they are bound to
read it and act and there is no God in Israel for what M.S. they
"dont find available"

I feel deeply for your kind letter of some days ago. There is
only one trouble with me. I am poor and have to work hard. If
you want to write me up go ahead—so long as you are discreet
and do not stick too closely to the truth its good to do so.

Awfully hard pressed—so good bye—

Yours in haste
Frederic Remington

P.S. I am working for the Magazine & painting these days—I have
nothing to do with Columbus—

*Lt. Alvin Sydenham wrote a description of meeting Remington in
1890. It was published in the* Bulletin of the New York Public Li-
brary *in August 1940.*

☐ **FREDERIC REMINGTON**

By Lieutenant Alvin R. Sydenham U.S.A.

If in America there is one artist distinct among the rest for the
fact that his horses are drawn upon the paper full of life and vigor
and spirit and accurately moulded anatomy; whose soldiers are
dust grimed warriors as well as stalwart men; whose cow-boys pose
with all the true devil-may-care swagger of the prairies; whose In-
dians are wild, and stern-featured, and statuesque; that artist is
Frederic Remington.

And if among the rest there is one found to be possessed of that
intuitive sense of graphical expression which people call artistic ge-
nius; whose products are those of the development of his own in-
herent resources, and not laboriously wrought compositions from
models, toned into respectability by long instruction in the schools;
that one is indisputably Remington.

One glance at his work, whether you see it on the pages of Harp-
er's Weekly, in the magazines, among the pages of editions de luxe,
or dependent from the walls of the Academy of Fine Arts,—one
glance is sufficient to impress upon the eye his individuality and
vigor of expression. It is true that he does not portray the likeness
of a man's face with the admirable color and fidelity to detail that
people are accustomed to see in portraits by Carroll Beckwith and
Benoni Irwin; he pays little attention to landscapes and marine
views, and none at all to interiors and other urban prospects; but
wherever action, vigor, and animation are concerned he revels in
his proper element, and his figures start from the canvass with
a life and fullness that causes the unexpectant observer fairly to
stand aside while they dash by. Herds of buffalo charging madly at
the cut-bank chasm that yawns ahead, concealed by the bristling
sage brush; Indians urging their bare-backed ponies in the chase,
with muscles tense and lances poised overhead; grim, ragged caval-
rymen, astride of gaunt, hungry-eyed horses, climbing wearily to
the mountain trail after renegade Apaches in a chase so stern and
unyielding that it knows not the name of rest; fields of the dead,
transfixed with arrows, and of the living dashing, madly in vic-
torious pursuit —such are the scenes which he alone has painted
before the eye of the public. He has brought them out of the heart
of the wilderness, and has written them on the pages of our history
in the language of lines and shadows. In a few years they would

have been known no more, and without him would have been forever forgotten.

He has gone out over the frozen snows into the pine-grown wastes of Northern Canada, the land of the Northwest Fur Company, and has returned to educate us with pictures of the French half-breed Indian in his native forests, and with the haunts of the moose and caribou. He has sweltered in the dust and heat of southern Arizona, where the luxuries of life fade into salt pork and hard bread, and the water is full of mud and monsters and alkali; and yet comes cheerfully back to paint the native Tonto on his trail, and the Apache in the act of lifting scalps. Again we find him mounted on a Cayuse pony clad in furs penetrating the heart of the bad-lands; and in a few days we have before our eyes the ghost-dance—not an imaginary sketch, but a genuine production—with all the gruesome concomitants of ghost dances, slaughtered Indians, and dead cavalryman. The cowboy shelters and feeds him, and helps him on his way, and thus we know how the cowboy looks, and feels, and swears. Even how he is in the cold heart of Russia with Poultney Bigelow braving the insults of a superstitious peasantry and the arrogance of the frontier police, trying to find out for us what it is to be a Russian, with famines, and Cossacks and Jewish oppressions, hatred of the Czar, and preparations for war. Such is his life work; such he has done and such he is to do. He paints not what you may see every day for your self if you drift along in the even tenor of life with your eyes wide open; but rather those striking features that dwell in far places, hidden and untrodden by the feet of ordinary men; those thrilling actions that exist only a moment and then pass away never to occur again, rarely caught by the dull eye of the multitude that behold them.

One thing peculiar to his drawings is the absence of detail of background. The figures stand out upon the page, and the eye is not distracted by painfully wrought foliage and blunt cliffs. Only the figure fills the eye; the background is open, dim, evanescent; just as it becomes when we fix our eye upon an object and the background fades, because the lens has ceased to focus upon it. This perhaps is the trick which gives the figure what appears to be aggressive life. We must look at it whether we will or no, for there is nothing else to look at. It is like the lines of beauty in nude sculpture, which because destitute of color, and background, and raiment, we are forced to regard attentively for lack of other features to check the eye.

The prudent biographer waits until his hero is dead before he unveils his life to the scrutiny of the world, and persons who write biographically are obliged to conform to this wise caution. There is little in the private life of a public man which the public has a right to know, providing he obeys the laws and keeps out of politics. Our curiosity is rarely excited by the lives of ordinary citizens. But with

artists whose pictures attract our attention from time to time, and with writers whose thoughts we appreciate so much as to adopt them as our own, the case is different. We are curious to know in what respect they are different from ourselves, in their appearance habits, manners, and personal character. Some of their peculiarities we may learn if we are fortune to meet them, or to meet some one who has met them; but if we read about them in the pages of current literature we must be satisfied to learn only what is seen by people with whom they come in contact in the course of their daily lives. Confidences, personal relations, and the criticisms of intimate friends, are as much forbidden to the printed page as are the sentiments of private correspondence. The records of the press deal only with the public and not with the private relations of men.

Therefore I feel that some apology is due for writing of Mr. Remington, and that it will profit me to invite attention to the fact that as he has not yet visited the Pacific Coast where these notes appear, he may never, without them, become known to some people. Then, too, he is at present buried in the heart of the Czar's empire; consequently he is sufficiently dead for the purpose at hand.

My first personal introduction to him took place on the dusty, alkaline banks of the Tongue river, among the Montana foot-hills of the Big Horn mountains, to which place Mr. Remington had penetrated in company with General Miles and an Indian Commission. The Cheyennes not being content with the proportions of the government ration, had taken to their usual diplomatic method of enforcing adjustment by going out into the timber and killing a few citizens together with divers of their choicest beeves; wherefore it became necessary to send the usual commission to reason with them. Mr. Remington recognized the opportunity and accompanied the expedition.

We first became aware of his existence in camp by the unusual spectacle of a fat citizen dismounting from a tall troop horse at the head of a column of cavalry. The horse was glad to get rid of him, for he could not have trained down to two hundred pounds in less than a month of cross country riding on a hot trail. Smoother down over his closely shaven head was a little soft hat rolled up a trifle at the edges so as not to convey quite that barren impression which you get from inspecting the head of a Japanese priest. Tending still more to impress the observer with the idea of rotundity and specific gravity was a brown canvas hunting coat whose generous proportions and many swelling pockets extended laterally, with a gentle downward slope to the front and rear, like the protecting expanse of a brown cotton umbrella. And below, in strange contrast with the above, he wore closely fitting black riding breeches of Bedford cord, reenforced with dressed kid, and shapely riding boots of the Prussian pattern, set off by a pair of long shanked English spurs.

As he ambled toward camp there was abundant opportunity to

study his figure and physiognomy. His gait was an easy graceful waddle that conveyed a general idea of comfortable indifference to appearances and abundant leisure. But his face, although hidden for the time behind the smoking remainder of an amole cigar, was his most reassuring and fetching feature. Smooth face, fair complexion, blue eyes, light hair,—would probably have been his facial description if he were badly wanted any place by telegraph. A big, good-natured, overgrown boy,—a fellow you could not fail to like the first time you saw him,—that was the way he appeared to us.

By his side a tall, cadaverous Indian Commissioner shambled along. My first lieutenant essayed the formality of an introduction, but his effort was not destined to meet with the usual success. Mr. Remington shook my hand vigorously.

"Sorry to meet you, Mr. Sydenham. I don't like second lieutenants—never did. Captains are my style of people— they land me horses. Eh? Yes. Where do you live? Well, don't care if I do," And thus we met. Notwithstanding his acknowledged prediliction for captains, commissioners, and generals, we occupied the dust at the rear of the column in company several times after that.

During evening we wandered among the tents of the commissioners and the aids, trying to get acquainted, and partaking of the government ration, and of the strong water which does not bubble out of the rocks at the foot of the pines. Casey came in with his scouts after the moon rose. The little Indian ponies could not keep up with the big horses of the cavalry, and in the sixty-five mile march of that day they were left far to the rear. Which caused Mr. Remington to observe, as he looked at the moon:

"They say an infantryman can't keep up with a cavalryman, but General Miles is an infantryman and he came into camp to-night half an hour ahead of that cavalry troop."

The General appeared to be proud also, but the cavalrymen noticed that he "didn't feel like sitting down" that evening, and much thoughtful walking around with his hands in his pockets, and a cigar in his mouth, appeared to harmonize better with his post-prandial meditations.

Without noticing this first meeting with much detail, it is enough to state that in the interests of the world I watched this fat artist very closely to see "how he did it." My stock of artistic information was as great when he went away as it was before he arrived. There was no technique, no "shop," about anything that he did. No pencils, no note-books, no "kodak,"—nothing, indeed, but his big blue eyes rolling around at everything and into all sorts of queer places. Now and then an orderly would ride by, or a scout dash up in front of the commanding officer's tent. Then I would see him look intently for a moment with his eyes half closed,—only a moment, and it gave me the impression that perhaps he was a trifle near-sighted.

One morning, just as the grey of dawn was about to brighten the

east, there was a prolonged scratching upon the fly of our Sibley tent. It awoke the ever watchful captain; the captain kicked the first lieutenant; and the first lieutenant took it out of the deeply slumbering subaltern.

"Who's there?" growled the captain.

"It's me." The voice was Remington's.

"What do you want?"

Breakfast." was the laconic response.

"It's too early for breakfast; you had better go back to bed," and the captain rolled over to his slumbers.

"Well, can't you give a fellow a cavalryman's breakfast, anyhow," pleaded Remington.

"What's that, old man?" I ventured on my own account out of the depths of my bed sack.

"A drink of whiskey and a cigarette."

"Ah-h-h! certainly!" After which he went away happy. But I could not see the logical side of his matutinal demand until the sentinel at the picket line informed me at reveille that, "The fat gentleman as was sleeping with the general was roaming around among the horses since daybreak, sir; and I didn't challenge him because I seen him talkin' at your tent, sir."

Two weeks later everyone saw the chief features of that Cheyenne Commission in Harper's Weekly, and the world learned how badly we had treated the fat staff artist. I only refer to the matter again by way of challenge to any artist who can take a week's with a column of soldiers, and then reproduce the same again as faithfully in black and white as did Mr. Remington on that occasion.

Not many months ago I met him in the Grand Hotel in New York City. His crowning glory was a tall silk hat that took the place of the skull cap; and a dark blue top coat of graceful model occupied the position formerly filled with credit by the expansive garment of brown canvas before alluded to. Tan kid gloves, patent leather shoes, and a portly stick with a buckhorn handle combined their effect to enforce the disguise; but in vain, for nothing could hide his broad good-natured face and laughing blue eyes. He wanted to know something more about saddles and stirrups and curb bits. He wondered if I had heard the Indians didn't hit him the day he rode into their advance guard in the bad lands. As far as I could see he was different only in the surface covering from the weighty party who had descended from the horse at the head of the troop that day on the Tongue river. The next day I watched him spread India ink and pencil marks over a piece of academy board that afterward challenged admiration as a full page illustration of Garza's minions on a raid into Mexico.

Whether you meet him on a bony troop horse jogging along a mountain trail, or astride a well fed hunter taking the hedges of the Rosetree Hunt, you are forced to admit that he understands the

horse and how to ride it; and this knowledge is not more the result of training than of a natural sincere love of the animal. Those in his own stable are of the kind you are familiar with in his pictures,—fiery, long-limbed, striding roadsters. One day as we were starting for a ride on the road he said, patting one of them on the flank, "I know the shape of every muscle in his body."

Among men he has the faculty of accommodating himself to circumstances, and he never is less at home on the floor of a teepee with a dozen ragged Indians elbowing him about, than he is when you meet him among the distinguished Americans of the Players Club. Always easy, always natural, he does not aspire to transfix the heart of those who meet him with the idea that he is a man among men. Yet for all that, unless their perceptions are very much dulled, they will not be slow in finding it out. His manners are somewhat blunt, and fully characteristic of that personality which we perceive in what he writes and paints; yet they never lack urbanity or consideration for the opposite party; so much that an Englishman would say he is a Philadelphian. Yet he is not.

He lives not farther than thirty miles from New York City in Westchester County, in a tasteful villa of his own which he calls "Endion." Here he enjoys his dogs and his horses, his easels and brushes, and the companionship of a charming wife. Here he hides away from the enviable publicity which his work has forced upon him, and industriously gives himself up to "making thoughts for sale."

Besides the regular staff work he does for Harper's Weekly, he is engaged in illustrating a new edition of the works of Francis Parkman, so that hereafter the heroes of the plains whose memories live in those pages will be immortal in figure and form as well as in words. Occasionally he steals time to complete a canvas, but his profession properly forbids any work but black and white. Last winter one of his large canvases,—the picture of a troop of cavalry coming left front into line of battle,—hung in the Academy of Fine Arts in Philadelphia.

Those who know him wonder greatly that he never perfected his art in the schools. While at Yale College he attended the art classes for a few months, and later still worked briefly at the Art Student's League in New York, but he added little to his faculty thereby. As he says, "They taught nothing there that I needed to know." His methods are as original as his productions. He is a born artist and that is all you can make of him.

His first work came before the public in 1885, when he illustrated a series of western stories by Theodore Roosevelt for Scribner's Magazine. It was a pronounced success. Since that time everyone is familiar with what he has done. When no literary correspondent accompanies him on his trips he furnishes the notes himself, and his style is at once clear, satirical, and humorous. His notes are as interesting as his drawings, but as many can write where only a few

can draw, he chooses to climb to greatness by means of the pencil and brush rather than the pen.

It is because he is preeminently a soldier's artist that I presume to offer these few lines concerning him. Stephen Bonsal has been introduced to the public as a newspaper man's man. Rudyard Kipling is certainly a soldier's author. Similarly Frederic Remington is a soldier's artist, and the world is learning so to regard him. There was at one time another American artist who might have laid claim to this distinction, namely Mr. Rufus Zogbaum; but he defected and went over to the side of them that go down to the sea in ships. Now he paints war vessels, and jack tars, and heavy guns; so we are unable to do more at present than to thank him for past considerations.

Let those who hereafter look upon his horses and his Indians and his soldiers remember that they are the creations of a young American born no longer ago than the Civil War, who paints them because he loves and feels the wild strange scenes they represent. And let these lines bear witness that he is not unhonored among those whom he has contributed so much to honor.

Chapter 4
Getting to See a War
1894–1899

I N THE TWENTY YEARS BETWEEN 1870 AND 1890, the American
people were concerned almost exclusively with domestic rather
than foreign affairs. Their efforts were concentrated on recon-
structing the South, settling the last frontier, dealing with the In-
dians, and building a network of railroads to undergird the devel-
oping industrial system. Frederic Remington had found a role for
himself in this period as a chronicler of these events, particularly
those relating to the Indian wars in the West. He was also begin-
ning to develop a position for himself as a spokesman on military
matters. The Army fascinated Remington, as it always had, but he
was now in a unique position. He had traveled with the troops in
the West and knew their concerns; he was outspoken and he had a
forum now in the articles he wrote as well as illustrated for maga-
zines such as *Harper's Weekly*.

With the vast citizen armies of the Civil War disbanded, the gov-
ernment relied on a small regular army that averaged 25,000 men.
After 1865, the only major enemies faced by Americans were na-
tive Americans on the western plains and mountains. From scat-
tered frontier outposts the Army policed the Indians, and when
necessary fought them. The small commands were well disciplined
and led, but not well organized and trained "for the purpose of
war." The peacetime organizational plan for the Army called for
one general, one lieutenant general, five major generals, and ten
brigadiers. There were to be ten regiments of cavalry, five of artil-
lery, and forty-five of infantry. This limited the number of commis-
sions that could be granted and made jockeying for promotions
common. One had to stay on track to make the rank of general. At
the top, the Army organization had three main elements: the secre-

tary of war, the commanding general, and the general staff or bureau chiefs. All competed with one another. The commanding general tried to exert supervisory authority over the staff, who not only denied his authority but would accept only loose supervision from the secretary of war, considering themselves subject only to the president and Congress. The commanding general was usually the senior officer with the greatest reputation, and he held office for the duration of his career. The bureau officers often had made their careers in Washington. Each group considered the others out of touch. In addition to the regular army there were voluntary militia units in many states called the National Guard. Most states thought of them as useful for suppressing strikes or other domestic disturbances, but not to fight foreign enemies.

The Army itself had several divisions within the United States. There were divisions of the Atlantic, the Pacific, and the Missouri, with departments within the divisions, e.g., Department of the East, Department of Arizona, Department of Dakota. Commands on this level put the officer in the public eye and provided opportunities for currying political favors. Battle heroes were regularly rewarded with promotions. Officers therefore sought posts on the front lines that might engender publicity and public visibility. Others took advantage of every political opportunity they could. If a Frederic Remington, or anyone else, could be induced to put in a good word with his Washington contacts, fine. If a Frederic Remington could be induced to write an illustrated article favorable to a particular officer's exploits, so much the better. Officers sought every advantage to get credit for victories, gain a combat command, or be personally attached to a general's staff. Politicking was rampant.

Interestingly, however, there was not a great deal of public concern about the state of affairs in the Army during this period. There was no immediate danger that called for land troops. The Navy was considered to be the first real line of defense. It had expanded rapidly after the Civil War and by 1898 was the sixth largest in the world. When Theodore Roosevelt became assistant secretary of the Navy in 1897, he was justifiably proud of his "White Squadron" and invited Remington to Washington to show off the fleet. It was only after the Spanish-American War was over that the massive breakdown in Army mobilization and supply and weaknesses in strategic planning became known; in 1899, Secretary of War Ehihu Root undertook reforms.

By the 1890s, Remington was also looking for "a new war." When he went to Europe with Poultney Bigelow in 1892, it was partly for the opportunity it offered to record details of army life there. When he wrote to Bigelow after the trip (see chapter 3), he referred again and again to the possibilities of war in Europe, hoping he might be able to witness a major European campaign.

Meanwhile, at home, there were new matters involving the military in the news. When the Pullman strike broke out in 1894, the railroad operators took the then unusual step of bypassing Illinois Governor Altgeld and requesting that the national government send regular army troops to end the strike. President Cleveland, using the argument that the railroads were necessary to keep the mails moving, ordered 2,000 troops to the Chicago area. The food supply in the city was dwindling. Bridges were dynamited. Stations were burned and men stoned and beaten. Rails were torn up. Remington covered the event for *Harper's Weekly*. He knew General Miles and members of the Seventh Cavalry and visited with troops bivouacked on the lakefront in front of the Auditorium Hotel. Three illustrated articles in *Harper's Weekly* resulted: "Chicago Under the Mob" on July 21, 1894; "Chicago Under the Law" on July 28, 1894; and "The Withdrawal of the U.S. Troops" on August 11, 1894.

Events like the Pullman strike cast new roles for military officers as maintainers of domestic order, and Remington made the irony apparent when he did a full-page illustration for the third of his articles and titled it "Watering the Texas Horses of the Third Cavalry in Lake Michigan."

Seeking to understand the new trends, he visited the headquarters of the Pennsylvania National Guard and collaborated with Owen Wister on an article for the September 1, 1894, *Harper's Weekly* about that military group. Later in the fall, Harper's published an illustrated article by Remington titled "A New Infantry Equipment" and some additional Remington illustrations related to the military.

Frederick Jackson Turner stated in 1893 that the ending of the American frontier had closed a period of American history. What was gone was Remington's West, the one he had loved and painted. While right in sensing that one form of expansionism had disappeared, Jackson was not taking into account the fact that a new Manifest Destiny, in the form of imperialism, was about to take its place. The 1890s were to resemble the 1840s as years when the augmentation of American territory and power became predominant motives shaping political and military decisions.

An increasing interest in acquiring foreign advantages and naval defense outposts led to American influence on the Pacific islands of Hawaii and Samoa. In the Caribbean, both Cuba and Puerto Rico were considered important for defense, and American interests had become deeply involved in the Cuban sugar trade. The two islands constituted just about all that was left of Spain's once extensive Latin-American empire. By 1895, Cubans were increasingly restive under Spanish rule. The Spanish, in an attempt to suppress the growing insurrection, sent Gen. Valeriano Weyler to Cuba. He ordered the entire civilian population of certain areas herded into

concentration camps where they, not surprisingly, died by the thousands. These and other stories of atrocities growing out of his command earned him the nickname the Butcher.

Meanwhile, William Randolph Hearst had purchased a daily newspaper, the *New York Journal,* in September 1895. Hearst's journalistic aggressiveness immediately created a circulation war with the established *New York World,* owned by Joseph Pulitzer. Hiring the brightest journalists money could buy, Hearst put the emphasis on news of crime, disasters, and scandal, liberally using illustrated feature material.

Remington was also interested in the Cuban situation, but from a potential war correspondent's point of view. His drawing "The Flag of Cuba: Insurgent Cavalry Drawn up for the Charge" had appeared in *Harper's Weekly* on March 7, 1896. Although Remington had not recently traveled in Cuba, he had passed through the country in the late 1880s.

In December 1896, Hearst commissioned Remington and Richard Harding Davis, the suave, well-dressed journalist, fiction and travel writer, and editor of *Harper's Weekly,* to cover the situation in Cuba. They were supposed to go on Hearst's fast steam yacht, the *Vamoose,* but after many delays ended up on a regular passenger vessel, the *Olivette,* to Havana. The *Journal* announced their going in a full-page spread on January 17, 1897. Spain, not at war with the United States, was reluctant to let Americans get too close to the scene, but Remington was able to interview General Weyler and found conditions deplorable. Even the Spanish troops were ill-fed. Remington, restless at the lack of action, soon returned home on the *Olivette* while Davis got a pass from General Weyler, went to some of the western provinces, and returned later. Two notorious pieces of journalistic history arose from this trip. The first is the famous exchange between Remington and Hearst. James Creelman, one of the *Journal's* top reporters, wrote in his reminiscences, *On the Great Highway* (1901), that Remington wired the following to Hearst: "Everything is quiet. There is no trouble. There will be no war. I wish to return." Hearst is said to have wired back, "Please remain. You furnish the pictures and I'll furnish the war." There is some indication that Remington had already left. The first Remington sketches appeared in the *Journal* on January 24, 1897. They took up all the first page and most of the second. The third page was devoted to a single drawing with the following caption, in part, by Remington at the bottom:

> The acts of terrible savages, or irregular troops called "guerillas" employed by the Spanish, pass all understanding by civilized man. The American Indian was never guilty of the monstrous crimes they commit. . . .

On February 12, 1897, the *Journal* printed an article by Richard Harding Davis that included a story about the searching of women on board ship, written after he returned from Cuba on the *Olivette*. The article included a five-column sketch of a young woman with a bare backside surrounded by three Spaniards, drawn by Remington, although he did not witness the incident. The article and drawing poured fuel on the war flames and stirred the warlike instincts already growing in the United States. It was one of the most sensational articles of the period. Though the incident was later determined to have been unfounded and had to be retracted, it was too late to correct the image of atrocities growing in the mind of the American public.

Remington spent the summer of 1897 at Cranberry Lake in the Adirondacks while Cuban tensions mounted. Hearst pushed on vigorously with his war-making propaganda. The Davis-Remington article and an Easter Sunday supplement to the April 11, 1897, issue of the *Journal*, with four full pages of Remington drawings of Spanish cruelty, put Hearst way out ahead in his private circulation war with Pulitzer and the *World*.

Remington's old friend Gen. Nelson A. Miles, by then commanding general of the U.S. Army, worried about United States readiness to participate in a war abroad. He had observed the Greco-Turkish War and had visited Russia and Germany in 1897. Miles was not moved by the war hysteria over Cuba. But he was in the minority. Richard Harding Davis, for example, followed up his trip to Cuba with the publication of a book early in 1898 called *Cuba in War Time*, an exposé of deplorable conditions that helped galvanize the growing sentiment that the United States had to intervene to save thousands of innocent lives.

The sinking of the battleship *Maine* on February 15, 1898, in Havana harbor was the catalyst needed to push President McKinley and the Congress into war, although the formal declaration did not occur until April 21, 1898. Remington, when told by his neighbor Augustus Thomas of the sinking of the *Maine*, contacted magazine publishers immediately. On March 26, 1898, the cover of *Harper's Weekly* carried his drawings of the recruits at Fort Slocum, Long Island, titled "A First Lesson in the Art of War." On April 2, the same magazine had a full-page drawing of "Maj. Gen. Nelson A. Miles U.S.A. Inspecting the Defenses of New York" and also an illustrated article by Remington, "The Training of Cavalry." Between April 26 and June 12, Remington's drawings appeared in the *New York Journal* on eleven occasions.

General Miles, succumbing to the inevitability of war with Spain, found Russell Alexander Alger, then secretary of war, an impossible superior. The pressures from Secretary of the Navy John D. Long, his deputy, Theodore Roosevelt, Col. Leonard Wood, and Senator Henry Cabot Lodge made armed combat inevitable, but

Miles thought a naval blockade of Cuba was essential while American troops were being trained and equipped. Since an invasion of Cuba was anticipated, volunteers would be needed to supplement regular army troops. Some new regiments sprung up as patriotic men raced to join the action. Wood and Roosevelt (who had by then resigned from his post as deputy to the secretary of the Navy) organized the Rough Riders, an interesting combination of New Yorkers and cowboys from the Southwest. Miles was sure the army was not ready and that there would be more volunteers than equipment. He also had the audacity to suggest to his superiors that Puerto Rico, not Cuba, receive top priority as the location of the first strike. Secretary of War Alger selected his Michigan companion, Gen. William Shafter, to head the American expedition to Cuba, and ignored and bypassed Miles when he could.

By April 1898, Remington was back to Key West, this time on commission, not only for the *Journal* but for *Harper's* and the *New York Tribune* as well. He managed to get a berth on the battleship *Iowa,* captained by "Fighting Bob" Evans, when the fleet moved out to blockade Cuba on April 22. He was not too happy. One bright spot was the friendship he established with Dr. Percy Crandell, a naval surgeon on board. As the only correspondent on the ship, he had to write as well as illustrate his own articles. "Wigwags from the Blockade" appeared in the May 14, 1898, *Harper's Weekly.* A second untitled article about the *Iowa* appeared in the book *Cuba at a Glance,* published in 1898. After seven days on board this "iron island," Remington transferred to the torpedo boat *Cushing* for passage to the *New York,* hoping for more company and more action. On May 1, the *New York* left the blockade at Havana and returned to Key West, where the captain ordered all reporters and artists off, including Remington, Richard Harding Davis, Rufus Zogbaum, and Stephen Bonsal. The orders had come from Secretary of the Navy John D. Long. What followed has been called the "rocking chair" period of the war, as reporters marked time sitting around on the porch of the Tampa Bay Hotel with the likes of John Jacob Astor, Clara Barton, and several notable generals. During this time Remington and the others conversed freely about the impending invasion. Remington sensed the agony of the "before-the-conflict" period and wrote "War Dreams," a satire, for *Harper's Weekly,* which appeared on May 7, 1898, and "Soldiers Who Cry," a sketch of army life in drab days, which appeared in the same magazine on May 21. He did illustrations of regular troops at Port Tampa, colored troops of the Ninth U.S. Cavalry, correspondents, and notable general officers. They duly appeared in *Harper's Weekly* in consecutive issues: May 21, May 28, June 4, June 11, and June 18. There was nothing to write about. He returned briefly to Endion, his New Rochelle home, sometime in May.

While Remington and the others were passing their time in this fashion, General Miles went to Tampa to find the chaos he dreaded most. General Shafter was organizing the expedition to invade Cuba at Santiago. Correspondents were permitted to go along wherever they could find berths; no separate press boats were permitted. Remington was lucky enough to find a spot on Shafter's command ship, the *Seguranca,* along with six other correspondents—Richard Harding Davis, Caspar Whitney, Stephen Bonsal, Frank Norris, F. J. Archibald, and Arthur H. Lee, a British military attaché. After several false starts they were underway by June 14. On June 20, the American force that was to take Santiago arrived near Daiquiri. Shafter let Davis, Bonsal, Whitney, and Remington go ashore with him for a strategy session with Garcia, the rebel leader, and Admiral William T. Sampson of the naval fleet that was already stationed outside Santiago harbor, but he did not then permit the correspondents to land with the first waves of troops. When they were finally allowed to go, Remington hit the beach with the Sixth Cavalry and camped with them overnight. He predicted, correctly, that the heat would force the men to shed their burdensome packs, strip themselves of their heavy uniforms, and leave their blankets behind. Following the troops as best he could, he witnessed the action from close up and afar. The correspondents suffered with the soldiers, marching and camping with them, composing stories in the rain and slogging back to get them aboard dispatch boats. But some of their problems were their own. Most of them had no war experience, proper clothing, or camping equipment. Remington was better prepared than many though not as physically fit. But he was back in his element, recording gallant, heroic deeds. Remington was able to obtain a horse, purchasing it from an invalid officer, which gave him a little more mobility. His article "With the Fifth Corps," which appeared in *Harper's Monthly* in November 1898, contains his account of the Santiago campaign and encounters with the enemy at Las Guassimas, Siboney, El Caney, El Pozo, and San Juan. The bravery of the Rough Riders and the other troops was highlighted. The effects of wartime conditions on men, mules, and horses were described in vivid detail. Opening the article is this paragraph:

> I approached the subject of the Santiago campaign with awe, since the ablest correspondents in the country were all there, and they wore out lead-pencils most industriously. I know I cannot add to the facts, but I remember my own emotions, which were numerous, interesting, and on the whole, not pleasant. I am as yet unable to decide whether sleeping in a mud puddle, the confinement of a troop ship, or being shot at is the worst. They are irritating, and when done on an empty stomach, with the object of improving one's mind, they are extravagantly expensive. However, they satisfied a life of longing to see men do the greatest thing which men are called to do.

Remington had experienced not only the heat but the fever; he visited the field hospital near the San Juan River but did not have to be confined there. He was nearby but not in viewing distance when the Americans went up San Juan Hill, the last of the attacks made in an attempt to soften up Spanish defenses so that the Navy could take control of Santiago harbor. His famous painting of Theodore Roosevelt leading the charge had its origin that day, but there is real doubt that the event occurred the way he pictured it. His friendship with Roosevelt was cemented, however, when the Rough Rider troops gave Roosevelt a Remington bronze, *The Bronco Buster,* at the time of their mustering out at Camp Wikoff in Montauk, Long Island, on September 15, 1898.

The defeat of the Spanish was swift. General Miles returned to Cuba at McKinley's request, and his presence got Shafter moving. Santiago was surrendered to the Americans on July 17. The naval victory that Commodore Dewey had achieved in Manila Bay in the Philippine Islands on April 20, plus General Miles's triumphant but belated march through Puerto Rico on July 25, brought an end to the hostilities with Spain on August 12, 1898.

On February 11, 1899, Remington returned to Cuba as a special correspondent for *Collier's* with his pen, ink, and brush. Although his assignment had been to cover activities of the occupation army, he found himself looking more at the Cuban people and the effects of the war on them. "Havana Under the Regulars" appeared in the April 1, 1899, issue of *Collier's*, "Under Which King" in the April 8 issue, and other sketches in the April 15 and 22 and June 3 issues. After an interview arranged by correspondent Sylvester Scovel, a friend of General Gomez, with a native Cuban displaced by the war, Remington wrote and illustrated "The Sorrows of Don Thomas Pidal, Reconcentrado" for *Harper's Monthly*. It appeared in the August 1899 issue.

Remington had finally found his war, and in the reporting of it dispatched a lifelong dream.

It is interesting to speculate about whether it was what he expected. In the article for *Harper's Monthly,* "With the Fifth Corps," his main treatise on his war experience, Remington said, "I could hear noises such as you can make if you strike quickly with a small walking stick at a very few green leaves. Some of them were very near and the others more faint. They were the Mausers, and out in front through the jungle I could hear what sounded like a Fourth of July morning, when the boys are setting off their crackers. It struck me as new, strange, almost uncanny, because I wanted the roar of battle, which same I never did find. . . . The modern soldier . . . may go through a war, be in a dozen battles, and survive a dozen wounds without seeing an enemy." As to the role of the correspondent, he compared it to a soldier's role, saying that there was a difference in the point of view. "One has his duties, his re-

sponsibilities or his gun, and he is on the firing line under great excitement, with his reputation at stake. The other stalks through the middle distance, seeing the fight and its immediate results, the wounded. . . . he will share no glory; he has only the responsibility of seeing clearly what he must tell; and he must keep his nerve. I think the soldier sleeps better nights."

Gen. Nelson A. Miles, who in September 1895 became commanding general of the Army, was one of Remington's most important military contacts, both in the field and in Washington. Their friendship, which began in 1886, lasted until Remington's death in 1909. Remington had already written and illustrated several articles favorable to Miles. With Remington established as an illustrator and perceived by Miles to have influence, Miles did not hesitate to ask Remington to intervene for him. For Remington, Miles represented, as he always had, official access to the Army.

☐ *NELSON A. MILES TO FREDERIC REMINGTON*

Confidential

Chicago, Ill., July 25, 1893

My dear Mr. Remington: I am much interested in the article in Harper's Magazine in which you illustrated the Prussian Army.[1]

I do not know just what your relations are with Secretary Lamont, but if they are intimate and friendly, I hope you will have a conversation with him soon concerning the reported reestablishment of divisions. The changes, innovations, and modifications that have been made in the Army during the last few years seem to me to be in the wrong direction, and I believe that they have discouraged the officers as well as the enlisted men. Some have taken form by positive legislation like the bill that was passed last year prohibiting a private soldier who is over thirty five years of age, or who has served ten years, from reenlisting, no matter how heroic a soldier he may have been, or how many battle scars he may carry. Thus the country is deprived of the services of experienced veteran soldiers.

The divisions that had existed for more than twenty five years were broken up, about the time we were in Mexico, and now it is said that General Schofield[2] is urging the reestablishment of divisions entirely different (if reports are true), from anything that

1. "Sidelights on the German Soldier" by Poultney Bigelow appeared in *Harper's Monthly*, July 1893.
2. Gen. John McAllister Schofield.

has heretofore existed. For nearly forty years New York has been the headquarters of the senior in rank to the General commanding the Army, and for twenty five years New York and Chicago have been the headquarters of the second and third ranking officers of the Army. Now reports say it is proposed to establish divisions with the headquarters of one somewhere south, either in Louisville or Columbus Barracks, and the other at Omaha, Nebraska, and it is proposed to move Major General Howard[3] and myself to these stations, and I presume New York and Chicago to be occupied by favorite Brigadiers for Department headquarters. There can be no military reason or good administration in such a change, and it appears to be purely in the interest of one person.

I hope that the President and the Secretary of War will not commit themselves to any such policy; in fact I hope you will ask the Secretary of War not to make any important changes in the Army until he has had time to consult with other men besides those who are stationed in Washington.

Under the present law General Howard will retire in a year from November, and if there is going to be any changes in the assignment of general officers that would be a favorable time for any general change.

I was in hopes I should see the Secretary when he was in Chicago, but he was only here a day or two and returned before I had an opportunity of seeing him. I was obliged to be in St. Paul during that week.

Please let me know what he says about these matters, and you will greatly oblige,

<div style="text-align: right">Very truly yours,
Nelson A. Miles</div>

☐ NELSON A. MILES TO FREDERIC REMINGTON

<div style="text-align: center">Governors Island
New York
June 25, 1895</div>

My dear Mr. Remington: I have read with much pleasure your article in Harpers' magazine concerning our hunt last autumn[1] and your descriptive powers are certainly very good. I think you will in time develop as much skill with the pen as you have genius

3. Maj. Gen. Oliver Otis Howard. Miles had been Howard's aide-de-camp in 1861 and crossed paths with him in a variety of ways during his military career.

1. "Bear Chasing in the Rocky Mountains" by Remington appeared in the July 1895 issue of *Harper's Monthly*.

with the brush. There is a bright future for you if you will adhere to my counsel.

I wish you would come over some day. I want to read to you my article on the Indians. If this is not convenient for you I will go to your place some day during the latter part of the week. I leave it to you to name the day and place as I want to talk with you about the possibility of your illustrating one or two old-time Indian scenes.

> Very truly yours,
> Nelson A. Miles

There is some evidence that by the 1890s Remington was beginning to play a political role of his own in military matters. Secretary of War Daniel S. Lamont had known Remington's family from his own Albany days, so the two men were not strangers to each other. Remington was not above plugging for some officers to receive good assignments or making specific suggestions regarding army clothing— in the following case, a fatigue cap.

☐ *DANIEL LAMONT TO FREDERIC REMINGTON*

> War Department
> Office of the Secretary
> Washington, D.C.
> May 5, 1895

My Dear Mr. Remington: I have your letter and thank you for it—I am inclined to agree with what you say about the fatigue cap.

I hesitated long about taking up the subject, appreciating the diversity of views and feeling that the outcome would meet with much disatisfaction.

The constant complaints of the discomfort and inutility of the present head gear and the appeals for the substitution of something more practical led me into the appointment of a board consisting of Col. Weeks of the Quartermaster Department, Major Babcock of the Adjutant-Generals Department, Major Sanger of the Inspection Department, Captain Craig of the 6th Cavalry stationed at Myer,[1] Capt. Barry of the 1st Infantry and Lieut. French of the Artillery. They revoted in favor of the proposed cap—unanimously after several conferences and thorough consideration of all the things involved—I was not satisfied with their findings and went with a member of the board to New York where we conferred with a number of military cap men. I wanted a higher cap some-

1. Fort Myer, Virginia.

thing like the one we now have but the increased height neces-
sitated a stiffening which made it so heavy so to be out of the
question. We examined all the military caps in use throughout the
world, inspected all manner of designs and I finally concluded that
the men who must wear them and those who have been engaged in
designing such things for years were more likely than I to be right
and I surrendered with some misgivings my views to those of the
board.

I am ready however to join you in damning the man who did it
and from the sidewalk point of view to declare that a great mistake
has been made.

My children decline to speak to me and your letter which they
have appropriated for a most prominent place in their autograph
collection—for they are of your special admirers—has given them
intense courage and delight—I am bound to confess, too, that they
have the active sympathy and support of their mother.

Seriously, I am very much pleased to have your suggestions and I
shall at all times appreciate a line from you.

With sincere regards,
 I am

 Very truly yours
 Daniel S. Lamont

*Remington sought and received official passes that opened the gates
and allowed him the freedom to sketch military activities without
restraint.*

☐ NELSON A. MILES TO DEPARTMENT AND POST COMMANDERS

 Headquarters of the Army,
 Washington, D.C.
 December 31, 1895
To: Department and Post Commanders:

This will introduce Mr. Frederic Remington who has been a
very good friend to the Army, and who now desires to visit some
of the Western posts on a tour of sketching. Any courtesies ex-
tended to him will be highly appreciated by him and myself.

 Nelson A. Miles
 Major General Commanding.

☐ *NELSON A. MILES TO FREDERIC REMINGTON*

Headquarters of the Army
Washington, D.C.
January 16, 1899

Frederick Remington, Esq.,
Endion,
New Rochelle, New York.
My dear Mr. Remington: Please accept my thanks for your neat
little note of Friday,[1] which I interpret as evidence that at least
one of my friends is not stampeded—as a matter of fact, however,
I have not heard that any of them have yet taken to the woods.

Very truly yours,
Nelson A. Miles

*Remington's friendship with Poultney Bigelow continued after their
trip to Europe in 1892. Bigelow had remained in Europe. Remington
wrote to him, vacillating on whether to make another trip himself.
What he really wanted was to see a war.*

☐ *FREDERIC REMINGTON TO POULTNEY BIGELOW*

New Rochelle
July 18 [1893]

Dear Bigelow: Do you think I could see a Grand maneuver this
Fall in Germany. Would I be allowed to see it. If I could I might
run over and do one with you. We could get some magazine stuff
and I would like to do a picture book with some little text.
 When do they come off?
 Answer immediately as the time is short.

Yours faithfully
Frederic Remington

1. It is difficult to know what Miles is referring to, but there had been a great
deal of dissatisfaction with the adequacy of the Army's readiness for the Spanish-
American War and with the many inefficiencies and outright blunders that
occurred in preparing for and carrying out the invasion of Cuba in the summer of
1898. After the war, McKinley appointed Elihu Root secretary of war, with the
specific mandate to carry out reforms. It is certain that Miles, as commanding
general of the Army, came in for his share of criticism.

☐ *FREDERIC REMINGTON TO POULTNEY BIGELOW*

New Rochelle
[1893]

My dear Bigelow: Start Saturday with Ralph for West Virginia and South Carolina—two weeks hunting.[1]

Tried to let Harper send me to the Spanish Moor campaign but no good. It would be great.

When are you coming to America? Be coherent for once and narrate facts.

I am going to Europe in the late winter and want to catch you. We may turn a trick.

D—— the war. I don't see how I can do it. I can never learn that tough old lingo. I guess I belong on this continent. I can wing a waiter with my Spanish and talk English to beat hell, and nothing else goes here.

Our state elections indicate that this country can run a Republican form of government. It's encouraging. The people rose up on their hind legs and fell on the bosses and they are too dead to skin. This great big thing called "the people" is passing strange. They are long suffering but when they turn loose, *"the fine Italian mechination"* has got to *show down*.

Was in New Haven the other day to football match. You wouldn't know Yale. Millions of the most magnificent buildings—fence gone,

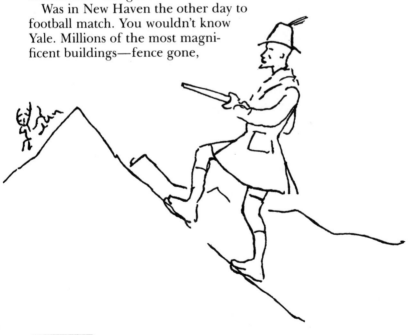

1. "Where Time Has Slumbered," an article by Julian Ralph illustrated by Remington, appeared in *Harper's Monthly*, September 1894.

some elms gone. 2500 students. New athletic Park and Gym. To
a man of your time it would be the New Zelander on the Bridge.
Why that d—— little drug store across from the campus is now
called a *Hall* with a big H in blue letters. The boys all smoke pipes
and look, *oh so young.* They even have no traditions of our time.
Old Howard Knapp of Camp's team[2] and a contemporary rusher
with me is a fat old gentlemen and as we talked it seemed like
pictures I have seen where the old white haired sailor spins his
yarns to little ox eyed kids. And the yarns get awfully laughed
at in the telling. I opine.

<div style="text-align:center">Yours faithfully
Frederic Remington</div>

☐ *FREDERIC REMINGTON TO POULTNEY BIGELOW*

<div style="text-align:center">New Rochelle
July 15 [1893]</div>

Dear Bigelow: Everson[1] has written me to know when I am
going to Europe. I do not know. Wrote him to that effect.

Well hope the war comes. Keep me posted. I would like to run
over and see some fighting.

When you get back to London I will send you a small water
color as per promise.

Hope you are enjoying yourself as you undoubtedly are. Mrs.
R. and I have been in Adirondacks two weeks.

We are having a devil of a financial round up over here. Hard
situation for Grover Cleveland. Don't believe the Dem's dare tin-
ker the tariff as per Chicago platform—they are d—— if they
do and d—— if they don't.

Did you send the Emperor a magazine of *Sidelights?*[2]

Regards to Mrs. B.

<div style="text-align:center">Yours faithfully
Frederic Remington</div>

P.S. Just handed in the "Jews"[3]

2. A teammate on the football team at Yale, of which Walter Camp was captain.

1. A commercial builder of canoes and boats from Long Island, Everson built
the canoes the two men took on their first trip.

2. "Sidelights on the German Soldier," written by Poultney Bigelow and
illustrated by Remington, appeared in *Harper's Monthly,* July 1893.

3. "The Russian and His Jew" by Bigelow and Remington was published in
Harper's Monthly, March 1894.

☐ *FREDERIC REMINGTON TO POULTNEY BIGELOW*

New Rochelle
July 28, 1893

My dear Bigelow: Suppose I do come over to see that Austrian maneuver—When will I start—how get there etc.—make an itinerary and could I get as far from the coast as you are on the English I know?

We might make an article or two on the Huns and the maneuvers.

Yours faithfully
Frederic Remington

☐ *FREDERIC REMINGTON TO POULTNEY BIGELOW*

New Rochelle
August 13, 1893

P. Big: Dear Sir—You are a lulu—how I envy you the Austrian maneuvers. Think I won't go to Germany this Fall.

If you ever get that mountain air out of your system and kind of get down on the Earth I wish you would tell me how I am to see that war next spring with you. I want to simply see it with a view to painting and magazine work after it's over.

How the devil do you suppose I am going to read that Dutch letter.[1] Get a butcher to, I suppose.

Tell Mr. Astor[2] that what I don't know about Bosmian rivers will be worth $125 a page if I work at all. Don't he want something about Hindo Koosh or Siam from me. I have always thought I would be "hell on a black charger" if I ever got at Hindo Koosh or Siam.

I am going to run over to Europe this winter about February.

Things are badly out of joint here—the west has resolved itself into a d—— lunatic asylum but I guess when they "hit the flat" they will be concious of the "thud."

Yours
Frederic Remington

1. Refers to Remington's not being able to read German.
2. William Waldorf Astor, son of John Jacob Astor and owner of *Pall Mall* magazine.

☐ *FREDERIC REMINGTON TO POULTNEY BIGELOW*

New Rochelle
November 12, 1893
My dear Bigelow: I intend to go to Europe late in the winter—when will you come here—February as I remember?

It looks to a man up a tree just as though there would be a scrap in the spring.

Can we put up a job to do the thing together—Harpers weekly or something else with it. Will you arrange it so that I can be permitted to sketch? I think the Russian border is our place.

Two horses apiece and an orderly I suppose.

Tell me how best I can go at this thing since I'm going to see that war if I have to enlist.

Yours
Frederic Remington
P.S.

There is some d—— good fighting going on down in Morrocco but Harper won't let me go.

F.R.

☐ *FREDERIC REMINGTON TO POULTNEY BIGELOW*

New Rochelle
November 25 [1893]
My dear Bigelow— I am much obliged to you for the interest you take in my case. Why do you doubt that you will go to war.

When are you coming over here? I will run over to Europe late in the winter but don't want to miss you.

If you could come over here early we could put up a job with Harper.

I will put in that application to the German Embassy but don't want to do that till I see you and can make a business arrangement to work against.

Make me a short draft of a "formal application" etc.—will you?

Its the chance of a lifetime for me as I could paint the thing after it was over. I suppose we should be on the ground before the thing starts with horses etc. My idea is to take a smart German American orderly in lieu of the "connon se doiche."

Yours truly,
Frederic Remington
P.S. Am shipping a W. color and a photo to you ———. Chelsea
R

☐ *FREDERIC REMINGTON TO POULTNEY BIGELOW*

Endion
New Rochelle
December 22, 1893

My dear Bigelow: I await your arrival in New York—then I will do what tricks you teach me.

Will probably go back to England with you. As to the invitation to the Austrian Tyrol, it's so far off can't say but would like to mighty well.

Yours faithfully,
Frederic Remington

☐ *FREDERIC REMINGTON TO POULTNEY BIGELOW*

Endion
New Rochelle
[1894]

My dear Bigelow: Yes, it makes wrinkles in me when I think that I did not see the maneuvers but I live in the hope of a war. I am toying with a Dutch professor in the hopes of acquiring a little German lang sang. I guess it will never make a book though— what I know but it's bound to make sundry Germans more or less uncomfortable.

I hope to go abroad this spring. In case of war how would we get into Germany without having 100 ton guns fired at us? Belgium I suppose.

I have the Recite de Guerre—it's immense.

We will talk over the illustrations when you lunch Feb. 2— 10 'clock Century Club—You are funny Bigelow.

When do you hit Chelsea S.W.—got a big photo and a water color for you there?

I think you are swelling my head when you say the Emperor inquired after me—it won't work old man—If you get a fall out of me you want to take hold some other way.

Watch Harpers Magazine this year—I'm in it.

I suppose you have had a fine summer.

Regards to Mrs. Bigelow

Yours faithfully
Frederic Remington

P.S.

Did the Chiefs crawl all over Weiss for having his picture and exploits published?

I've got the best horse in N. America now, built like this. Raised in Ireland.

Although it appears from the correspondence that Remington did not make another trip to Europe, he seems to have joined Bigelow in North Africa sometime between the middle of February and the first of April, 1894. Bigelow's article, "An Arabian Day and Night," in Harper's Monthly, *December 1894, begins thus: "We were jogging along gently through the sand of the Sahara Desert one fine windy day in March . . . How we happened to be at this point is soon told. Remington was used up with hard work; so was I. Both agreed that a few days under a burning African sun would be of unestimable value in curing us of our ailment, so common to the industrious American that it might as well go by the name of Americanitis." A second article, "French Fighters in Africa," appeared in* Harper's Monthly *in February 1895, also illustrated by Remington. There are references to Remington in that article, too, indicating his presence. The illustrations are of Turco, Spahi, and Zouave fighting men and officers. Remington's only references to the trip in the following letters to Bigelow are to his arrival in Liverpool, England, and to "Zouave stuff" which Bigelow sent him. He does refer to the trip in his exchange with Wister.*

Remington and Owen Wister met in 1893 and through the rest of the 1890s shared a business relationship and friendship that will be covered in more detail in the next chapter.

☐ *FREDERIC REMINGTON TO OWEN WISTER*

New Rochelle
[January or February 1894]

Dear Wister— I go to Europe soon—cant you come up here for Sunday—

Did you ever hear of a fight at Apache Pass—Arizona—where two companies of infantry were put in covered wagons and sent

into the pass—Apaches charged gallantly—
infantry got a Foot—shot em up to beat hell—
very smooth trick—would work in well in
some of your stories—dont you think—

Yours

Frederic R—

P.S.

Met Kelly—you'l like him—he talks better
about the *"Sea"* than anyone I ever heard—He
commands them. He is a *Commander*—dont
call him Lieut.

Lieut Commander J.D. Jerrold Kelly U.S.N. League Island.
I knew d—— well you couldn't guess.

☐ *FREDERIC REMINGTON TO OWEN WISTER*

New Rochelle
[February 1894]

Dear Wister— Sorry old man but I sail on the *21st* and will not
be at home after Sunday. Its no matter I simply thought if you
had "nothing to do—but breathe" you might run over.

You will not be disappointed in Kelly. He writes sea-stories—
and is said by his friends to be "the most garrulous man in the
Navy."—

Got "Specimen"[1] Illustrated. Did not do the fight. That's one of
those stories where one wants to leave the situations to take care
of themselves and to put simply the figures into shape so that the
reader will know who did all those curious things.

Mrs. R—sends her regards.

Yours faithfully

Frederic Remington

Friday

1. "Specimen Jones" by Owen Wister was published in *Harper's Monthly* in July
1894.

☐ *FREDERIC REMINGTON TO OWEN WISTER*

New Rochelle
[February 21, 1894]
Dear Wister— I pull my freight for Europe to day. The photos
will be returned—If you will have prints made of those marked X
I will pay the bill and be happy.

Sorry I couldn't see you. Suppose there will be 11 or 12 M.S. by
time I return.

Y——tr——
Frederic R——

☐ *FREDERIC REMINGTON TO POULTNEY BIGELOW*

Cunard—Royal—Mail—Steamship—"Cucania"
March 2, 1894
Dear Bigelow: Got off all right at Liverpool—fine weather so far
but no Zouave package. You had better drop the Cunard folks at
Liverpool a note asking it forwarded to New Rochelle by next
steamer.

Don't forget to "cable me."

If Cook will give you anything on your ticket I'll send mine over
to you.

I'm delighted that you got the Zo Zo stuff—I'm fixed for life now.

You're lucky after all that you stayed in Paris since if Mrs. B.
had struck that city and you had been in London—there would
have been more trouble than old Black Joe ever dreamed of.

Yours
Frederic Remington
P.S. No more Continent in mine Charlie—English will do.

☐ *FREDERIC REMINGTON TO OWEN WISTER*

New Rochelle
April 1 [1894]
My dear Wister— I am back from the Arabs[1] and the fleas and
the French language which I do not understand—How's the
"Bluff"[2] getting on—and the health, that I hope is better.—
Yours faithfully,
Frederic Remington

1. Refers to the trip to Africa and Europe in early 1894.
2. "The General's Bluff" by Owen Wister, illustrated by Remington, was
published in the September 1894 *Harper's Monthly.*

*After his return from Europe, Remington chided Bigelow on his in-
ability to produce articles for illustrations. He had the habit of send-
ing subtle reminders that his livelihood depended on others.*

☐ *FREDERIC REMINGTON TO POULTNEY BIGELOW*

New Rochelle
Thursday April 13, 1894
Dear Bigelow: Here is the check for 220. bones.

I am very weak my pulse is 117 and I am breathing heavily.
The doctors have not given me up but I have little hope. You see
the shock was so great when I got Harpers telegrams saying "and
now Mr. Bigelow informs me that he is engaged for that night"
and our dinner is off.

It is suicide, it's hari-Kari, A bull-frog is in a swamp, it is a great
big breathing mass of enthusiasm and singleness of purpose be-
side you. I have not committed homicide up to date but I think I
will, if I ever get over this shock—You're a jim-dandy, "an india
rubber idiot on a spree.

I have fainted
Frederic Remington

☐ *FREDERIC REMINGTON TO POULTNEY BIGELOW*

New Rochelle
April 16, 1894—Monday
Dear Bigelow: Been building a place to work in this summer.

You old lump of inanimate matter if you don't work I can't.
How are the Timbucto articles[1] getting "thar." Fire up—say lots
of things that aint so—let your imagination play—every other
fool will howl in chorus that you are not so—then don't say it but
let it be known that you are interesting and lay back on Sol-
oman—there is nothing new. EXCEPT HISTORY

Mrs. R. wants to meet you and Mrs. B—particularly Mrs. B—
she knows that you are not; oh well—I have told her—can't
(Kant) we have a little lunch some day at some *chop house.* All by
our "lonely";—you—Madam and our end of the table—pigs
knuckles and beer and conversation—I want to tell Madam all
about you—If you go back to England without conforming to the
"customs of the country"—which is to let us know you—Then I

1. Probably the two articles on the African trip that appeared in *Harper's
Monthly* as "An Arabian Day and Night" (December 1894) and "French Fighters in
Africa" (February 1895) written by Bigelow and illustrated by Remington.

say you don't live up to your blue china. I hope I will never meet
you again.

<div align="center">Yours faithfully</div>

Faithfully—I got that word from you and how can you beat it.

<div align="center">Frederic Remington</div>

P.S.

Mrs. R. has "shipped her trolley" for three or four days.

<div align="center">Avis</div>

☐ *FREDERIC REMINGTON TO POULTNEY BIGELOW*

<div align="center">Endion

New Rochelle

May 15, 1894</div>

My dear Bigelow: Well you old hearse driver. Alden has been
mentally paralized by receiving a M.S. from you—in his ravings
he told me it was invisable. He had his feet on the desk, a cigar
going 40 miles an hour and his eyes twinkled, while his best grin
played over the Bigelow M.S. He said you were good stuff but
too d—— lazy to lie quiet in a grave.

Give us another, and another and yet more.

The latest news is that I haven't had a drink in three weeks and
aint going to have any more till I am about to die—when after a
Consultation of physicians I am going to take one Martini cocktail
before I go up the Golden. I feel better.

I got my stuff through to the Customs House without duties.

I must owe you 50 francs. Is that right? For the Zouave stuff,
which is very nice. Where will I send it, to your bank here?

Have been up north for two weeks in training. Did 15 miles a
day on foot and am down to 210 lbs. I have been sick for two
years and didn't know it. Too much rum.

<div align="right">Yours truly

Frederic Remington

Give Astor hell.</div>

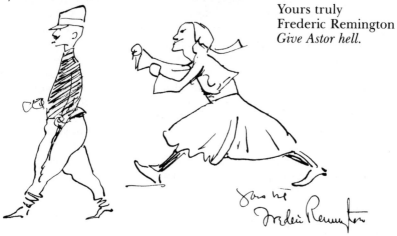

☐ *FREDERIC REMINGTON TO POULTNEY BIGELOW*

Endion
New Rochelle
May 21, 1894

My dear Bigelow: Have just read your *"An Arabian Day and Night."* Proud to know you sir—great honor I assure you—bound to be a very great man—are you?—Always said if you could cultivate out of your head—that d—— genius for facts (which there are no such things) those maps, etc. you can be a magazine writer of the first water. Of course you are lazy—that may have been only an evidence of genius but if you can do such work right along I can't see how there can be any insect life on you.

<div align="right">Yours faithfully
Frederic Remington</div>

P.S.

I'm going to do a belly dance which will bring the tears to the eyes of old ladies.

<div align="center">R.</div>

☐ *FREDERIC REMINGTON TO POULTNEY BIGELOW*

Endion
New Rochelle
June 14, 1894

My dear Big: *"Blood is thicker than water"* very fair and easy and like lots of picturesque statements requiring qualification In the case of Ben Harrison (late P of the U.S.) it was not so. His blood would run up hill. It was bully talk—yours in Harper Weekly. Positively exhilarating, everyone take a drink.

You have often been suspected of *"conversing through your bonnet"* in the picturesque New Yorkese and I pay you the tribute of knowing that there never was and never will be any trouble between the English people, but there always has been trouble and there always will be trouble between the puritanical republican idea and the *rags of the feudel system.* They are both uncompromising and you are too good a student of history to know that the world moves backwards. However I am glad as are all English-Americans to believe that "blood is thicker than water." Mine is, you can gamble. It's too thick for my own good. I think you and I will both get killed in Afgahnistan.

Give Mr Crocker,[1] late Tammany Chief, a dinner in London. Exploit him as a sample of Irish governmental genius, that would be smart and a great scheme

1. Richard Croker (1841–1922), head of Tammany Hall from 1886 to 1902.

I am boring on Spalus[2] and Turcos.[3]

Do we go to India?

I don't want any more European wine. In the language of G— Washington "America is too good for me."

<div style="text-align:center">Yours faithfully
Frederic Remington</div>

P.S.

If I ever can think of it I will send you what I owe you.

☐ FREDERIC REMINGTON TO POULTNEY BIGELOW

<div style="text-align:center">New Rochelle
August 4, 1894</div>

My dear Bigelow: Tried to send you exchange for 50 rubles and 50 francs.

Knauth, Nachod and Kuehne or ever what their names are give it up. I am advised by the Lincoln National Bank to have you draw on me at sight for about $36.83 cents. It's too d—— complicated to put an American credit into rubles, francs and then into Austrian shin plasters. That's the best way.

Sorry to have delayed that long.

Harper says have written you for further particulars as to India—give in quick—I'm in a low fever to get away—Canada, New Mexico etc. but if there really is a war, prove it and I'm wid ye.

China and Japan are having a turn up but I can't make those apes seem like real soldiers. It's more like an Italian hand organ man's monkey with a red coat.

That India scheme is covered by patent which I hold and d—— you, you don't want to infringe it by leaving me out.

<div style="text-align:center">Yours faithfully
Frederic Remington</div>

☐ FREDERIC REMINGTON TO POULTNEY BIGELOW

<div style="text-align:center">New Rochelle
July 27, 1894</div>

My dear Bigelow: Just a word—am hard at turning out stuff. Didn't send money yet but don't seem to get around to it—will shortly.

2. Spahis in the French army were certain Algerian and Senegalese cavalry units, famed for their flashy dress uniforms.

3. Turcos were Zouave soldiers in Algeria.

Just back from Chicago[1]—mob and soldiers—hot stuff. Got to have a big killing in this country. Don't you let any of those English papers make you think this country is going to hell. You may have to come out here and help us lick the lice from Central Europe.

<div align="right">Yours
Frederic Remington</div>

P.S.

Haven't seen Harper about India but don't think he will put up enough to make it possible.

Tell Allen not to mind the d—— Cossack saddle. I'll get one of Buffalo Bill.

☐ *FREDERIC REMINGTON TO POULTNEY BIGELOW*

<div align="center">New Rochelle
August 19 [1894]</div>

Dear Bigelow: Your note here relating to Europe—but sorry can't go. I have written 4 mag. articles this last year on Mexico[1] and go to Canada to do some more this Fall when I will have a book[2]

<div align="center">by
Frederic Remington</div>

with royalties, perquisits and appurtences thereto. Would like to see the maneuvers but alas—and also wouldn't mind meeting you but am afraid I shall never grow to like Europe—the language is not as good as English and my bump of reverence is a hole.

But the war—I'll do that English or no English. Mrs. R. sends regards.

<div align="right">Yours
Frederic Remington</div>

1. Remington was in Chicago at the time of the Pullman strike. He wrote and illustrated three articles for *Harper's Weekly*, "Chicago Under the Mob," "Chicago Under the Law," and "The Withdrawal of U.S. Troops," which appeared on July 21 and 28 and August 11, 1894.

1. "In the Sierra Madre with the Punchers" had appeared in *Harper's Monthly* in February 1894, and "A Rodeo at Los Ojos" had appeared in March 1894. Illustrations on Mexican topics had appeared in *Harper's Weekly* on December 9 and 30, 1893.

2. *Pony Tracks*, an anthology of his earlier stories, was published by Harper's in 1895.

□ *FREDERIC REMINGTON TO POULTNEY BIGELOW*

New Rochelle
[September 1894]
My dear Bigelow: All right. Have sent check to your banker.
$36—10 francs and 50 roubles. That's what my banker says.

You are as the cookoos say—a most impossible fellow. You say
to Harper that you are going to India and you say to me I am
going to India, neither Harper and I knew a d—— thing bout it.
Hope you will have a good time but if you want Harper Bros. and
I to participate in the enterprise it takes a little more *talk*.

How I would like to see the maneuvers. I am going on a
months hunting trip the 16th. Have worked all summer like a
wild cat.

I will raid Harper Bros. next week and write you what they say.
Ralph has gone to China and Japan and I am afraid they will not
want any more Orient for awhile.

Yours
Frederic Remington

□ *FREDERIC REMINGTON TO POULTNEY BIGELOW*

New Rochelle
October 23, 1894
My dear Bigelow: So you crossed the Alps—others have done
it—Napoleon for one. Can you "gondel"[1]—your canoeing ought
to fit you.

It's a mistake that I am not in Japan.[2] I believe those fellows
would let me sketch—they are civilized.

If the Czar dies will there be war?

India—well Ralph will fill up the Orient and Weeks is doing
India in Harpers—Someday we may. It will stay there.

I may run over to Europe this winter. I have a scheme. Will you
be in London?

Yours faithfully
Frederic Remington
P.S.
Just written article on Bear Running with Hounds in N. Mex.[3] Our
"Cossacks" come in Harpers this month.[4] How are illustrations?

1. Row a gondola.
2. In 1894, Japan attacked China, defeated her with ease, and forced her to pay
a large indemnity and to give up Korea (which Japan annexed in 1910) and the
large island of Formosa.
3. "Bear Chasing in Rocky Mountains" would appear in *Harper's Monthly* in
July 1895.
4. "The Cossack as a Cowboy, Soldier, and Citizen" by Poultney Bigelow,
illustrated by Remington, appeared in *Harper's Monthly*, November 1894.

☐ *FREDERIC REMINGTON TO OWEN WISTER*

Endion
New Rochelle
[Early November 1895]

Dear Wister— The Burial of the B.S. is good.[1] You may know all
about my sale,[2] kind sir—the first thing is that it opens on the 14
and the whole "billin" is sold to the most enthusiastic bidder on
the night of the 19th and thats the end of it because "I run a
square game" and what in hell kind of a game do you think a
fellow can play and have "the gang wid him."

Hope you will land your two friends down there on the Buster.

Hope Tamaney[3] gets done to day but I aint cock sure about it.

Hope we can go southwest together in February—I want
to paint. After my *sale* I am going to Virginia for a week's shoot-
ing—quail.

They are writing editorials out west about the *Buster.*[4]

I think I smell *war* in the air. When that comes to the Wild West
we'll have passed into History and History is only valuable after
the lapse of 100 years and by that time you and I will be dead.

Kiplings "Out for India" is splendid.

1. "The Burial of the Biscuit Shooter" by Wister (later retitled "Destiny
at Drybone") was published by *Harper's Monthly* in December 1897.

2. November 14, 1895, Art Show and Sale by the American Art Association,
Madison Square South, New York City.

3. Tammany Hall did make a clean sweep, which was attributed in part to
capturing a very high percentage of the German immigrant vote.

4. *The Bronco Buster.*

Joel Burdick was a frequent Adirondack hunting and fishing companion. An old friend from Remington's days in Albany, he had been a general passenger agent for the Delaware and Hudson Railroad Company before becoming president of West Penn Steel Company.

☐ *FREDERIC REMINGTON TO JOEL BURDICK*

New Rochelle
[April 15, 1896]

J.W. Burdick Esq.
"D & H"[1]
Albany, N.Y.
Dear B— Get ready—order canoe 13 ft. by 29 inches Rushton, Canton[2]—immediately—have shipped to Larabee's Point: Everything arranged—Wright and Harry and two other fellows are going with me on 15th of May for 10 days cruise on Champlain and George.

Frederic

☐ *FREDERIC REMINGTON TO JULIAN RALPH*

New Rochelle
April 6, 1896

My dear Julian— With police assistance I have at last gotten an address said to be yours. All I want is to inquire after you and how you like London, &c.

I am plugging away at my game. Nothing is happening. We rather hope for a war with Spain. Bigelow is in Egypt. Davis in Moscow.

Wright Burdick & I go canoeing on Champlain on the 15th for 10 days.

How is the boy doing—studying art in Paris I suppose?

1. Delaware and Hudson Railroad.
2. J. Henry Rushton, famous canoe builder in Canton, New York.

If you ever come across a field uniform of the British Army for 40 cents,—one of this kind, buy it for me. I have just written my first story for Harper's Magazine.[1]

The Journal seems to be selling & is a good newspaper, bar its weakness for 2 col. murder.

I suppose you look like this now. —get on to his English.

Do you see Dana Gibson[2] in London? Give my kind regards to the Prince & believe me.

Yours
Frederic R.

☐ *FREDERIC REMINGTON TO OWEN WISTER*

New Rochelle
[Early April 1896]

Dear Wister— Well Ide like to see you before you go to Europe and get acquainted with the new man—

I think it is a good scheme for you to go over to Europe it will take you out of yourself and if you dissipate recklessly you may find the old Wister will come back in the flesh. I expect you will see a big war with Spain over here and will want to come back— and see some more friends die. *Cuba libre*. It does seem tough that so many Americans have had to be and have still got to be killed to free a lot of d—— niggers who are better off under the yoke.[1] There is something fatefull in our destiny that way. This time however we will kill a few Spaniards instead of Anglo Saxons

1. Remington must have erred. He had written articles for both *Harper's Monthly* and *Weekly* before 1896.

2. Charles Dana Gibson (1867–1944), American illustrator whose work appeared in many magazines with Remington's.

1. Remington expresses a prevalent bias of the day concerning racial differences. It was a dreary outlook but tailor-made for propagandists who related the war of liberation in Cuba to the emancipation of Negro slaves in America.

which will be proper and nice. Still Wister you can count the fellows on your fingers and toes who will go under in disease—friends of yours.

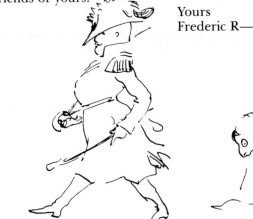

Yours
Frederic R—

Going to War *The Vomito*[2]

☐ *FREDERIC REMINGTON TO OWEN WISTER*

New Rochelle
[June 1896]

My dear Wister.— Got my work done on book[1]—its "Away from the Kodac"[2] and when I get fixed want to load you up with ball cartridge and fire you off.

Am going Montana for two months—to sweat & stink and thirst & starve & paint—particularly *paint*. If we dont go to War with the Dagoes or the Yaps wouldn't that be just our ticket for soup though—Lets form a partnership on the *scrap*. only if it promised hot enough I will start in as Capt of Infantry.

Yours truly
Frederic Remington
Capt.—1st N.Y. Vols. U.S.A.

2. Yellow fever.

1. *Drawings*, sixty-one illustrations published by R. H. Russell, New York, 1897.
2. Indicates that Remington did the drawings without referring to photographs.

Remington wrote to his wife before leaving Key West for Havana.
He and Richard Harding Davis were to report on this trip for
Hearst's New York Journal.

☐ *FREDERIC REMINGTON TO EVA REMINGTON*

Key West
Christmas [1896]
Dear Kid— Vamoose[1] is here being painted grey—it is blow-
ing hard and we may not go before tomorrow night—dined with
the Menards war ship folk last night—go to Collector of the Port
to-day.

I am well—weather is fine here—

See Chicago banks are unsafe—watch out and if you think
New York gets weak check out most of our money.

☐ *FREDERIC REMINGTON TO EVA REMINGTON*

Key West
Saturday [December 1896]
Dear Kid— It is now 4 o'c—we leave at six—the boat lies at the
dock steaming up. The towne is wild with excitement—We have
only the Custom House to fear. Two Cuban officers go with us—I
am well—and feel that I am to undertake quite the most eventful
enterprise of my life—I think there will be a war with Spain—

I leave my effects at the *Duval* House *here*—Good bye little
one—from

Your loving old boy
Frederic

☐ *FREDERIC REMINGTON TO POULTNEY BIGELOW*

New Rochelle
January 28, 1897
My dear Poultney: Just home from Cuba—saw more hell there
than I ever read about. Went for New York Journal—small pox—
typhoid—yellow jack—dishonesty—suffering beyond measure.

1. Hearst's yacht, which was originally to provide their transport from Key West
to Cuba.

Davis will tell and I will draw but can't do much in a Yellow Kid Journal[1]—printing too bad.

Heard the baby died—too bad old man—Put it frankly this way to Mrs. B.

Never mind your d—— supplemental proceedings—no one cares a d—— about 'em. Your S. Africa work[2] is artistic—for once—not exactly for once old man but you are a little hard in the head—and if I had you on your back in a dark room you would admit it. The Pad . . . and Pol . . . on the Danube[3] was your greatest art work.

On the water wagon for fair and working like mad man. You'll never help bury me old hoss. I'm beating the game slowly surely—and only hope I will never be rich cause I don't think I would be any bloody common good if I had money.

My great aim in life is to take a Canadian canoe trip next fall. Going to get out a picture book this year.

<div style="text-align:center">

Yours

Frederic R.

</div>

P.S. Do you never see old Ralph W. Lunnion, 80 Fleet St—

P.S. from Kid

My kindest regards from Kid to Mrs. B. and yourself and *very* much sympathy too for the loss of your dear baby. I hope you are all very well. Too bad you are so far away.

I had no picnic while my massive husband was with those civilized friends in Cuba who care no more for a man's life than they do for so many rats.

<div style="text-align:center">

Eva A. Remington

</div>

1. "The Yellow Kid" was a cartoon character drawn by Richard F. Outcault that had appeared first in Pulitzer's *New York World.* It was originally a page-wide drawing with many "kids" from the tenements commenting on situations of the day in New York and featuring a "central kid" dressed in yellow. After Hearst lured Outcault to the *New York Journal,* the *World* hired George B. Luks (1867–1933) to continue the feature. Luks was an American portrait and genre painter who worked as a newspaper illustrator and caricaturist until 1902. Thus New Yorkers were treated to two "yellow kids" every Sunday. Critics of the sensationalist press looked on the cartoon as symbolic of that type of journalism and thus the phrase "yellow journalism" or "yellow press" was coined.

2. "White Man's Africa" appeared in *Harper's Monthly* in February 1897 illustrated by Remington from photographs. There is no evidence he ever went to South Africa.

3. *Paddles and Politics Down the Danube* by Bigelow was published by C. L. Webster and Co. in 1892.

☐ *FREDERIC REMINGTON TO POULTNEY BIGELOW*

New Rochelle
[1897]
My dear Bigelow: All think we will arrive as per note of yester-
day—I haven't anything for mess—sold everything this winter—I
sold two bronzes in London thanks to your list of addresses and
more promising if I make a hit there, its a good business. Want
you to come over here soon, will show you another "mud." Think
we will have a war with Spain—that's good.—
Yours
Frederic R
As for "Rum—I am on the water wagon—last drink was 30th
Jan'y 96—it will be "last too"

*Remington and Theodore Roosevelt had known each other since
1888, when Remington did the illustrations for Roosevelt's* Ranch
Life & the Hunting Trail. *The book consisted of articles done by
Roosevelt for* The Century Illustrated Monthly Magazine *that
same year. Roosevelt became assistant secretary of the Navy in 1897,
and he invited the artist to spend a few days visiting a fleet of
battleships off the coast of Virginia. Remington went but it does not
appear that he wrote or illustrated any articles about the experience.
Roosevelt's letter of September 15, 1897, indicates that perhaps his
own loyalty, too, was not to the sea, but to the plains.*

☐ *THEODORE ROOSEVELT TO FREDERIC REMINGTON*

August 18, 1897
Mr. Frederick Remington,
 New Rochelle, N.Y.
My dear Remington: It may be that I shall be able to take three
days in some government tug or other—possibly the DOLPHIN—to
visit the fleet of battle ships when they are at their maneuvers off
Hampton Roads early in September. I may be able to take two or
three men with me, although I can't be sure. Two of these will
have to be correspondents of the Associated and non-associated
press. The third I should be delighted to have yourself if you
would care to come. Would you like it? I can't give you a definite
invitation yet, but I would like to know whether you could come,
so if I am able to arrange it I can telegraph you.
 I am having a bully time as Assistant Secretary
Very sincerely yours,
Theodore Roosevelt

☐ *THEODORE ROOSEVELT TO FREDERIC REMINGTON*

August 26, 1897

Mr. Frederick Remington,
 New Rochelle, N.Y.
My dear Remington: Gibbons[1] is now at the torpedo station,
Newport, R.I. As Monday the 6th is Labor Day the Department
may be shut. My house is No. 1020 N Street. If you get to Wash-
ington early enough take lunch with me at the Metropolitan Club
at 1 p.m. If not, come to my house; and if there is any hitch at all,
meet me at the Norfolk boat, which leaves the foot of Seventh
Street at 7 p.m. At Fortress Monroe the next morning we will
be met by the DOLPHIN, and I can give you fairly comfortable
accommodations.

Sincerely yours,
Theodore Roosevelt

☐ *THEODORE ROOSEVELT TO FREDERIC REMINGTON*

September 15, 1897

Mr. Frederic Remington,
 301 Webster Ave.,
 New Rochelle, N.Y.
My dear Remington: I wish I were with you out among the sage
brush, the great brittle cotton-woods, and the sharply-channeled,
barren buttes; but I am very glad at any rate to have had you along
with the squadron; and I can't help looking upon you as an ally
from henceforth on in trying to make the American people see the
beauty and the majesty of our ships, and the heroic quality which
lurks somewhere in all those who man and handle them.

Be sure to let me know whenever you come anywhere in my
neighborhood.

Faithfully yours,
Theodore Roosevelt

1. J. H. Gibbons was a naval officer whom Remington first met on the U.S.S.
Raleigh in December 1896.

☐ *FREDERIC REMINGTON TO J. HENRY HARPER*

Tampa
May 18, 1898
[In Harper's hand:] Mark your
double page this week and
triple next
(telegraphed May 16, 1898)

J. Henry Harper

Dear Sir:— How do you like the work I am turning in now. Some more goes today—protect me against the blight of the "half-page" Oh Worshipful One.

I am going with the first advance and will do the thing. I may have to come back here since I dont think a man can turn out immortals under a palm leaf but I will return to Cuba—Troops in good shape—mad at being held. Those ridiculous old ladies in Washington—Why don't you pound them—truly they deserve it.

We are nearly bored to death here. The only excitement is that the great multitude of Harper men gather once a day and d—— Mr. Henry Loomis Nelson[1] by all their Gods. If the Army fails— the Harper battalion can conquer Cuba—

Yours faithfully,
Frederic Remington

Percy Crandall was a naval surgeon on the Iowa *when Remington was on board in April 1898. The two got on well and developed a correspondence. In May, while Remington was back at Tampa Bay, Crandall was still on the ship off Puerto Rico.*

tjw we took Havana. -

1. Retired editor of *Harper's Weekly* who at this time was writing articles on public affairs for *Collier's*.

☐ *R. PERCY CRANDALL TO FREDERIC REMINGTON*

<div align="right">Vinuard [illegible] Passage

May 16, 1898</div>

Looking for
Spanish Fleet

Dear Remington A thousand thanks for the case of Joy you
sent me. It bought a great happiness into my sad life—"He
certainly was good to me." We are just returning from having
knocked Hell out of San Juan in Puerto Rico. We journeyed down
there to cook the Spanish Fleet but they were "non est" so we
worked the forts for about three hours for spite and raised Hell
with the town. Van Dizer's first shell went plum through the light
house—you would have enjoyed it immensely. We were struck
twice the second shell tearing up our superstructure and wound-
ing three men. Rodgers, the Captain and many others were struck
but not injured. The New York lost one man and several
wounded. One man died from heat on the Ampihtute [illegible].
The water fairly boiled around us at one time and all the air was
full of "shelly shrieks" (that's good—you ought to use that) But
they failed entirely to get our range. It was a beautiful sight I will
never forget it. I did not lose my thirst during the action. We
heard yesterday that the Spanish are around here somewhere and
we are keeping our eyes open. I enclose your mess chits they are
all paid. You had a balance due from regular mess which just
about covered it. How about Manilla? I see they have bought
200,000 cotton drawers for the Army so I guess the Country is
safe now. Well so long old man. We all miss you very much. All
the boys send love.

<div align="right">Thine

R. Percy Crandall</div>

Your "Niquags"[1] was great

Drop me a line occasionally. I am very lonesome

☐ *FREDERIC REMINGTON TO OWEN WISTER*

<div align="right">Endion

New Rochelle

[June 1898]</div>

My dear Wister: Am just back from the South for a few days
to "get cool"—I go Thursday. If I dont become a bucket of
water before that time I hope to see the landing in Cuba but if

1. Probably refers to "Wigwags from the Blockade" by Frederic Remington,
which appeared in the May 14, 1898, issue of *Harper's Weekly*.

any yellow fever microbes come my way—I am going to duck. They are not in my contract.

I understand you are married—Mrs. R. got your cards but was sick at the time—she had what I call the "battle-ship attack" for I was at the time sailing around with Mr. Fighting Bob Evans[1]— and meeting with no worse harm than too much eating and drinking will bring where you dont have exercise enough.

Well old man—I congratulate you—I didn't think you would be caught but these chaps who seem to have escaped out into the brush get rounded-up just the same as tame stock—mostly.

Give my regards to Mrs. and tell her I think she got a pretty good fellow but she wants to keep a rope on you—you have been *broncho* so long—its different with kids.

Put this in her kind of English. We hope to see you over some time—after we lick the Dagoes—Say old man there is bound to be a lovely scrap around Havana—a big murdering—sure—

Yours faithfully
Frederic Remington

Remington was busy sketching everything, and the following draw-ings show how thorough he was. His sketches on the landing at Dai-quiri in Cuba included marginal notes for later use.

☐ *FREDERIC REMINGTON TO EVA REMINGTON*

In the Field near Santiago
June 29 [1898]

My dear Kid:— Just got notice that mail will go down to the post.—we are about 5 miles from Santiago and except the fight which the cavalry brigade had the other day the Spanish have not opposed us—I—Davis and John Fox went to within 2 miles or nearly 1½ miles of Santiago yesterday on a reconnaissance— everything is quiet in and about the city—what one might call an ominous lull—

The first night ashore it rained and I slept all night wet.—I stayed with the 6th but found they did not move stalled—I got lifts for my pack most of the way—at the *second base* I found Ed-die Burke sick—I nursed him up—got a d—— doctor to promise to invalid him and went on. Afterwards I found he had joined the Regt.—and was sick with Typhoid—he has been sent back.

I have an awful cold—and cant get over it—the country is healthy. . . .

John Fox and I sleep on the same blanket. We *burn* at Genl.

1. Capt. Robley Dunglison Evans, commander of the *Iowa*.

The cosmopolitan landing by nore

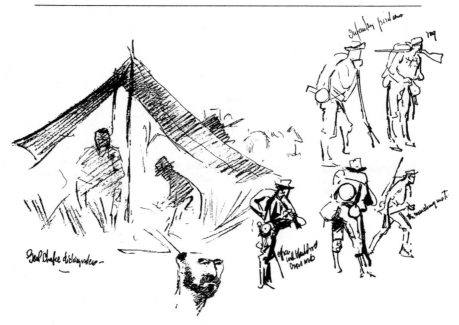

Chaffee mess—*crackers, coffee* and *bacon*—by God I haven't had
enough to eat since I left Tampa—I am dirty—oh so dirty. I have
on a canvas suit and have 2 shirts—my other *shirts* as the boys call
them.—I have no baggage which I do not carry on my back—
 I bought a horse and equipment from Col. Benham 7th Inf for
$150 gave my check last night—he goes home sick—so now I
wont have to suffer—If I could get my hammock some cegar and
a quart of whiskey I would be it. But I am seeing all the actualities
of campaigning—
Hearst is at the port I understand I hope to get home soon—I
hope I dont get ten days quarantine either—
<div style="text-align:right">

Yours lovingly,
Frederic R——
</div>

□ *FREDERIC REMINGTON TO HARPER BROTHERS*

<div style="text-align:center">

New Rochelle
[Summer 1898]
</div>

Harper Bros: Guiele—In reply as to the *"block-house not being
right"*—I lost my sketch book on the battle field and did not get a
photograph as I hoped—so when I came home I found I had no
notes of the block-house and also had forgotten just how it looked
in my excitement—which I informed the art dept. but you
wanted a picture right away—so I put in the block house from

memory and subsequently when the photos came in it was not like mine as I expected. No one ever noticed this fact but myself and doubtless no one will unless I tell them. But as a fact you see how badly off the Zeigler artist is—having followed me on one of the very few occasions which I was faulty.

I will call on Mr. Geolitz

<div style="text-align:center">

Yours Faithfully
Frederic Remington

</div>

Enclosed find receipt—please forward to art dept.—and oblige me.

John Fox, Jr., was an American novelist who lived and worked in the Cumberland Mountains in Virginia. His stories of mountain life achieved much popular success. He and Remington met and slept under the same poncho when they were both covering the Cuban campaign for Harper's in 1898. They had missed the first battle at Las Guasimas and were determined not to let it happen again. General Chaffee and General Lawton were two of the commanders whose units' mess they shared. Remington had taken ill, and Fox sent his belongings home.

☐ *JOHN FOX, JR., TO FREDERIC REMINGTON*

<div style="text-align:center">

Tampa
Frasaline on Board the Damned
Aransas July 28, 1898

</div>

Dear Frederick Hail! I took care of your things up to the last day put them on a wagon—all of them—with my own, gave the driver gold to carry them to Siboney[1]—and I never saw yours or mine (or Whitney's)[2] again. I left word with a friend to send all to N.Y. if he had the chance. I also paid your very small mess bill at General Chaffees and I mention the fact merely because it occurs to me that you may have been worrying about it. Damn Cuby, Cubyans and the red handed War! I get away from here on Sunday & then Ho for the Heaven of Home! Good luck to you Frederic. Best remembrances to the Thomases[3] and to your better (much, much better) half, Mrs. Remington. Thy comrade-in-arms under the mango tree and in the dewy poncho

<div style="text-align:center">

John Fox Jr.

</div>

Read my next letter in Weekly on Shafter if the Harpers dare print it.

1. Town in Cuba.
2. Caspar Whitney, editor of *Outing*.
3. Augustus Thomas, a playwright and neighbor of Remington.

☐ *JOHN FOX, JR., TO FREDERIC REMINGTON*

Big Stone Gap, Virginia
August 15, 1898

Frederic Remington, Esq.,
New Rochelle, N.Y.

Dear Old Frederic:— Many—many thanks for your letter of August 2nd. I went all to pieces when I struck Tampa and had to lie up for a week in the hospital at Louisville, with my temperature playing about the merry height of 106. I am still weak but am getting all right again, and this is why you must pardon this dictated letter. Many thanks for the distinction you are going to give me in that article to come; I shall be devilish glad to see it. Do you see how I touched up His Fatness, Your "Major-General Guts," [1] this week? Well, I am going to hit him again pretty soon and hit him pretty hard. I am sorry I can't send you a worthy answer to your letter just now. Remember me to the Thomases and my best regards to Mrs. Remington, and a hearty shake across the fields to you. You owe me nothing except a large, fine drink the first time we strike each other. Good luck ever,

Yours faithfully,
John Fox Jr.

Casey Bunyan was an ensign in the U.S. Navy who had met Remington on the U.S.S. Raleigh. *He maintained contact with Remington throughout the Spanish-American War, describing naval battles in which he took part. Bunyan recounted the shared experience in Remington's guestbook in later years.*

☐ *CASEY BUNYAN TO FREDERIC REMINGTON*

U.S.S. Raleigh
Manila Bay
September 15 [1898]

Dear Frederic I was intensely interested to get your letter and also sorry that you had come home from Santiago ill. It must be hell down there. We have it "hotter than the hinges" [illegible] oven here but am free from the discomforts of camping in swamps and besides have enjoyed remarkable immunity from fever and other diseases.

I occasionally see some of your work in the "Journal" and also

1. Maj. Gen. William R. Shafter, who was very overweight.

some in the magazines. Naturally it always interests me greatly.

I say old chap, but didn't Davis give you a "send off" in that article about the Tampa Bay Hotel? I can just imagine the times you must have had meeting all your old running mates of the army and the good liquor you must have punished. I gather that you & *Richard* must have reestablished the enliste candisle [illegible].

I am sending you (by registered mail probably) a little souvenier of the Philippines for your collection of arms in the studio. It is an old Malay kriss. It came into my possession in the following way. The Raleigh & cannon [illegible] bombarded & reduced the Spanish garrison on Mande [illegible] Island. The prisoners (628) with their arms were turned over to the Philippines Insurgent General. I had charge of the transfer. He presented me with the "kriss" which he wore at the time. Said he had carried it thro the last two rebellions against Spain & added, with a leer, that he had killed *many Spaniards with it.* He may have been lying but he looked like a regular cut-throat and had the reputation of being a damn hard character.

My time out here is getting short. I hope & I look for orders home as soon as the Peace is signed. I long for a chance to fall off a cable car on Broadway once more. Hope to do this about Xmas.

Give my kindest regards to Mrs. Remington and believe that I am

<div style="text-align:right">Ever yours faithfully
Casey Bunyan</div>

Chadwick[1] also sends his best

☐ *CASEY BUNYAN TO FREDERIC REMINGTON*

<div style="text-align:center">

[1898]
Jefatura De Sanidad
Del
Arsenal De Cavite

</div>

I know better for I've seen him do it & have an idea he'll do it again. I can imagine no greater valor then they showed in fighting their ships to the last, long after they must have seen that all was up with them. You ought to see the effect of some of our shells on their vessels & the arsenal buildings where they fairly ripped things wide open. We are making our headquarters at Carila [illegible] (7 miles from Manila) & already blocade the latter place. Will take it as soon as troops arrive. I fear that will be some time however. Oh! but it is hot in this neck of the woods & now that

1. Ensign F.S. Chadwick, a shipmate of Bunyan, who had met Remington before in Key West in 1896.

the battle business is over it is damn montonous & dreary. Of course our fear is torpedo attack or fire from some crazy spaniards in Manila, so have to keep the strictest of watch with all lights obscured by battle plate which makes the ship nice to sleep in. Guess I can stand it however.

I thought you might like to have a line from this side of the "ball" so have written the above. Be good and send me a few characteristic remarks on affairs on your side. I suppose these will be forwarded O.K. My kindest regards to the good wife. Hope to drop out to see you about next December when my time will be up & the war over. The calls has been cut by us so we only get dispatches by steamer from Hong Kong. Am watching the "McCulloch" now. I am giving the news from this side to the "Associated Press." Harpers Weekly & the "world" each have a man here. Silsbury of the Herald who was attached to the Admiral staff during the battle has good hours. Where is Davis? Remember me to him if possible.

<div align="right">Casey Bunyan</div>

The Rough Riders, as a tribute to Theodore Roosevelt on the occasion of their mustering out, gave him a Remington bronze, The Bronco Buster. *Remington was thoroughly pleased, as was Roosevelt.*

☐ *FREDERIC REMINGTON TO THEODORE ROOSEVELT*

<div align="right">Endion
New Rochester
[September 1898]</div>

My dear Colonel Roosevelt— What can give the blood a stronger action then when the whole tribe says "Ha"—? you know—you have felt it:—

And what is next—is the sensation, when the tribe says "aye"—I have felt this—

The greatest compliment I ever had or ever can have was when the Rough Riders put their brand on my bronze.

After this everything will be mere fuss—I am

<div align="right">Yours faithfully
Frederic Remington</div>

Thursday—

☐ *THEODORE ROOSEVELT TO FREDERIC REMINGTON*

(*Dictated*) Oyster Bay, Long Island
 September 19, 1898
Frederick Remington, Esq.,
 New Rochelle, N.Y.
My Dear Remington:— I think your letter pleased the rough
riders who saw it, as much as their action pleased you. It was the
most appropriate gift the Regiment could possibly have given me,
and the one I would have valued most. I have long looked hun-
grily at that bronze, but to have it come to me in this precise way,
seemed almost too good.

 Faithfully yours,
 Theodore Roosevelt

☐ *FREDERIC REMINGTON TO JOEL BURDICK*

 New Rochelle
 November 15, 1898
My dear Burdick:— Just back from Burlington, Vt. Went to
Webbs. Mighty fine country. Guess I'll give you the drawing
"Grimes Battery"[1]—in consideration of past favors and in the
hopes of more to come.—I am making a big painting of it.—

As to the address before The Albany His. Sc. etc.—if I got on a
platform before a lot of dress-shirts and low-necks I would have
a case of yellow fever right there on the stage. Not on your rhine-
stone. I aint no bloomin' wind jammer.

 Hope to see you when you are down—
 Yours
 Frederic Remington

Clarence Clough Buel was an assistant editor at The Century Il-
lustrated Monthly Magazine *who often wrote on topics of public
interest. He lavished praise upon Remington for his coverage of the
war in Cuba.*

1. "Grimes Battery Going Up El Pozo Hill" depicts Captain George Grimes and
his squad driving horses as they pull cannon up a hill during the Spanish-
American War in Cuba. It appeared as a full-page illustration in Remington's
article "With the Fifth Corps," *Harper's Monthly,* November 1898.

☐ *C. C. BUEL TO FREDERIC REMINGTON*

<div align="right">

131 East Sixteenth Street
October 28, 1898
</div>

My Dear Remington: I have just finished your experience with
the "Fifth Corps" and I write to thank you for leaving your fel-
lows of the quill so far behind. A well-conducted artist in the field
should subordinate himself to the professional word painters,
while travelling in their company. But here you are making the best
pictures of the Santiago campaign, and on top of that outdoing
everybody with a description of the scenes and the emotions of
that remarkable advance to San Juan. Yours is the only article I
have read on the subject which is wholly satisfying & satisfactory.
Capt. Arthur Lee's[1] I would place next, for my own taste, and by
comparison is special and less stimulation. So much ill-temper has
been spread on paper about those events, that I think your fair-
minded poise, and bonhommie deserve a loud toot of praise. The
whole paper is bubbling over with vitality; and a raciness and apt-
ness of phrase, give it the true literary stamp—and you write
about the things you saw and felt, and convey the conviction that
you understood them! I am laying it on a little thick, because
you have greatly moved me. And incidentally I think you never
did anything more dramatic and artistically powerful than the
charge of Grimes's battery up El Paso. But that is in your line and
no crime.

<div align="right">

Effusively thine,
C.C. Buel
</div>

Your wry face at ships reminds one of the day I had you and
Zogbaum[2] at my mercy in the *Bee.*

> *Robley Dunglison Evans was a captain in the U.S. Navy. When in
> command of the* Yorktown *at Valparaiso, Chile, in 1891, his actions
> earned him the name "Fighting Bob." As commander of the* Iowa *in
> Sampson's fleet off Santiago, he took an active part in the battle with
> Cervera's fleet on July 3, 1898. He was made rear admiral in 1901.*

☐ *R.D. EVANS TO FREDERIC REMINGTON*

<div align="right">

324 Indiana Avenue
Washington, D.C.
January 31, 1899
</div>

My dear Remington, Yours of Monday reached me today & I am
truly glad to hear from you and am sorry that I am not in striking

1. Arthur H. Lee, British military attaché.
2. Rufus Fairchild Zogbaum, Western illustrator and artist.

distance for I should be glad to see the many good things you
have done of the late war. How sorry I am that you did not stick
to oldship and see the fighting with us—it was beautiful & you
could have made such lovely pictures of it all—I saw one of your
pictures of my dear old friend Allan Capron[1] in command of
E Bat 1st Art—It certainly was most characteristic & life like. You
had him on horseback just riding up some rising ground & look-
ing for the Dons. I suppose the "doughboy" fever was really too
strong for you and you couldnt stand the quiet ways of the "web
foot"?[2]—

Good luck to you, old man, & if you come this way be sure you
look me up.

> Faithfully yours.
> R.D. Evans

*Remington summed up his ambivalent feelings about the war in
Cuba in a letter to Wister in 1899. The West, he says, "was my War,"
and that, he concludes, is what he will devote his time to.*

☐ **FREDERIC REMINGTON TO OWEN WISTER**

> New Rochelle
> September 1, 1899

My dear Wister:— Just back from two months in Montana and
Wyoming—trying to paint at the impossible—had a good time—
as Miss Columbia said to Uncle Sam "That was my War"—that old
cleaning up of the West—that is the War I am going to put in the
rest of my time at.

I am doing a big painting for Paris[1] now—derived from Reno's
repulse—where they all crossed the ford in a huddle—its kind of
unpatriotic but art, is impersonal I am told.

I am meanwhile tusseling with your d—— subjectives in *"The
Game and the Nation"*.[2] You get harder all the while for the plas-
tic man.

What do you think of my little stories[3]—they must feel ama-

1. Captain Allyn R. Capron was killed at the battle of Las Guasimas on June 24,
1898.
2. A navy man.

1. His painting for the Paris Exposition of 1900 depicted Sioux warriors
turning Col. Marcus A. Reno's troops back from the Little Big Horn Creek in
1876. It was never exhibited.
2. "The Game and the Nation" by Owen Wister appeared in *Harper's Monthly*,
May 1900, illustrated by Remington.
3. Could refer to Remington's little book, *Stories of Peace and War*, published by
Harper's in 1899.

teurish to you but they are not subjective and they give me a chance to use "my right" as they say in the arena.

How do you get on with your wife—who is boss? or haven't you had time to settle that yet. I believe that sometimes takes several campaigns. Annexation is attended with difficulties.

I am going to Saratoga Monday. Do you take the National Institute seriously?

That was a great poem of yours but if I ever get a chance at you I will cure that Boston fever—I thought you argued too well for Columbia—d—— her in that case.

<div style="text-align:center">Yours faithfully
Frederic Remington</div>

Remington was always a supporter of Gen. Nelson A. Miles. He had little respect for Shafter, especially after the way he handled the Cuban invasion. Remington was on the latter's flagship and saw it first-hand.

☐ *FREDERIC REMINGTON TO POULTNEY BIGELOW*

<div style="text-align:center">New Rochelle
December 11 [1899]</div>

My dear Bigelow: Got card for your lecture but couldn't come. Why are you not in South Africa? The British are up against it. They ought to have Roberts[1] and Kitchener[2] out there. I am afraid they are like us, keeping their Miles'es at home and sending their Shafters and Otises out—if they have any such chromoes in their army.

Too overpowering this Harper business, isn't it.

I am plugging away. When do you go back!

<div style="text-align:center">Yours
Frederic Remington</div>

1. Sir Frederick Sleigh Roberts, British general who in 1899 took supreme command in the Boer War.

2. Horatio Hubert Kitchener, British general who became chief of staff during the Boer War (1899–1900) and was then made commander-in-chief (1900–1902).

Chapter 5
Visible at Last
1894–1902

THE DECADE OF THE 1890s was a watershed in American history. Primarily rural and traditionally isolationist before this period, the United States emerged as a leader in world affairs after the Spanish-American War in 1898. In between, there was tremendous technological growth.

Before 1890 the magazine field was dominated by respectable monthlies such as *Harper's Monthly, Scribner's Monthly,* and *The Century Illustrated Monthly Magazine.* They were devoted to literature, not issues, and handsomely illustrated. *Harper's Weekly* was more issue-oriented than the monthlies, and featured articles, short stories, and drawings. Current events were discussed with scholarly objectivity. Finally, there were magazines for children, such as *St. Nicholas* and *Youth's Companion.* Some of the best writers and illustrators of the day were contributing to these magazines, including Remington, Howard Pyle, Edwin A. Abbey, Arthur B. Frost, and Edward Kemble.

Popular taste of that time leaned toward paintings that told a conventional story, pointed to a moral, or realistically reproduced familiar people and scenes. The artists most widely viewed were illustrators for the popular monthlies and weeklies. Within this context Remington found his work in great demand.

By the late 1880s, however, a spate of new monthlies (such as *Munsey's, Cosmopolitan, McClure's,* and *The Outlook*) and weeklies (such as *Collier's* and *Literary Digest*) were arriving on the scene. Applying the techniques of industry, their publishers and editors reasoned that good fiction and solid articles would sell to a mass market if the magazine were packaged attractively and priced low. The magazines were also distinguished by a lively interest in cur-

rent problems and leaned both toward the developing progressive attitudes of the day and toward sensationalism. *The Saturday Evening Post* made its appearance at this time and soon became the most powerful and popular of the new weeklies. It was rivaled by a host of imitators, including *Woman's Home Companion, Collier's,* and *Cosmopolitan.*

Remington's association with Harper's continued into the early part of the twentieth century. His work appeared not only in *Harper's Monthly* and *Harper's Weekly* throughout the year, every year, but also in *Harper's Young People* in 1894, in *Harper's Round Table* in 1896, 1897, and 1898, and in *Harper's Bazaar* in 1893 and 1899. He continued his long association with *The Century Illustrated Monthly Magazine* (illustrations appeared in 1890, 1891, 1892, 1893, 1897, 1898, 1900, 1901, 1902, and 1904) and *Outing Magazine* (illustrations appeared in 1892, 1893, 1895, 1899, 1900, 1901, 1902, and 1903). He also developed new associations. Beginning in 1898, his work appeared in issues of *Collier's* every year until 1913, four years after his death. *Cosmopolitan* frequently used Remington's work, which appeared in issues every year between 1891 and 1898 and again in 1901, 1905, and 1906. Other magazines of the period that carried Remington illustrations were *Everybody's* (1901, 1902, 1903, 1905); *McClure's* (1899, 1900, 1901); *Metropolitan* (1896, 1906, 1908); *Outlook* (1897); *Quarterly Illustrators* (1893, 1894); *Saturday Evening Post* (1901); *Scribner's* (1892, 1893, 1899, 1901, 1902); *Sunday Telegraph* (1903); *Woman's Home Companion* (1902); and *World's Work* (1905).

Photography emerged to revolutionize magazine illustration in the 1890s. In the 1870s photography had been a cumbersome process employing heavy glass plates, tripods, and large cameras, but toward the end of that decade, a new, smaller, faster dry plate was introduced that in turn made possible smaller, lighter cameras that could be easily used by an amateur. (The new techniques also made possible Eadweard Muybridge's brilliant stop-action photographic studies of animals in action, which incidentally enabled Remington to prove that a horse in motion could have four feet off the ground at once.)

Remington himself used a camera, especially early in his career on his western trips. His letters indicate that he used photographs to jog his memory of places and people. Although it is not clear from the correspondence, there is speculation that he even posed scenes for pictures from which he then drew his illustrations. He owned a camera, perhaps several, and in the 1880s sent cameras to his friend Powhatan Clarke, urging him to take pictures and send them to him. He also purchased photographs from soldiers when he could and relied on his vast collection of memorabilia for details when his memory or photographs were insufficient.

When Remington sold his first sketch to *Harper's Weekly* in 1882,

photographs and drawings were reproduced by means of wood-engraving. In order to speed up this rather slow process, publishers would have a large block of wood sawed up, distributed to different artisans for engraving, and then reassembled for printing. Because each engraver's style varied a little, artists were not altogether happy with the results. More to their liking was a new photomechanical halftone process that made it possible for art to be reproduced directly without the intermediate step of the engraver. Although the early photogravure method could reproduce the artwork beautifully, it had to be done on a separate intaglio press and bound into the book. This took time and made the book more expensive. Houghton Mifflin used this technique in 1890 for Remington's illustrated edition of *Hiawatha*.

By 1892 a single copper halftone plate had been developed that was mounted with the type so that halftone and type could be printed simultaneously. This became the generally accepted method for printing illustrations and photographs in the 1890s. The next step would be color.

"Color process printing did for Frederic Remington and his art what the incandescent lamp did for Edison and the telephone for Bell."[1] Five-color photomechanical reproduction of paintings became a reality after the turn of the century, and Remington would take full advantage of the opportunities it offered.

Meanwhile, as cameras improved so did the use of photographic illustrations increase, particularly as they became available at a fraction of the cost of drawings. Although he continued to provide illustrations for a number of magazines well into the twentieth century, it is interesting to speculate what effect this trend may have had on Remington's gradual movement away from illustrating magazines and toward sculpture, writing, and fine art.

It was during this period that the relationship between Remington and Owen Wister evolved. Wister had been a student at Harvard when Remington was at Yale. He graduated Phi Beta Kappa in 1882, studied music in Paris for a year, entered Harvard Law School in 1885, graduated in 1888, and began to practice law in Philadelphia. His law career was soon subverted by his interest in writing fiction about the West, where he spent his summer vacations in 1887, 1888, and 1889. Two of his articles were accepted by Harper's in January 1892, and two more in June 1893. Harper's gave one of the latter—"Balaam and Pedro"—to Remington to illustrate, probably because of his familiarity with Mexico. Wister's article appeared in the January 1894 issue of *Harper's Monthly* with a full-page illustration.

When the two men met, on September 8, 1893, in Yellowstone

1. Atwood Manley, *Frederic Remington in the Land of His Youth,* prepared for Canton's Remington Centennial Observance, 1961.

Park, it was quite by accident. They were compatible from the start. As Wister put it in his diary:

> Remington is an excellent American; that means, he thinks as I do about the disgrace of our politics and the present asphyxiation of all real love of country. He used almost the same words that have of late been in my head, that this continent does not hold a nation any longer but is merely a strip of land on which a crowd is struggling for riches. . . . Now I am a thin and despondent man and every day compel myself to see the bright side of things because I know the dark side impresses me unduly; but Remington weighs about 240 pounds and is a huge rollicking animal.

They did make an unusual pair. Wister was slender and somber, a product of Philadelphia's Main Line and well traveled; Remington was large and outgoing, with a small-town informal manner filtered through the cowboy lingo he had gleaned from his many trips to the West.

Harper's saw the pair as complementary and began using them to portray Western topics for publication in their monthly magazine. This collaboration resulted in "The Promised Land" (April 1894), "Kinsman of Red Cloud" (May 1894), "Little Big Horn Medicine" (June 1894), "Specimen Jones" (July 1894), "The General's Bluff" (September 1894), "The Second Missouri Compromise" (March 1895), "La Tinaja Bonita" (May 1895), and finally, "The Evolution of the Cowpuncher" (September 1895). It was this last article that epitomized their collaboration and conflict. Remington's idea of the cowboy was quite different from Wister's more noble figure.

The Wister cowboy was eventually fully realized in his book *The Virginian*, which appeared in 1902. Remington's would be *John Ermine of the Yellowstone*, published later in 1902 and rewritten for the stage in 1903. The voluminous correspondence between Wister and Remington between 1894 and 1902 chronicles their ongoing debate over the "authentic" cowboy and indicates the intertwining of their business and professional lives during that period. Their letters range over the vagaries of the marketplace, criticism or praise for one another, and support and suggestions that reflect their search for perfection. When three books of Remington's drawings were published by R. H. Russell—*Drawings* (1897), *A Bunch of Buckskins* (1901), and *Done in the Open* (1902)—the artist asked Wister to write the prefaces and in one case (*Done in the Open*) to contribute verses for captions. The fact that Remington did not return the favor and illustrate Wister's article "In the Back," however, did not help their relationship.

Between 1895 and 1902, Remington illustrated only three Wister articles for *Harper's Monthly*—"A Pilgrim on the Gila" (November

1895), "Destiny at Drybone" (December 1897), which included the picture of Lin McLean, and "The Game and the Nation" (May 1900). He illustrated Wister's "Superstition Trail," which appeared in the *Saturday Evening Post* on October 26 and November 2, 1901.

After 1902, they no longer worked together. Remington had already seen several anthologies of his magazine articles published (*Pony Tracks*, 1895; *Crooked Trails*, 1898; *Sundown LeFlare*, 1899; and *Men with the Bark On*, 1900). With *John Ermine of the Yellowstone* he created an original illustrated story. In 1906, *The Way of an Indian* would appear containing articles that had been published serially in *Cosmopolitan Magazine*. But he was continuing to question his approach to art and was moving away from the purely representational medium that had served him so well. The number of his illustrations appearing in magazines would decline as his artistic direction changed. On the other hand, as he produced more paintings and sculpture and the quality of reproductive techniques improved, his new work was seen even more widely. Evidence of Remington's change came in December 1901, when he showed fifteen of his paintings and ten pastels at Clausen's Gallery in New York. It was his first exhibition as a serious fine artist.

Credit is usually given to playwright Augustus Thomas, Remington's neighbor in New Rochelle, for stimulating his interest in bronze sculpture. He is said to have commented that Remington had a "sculptor's degree of vision" and was able to see things three-dimensionally. Thomas and sculptor Frederic W. Ruckstull both encouraged him, and early in 1895 Remington wrote to Wister that he was modeling in clay (he also used plasticine, a clay substitute that does not dry out when exposed to air) and that he was going to "endure in bronze." The letter included a sketch of *The Bronco Buster*. Remington completed the sculpture in August and took it to the Henry-Bonnard Bronze Co. in New York City to be cast. The firm was the best sand-casting foundry at that time. The model was recast in plaster, a standard technique, and then, because it was too large to be done in a single piece, the plaster was cut into sections. The tail, the rider's outstretched hand, and the base, for example, were all cut separately and reconnected with pins after casting. Although the plaster mold was lost with each casting, the foundry retained a master plaster mold from which it could make a negative mold for each new bronze. The disadvantage to the artist was that he could not make any changes to the piece without having a new set of molds made.

The *Bronco Buster* was copyrighted October 1, 1895, and Remington immediately set to work and completed a second bronze, *The Wounded Bunkie*, which was copyrighted in July 1896. He finished two more bronzes, *The Wicked Pony* and *The Scalp*, over the next two years and copyrighted them in 1898. They ranged in height from 20 to 26 inches. The reviews were good even though sales

were less than he had hoped for. Remington was pleased but busy. He was writing, illustrating, painting, and working in bronze all at the same time. He had also invented a munitions carrier for the military, obtained a patent on it, and sold a half interest in the patent to his friend Joel Burdick. For relaxation, he was riding his bicycle, a popular pastime in the 1890s.

As a sculptor in bronze, Remington soon became aware of another method of casting—the "lost wax" method. Not only can the sculpture be cast in one piece, but the malleability of wax as a medium allows the artist to attain textured surfaces and intricate details. Also the surfaces of the wax model can be reworked before casting. This means that each sculpture, if individually retouched prior to casting, is unique. The opportunity for additional artistic involvement was very appealing to Remington. After the Henry-Bonnard Foundry was destroyed by fire in 1898, he looked for a foundry using the lost wax method. In 1900, he began doing business with Riccardo Bertelli and the Roman Bronze Works in Greenpoint, Brooklyn. He worked closely with Bertelli over the years, and their business relationship grew into not only a friendship but an informal partnership with Remington exercising a good deal of control over the casting and the distribution of pieces for sale.

During the 1890s, Remington continued to make regular trips back to northern New York. "I leave for the north in two weeks," he wrote to Clarke in July 1892. Again to Clarke in April 1893, when work was proceeding on the New Rochelle house: "House is full of painters and paperers—fixing up—going to sell out and make a home where I came from—raise horses—canoe—be happy." A few weeks later, in June, he wrote, "I expect to go north in August and canoe for a while." In May 1894, he wrote to Bigelow that he had "been up north for two weeks in training." Usually on his return from these regular visits he had lost weight and felt good.

In the summer of 1897, Remington and his wife spent a month at the Witch Bay camp on Cranberry Lake. Marshall Howlett Durston, then eighteen years old, was visiting his uncle Fred Howlett at another camp on the lake, Tramps Retreat. As the residents of the different camps often socialized together, there was ample opportunity for young Durston to see Remington. He kept a diary that summer mentioning among other things that he rode in on the stage with Mr. and Mrs. Remington. In 1960, while being interviewed by Albert Fowler preparatory to the publication of his diary, Durston, then in his eighties, elaborated on Remington: "His typical day at the lake was to get up about 1 p.m., have three drinks, lunch, a couple cigars, start painting about 3 p.m., and work till midnight."

Typical activities for anyone there at the lake, as described by Durston, included swimming, playing poker, picnics, setting off

firecrackers, and singing around the piano, along with general re-laxation and conversation. When Remington wrote to Rob Sack-rider in the spring of 1899 that he and Eva were going to Cran-berry and wanted Rob and his wife to join them, it was with a sense that he was not yet too old to enjoy it there. With fame and money, however, also came a desire for privacy, and when the chance came in 1900 to purchase Ingleneuk, an island on the St. Lawrence River, he took it.

The American historian Francis Parkman (1823–1893) wrote The Oregon Trail *in 1847. Based on a trip to Wyoming he had made in 1846 with Henry Chatillion and Quincy Adams Shaw, it described the time he lived with and studied the Sioux Indians. In 1892, Remington was asked to illustrate a new gilt-topped edition of the book, to be published by Little, Brown and Company of Boston. The correspondence with Parkman is illustrative of Remington's style and his desire to get the details right.*

☐ FREDERIC REMINGTON TO FRANCIS PARKMAN

New Rochelle
January 5, 1892

Mr. Francis Parkman My dear sir:—As you are probably aware I am to illustrate your "Oregon Trail" and I write to ask you for certain material to aid me in the task. Anything sent to me will be taken care of and returned directly I am through with it. For any such I will be grateful.

Have you a photo of yourself which was taken about that time? (the trip West). State whether or not you had a beard.

Did Mr. Shaw have a contemporary photo and may I see it? As you both will occur in the pictures I want to do the best I can.

Have you any photo of Henry Chatillion or could you make a sketch which will give me the idea of how he looked. The rough-est sort of lines will convey a great deal to me.

Did you carry flint or precussion rifles.—What sort of hats were generally in vogue among hunters at that period. Which of these are the nearest. I suppose after men had been long out in the mountains they wore fur hats since the cloth hats would wear out.

Did the soldiers you met wear the U.S. regulation uniform of that period? It is very rare that soldiers do live up to the awful possibilities of the "full fig."

I think the above information will be enough for my purposes. You paint men very vividly with your pen and I fancy I can almost see your people. I shall never be able to fill your mind's eye but if I manage to symbolize the period successfully I shall be content.

Trusting that I may hear from you shortly since I am head over heels in the period of 1847 I have the honor to be

Very Respectfully yours
Frederic Remington

☐ *FRANCIS PARKMAN TO FREDERIC REMINGTON*

50 Chestnut St.
Boston
January 7, 1892

My dear Sir, I am very glad that you are to illustrate the "Oregon Trail," for I have long admired your rendering of Western life, as superior to that of any other artist. You have seen as much and observed so closely that you have no rival in this department.

There is no photo of either Shaw or myself taken near the time of the western trip. I will send you one or more of myself, taken a few years ago that will show the form of the features. Both S. and I were close shaven through the whole journey. I had an oval face, regular features, which may be described emphatically as "high cast." He was known as one of the handsomest men in Boston, though he seemed quite unconscious of being so having no vanity whatever. He was tall, lithe, and active and even in the roughest dress, had an air of distinction.

If I were asked to name the most striking combination of strength and symmetry I have ever seen, I should say Henry

Chatillion. In 1867 or '68 I saw him at his home in a suburb of St. Louis, a married man. He then gave me his daguirreotype, taken 10 or 12 years before when he was on the point of marriage, and got up in his "Sunday best," which of course spoiled him. His face, generally alert and vivacious, had in the picture the solemnity and dullness of a man oppressed and ill-at-ease. But, putting life and cheer into it, and adding a figure so well knit and well moulded that awkwardness was impossible to it, one would get the Henry of 1846. His dress on the Plains was a felt hat, a good deal like the

first of your three sketches—as were also Shaw's and mine—They lasted, in a rather demoralized state, till the end of the journey. Such hats were generally worn by trappers etc. Henry's picture is at my house out of town; but I will send it in a few days.

Shaw carried a double barrelled gun (percussion). I carried a long old fashioned western percussion rifle curved inward at the butt to fit the shoulder. In travelling it rested across the forward of the saddle, being too heavy for slinging.

S. and I for the first two months, or so, wore the frock and trousers of civilization and when these wore out, we got the squaws to make us fringed buckskin frocks, and trousers to match, with moccasins of the Sioux pattern.

The volunteer soldiers we met on the Arkansas were usually long legged Missourians, in homespun, over which were slung their powderhorns, bullet pouches, etc. There were a few regulars following a little behind, in regulation uniform that would hardly bear inspection.

My own equipment was an old fashioned powder horn and bullet pouch, with a belt and hunting knife.

I will get such photos etc. as I can and send them to you by express.

Do you know the admirable drawings of Charles Bodmer, the artist (an Alsatian, I believe) who accompained Prince Maximilian of Wied to the Upper Missouri in 1833 '34? They are printed in colors in a large folio volume of illustrations to the Prince's book called "Travels in the Interior of North America."[1] It must be in the Astor or the Lenox library. He paints the Indians exactly as S. and I saw them, before any touch of civilization had changed them in costume or otherwise.

> Believe me
> With high appreciation
> Yours very truly
> F. Parkman

1 *The Interior of North America, 1832–34* (Coblentz, 1839–41) by Prince Maximilian. R. G. Thwaites translated this work into English in *Early Western Travels, 1748–1846*.

☐ *FREDERIC REMINGTON TO POULTNEY BIGELOW*

New Rochelle
August 19, 1893

My dear Bigelow: Just back from prarie chicken shooting in North Dakota[1] and from the Yellowstone Park.[2] Made the d——est ride with a detachment of 6th Cav. over the mountain. One would not believe where a horse will go.

Sorry I could not come to maneuvers but it was too late and Harper did not want any more of that stuff.

Have seen the World Fair.[3] It's the biggest thing that was ever put up on this rolling sphere.

Glad you are coming over this winter. Will talk it over. If I can get a publisher to pay we would tackle your history with avidity, but everyone is hiding behind a financial mask of "painted" figures" and promises and clearing house certificates go for gold. To tell the truth—things are badly out of joint here and with a lot of retained attorneys who are Senators I do not see how the people are going to get what they want. There is an era of unrest here and no man can forsee the future. In hard times the *crank* comes to the fore in America and it is near impossible to suppress him. We have so few traditions in America and busted people are willing to attempt any scheme which promises a change—taking all chances that it may be for the worse. I think in time we Americans will have to take down our Winchesters from over the fireplace and "clean up" a lot of garbage that Europe has sent us. The German crank is the worst of all. There are two kinds of Germans. One is the best citizen we have and the other is a d—— erraticable lunatic, who makes up in enthusiasm what he lacks in brains. They are getting the art of "holding up railroad trains"[4] down to an abstract science here.

I have an imported Irish hunter "be God"—am the best mounted man in Westchester Co.

Regards to Madam—you and your family must have had a pretty summer.

Yours faithfully
Frederic Remington

1. "Stubble and Slough in Dakota," an article written and illustrated by Remington, probably a result of this trip, appeared in *Harper's Monthly* in August 1894.

2. "Policing the Yellowstone," also probably a result of the trip, appeared in the January 12, 1895, *Harper's Weekly*. This would also be the trip on which Remington met Owen Wister.

3. A Remington illustration, "Columbian Exposition: A Note from the Wild East," was the cover of the October 21, 1893, *Harper's Weekly*. The Columbian Exposition in Chicago in 1893 was also called the World's Fair.

4. He is probably referring to the increased unrest among railroad workers, the most notable example of which was the Pullman strike in Chicago the next year.

Remington's relationship with Harper's had long been an amicable one, with Remington exercising a good deal of artistic control over the use of his illustrations. The following letter indicates, however, that some strains were beginning to develop.

☐ **FREDERIC REMINGTON TO J. HENRY HARPER**

New Rochelle
October 30, 1893

My dear Mr. Harper:— I do not at all understand what the basis of my pay is for work for your house and wish to remind you of our conversation of this afternoon ask you to investigate.

"Stubble and Slough in Dakota" was one article—gotten on a trip which I had talked with you about and said that three articles might be gotten out of—to which you consented—they to pass muster at your discretion. I only get two—that being one. For some 4000 words I get $50. and numerous drawings are made only two pages and not paid for at $125. a page. This I do not understand and did not expect.[1]

Also I got $75. for the British Soldier in Madison Square.[2] Is this all you propose to pay me for weekly material per page. Do I have those drawings returned after this one?[3]

What am I to understand I am to be paid for the Owen Wister[4] Magazine stuff and do I have the drawings returned?[5]

A reply to this will be appreciated.

Yours faithfully,
Frederic Remington

1. In the margin on the side of this paragraph is written in Harper's hand, "$125 and we keep drawing." A mistake.

2. "Sketches at the Horse Show, Madison Square Garden," *Harper's Weekly*, November 24, 1894.

3. Marginal notes by Harper around this paragraph: "Return *Drawing*. Not ordered by us—and really not available in view of its recent handmarks by Thulstrup—We did not want him to lose his work, however, and greatly admired his drawing so we used it and paid him his regular price for both pages."

4. Articles by Owen Wister illustrated by Remington began to appear in *Harper's Weekly* and *Monthly* in 1894.

5. In Harper's hand: "$100 a page and retain the drawing."

When Harper's Monthly *began to publish stories about the West by Owen Wister, illustrated by Remington, the pattern was for Wister to write the story, Henry Mills Alden, editor at Harper's, to review the manuscript, and Remington then to illustrate it. Remington, however, often suggested name changes or specific facts about characters who were like people he had met out West. The article in progress was Wister's "Little Big Horn Medicine," which later appeared in Wister's anthology* Red Men and White *published in 1896.*

It's pretty, but is it Art? —Kipling.

☐ *FREDERIC REMINGTON TO OWEN WISTER*

New Rochelle
[Before June 1894]

Dear Wister— Have the photos—had no idea that there were millions of them—very interesting and well taken.

Just gone over Big Medicine[1] carefully and its a strong story.
"I am a medicine man
"Temperize Johnson baby temperize
"The dead medicine man are the points of illustration.

I would change "*Young man afraid of his moustache* to some other Souix name. That has been made game of. You will find some good Souix name in the M.S. of the Council.—
 Yours
 Frederic R—

☐ *FREDERIC REMINGTON TO OWEN WISTER*

New Rochelle
[Before June 1894]

My Dear Nerve-cell— The more I study & contemplate "The little Big Horn M-" the more I must say—its a very strong story— its a dead tie with the *"Kinsman"*[1] and I only hope I can realize

1. "Little Big Horn Medicine" was published in *Harper's Monthly,* June 1894.

1. "A Kinsman of Red Cloud" by Owen Wister, illustrated by Remington, was published in *Harper's Monthly,* May 1894.

enough in the illustration. You can put your mind at rest as to this story—it will certainly do.

Yours truly
Frederic Remington

P.S.—I am utilizing my cultivated ability to tell the truth—FR

☐ *FREDERIC REMINGTON TO OWEN WISTER*

New Rochelle
[Before June 1894]

Dear Nerve-cell— I notice in Big Horn you make conversation easy between Souix & Crow—they would employ a squaw interpreter or the sign language—

This is awful—but its true—and I suppose it is artistically insurrmountable—I only *"throw it out causually."* No one but some old chump would ever get on to this and I want to put you in mind of it so that you are surely justified in your own mind.

The thing itself (Little Big Med) is so d—— true.

Yours truly
Rocky Bear
after dinner—

☐ *FREDERIC REMINGTON TO OWEN WISTER*

New Rochelle
January 31 [1894]

Dear Wister— I interpolated the sentence you gave me—Its good—it does the trick.

Just as you like about *Old Man* Afraid & it does not much matter—As to "Pounded Meat"[1] I think thats more than good—its thoroughly characteristic and indian to the core.

I have turned in the illustrations and they are average.

Yours faithfully
Frederic Remington

1. "Old Pounded Meat" was an Indian name used in "Little Big Horn Medicine."

☐ *FREDERIC REMINGTON TO OWEN WISTER*

New Rochelle
February 8 [1894]

My dear Wister—Well compadre, what do think of "Black Water and shallows"[1]—Fly into me and jump on me and make it so that when I convalesense I will know more.

What's Stewarts sons address?
Yours faithfully
Frederic Remington

do a scrap! —

☐ *FREDERIC REMINGTON TO OWEN WISTER*

New Rochelle
April 12 [1894]

My dear Wister—Are you well—I hope so and please get a move on—I am starving—I want M.S. to illustrate.

Fire a half dozen in at Alden and I'll live to bless your memory. Put every person on horse back and let the blood be half a foot deep.—Be very profane and have plenty of shooting. No episodes must occur in the dark.

Yours faithfully
Frederic Remington

1. "Black Water and Shallows" was a story set in the Adirondack Mountains in New York State. It had appeared in *Harper's Monthly* in August 1893.

☐ *FREDERIC REMINGTON TO OWEN WISTER*

Endion
New Rochelle
[1894]

My dear Wister—I don't know if you have lit out—however I have to write—you made it imperative that I take as a gift what my tact (if I had any) would have known could not have been gotten otherwise, than by a lack of it. *Much obliged*—d—— that—its nice of you.

We have read *The Ships that pass in the Night*[1]—its cold hard damp *genius*—is there more "to say?"—To come down to *"figgers"* it raised me off the chair—but however *A Kinsman of Red Cloud*—how can you beat it—I don't know.

Yours faithfully
Frederic Remington

☐ *FREDERIC REMINGTON TO OWEN WISTER*

New Rochelle
[Before July 1894]

Dear Wister—In Speciman Jones[1]—why dont the white fellows run away—they are a hoss-back and the Inguns on foot?

Yours
Frederic R

P.S. Thats what I did under much more complicated circumstances on an occassion.

P.S. Change, so that they are *surrounded.*

☐ *FREDERIC REMINGTON TO OWEN WISTER*

Endion
New Rochelle
[Before September 1894]

My dear Wister. Things are done by the great house of Harper that jolt the intellect of common mortals. They play on the credulity of a pencil pusher like a state legislator does on his

1. Could be the title of a story but is not one jointly produced by Remington and Wister.

1. "Specimen Jones" by Wister, illustrated by Remington, was published in *Harper's Monthly*, July 1894, and later appeared in Wister's book *Red Men and White* in 1896.

followers. They explain it in such a careful way after-
wards, that no one knows anything about it and we can-
not change this—we are too few.

You jump my spelling carons! [illegible] but pooh to
you—every compositer and typewriter can spell words
that you never heard of.

I have got to lay myself out on "The Generals'
Bluff"[1] to knock out the inspiration of the "other artist."

I will get the miner *un*sophisticated.

Yours faithfully,
Frederic Remington

E. S. Martin, a satirist, wrote a column for Harper's Weekly *in Au-
gust 1894 in which he seemed to be subtly criticizing Remington for
trying to write as well as illustrate. In another column he seemed to be
encouraging Wister to stop writing about the West and do "polite so-
ciety" instead. This made Remington angry.*

□ *FREDERIC REMINGTON TO OWEN WISTER*

New Rochelle
August 9 [1894]

My dear Wister—In the last Harper's Weekly—a piece of office
furniture fell on you—the upholstery of a library chair sprang all
over you.

The first concern of polite society is not to be a d—— snob if
one finds that he is one he ought to try like the devil to conceal it—
Just write Mr. Martin or Harper's to that effect, old man. Jump on
'em heavily—

Yours faithfully
Frederic Remington

□ *FREDERIC REMINGTON TO OWEN WISTER*

New Rochelle
August 10, 1894

My dear Wister—Paine—Editor Harpers W. says I must do your
work. Had allotted on meeting you at Penna. State Camp.[1] I want

1. "The General's Bluff" by Wister, illustrated by Remington, was published in
Harper's Monthly, September 1894.

1. Remington convinced Wister to meet him at Camp Crawford, near Gettysburg,
Pennsylvania, to collaborate on an article on the National Guard. "The National
Guard of Pennsylvania" by Owen Wister was published in *Harper's Weekly* on
September 1, 1894.

to see how you can wrestle the military proposition. Sorry you don't go, I was going down next Wednesday to do pictures. Better reconnoitre it—go down—tell how much better red-blooded soldier are than little stinking library up-holstery such as Martin of Harper's is. Great opportunity.

Yours faithfully,
Frederic Remington.

☐ *FREDERIC REMINGTON TO OWEN WISTER*

New Rochelle
[undated]

My dear Wister So glad to hear from you again—Yes—you are "a pig." Please be more human in the future.

But I say—it will be forgiven if you go into poetry & "sich" but why go East? Why do that pie and pine tree mourning necessary to do New England unless you are going to do the "Smedley" part—creased "pants" and bric-a-brac.

You were the only "good thing" that ever came my way. Whatever are left will die of running after Phillipos under hot suns.

Come back—do the 4 volume novel about a South Western Natty Bumpo— Believe me, I know. I was born in October and that "sign" gives "savy."

Mrs. R. has been sick for a week—all right now. Want you to come up—when you get ready. Mrs. R. says bring the "kid." We will put a pipe-line on your cow.

Where are you going to settle.

How's this for a Presbyterian.

Yours
Frederic R.

☐ *FREDERIC REMINGTON TO OWEN WISTER*

New Rochelle
[September 1894]

Dear Wister—I had to have all my stuff in Tuesday night and couldnt do *Hoodo*.

Only had page & half as it was—poor business.

Don't know just when I go West—will let you know soon as hear from Miles

Am writing "Bicycle *Infantry*"[1]

Penna. Squad great—greater as d—— further off. It grows on me.

Glad you like Girl

<div align="center">Yours
Frederic Remington</div>

"As a rather noteworthy piece of library unholstery once said on his first sight of red blood in text—it does not concern polite society."—

Remington went West with Gen. Nelson Miles in September 1894. Their goal was grizzly bear hunting on the New Mexico ranch of English-born Montague Stevens. They went in Miles's private railroad car. Miles's son, Sherman, went along. They did kill a 300-pound black bear.

As Remington prepared to go West in the fall of 1894, he remembered some misplaced shoes that he wanted for the trip. Even in this plea for help, he managed to sneak in some business chatter.

☐ FREDERIC REMINGTON TO OWEN WISTER

<div align="center">New Rochelle
[September 1894]</div>

My dear War Eagle—I left a pair of crocodile shoes in Col. McClenllan's tepee[1]—got letter from him "Phila Club"—awful signature—couldn't be sure of it—said he had "spoke" to you about them—I wrote him—do not hear—want to go West—can't go without my *crocodiles*—

can you help a fellow.
Do you ever see him—
Does he live there
or in Harrisburgh?

How goes it—war
eagle—how do you like
your self in your new role—
look out for the "Rats"—
they may get next to you.

<div align="center">Frederic—</div>

1. "The Colonel of the First Cycle Infantry" by Frederic Remington was published in *Harper's Weekly*, May 18, 1895.

1. Probably during their time in Gettysburg in August 1894.

☐ *FREDERIC REMINGTON TO OWEN WISTER*

New Rochelle
—Saturday [September 1894]
My dear Wister—Have gotten the "crocodiles"—dont bother—
Leavenworth—Riley—Wingate[1]—New Mexico[2]—Hope to meet
Specimen Jones[3]—

I sent an "ile paintin"—Mexican
cavalry to Grant[4]—officers mess—
nice of me, wasnt it?
 Keep me informed when you
discharge M.S. at Alden.[5]—
Yours faithfully
Frederic Remington

This is an example of Remington's humorous prodding of Wister to do a cowboy article. Remington is on his way to the Southwest, having met Miles and the rest of the party in Chicago.

☐ *FREDERIC REMINGTON TO OWEN WISTER*

New Rochelle
[September 1894]

Great & rising demand for—a
cow-boy article.—"—The
Evolution & the Survival
of the Cow-boy" by
O. Wister with 25
illustrations by the
eminent artist *Frederico
Remintonio.*—just out.

1. These were forts Remington expected to see on the trip West with Gen. Nelson A. Miles.
 2. Montague Stevens's ranch in New Mexico was his ultimate destination.
 3. Specimen Jones, the main character in Wister's story of the same name.
 4. Camp Grant, Arizona Territory.
 5. Remington wanted to make sure he was around to illustrate Wister's latest work when editor H. M. Alden at Harper's was ready for him.

☐ *FREDERIC REMINGTON TO OWEN WISTER*

Endion
New Rochelle
[Early October 1894]

My dear Wister—Just back from New Mexico—had a good time—bear hunting—two bear.

I will jump Harper for last M.S. I will not recognize any resemblance to myself in the M.S. unless it be very flattering.

That about being too much before the public is d—— rot—— (pardon me) but I must tell the truth. The public is always in a frame of mind to forget you if you will let them and shortly they will give up trying to get rid of you.

Yours faithfully
Frederic Remington

☐ *FREDERIC REMINGTON TO HENRY L. SACKRIDER*

The Deacon—

New Rochelle
[1894]

My dear Grandpa—Have been thinking of you—have just come from a bear hunt in New Mexico—chased them with hounds, we on horseback. Great sport—got a silver tip 700 lbs. one black 300 lbs. Cowboy caught the silver tip with their ropes—three of them and killed him with rocks and a knife. They had no guns—I shot an antelope at 200 yards through the heart.

I am very hard at work painting horses in my back yard. Its warm here. As soon as it cools will ship you some oysters and clams. Its a little warm yet.

Havent had much fun this year—had to hustle for a living but you see Harpers and know about how I do it.

I dont think there will be any more Democrats ever again—They have made such cussed idiots of themselfs that they are going out of business. They will lick Tammany in New York City and that is a blessing.

The trouble with this country is that there are too many d—— fools in it, but the fool-killer is sharpening up his knife and there aint going to be so many after a bit.

myself at work.

Eva sends love and I wish you good health for a long while yet.

I am a very busy man and dont have time to black my boots—much less write letters or I would so often. Eva writes to Em.[1] though and you hear about us and we you.

Tell Rob that my man Tom wants two (not loud colored) of those macanaw lumberman's shirts this winter and he can send them on with the veal—also bill

Yours faithfully,
Frederic Remington

After Remington returned from the bear hunt, he wasted little time in pushing Wister to write an article about the cowpuncher. Wister agreed and Remington wrote several letters filled with details of cowboy lore to help the writer. Sometimes detailed sketches helped dramatize the point.

"The Evolution of the Cowpuncher," written by Wister and with five full-page illustrations by Remington, appeared in Harper's Monthly *in September 1895.*

☐ *FREDERIC REMINGTON TO OWEN WISTER*

Endion,
New Rochelle
[September or October 1894]

Say Wister—Go ahead please—make me an article on the evolution of the puncher—the passing as it were—I want to make some pictures of the ponies going over the hell roaring mal-pair

1. Emma Caten, Eva's sister.

after a steer on the jump. I send you—a great story by Stevens [1] of the S. U. ranche—"front name Dick." [2]

I will give some notes—

Title "The Mountain Cow-boy [3]—a new type"—

—this idea can be worked in

bunch of cattle

cow boys .

The early days 65 to 1878 he was a pure Texas &c—cattle boom he was rich—got $75 a month—wore fine clothes—adventurous young man from all parts went into it—just as they would be Kuban Cossacks if they got $100-a month. Cheyanne saddle—fine chaps— $15 hats—Fringed gloves—$25. boots &c. With the crash of the boom— Yankee ingenuity killed the cattle business as much as anything,—the Chicago packers—the terrible storms, the drought &c.—then the survival of the *Stevens cow-boys*—run down a hill like as fast as a steer—over mal-pai—through juniper—they fall and are hurt—they run into bear—they are all Texans—do not drink now—get 30 a month—work the year round—the country is deserted by whites—a great waste (N.E. New Mexico). Stevens had a hell of a time killing off and running out thieves—Had 5000 in bank—to go to the man who killed the man who killed used to bushwhack—14 over a maverick.— wear very wide chaps 7 horses to a mount, the time. *"ramūda"* bred in mountain— hoop like iron—To hold alkali puddles—the deer—do not wait for quick as deer—are killed by bear and wolves—mavericks in bunches—some 8 & 9 & 10 year old. Dan roped steer over cliff—

him.—they men killed they dress poorly, —have 3 mounts are in saddle all horse herd—horses great lung power—and cattle they bog in the cattle—are as wild as punchers but pull out as

1. Montague Stevens, a graduate of Trinity College, Cambridge, first experienced the American West in 1880 on a trip to Wyoming. In 1882, he started ranching in New Mexico and by 1893 was one of the largest landowners in the region.

2. "Front Name Dick" by Montague Stevens, illustrated by Remington, was published February 1897 in *Cosmopolitan*.

3. The name Remington gave to the type of cowboy who worked the Stevens ranch.

— edge of cliff

it ran over after being roped—rope tied to saddle horn—pony set back on edge of cliff,—hell of a position. Stevens had new rope—60 ft. horse fell on mountain side—rope caught on stub—horse fell over cliff—so did Stevens—d—— near killed him—When woke up found pony hanging—the rope was new—sprung and did not break.

Jokes—
"I understand you went up a tree with the bear just behind you"
—"The bear was not ahead of me"

Speaking of good horse "A meal a day is enough for a man who gets to ride that horse!"

Well go ahead—will you do it.—get a lot of ponies "just a smokin" in it. Chaps are caught by two buckles otherwise they fly loose—

Frederic Remington

*While they were collaborating on the "Cowpuncher" article, Reming-
ton illustrated another Wister article, "The Second Missouri Compro-
mise," which appeared in* Harper's Monthly, *March 1895.*

☐ *FREDERIC REMINGTON TO OWEN WISTER*

New Rochelle
[October 13 to 18, 1894]

My dear Wister:—Well—old man—what's the matter of your com-
ing out here for next Sunday. Why, also, cant you come so that we
can have a ride Saturday afternoon. Leave Phila. early and that will
make it. Better bring your boots and breeches—it may be nasty.

I have the "Second Mo. Com.—and its bothering me to know
just how to illustrate. We will "raise our voices" in the matter.

Write if you'l come and when.

Yours faithfully
Frederic Remington

☐ *FREDERIC REMINGTON TO OWEN WISTER*

Endion
New Rochelle
[October 20 to 30, 1894]

[Dear Wister] I wrote an article in "The Century"[1]—The horse of the Plains '87—I went into that—I cant find the article.—

Cortez[2] had horses but they must have been all killed—subsequent importations—stolen and lost—the Sioux have a legend of the first horses—they were stolen from Mexico.—

"Cayuse"—a north western indian tribe who raised good horses—the term grew and is localized in the north west.—

"Mustang"—a California word for a steed.—much used by '49 but never established in use (out of story books) East of Mountains.—

"Broncho"—"wild" Spanish—means anything north of where the people don't understand Spanish.—

Cheyanne saddle—made in city of cheyenne from California models—are so called all over—there are many forms of California saddle & also Cheyenne. Are made in St. Louis I believe.

Pure type Cheyanne

Mexican Tree—dont know how (the cowboy) was affected by the Mex. war— he did not exist as an American type— [illegible] was later a combination of the Kentucky or Tennessee man with the Spanish.

Mexican Tree.

In Civil War he sold cattle to Confederate Armies—but was a soldier in Confed army but as pure thing he grew up to take the cattle through the Indian country from Texas to meet the R.R.—at Abilene— or before that even he drove to Westport Landing—These were his palmy days—when he literly fought his right of way—he then

Brazos Tree

1. A much earlier article of his, "Horses of the Plains," which had appeared in *The Century Illustrated Monthly Magazine* in January 1889, not 1887.

2. Hernando Cortez, Spanish adventurer and explorer who colonized Mexico in the early sixteenth century.

drove to the north and stocked the ranges—then the thing col-
apsed and he turned "rustler"—and is now extinct except in the
far away places of the Rocky Mountains.—Armor[3] killed him.—
Don't mistake the nice young men who amble around wire fences
for the "wild rider of the Plains."—

And incidentally speak of that puncher who turned horse &
cattle thief after the boom slumped and who was incidentally hung
and who still lives and occassionally in the most delicate way goes
out into the waste of land and ship theirs to Kansas City—after
driving a great many miles to avoid livestock inspectors. &c &c

<div style="text-align:center">F.R.</div>

(On the back page, Remington added another note:)
Have a good start on a big oil. (I couldn't monkey with it) on
The Second Missouri.—[4]

Got a side face of Specimen. I will fix him for
all time—unless you give me a back view.

<div style="text-align:center">Who looks like this in life—</div>

<div style="text-align:center">F.R.</div>

"Fire and Sword"[5] is the greatest book
I ever read where Fallstaff says "I
will die with my fleas"

3. Philip Danforth Armour, merchant and capitalist, who was head of Armour
and Company—and responsible for the appearance of meat-packing plants.

4. Another Remington drawing of Specimen Jones appeared in Wister's
"Second Missouri Compromise."

5. A book written by R. Slatin, a British colonel, which described the author's
adventures as a captive of the fierce Mahdi tribe in the Sudan. Falstaff was a Su-
danese chieftain who resembled Shakespeare's character in his size and love of the
good life.

☐ *FREDERIC REMINGTON TO OWEN WISTER*

Endion
New Rochelle
[November 1 to 10, 1894]
Mr. Nerve Cell—That's what you are—Have just read the Tinaja[1]
and its enormous—its just so—that what the people in it would
say and you are right on to 'dobe holes—and of course that's just
the way Arizona is but after its published you can't go down there
any more or the real estate fellows will hang you. Only half pages
but I could do 300—It's a whole book on Arizona. It's pretty fine
for a dude who has never been in A. to follow you, but it will just
make fellows who have "slap each other on the back."

You have an air tight cinch on the West—others may monkey
but you arrive with a horrible crash every pop.

Frederic R.
"What size hat are you now wearing."

*Montague Stevens, Remington's host for the bear hunt in September
1894, wanted to write an article about their visit for Remington to
illustrate. Remington demurred.*

☐ *MONTAGUE STEVENS TO FREDERIC REMINGTON*

Union Depot Hotel
Pueblo, Colo.
November 29, 1894
My dear Remington, Just a line to acknowledge your last letter. I
am now on my way to Albuq. for a few days and then hope to
start East stopping with friends in Chicago & Buffalo en passant. I
would expect breach New York somewhere about the 20th Dec. As
regards the writing of the article you are of course the best judge

1. "La Tinaja Bonita," written by Wister and illustrated by Remington, was
published in *Harper's Monthly* in May 1895.

& if you would prefer Wister to write it I will cordially do my level best to aid him in any way that I can.[1] Of course it will be a handicap for him to accurately describe a hunt in which he did not participate & for that reason I would think that it would not be a bad plan if we were all three to enter a sort of triple alliance whereby an article might be evolved that would at once be artistic and also factual. I would therefore suggest that you arrange a meeting either at N.Y. or Philadelphia (whichever is most convenient to yourself & Wister) for the purpose of collaborating. How does this idea strike you?

As there will hardly be time for me to receive an answer from you before I leave Albuquerque please address in care of Edward H. Reed Esq., Corner Maple & Lake, Evanston, Illinois where I shall be staying about Dec. 12th.

With kind regards,

> In great haste
> Yours ever
> Montague Stevens

[In Remington's hand:]

> [December 1 to 5, 1894]

My dear—[Wister]

You must come to New York when I send for you—to meet Stevens—has good game for you—will you—

> Frederic R.

☐ *FREDERIC REMINGTON TO OWEN WISTER*

> Endion
> New Rochelle
> [Early December 1894]

My dear Wister—Stevens—cow baron of N. Mex. writes that he hits this clearing about the 22nd and wants to meet you.

Will you come over any day I send for you bar Xmas of course? since I don't know how long S. will stay. He is probably treading for *Heng*land

> Yours
> Frederic

Just turned in Tijana—

man in "dobe hole" talking to ravens—

How's that hit you

Didn't get the girl "pretty as the second word unfortunately says she was—but no one can expect that of me, but I got the dobe-hole dry.—

1. Remington did not collaborate with either man. He wrote the article himself and illustrated it. It appeared as "Bear Chasing in the Rocky Mountains" in the July 1895 *Harper's Monthly*.

☐ *FREDERIC REMINGTON TO OWEN WISTER*

Endion
New Rochelle
[December 20 to 30, 1894]

My dear Wister—Stevens thought (he misunderstood me) that you were to do the *bear hunt*—which I have written and which I can do much better than you because it was a lot of little things which happened and very little *bear* and you were not there anyway—but this Stevens is a character (not a sergeant with a hat knocked back) but a most impossible combination of English *"Ah s! Ah s"* and the best kind of horse sense (American stand-point) and *sand*—say O. W.—more *sand* than you could get in a freight car. Well, he is billed for Dec. last week of it and we must make a talk—guess we will have to do it in my room here—one night and down town the other—the two kinds of discussion differing in the degrees of "bottled sunlight" which occupies the center while we sit around.

 Stevens like any bonafide Englisher has got to be thawed out— he is thin and nervous but eleven or twelve hundred generations of fog inhalers cant be overcome in one short lift of life—say 35. He don't look like this but this is the way a physiognomy sharp would fill the curves just the same as he would (with sombrero & Bad land background) fill yours I often wonder how I look—and every man sees with his own eyes—otherwise how could an oculist get rich—hence the expression "Come off the grass"—

Yours feelingly
Frederic (O Bear)

P.S. By the way never use that "O Bear" again—I will trade that for my wooden indian—I have ended my bear article "O Bear"—
R

☐ *FREDERIC REMINGTON TO OWEN WISTER*

New Rochelle
[December 29, 1894]

My dear Wister—Stevens came through here on the run—going to England—Saturday—no time to get together.

 How is the cow-boy article coming on?

 I may take a run up to Canada soon for a couple of weeks. When do you go West.

Frederic R——

*Early in 1895 there was the beginning of a change in Remington's
activities. He had just begun to work in bronze and liked it. Also,
Pony Tracks, a collection of his stories, was copyrighted in April
1895 and published by Harper's, giving him new status as an au-
thor. He and Eva decided to go to Florida for a vacation and invited
Wister to join them.*

☐ *FREDERIC REMINGTON TO OWEN WISTER*

New Rochelle
[January 1895]
[Dear Wister]
Either leave the country—Manuscript
or Die—
 I feel that I may—I have *grip*—and
there is a riot in Brooklyn and I am
tired out—and two servants are sick and the old lady has to work
and is out of temper and I am going to Florida for a month the
very minute I can get the Doc. to say I can.
 Come—go 'long—alligators—tarpon.—
 I have got a receipt for being *Great*—
everyone might not be able to use the
receipt but I can. D—— your *"glide
along"* songs—they die in the ear—your
Virginian [1] will be eaten up by time—all
paper is pulp now.
 My oils will all get old and watery—that
is they will look like *stale molasses* in time
—my water colors will fade—but I am
to endure in bronze—even rust
does not touch.—I am
modeling—I find I do
well—I am doing a
cow boy on a bucking
broncho [2] and I am
going to rattle down
through all the ages, unless some An-
archist invades the old mansion and
knocks it off the shelf. How does
this strike your fancy Charles—

1. *The Virginian* by Wister, which was eventually published by Macmillan in 1902,
consisted of several cowboy stories with which Remington was already familiar.
The picture of the cowboy that emerged from *The Virginian* was to be the
prototype for a generation of stories, movies, and songs.
 2. The sculpture *Bronco Buster* would be completed by summer 1895. It
signaled Remington's start as a sculptor.

I have simply been fooling my time away—I cant tell a red blanket from a grey overcoat for color but when you get right down to facts—and thats what you have got to sure establish when you monkey with the plastic clay, I am *there*—there in double leaded type—

Well—come on, let's go to Florida—you don't have to think there. We will fish.

<div style="text-align:right">
Yours

Frederic R.
</div>

☐ FREDERIC REMINGTON TO OWEN WISTER

<div style="text-align:right">
Hotel Punta Gorda,

Punta Gorda, Florida

[February 1895]
</div>

My dear Wis—Sorry you cant come—I am like a sixteen year old school girl now.

The "Cow-boys" are all right.[1] Tell of the settlement and decline of the cattle business and of the *survival*—such as we find in the mountains.

There is a man down on the neck of land who owns 90,000 head of cattle—but that's another Story.—

Mrs. R. wishes you were coming and sends regards

<div style="text-align:right">
Yours

Frederic R
</div>

1. He is responding to the early draft of the "Evolution of the Cowpuncher" and making suggestions.

Upon his return from Florida he read the final Wister draft of the "Evolution of the Cowpuncher" and added some advice for finishing touches. Remington then wrote and illustrated "Cracker Cow Boys of Florida," a far different breed from Wister's cowboy. It appeared in Harper's Monthly *in August 1895, a month before "Cowpunchers."*

☐ **FREDERIC REMINGTON TO OWEN WISTER**

New Rochelle
[February 1895]
Dear Wister—I send back M.S. It's all right. Tell me when you present it. I want cavalry charge.

I think "chaps" comes from "chaparajos"—what that came from d—— if I know.

Strikes me there is a good deal of English in the thing—I never saw an English cow-boy—have seen owners.—

You want to credit the Mexican with the inventing the whole business—he was the majority of the "boys" who just ran the steers to Abiline Kansas.

I have just written article on "Cracker Cow Boys of Florida" Weekly[1]—

Yours
Frederic R

☐ **FREDERIC REMINGTON TO OWEN WISTER**

New Rochelle
[February 25 to 28, 1895]
My dear Wistie.—I want the "essay"[1] for the Magazine—of course—My Florida article is in the Weekly.[2]

No particular hurry about sending it in only would like it as soon as you can without throwing a spasm.

The article is all right—I would make *more scenes* and less essay—if you can see your way to do it. Make more of the 14 men and the maverick &c.

You just ought to see the "great model"[3] I am making—its a "lolle."

Yours
Frederic R

1. It appeared in *Harper's Monthly*, not *Weekly*.

1. "Evolution of the Cowpuncher."
2. It was in *Harper's Monthly*, or he may have been referring to "Winter Shooting on the Gulf Coast of Florida," which appeared on May 11, 1895, in *Harper's Weekly*.
3. Probably the *Bronco Buster* bronze.

☐ *FREDERIC REMINGTON TO OWEN WISTER*

Endion
New Rochelle
[March 1895]

Dear Wister—Well you are a Derby winner—you ought to get a small cheap man with just ordinary good sense to act as your guardian—some fellow to kind of look out and see that you don't starve to death in a restaurant or go to bed with your hat on—little precautions which are usual for persons to take.

I hope you find the M. S.[1] but you had better watch out or you'l have a jury of lunacy sitting on your spine.

Some fellow will paint a Liver Pill sign on your back if you are not more alert.

My "Cracker Cow Boys" went into the Magazine.

Yours
Frederic R——

☐ *FREDERIC REMINGTON TO OWEN WISTER*

New Rochelle
[March 9, 1895]

My dear Wister—I am to attend a dinner on the night of the 13th in Philadelphia—by the Nameless Club—an Art Club as they say. Wish you were invited—rustle around and get an invitation.

Go ahead with your d—— epic poem—my *model* is said by competant judges to be immortal—your sneer will live to haunt you.—

When oh when is the cow-boy to come.

Yours,
Frederic Remington

☐ *FREDERIC REMINGTON TO OWEN WISTER*

New Rochelle
[March 11, 1895]

Dear Wister—Dont know what hotel—will try Bellevue—Thursday I shall be under a Doctor's care—but you can come in and look at the remains before they are shipped back to New York for burial.

Yours truly
Frederic Remington

Leave here 3 o'clock will be in Philadelphia by six—Bellevue—if the Club dont take us in charge which seems probable, since they have bought my ticket.—

1. Wister temporarily lost the manuscript to "The Evolution of the Cowpuncher."

☐ *FREDERIC REMINGTON TO OWEN WISTER*

Endion
New Rochelle
[March 31, 1895]

Dear Dan—I am going to Washington Friday morning to dine with Theo. Roosevelt.[1] He said Dan Wister was coming—are you Dan—if so you have been trifling with me.

Still if you are Dan—why cant you meet me in Phila. and go on the same train.—

Yours faithfully
Frederic Remington

Remington's correspondence with Poultney Bigelow continued through the 1890s and emphasized his efforts at fitness—biking, walking, and trips north to Canada and the Adirondacks for canoeing. Bigelow had remained abroad. Remington illustrated one more article for Bigelow, "White Man's Africa," which appeared in Harper's Monthly *in February 1897.*

☐ *FREDERIC REMINGTON TO POULTNEY BIGELOW*

New Rochelle
[May 18, 1895]

My dear Bigelow: Just have your letter. I go to Canada tomorrow for 10 days fishing—Lake St. John 200 miles N of Quebec. I do not fish but I sketch the other fellows fish.

I am sorry you busted your ribs. You must have been having fun with "my British friends"—you are a d—— unfortunate chap—every letter contains how you were drowned—or broken or cut or licked or found bad titles to booksmor something like these.

Mrs. R. and I both ride—it is great fun—but d—— it every living human being in America rides "bike." Did you see my last article in Harpers Weekly on "bikes"[1]

I have concluded or did conclude some time since to quit drinking.—I reasoned that I had had all that kind of fun one man could expect to have and do anything else so I cut square off and feel better—but I am not a d—— bit sorry about any drink I ever had. I only hope to die sane enough to feel that whatever I do is all right, since I mean to do right.

1. Theodore Roosevelt was a member of the United States Civil Service Commission at that time, having been appointed by President Harrison.

1. "The Colonel of the First Cycle Infantry," written and illustrated by Remington, appeared in *Harper's Weekly* on May 18, 1895.

Sorry for your sake about the
big house. Money is a big thing to
have—but I guess old man that one
has got to make it to really enjoy it or
keep it. It comes so d—— slow that
there is never any confusion in ones mind
about how to place it. After he has so much
that it's hard to keep track of it don't mind if it
is lost, a little of it anyway. "Eggs in one basket"
is the great financial vice. Don't fail to give me
your new address.

Can you go up a hill as steep as this? I can.

Yours faithfully
Frederic Remington

☐ FREDERIC REMINGTON TO POULTNEY BIGELOW

New Rochelle
[1895]

My dear Bigelow: Your note here—and so now you are poor—
well—I don't believe it—but why speak of that—I have always
been so—and as for your saying you like it, that is d—— rot—no
one likes it—You once told me that my friends would have to pass
the hat for me some day—well—I guess "no."

Your suggestion of "biking" in France catches me but I have
determined not to go to Europe again unless I have to 'cause I
hate Europe. If they had a war or did anything new I might run
over and see it; but Europe is too set in its way for me—I rather
incline to America—it's always doing something new and no one
knows "what next" besides I am much *set* in this environment and
I feel that I am too good a thing to put a new fashioned frame on.
I already have a great reputation as a
European traveller (thanks to you d—— you)
and I have never said so in print but I
know the whole thing is spurious.

I am going to Lake Superior and
come down by canoe—that seems
worth while.

I am riding "bike"—it's great fun
—Everyone in America is riding
"bike." It makes the grease come
out of a fellow and is the
greatest thing to produce a
thirst for beer—besides
anyone can desecrate the

Sabbath on a bike and be forgiven by the other U.S.A.'s who all do the same. In that respect it is like going to hell—everyone is there whom I like.

I got the *Borderland*[1]—a striking title—and a cover—ye God—it would scare a car horse—a Florida negress would wear calico underclothing as bad as that.

I won the law suit—we smothered the defense—a d—— song writer does "Two Little Girls in Blue"—gets rich—buys a d—— plug—thinks he owns the roads—runs into the wrong man—gets it in the neck for $150.—no moral.[2]

As for your title—guess again from Yena to W——" no good—to book shelf'y. Put some mystery—some fog into it. something imaginative—like the title of my new book—*"Pony Tracks"* that's the stuff me boy.

Did I tell you that I was about to become a great sculptor.—if not—well d—— my modesty—it is so.

We are pot boiling along—raising Japanese spaniels and pointer dogs, having a little dissipation—making a living and waiting for "hard times" to let up so we can sell some pictures. You never tell me what you think of my French soldiers—no one else does—so I guess they are not much good—No one ever says anything about what I do outside of America so I guess I work the "main lead"—it goes 10 to the ton and not try to burrow for pockets. "Cowboys are cash" with me.

Owen Wister in Harpers—how do you fancy him.—I did not go to meet Kipling—unfortunately—but was sick.

Rather hope there will be a big turn up all over the world.—You tell your English friends that she don't want to get fresh down in South America—it only needs a "spark." We are sporting for a fight over here.

Regards to Mrs. B.—Write

> Yours faithfully
> Frederic R

☐ *FREDERIC REMINGTON TO POULTNEY BIGELOW*

> Endion
> New Rochelle
> [1895]

My dear Bigelow: I suppose you have gotten through throwing light onto German historical sensibilities and due back in that sad grey London—writing letters to everyone you know. You don't

1. *The Borderland of Czar and Kaiser.*
2. Refers to an incident in which songwriter George Spaulding's rig hit Remington's. Remington sued for damages and won.

tell me anything about yourself any more. I hope I will never meet you again but still I want to know what you are doing. I am modeling a "bronze" which is to be one of the world's treasures and I suppose you are getting Germany done up so that the "coming race" will not have *that* to worry about any more.

I never got my letter from De Maurier[1] saying "thanks d——you." I would frame it but one can't have everything. I go to Washington tomorrow to dine with Roosevelt and meet Kipling.[2] All the good men are in America. Villiers[3] the other night etc. I think we will have a "big row" here before you ever do over there.

I am riding a "by cic" now. I am happy. I have only one am-

bition and that is to see a war. I have just learned how to paint—I have invented a military appliance[4] which will make me "rich" and by God sir I have read "Borderland of Czar and Kaiser" and I am going to have a d—— sight better book published myself within a month—called "Pony Tracks."

Write me.

Frederic R.

☐ *RUDYARD KIPLING TO*
FREDERIC REMINGTON

[1895]

It was great fun at
Roosevelt's dinner: but
I had counted a good
deal on your also being there.
Dear Mr. Remington—This is a good business: for I did not know

1. George Louis Du Maurier (1834–1896), British artist and novelist. Remington had written a "fan letter" to him through Bigelow about Du Maurier's book *Trilby*.

2. Rudyard Kipling, the English author, was living in Vermont at this time.

3. Charles Pelham Villiers, English statesman.

4. On July 29, 1895, Remington assigned his interest in a patent for the improvement of stretchers and ammunition carriers to Joel Burdick.

that the *Cosmos*[1] had the maltese cat[2] or that you had aught to do with *cosmos* but why oh *why* drag in soldiers thee to assist at a polo match? Its entirely a horse-affair and no one can do western horses like you and if you dont make em too much broncos your cow ponies will be lovely. But I warn you fairly that if you make mistakes in detail about soldiers uniform you'll catch it—not from my hands but others. There was a man here who put a revolver on the wrong side of a cowboy in a picture.

Do you remember?

<div align="center">Very Sincerely
Rudyard Kipling</div>

☐ *FREDERIC REMINGTON TO OWEN WISTER*

<div align="center">New Rochelle
[April 1895]</div>

D. Wis— I am by nature a sceptic—I would not recognize the Second Coming if I saw it—I have long held *you* in mental *reserve*—In the market place I have said "Behold you d— ignorant gold bessodden rum bloated mugs"—"Wister—not Kipling"—not *King*[1]—Wister is *doing* it "The *Boom in Tucson*[2] fairly tells me that *we* have reached the *ideal* stage—we have long forgotten the *things we know* and are now going to do the *rally* [illegible]—I am simply lost in the immensity of space with the "Evolution"[3] & I am going to get *"Lost"* on Tucson.

Aside from your d—— lady[4]—you are to me welcome, you desert air—

<div align="center">Frederic R</div>

1. *Cosmopolitan Magazine.*
2. "The Maltese Cat" by Rudyard Kipling appeared in the July 1895 issue of *Cosmopolitan.* Remington illustrated it.

1. Gen. Charles King, a writer of Western stories during this time.
2. It appears that this was the early title proposed for "A Pilgrim in the Gila," written by Wister and illustrated by Remington, which appeared in *Harper's Monthly,* November 1895.
3. The "Cowpuncher" article.
4. Remington is expressing his dislike of widow Sproud, a female character in Wister's "A Pilgrim on the Gila."

☐ *FREDERIC REMINGTON TO OWEN WISTER*

Endion
New Rochelle
[April 1895]

My dear Wister—You are a crackajack—giving me the Apache[1] to do—way no—hell of a heap good.

More nice fellows are going to waste Monday evening than you are like to meet every day—If you will dine at the Players I will be there & then the Deluge—Enclosed invitation

Yours
Frederic R

Of course you have one before this.[2] Miles—me—you—Roosevelt &c. &c.

(*Card enclosed*)

The Aldine Club
75 Fifth Avenue

Mr. A. W. Drake

invites you to sit around

A WESTERN CAMP FIRE

which will be lighted at the Club House

on Monday evening, April 20, 1895, at eight-thirty o'clock,

To Mr. . . .

☐ *FREDERIC REMINGTON TO POULTNEY BIGELOW*

New Rochelle
[June 10, 1895]

P.B.— Now I have got you—
now I will get "heck" with you
for all the bad half hours and
the published slanders you have
put upon me. I aim to tell the
world in Harpers Weekly just
what kind of a lunatic you are and
"I will feed fat the ancient grudge I
owe you."

You will swear and tear your curly locks
and get the big wadi to kick your backsides.

Frederic Remington

1. A second picture Wister asked Remington to do for "A Pilgrim on the Gila."

2. A dinner invitation for April 5 with Gen. Nelson Miles and Theodore Roosevelt, et al., which Wister and Remington were to attend.

☐ *FREDERIC REMINGTON TO POULTNEY BIGELOW*

Endion
New Rochelle
July [1895]

My dear Bigelow: Should like to go to Kiel with you—great doings I imagine.

You come out this month with the Dutch and I with a Bear article—Harpers.

I am hard at work—going to do 600 miles on the Ottawa river this fall in canoe.

Looks pretty squeally over there in Europe now—think somebody is going to fight before long. Did you see my friend the *Kahns* Kid—he must be a brute for all we read.

Yours faithfully
Frederic Remington

P.S.
Sorry you are so poor—you can borrow 10 from me anytime.

Remington was enthusiastic about his first bronze, The Bronco Buster, *and favorable response began to surface after its appearance in fall 1895.*

☐ *FREDERIC REMINGTON TO POULTNEY BIGELOW*

Endion
New Rochelle
August 16, 1895

My dear Bigelow:

So you are on a canal boat now—that's odd—look out for the cholera.—Those nasty European sewers are dirty. I am going on a six weeks hunt on the Ottawa river.[1]

I sent a copy of my book "Pony Tracks" to 10 Chelsea. Did you get it?

I wish you wouldn't try to "jolly" me about the Emperor.[2] He never heard of me in his existence but when you Europeans get your two eyes on my bronze[3]—you will say *"Ah there*—America has *got a winner."* It's the biggest business I ever did and if some

1. A forthcoming trip with Julian Ralph, the author.

2. Emperor William II of Germany, whom Remington met with Poultney Bigelow on their 1892 trip to Europe.

3. *The Bronco Buster* (October 1, 1895): "Equestrian statue of a cowboy mounted upon and breaking in wild horse standing on hind feet. Cowboy holding onto horse's mane with left hand while right hand is extended upwards."

of these rich sinners over here will cough up and buy a couple of dozen I will go into the mud business.

I may ask you to get one on ex. in Berlin. Could you without much trouble.

I can't learn German and that's settled. I might as well try back-slip-flaps or total abstinence. Get me over to your d—— old war if you can and I won't talk anything but English and that can't do any harm in Germany if I remember rightly.

I bought Mrs. B's "Diplomatic etc" but a neighbor lugged it off and I have not read it.

<div align="right">
Yours faithfully

Frederic Remington
</div>

☐ FREDERIC REMINGTON TO POULTNEY BIGELOW

<div align="right">
New Rochelle

August 17 [1895]
</div>

Dear B:

Hustling myself—too hot to bike—later I may run over—come over any time you feel like it.

I suppose you took photographs in S. Africa. I would like to get the illustrating of your stuff. Use your influence for me.

I could make high wiggles.

<div align="right">
Yours

Frederic
</div>

"The Evolution of the Cowpuncher" finally appeared in Harper'.
Monthly in September 1895, with five full-page Remington draw-ings. The story created a mythical prototype for the cowboy of twentieth-century stage, screen, and story and brought Wister great fame. Remington's role in its literary creation has never been fully acknowledged.

☐ FREDERIC REMINGTON TO OWEN WISTER

<div align="right">
Endion

New Rochelle

[August 18 to 22, 1895]
</div>

My dear Wister— You ought to strike Phila—more often in your orbit—you are a d—— eccentric comet.—

Yes please Mister you may come next Sunday.

I "charged" on The "Evolution"[1] and the enemy broke before every forward movement. They did not wait for the "shock action" but pulled immediately when they heard my bugles—I captured 5 pages and Wister if we can't lug you into the immortal band with 5 pages you had better turn lawyer and done with it.

I want you to see my model—I am afraid it will be cut up this week.

You talk about fellows who have arrived—all they have got to do is to keep my name in stereotype in printer's cases—they will have to use it right along because if my model wont do I am going to be the most eminent market gardener in the suburbs of New York.

<div align="right">Yours
Frederic R.</div>

☐ *FREDERIC REMINGTON TO OWEN WISTER*

<div align="center">New Rochelle
October 24 [1895]</div>

My dear "Dan"—As that seems to be the only way I can identify you with your friends *Well* Dan—I want *Redmen & White*[1] with you in it, with no d—— commonplace sentiment like *yours truly* top of your name and as for "Pony Tracks" the next time I am in Franklin Square I will inscribe my theory of nerve-cells & ship to you.

I have only one idea now—I only have an idea every seven years & never more than one at a time but its *mud*—all other forms of art are trivialities—mud—or its sequence "bronze" is a thing to think of when you are doing it and afterwards too. It dont decay—the moth dont break through & steal—the rust & the idiot can not harm it for it is there to say by God one day I was not painted in an other tone from this—one day anyone could read me now I am *black-letter*—I do not speak through a season on the stage—I am d—— near eternal if people want to know about the past and above all I am so simple that wise-men & fools of all ages can "get there" and know *whether or not.*

Hope to see you—Just got the Xmas Story[2]—am doing it.

<div align="right">Yours
Frederic R—</div>

1. He is finally able to begin the illustrations for "Evolution of the Cowpuncher."

1. Wister's forthcoming book, *Red Men and White*, published by Harper Bros. in 1896.

2. "A Journey in Search of Christmas" by Wister, illustrated by Remington, appeared in *Harper's Weekly* on December 14, 1895.

☐ *OWEN WISTER TO FREDERIC REMINGTON*

October 26, 1895

Dear Mud: You are right. Only once in a while you'll still wash
your hands to take hold of mine I hope. It would be an awful
blow to one of this team if bronze was to be all, hereafter. I am
going to own the Broncho Buster. The name is as splendid as the
rest. I am glad you're doing the Christmas Story—if you'll put
in that suggestion of the eternal that you had all through the
Evolution. If you haven't already got your notions, bear Santa
Claus in the window in mind. I read an old note from you this
morning in which you spoke of our "forgetting the things we
know"—and striking the ideal. It is something worthwhile, if
true. Worth all the Kodaks in Narragansett. I liked "Three Old
Friends" in the Maltese Cat. If the sinews and nerves don't go
back on me, there shall be five good stories presently, and all
moving away from the Kodak. Tomorrow, Saturday, I shall see
the Broncho Buster at 430 West 16th Street. I am dining an en-
gaged man in the evening. My best regards to Mrs. Remington; &
the Gods prosper you.

Always yours,
Owen Wister

☐ *FREDERIC REMINGTON TO OWEN WISTER*

New Rochelle
[Late October 1895]

My dear Wister Bully for you going up against my bronze—As
for the Last of the Cavaliers[1]—it is yours but you must pay for the
frame. I am going to have a sale in November and it was going
in so that's why the frame is ordered. I will scratch it in my cata-
logue, and have it shipped as soon as I can.
 Will that be cheap enough—

Yours faithfully
Frederic Remington

1. A painting that Wister loved. It appeared as an illustration in "The Evolution
of the Cowpuncher." This was a prize gift, perhaps a response to the earlier Wister
letter on October 26 when Wister said he was going to own *The Bronco Buster*.

☐ FREDERIC REMINGTON TO OWEN WISTER

> Endion
> New Rochelle
> [Late October 1895]

Dear Nerve Cell—"I *open*" as the theatrical folks say on Nov. 14. American Art Association—6 E. 23rd and sell everything but "the old lady" on the night of Nov. 19 [1]—I am going to send you a bunch of my cards and ask you to mail them to Phila. folks where they may do some good.

I will tell Wilmert & Son [2] to ship you the picture [3] and bill. My framing-bill is bigger than the Taj-Mahal and I am shy on it—but you would have to frame it anyway and it will be done "right" now. Did you see the original? It may not be ready in a week.

I am d—— near crazy between illustrating talky-talky stories where everything is too d—— easy to see in your mind's eye and too d—— intangible to get on a canvass—(that's you and I except—Mr. Whitney's [4] musk-ox so far as he is concerned but I'm d—— if you can imagine how little I know about musk-ox when you get down to brass-tacks)

I'll never think about Pony Tracks but I'm trying to beat the band.

That *sale*—the bronze—magazines Horse Show pictures [5]—a patent I am trying to engineer—a story (good one) which I can't write about canoeing (by the way I'm going to do that all over again with you to make copy) and several other things make life perfectly *Chinese cookie* to me

> Yours
> F. R.

hoylied cael-

1. Remington's buyers at the November 19, 1895, show included Wister, Hearst, and Pulitzer.

2. Art dealers who framed many Remington pictures.

3. *The Last Cavalier.*

4. Caspar Whitney, author and friend. Remington illustrated a five-part series for Whitney. A musk-ox illustration appears in Part V of the series, which was titled "On Snow-Shoes to the Barren Grounds" and appeared in *Harper's Monthly* in December 1895 and January, February, March, and April 1896. Caspar Whitney was an expert on the outdoors.

5. "Getting Hunters in Horse Show Form" appeared in *Harper's Weekly* as a full-page illustration on November 16, 1895.

☐ *THEODORE ROOSEVELT TO FREDERIC REMINGTON*

<div align="center">
Police Department of the City of New York

300 Mulberry Street New York

November 20, 1895

Board of Police Commissioners

Theodore Roosevelt, President
</div>

Frederic Remington, Esq.,
New Rochelle,
New York

My dear Remington:—I never so wish to be a millionaire or indeed any other person other than a literary man with a large family of small children and a taste for practical politics and bear hunting, as when you have pictures to sell. It seems to me that you in your line, and Wister in his, are doing the best work in America to-day.

In your last Harpers article you used the adjective "gangling;" where did you get it? It was a word of my childhood that I once used in a book myself, and everybody assured me it did not have any real existence beyond my imagination.

<div align="center">
Faithfully yours,

Theodore Roosevelt
</div>

☐ *CASPAR W. WHITNEY TO FREDERIC REMINGTON*

<div align="center">
Harper & Brothers'

Editorial Rooms.

Franklin Square, New York.

December 7, 1895.
</div>

Dear Remington: I must send you a line and tell you how very much pleased I am with those drawings that you have made of the Barren Grounds. You have caught the barrenness of the country to a T. That scene of the Indians and dogs running down hill with the rocks sticking up through the snow is the exact thing; so also is the muskox scene. It is fine, I am awfully pleased with it, I think it is awfully fine. You need not get stuck on yourself though and come down here swelled out like a porpoise when you come into my little office; you might blow out the sides of the shanty.

I have asked Penfield[1] when he writes you to ask for another

1. An employee of Harper's who handled Remington's material for the magazine.

page, or page and a half, or half page on similar subjects. That is, if you have enough material left of the muskox and caribou scenes of which I told you to make another half page, or page and a half, or page, I would like very much to have it. Of course the order would go through Penfield to you.

> Yours truly,
> Caspar W. Whitney.
> (per H.C.P.)

Frederic Remington, Esq.

William Dean Howells, a novelist and dean of the American literary establishment, contributed to Harper's Monthly *and* Weekly *between 1886 and 1891 and later wrote the "Editors Easy Chair" for* Harper's. *He was full of praise for Remington's sculpture.*

☐ W. D. HOWELLS TO FREDERIC REMINGTON

> 40 West Fifty-Ninth Street
> December 22, 1895

Dear Mr. Remington: I'm glad you liked what I said of Wisters' work! I tried to insinuate my sense of yours into the same criticism. Where is the Broncho Buster to be seen? The picture of the statue took me tremendously. You are such a whaler in every way that it would be no wonder if sculpture turned out to be one of your best holds.

Why should you think I might not care for the Truth even in Indians? I care for it in everything above all things. What have I been shouting about for the last two years?

> Yours ever,
> W. D. Howells

Remington wanted Wister to go to the Southwest with him for fresh story material and be with him to be painted. His new interest in color in his work is apparent. Wister's health did not permit the two friends to join forces, and as a result future collaboration was probably slowed.

☐ *FREDERIC REMINGTON TO OWEN WISTER*

New Rochelle
[December 1895]
Dear Wis—Just got the Book dealer[1]—you & the Govt. hoss[2]—
his head is bigger than yours and thats a good sign—

Do you propose to dream with me on the Rio Grande—?

Why *kant* you come up here any old Saturday—

☐ *FREDERIC REMINGTON TO OWEN WISTER*

New Rochelle
[Before February 1, 1896]
Dear Sick Person—It was a great misfortune to you—'cause you
couldn't come up to the Hotel de Rem—I had a M.S. for you to
correct and a "Frontier Cavalryman"[1] in mud for you to make a
final kick against before it became immortal. We are still here if
you will come again—

Do you say you are going West with me "to dream dreams"
on February 1st—" any where will do me if the Sun is strong—
Lets try for two months—you investigate folks and I have to
find out for once and for all "if I can paint".—I have missed my
"shooting" this Fall but I don't care—Westward Ho! Ave course
I'll take me shoot-gun—

The thing to which I am going to devote two months is *"color"*

I have studied *form* so much that I never had a chance to *"let
go"* and find if I can see with *the wide open eyes of a child* what I

1. Refers to a December 1895 article by Nancy Huston Banks for *The Bookman*
that praised Wister's book *Red Men and White*.

2. A picture of Wister standing next to a horse that appeared in the Banks
article. It provided a target for Remington's irony.

1. Probably *The Wounded Bunkie*, Remington's second bronze.

know has been pounded into me I *had* to know it—now I am
going to see—I am sufficiently idolic to have a *color sense;* and
I am going to go loco for 2 mo.—I would like a man with me
whom I know is crazy.

Come! C O M E ! COME! C O M E !—Say you will—so we can ar-
range If Yes—we must have a talk[2]—

Yours
Frederic the No Good

☐ *FREDERIC REMINGTON TO OWEN WISTER*

New Rochelle
March 6 [1896]

Dear Wister—Just back from Texas & Mexico, got an article—
good illustrations but I tumble down on the text—its a narrative
of the Texas Rangers—I call it *"How the law got into the chap-
paral"*[1]—May have to ask you to bisect, cross-cut—spay alter,
eliminate, quarter and have dreams over it and sign it with the
immortal sign of he who wrote *"Where* Fancy was bred" had a
good time—painted—shot—loafed—quit drinking on Feb. 1
for ever and got some ideas—

I think we are going to have that war—then we are as yester-
day—? But we may not get lost in the shuffle after all—we are
pretty quick in the woods ourselves.—

Want you over here come a week from this Saturday—stay over
Sunday. Got big ideas—heap talk. New *mud*—"How the broncho
buster got busted"—its going to beat the "Buster" or be a com-
panion piece.

R. S. V. P.

Yours
Frederic R

2. Remington went to the Southwest in February 1896; Wister went to Europe.

1. Written and illustrated by Remington, "How Law Got into the Chapparal"
appeared in *Harper's Monthly* in December 1896. Several other articles resulted
from the trip.

☐ *FREDERIC REMINGTON TO OWEN WISTER*

New Rochelle
[June or July 1896]
My dear Wister Have concluded to build
a butlers pantry and a studio (Czar size)
on my house—we will be torn for a
month and then will ask you to come
over—throw your eye on the march
of improvement and say "this is a
great thing for American art.
 The fireplace is going to be like
this—old Norman farm house—
Big—big—
 Yours
 Frederic Remington

"Separs V. good"—[1]

Caspar Whitney praised Remington's Pony Tracks *after receiving
some complimentary remarks on his own work.*

☐ *CASPAR WHITNEY TO FREDERIC REMINGTON*

21 West Thirty-First Street
June 2, 1896
Dear Remington, Brave men are always making light of their
own and of making much of their friends achievements—that is
why you in your generosity are so complimentary of my Barren
Ground trip.[1]—
 Your Pony Tracks—full of a dozen adventures any one of
which we should feel proud to have accomplished. If my story
gives you as much pleasure—as Pony Tracks gave me—I shall
feel—well repaid—dont forget our solo exploit (to be)
 Yours,
 Caspar Whitney

1. Wister wrote a book of Western stories, *Lin McLean*, which was published
by Harper's in December 1898. "Separ's Vigilante" appeared in it.

1. The trip made by Whitney which led to "On Snow-Shoes to Barren Grounds,"
a series of five articles for *Harper's Monthly*.

Two matters of urgent business—Wister's acceptance of Remington's character sketch of Lin McLean, a fictional cowboy, and Wister's preface for a book of drawings by Remington—dominate many letters. Such matters did not keep Remington from escaping to the Adirondacks when the call to the wild came, as it did at regular intervals during the summer.

☐ FREDERIC REMINGTON TO OWEN WISTER

New Rochelle
[May 29, 1897]

My dear Wister.—I have your documents and note carefully. I will do L. Mac L——[1] justice or bust. It is not always possible to live up to the strange ideals of such a fanciful cuss "as you be."

When will Harper give me the order?

Can you come over here and spend next Sunday with us?

We are just home from a week in the Adirondacks—feel better. Mrs. R. says tell Wister be sure come—

Yours faithfully
Frederic Remington

☐ FREDERIC REMINGTON TO OWEN WISTER

New Rochelle
[1897]

Dear Wister—So you are coming on *Sunday the 13th*—Yes? Well come on!

I am as you know working on a big picture book—of the West and I want you to write a preface. I want a lala too no d—— newspaper puff saying how much I weigh etc etc. but telling the d——

public that this is the real old thing—step up and buy a copy—last chance—aint going to be any more West etc.

How's that hit you? Will you?

Yours
Frederic Remington

lin Maclean
after photograph

1. Remington's full-page drawing of the character "Lin McLean" appeared in a December 1897 story in *Harper's Monthly* by Wister titled "Destiny at Drybone." The book *Lin McLean* was published in 1898.

☐ *FREDERIC REMINGTON TO OWEN WISTER*

New Rochelle
[1897]

Dear Wister I have drawn Lin MacLean and he is just as he ought to be—He is better than Specimen.

Destiny at Drybone[1] is "Pool" on titles.—

I go away for month tomorrow—Cranberry Lake, St. Lawrence Co., N.Y.[2]

You must not run off without writing my *preface*.

It don't want to be long.

Yours
Frederic Remington

☐ *FREDERIC REMINGTON TO OWEN WISTER*

Harewood, St. Lawrence Co., N.Y.
[July 29, 1897]

My dear Wister—As you will see we are here—and probably wont come out (if it ever stops raining) until 15 Aug.

Write me what you (address New R—) want done with McLean—I will redraw—

Write me short preface such as will stun the public by its brevity & by its Homeric style. Get off the Earth—see visions—go back—launch into the future—& just send to R. H. Russell, 33 Rose St. N.Y. and ask him for set of proofs—he knows & will send them—

for these many thanks

Going West I suppose—

Sorry not to have been able to see you at New Rochelle—but later we will manage—When will you be back?

Yours
Frederic Remington

As Remington continued his emphasis on the West with Wister, his correspondence with Bigelow on Europe and the rest of the world continued apace. Remington was sensitive to the need to keep all his literary friends in touch.

1. "Destiny at Drybone" by Wister and illustrated by Remington appeared in *Harper's Monthly*, December 1897.

2. At Cranberry Lake, the Remingtons stayed with the Keelers from Canton at their Witch Bay camp. Entries from the Diary of Marshall Howlett Durston show the Remingtons arrived on July 20, 1897. He worked and played hard on this excursion, as was his habit.

☐ *FREDERIC REMINGTON TO POULTNEY BIGELOW*

<div align="center">
New Rochelle

August 9, 1897
</div>

My dear Bigelow: Just back from the Adirondacks. Going to Montana first of month—kill elks—get short stories and paint.

I read every week your American point of view. I never admit a free trader as an American—such are cosmopolitan—Mongrel Chinese, Bermingham, Malay—sort of all round Hautburgers—but of course I instantly recognized that you appreciate my iron Dragoons.

Your South African stuff[1] is attractive and "goes" here. It's a good safe subject to talk politics on as no one knows a d—— thing about it here. Is Miles in Berlin? Are you going to the manuevers?

No honey—I shall not try Europe again. I am not built right. I hate parks, collars, cuffs, foreign languages, cut and dried stuff. No Bigelow—Europe is all right for most everybody but me. I am going to do America—it's new—it's to my taste.

I am writing short stories. Got a "hummer" in next Harp. Mag.[2]—dialect—by God and that will give Alden a hemorage unless it's a top ropes. I am now writing an alleged journal in the diction of 1650.

I have been canoeing on a lake[3] with 125 miles of shore—catching trout and killing deer.—feel bully—absolutely on the water wagon but it don't agree with me. I am at 240 lbs. and nothing can stop me but an incurable disease.

Your house boat sounds attractive but I suppose the policemen walking around you all night must keep you awake—and instead of the wood wrens call in the morning you hear "milk below." Oh I sometimes think you have sentiment but it's a d—— crusty sort.

Hope to see you in when you are here. Regards to Madam.

<div align="right">
Yours faithfully,

Frederic Remington
</div>

1. Bigelow's articles and his book, *White Man's Africa*.

2. Probably "The Great Medicine Horse," written and illustrated by Remington, which appeared in *Harper's Monthly*, September 1897.

3. Cranberry Lake in New York State.

☐ *FREDERIC REMINGTON TO ROBERT HOWARD RUSSELL*

Endion
New Rochelle
September 21 [1897]

My dear Russell—This is a bad business—The Werner Co. are using my illustrations for Miles book.[1]

I am going to jump them somehow—I think I shall sue for drawings not returned.

Yours truly
Frederic Remington

☐ *THEODORE ROOSEVELT TO FREDERIC REMINGTON*

October 26, 1897

My dear Remington: I am almost ashamed to take your beautiful book;[1] but I am going to take it, for nobody could have given me anything which I would value so much. You know you are one of the men who tend to keep alive my hope for America!

It was great fun having you down aboard the White Squadron.[2] You never will care for the ship as you do for the horse and his many, many riders; but you must like the ship, too, and the man aboard in particular, for he is simple and honorable, and he works hard, and if need be is willing to die hard.

Always yours,
Theodore Roosevelt

Mr. Frederick Remington,
 New Rochelle, N.Y.

I like your backwoods ranger almost as much as your cowpuncher.

1. Since Harpers did not publish art books, Remington had entered into a contract with Robert Howard Russell, a smaller New York publisher, to publish *Drawings*, a collection of new work for which Wister had written the preface. He was very upset to learn that the Werner Co. had issued a competing book, *Frontier Sketches*, from which Remington was receiving no royalties. The Werner Co. had published *The Personal Recollections and Observations of General Nelson A. Miles* with Remington illustrations in 1896. *Frontier Sketches* was a reissue of illustrations from the Miles book. Remington was later to use the same technique himself, reissuing already published illustrations in book form and as separate prints before selling the original.

1. Remington sent Roosevelt a complimentary copy of *Drawings*.
2. He is referring to Remington's earlier tour of the naval fleet.

☐ *THEODORE ROOSEVELT TO FREDERIC REMINGTON*

November 11, 1897

My dear Remington: No, that was not too much. Marshall's History[1] is a rare book. It was first published in 1812, but the second edition is much fuller. Marshall is the only one of those old staid historians who writes at all interestingly. You will, however, find many accounts of the early Indian fighting in Heywood's History of Tennessee, published about the same time. If you haven't got it, or can't get it next summer I will send you on my copy—which is an instance of my trusting nature.

If you happen to come across my volumes called "The Winning of the West,"[2] you will find a good many descriptions of the early Indian fighting. Sometimes I have used Marshall as my authority; at other times I have used manuscript diaries and letters of the old fighters themselves. It would not be worth your while to get "Winning of the West," but if you will order it from the circulating library you might be interested in looking at some of the fights.

I don't think I ever thanked you half enough for your book. I look over it again and again, and enjoy every single picture. Dr. Wood[3] was in last night, and in the badger fight was pointing me out himself.[4] By the way, the only criticism in all the pictures which I could make even in the most hypercritical spirit, would be that the badger's legs are too long and thin. There were some naval men in too, including Bob Evans[5] and Sampson,[6] the Captain of the IOWA, and we were all wishing that you would do something about the Navy some time. We don't want you to forsake your old love, but just devote a wee bit of attention to another also.

<div style="text-align:right">

Faithfully yours,
Theodore Roosevelt

</div>

Mr. Frederick Remington
New Rochelle, N.Y.

1. Humphrey Marshall, *The History of Kentucky* (Frankfort, Kentucky: Henry Gore, 1812).

2. *The Winning of the West,* 4 vols. (New York: P. F. Colliers & Sons, 1889–96).

3. Dr. Leonard Wood was President McKinley's personal surgeon and a friend of Roosevelt. At the outbreak of the Spanish-American War in 1898 he became associated with the Rough Riders and as a result became a major general.

4. One of the illustrations in Remington's *Drawings*, "Fox Terriers Fighting a Badger," has Roosevelt in the picture as a spectator.

5. Robley Dunglison Evans was an American admiral who commanded the *Iowa* in Sampson's fleet off Santiago, Cuba, and took part in an active battle with Cervera's fleet on July 3, 1898.

6. William Thomas Sampson (1840–1902), American admiral and commander of the North Atlantic squadron who led the blockade of Cuba and the attack on San Juan.

☐ *FREDERIC REMINGTON TO THEODORE ROOSEVELT*

New Rochelle
December 25, 1897
My dear Mr. Roosevelt—Mrs. R. had the good sense to give me
"The Winning of the West" for Xmas—I don't have to go to a d——
old library as you suggested. I am deep in it—I am supremely
happy, and only wonder why I have not had it before—I suppose
because I cant have everything I want. I also had an idea that I
did not want to read history but only original documents for more
sure inspiration to do "my little things" but I am wrong—one cant
know to much—and you are the thing in a very big way—which
will only set me straight on my little things—
 Also have you "Men, Women & Manners in Colonial Times"—
Yours faithfully
Frederic Remington

☐ *THEODORE ROOSEVELT TO FREDERIC REMINGTON*

December 28, 1897
My dear Mr. Remington: You render it a little difficult for me to
write you because when you praise my book, and especially the
piece of work of which I am prouder than anything else I have
done, you make it difficult for me to write what I started to after
finishing "Masai's Crooked Trail."[1] Are you aware, O sea-going
plainsman, that aside from what you do with the pencil, you come
closer to the real thing with the pen than any other man in the
western business? And I include Hough,[2] Grinnell[3] and Wister.
Your articles have been a growing surprise. I don't know how you
do it, any more than I know how Kipling does it; but somehow
you get close not only to the plainsman and soldier, but to the
half-breed and Indian, in the same way Kipling does to the Brit-
ish Tommy and the Gloucester codfisher. Literally innumerable
short stories and sketches of cowboys, Indians and soldiers have
been, and will be, written. Even if very good they will die like mush-
rooms, unless they are the very best; but the very best will live and
will make the cantos in the last Epic of the Western Wilderness be-
fore it ceased being a wilderness. Now, I think you are writing this
"very best."

1. "Masai's Crooked Trail" by Frederic Remington appeared in *Harper's Monthly*, January 1898.
2. Emerson Hough (1857–1923) wrote popular novels of frontier life that were noted for their historical fidelity and understanding of pioneer character.
3. George Bird Grinnell (1849–1938), American naturalist and student of Indian life, is best known for his books on the Plains Indians.

In particular it seems to me that in Masai you have struck a note of grim power as good as anything you have done. The whole account of that bronco Indian, atavistic down to his fire stick on trial [illegible] revival, in his stealthy, inconceivably lonely and bloodthirsty life, of a past so remote that the human being, as we know him, was but partially differentiated from the brute seems to me to deserve characterization by that excellent but much-abused adjective, *weird.* Without stopping your work with the pencil, I do hope you will devote more and more time to the pen.

No, I haven't got "Men, Women and Manners in Colonial Times," but I will get it. With the vanity of an author I shall call your attention in my book to the chapters dealing with Wayne's victory, St. Clair's defeat, the Battle of King's Mountain, and Clarke's conquest of the Illinois. (If I am able to get on with the next volume) I shall try to give some account of what the plains were to the first plainsman, and what these plainsmen did, just as I did with the backwoodsman.

Now let me ask you a question: Do you know my "Wilderness Hunter?"[4] If not, will you let me send you a copy? There are two chapters in it—the first and one of the last—which I should rather like to have you read. So just drop me a line, and tell me whether you have it.

<div style="text-align:center">Faithfully yours,
Theodore Roosevelt</div>

Mr. Frederic Remington,
New Rochelle, N.Y.

☐ *THEODORE ROOSEVELT TO FREDERIC REMINGTON*

<div style="text-align:center">December 31, 1897</div>

My dear Mr. Remington: I have directed that a copy of the "Wilderness Hunter" be sent you. In it you will find an account of the only caribou *I* ever killed.

<div style="text-align:center">Always yours,
Theodore Roosevelt</div>

Frederic Remington, Esq.,
New Rochelle, N.Y.

> *The spring of 1899 found Remington returning to his Adirondack retreat at Cranberry Lake. His eagerness to become an outdoorsman once again is apparent.*

4. *The Wilderness Hunter* (New York: G.P. Putnam's Sons, 1893).

☐ *FREDERIC REMINGTON TO ROBERT SACKRIDER*

New Rochelle
[Spring 1899]

My dear Rob—I will be through work in two weeks[1]—look out for me—I want you and Em to go up to Cranberry with us—get ready—these are busy times and you may never get another chance—we used to have fun at Cranberry—I guess we aint to old now.

Is the *River* open—so I can canoe there. We want to board with you for a month—will you take us as star boarders—otherwise we are going to the hotel—I am getting old and Frenchy and am going to send my own Claret up for driver. Look out for it when I ship.

Eva is not very well and needs a change and I have worked so d—— hard and so d—— long that I propose to know what its all about. If fellows who sell groceries can take a vacation I don't know why I cant.

I haven't had a drink of anything stronger than claret or beer since Feb. 1—'96—I weigh 295 lbs.—net.

Eva is grey—almost white—very skinny care-worn—but not yet in need of a maid—though I have to hook up her dresser and am in favor of the maid. But the time is not yet.

I have just been to Davids Island for a self-water bath—first of the season. It was grand but *we* want mountain air. Did you ever imagine Rob that Canton ozone would rate as mountain air?

This is the way we look
Yours
Fred

Howard Pyle was one of the many good artists doing illustrating for the better monthlies and weeklies. He specialized in historical and children's subjects.

☐ *HOWARD PYLE TO FREDERIC REMINGTON*

Wilmington, Delaware
March 29, 1899

Dear Remington—I received your letter the other day and read it with no small amusement. At the same time, there was an undercurrent of something else than jocularity that caused me a feeling

1. Written in above: "Eva says one week."

of real discomfort—a feeling that somehow you were not happy in your heart. I agree with you that one cannot be entirely successful when one departs out of one's line of work. Your line of work is very strong—both in painting and drawing—that is always a matter of respect with me when I see you depart from it. Probably you do not know how many admirers you have and how great they regard and justly regard—your great art.

I wish we lived nearer to one another so that I might see more of you but you never come on as far as Wilmington and I rarely come to New York now-a-days. I find myself as the years go along becoming more and more a miser of my time. When I look ahead, the end seems so close and I have done so little that I almost despair of accomplishing anything. I feel as though I stood only on the threshold *of such* art with almost nothing to show for twenty three years of effort. So it is true I judge every day lost to my art, almost never come to New York, and lead a life like that of a hermit.

The evil of it is that I cannot unite myself to such friends as I might find in you. I wish it were otherwise!

> Faithfully yours,
> Howard Pyle

☐ *FREDERIC REMINGTON TO HOWARD PYLE*

> New Rochelle
> November 5 [1899]

My dear Mr. Pyle—Just saw your "Flying Dutchman" in Colliers— Great—simply Great—you are *it*. Anxious to see the original.

Just back from a trip to Colorado and N. Mexico. Trying to improve my color. Think I have made headway. Color is great—it isn't so great as drawing and neither are in it with Imagination. Without that a fellow is out of luck.

> Yours,
> Frederic Remington

☐ *HOWARD PYLE TO FREDERIC REMINGTON*

> Wilmington, Delaware
> December 23, 1899

Dear Remington:—Your kind words of encouragement and appreciation reached me after your delay in receipt of them. It is like your great heart and generous soul. To send such words of greeting to a man so out of the world as am I. I wish you joy and prosperity with the season, the New Year and its new century.

> Sincerely your friend
> Howard Pyle

Remington rarely gave advice to publishers on marketing. His letter to Harper in the first following instance includes specific thoughts on marketing Sundown Leflare *(published January 4, 1899). Comments regarding* Men with the Bark On *(published January 20, 1900) reveal he was very involved in all aspects of publishing. Remington had first used the phrase "men with the bark on" in a letter to Bigelow in 1893 referring to "his people," the "simple men" in the West.*

☐ *FREDERIC REMINGTON TO J. HENRY HARPER*

[In Harper's hand:]
Ans.
Feb. 6 [1899]

Endion
New Rochelle
February 3, 1899

J. Henry Harper Dear sir:—In reply to your answer to suggestion that "Sun Down Leflare" be put on book stands—the thing occurred to me that it should be found there when I suggested the form of its publication and its price $1.25—and now friends ask me why they do not find it there etc. Not having time to go out of their way to the big book stores etc. *Bound books* are found on the news stands of the hotels and rail-road stations and I wish my book could be found also.

Of course I know nothing of *trade* conditions and may overestimate my own book etc. and only agitate this matter because it interests me. I also appreciate that your firm will probably do everything possible in the matter though I should like to understand why my book is not available for the popular exposure in order that I may not in the future try to do something in a line which does not seem successful.

Yours faithfully,
Frederic Remington

☐ *FREDERIC REMINGTON TO J. HENRY HARPER*

New Rochelle
September 2, 1899

My dear Mr. Harper A small book could be made out of the following stories. There may be others which I have forgotten and some [Harper's] Weekly pictures of the war might go too— like "how the Horses die for their country &c.

It might be called "Men with the Bark On" What is your opinion?

<div align="right">Yours truly
Frederic Remington</div>

A Book—"Men *with the Bark* on"
1.	Dreams of War—Weekly		May 7, 1898
2.	The Bowels of a battleship	"	May 14, 1898
3.	The Honor of the Troop—Mag.		July 1899
4.	A Sketch by McNeil	"	May 1899
5.	The Story of the Dry Leaves	"	June 1899
6.	A Miscarriage of Justice	"	———
7.	Don Tomas Pidal, Reconcentrado	"	Aug. 1899
8.	When a Document is official	"	Sept. 1899
9.	The White Forest	"	Dec. 1898
10.	They Bore a Hand	"	April 1900
11.	The Trouble Brothers	"	Nov. 1899

 M. R. Howell
 Please to send me copies of the *Weekly* and *Magazine* of the above dates (For M. J. Henry Harper)

F.P.K.
Sept. 6/99

☐ *FREDERIC REMINGTON TO J. HENRY HARPER*

<div align="center">New Rochelle
January 19, 1900</div>

Harper Brothers
 Gentlemen: The cover is all right—couldn't be better. I note that you are to say "Illustrated by Author"
 Also please put the following where the dedication is usually placed
 "Men with the bark on die like the wild animals,
unnaturally—unmourned and even unthought of mostly."

<div align="center">Y——
Frederic Remington</div>

A high level of activity and collaboration between Remington and Wister was apparent in 1899 and 1900. Specific references to projects underway or completed abound. An injury to Remington's foot from a riding accident was the subject of some humor. Remington's break with Harper's, ending many profitable years of association, is noted in the correspondence. Two Remington picture books, A Bunch of Buckskins *and* Done in the Open, *received great attention. Remington wanted to capitalize on the Wister name and prestige to add luster to his major artworks depicting the American West.*

☐ *FREDERIC REMINGTON TO OWEN WISTER*

New Rochelle, N.Y.
[March 1900]

My dear Wister: Well—well—well—what did I write—I didn't mean to say anything which should sound heavy. Let us believe we are both heavy-livered in Spring time.

You must give me lots of time to illustrate your great story[1] properly.

I may write a short character story much like Sun. Down Le-flare. I dont intend to "do the West" and I couldnt if I would. I am only a character man. What we do along such lines can have no comparison. I'm a snare drum and you are an organ.

Can't come over now—I am going to my island[2] on 1st of June—and have work to finish—and am tired out—worn to a frazzle.

Dont forget the poems[3]—Where do you summer?—

Yours
Frederic Rem.

☐ *FREDERIC REMINGTON TO OWEN WISTER*

New Rochelle
[April 1900]

My dear Beard Thank you for the "broad horn" tip.

Horse fell on me Sunday and pancaked my left foot—be all right in few days.

Yours
Frederic Remington

Thursday

☐ *FREDERIC REMINGTON TO OWEN WISTER*

New Rochelle
[April 1900]

My dear Wister Thanks for your interest in my misfortune. My 1300 Lb. mustang fell like a beef on a brick pavement and I got clear all but one foot which he made rather pulpy. Sprains are long winded affairs and it may be some time before I can play tennis. Think I'll do my sporting in a Trolley car after this. They are about my size. Am busy and it knocks out my calculations.

1. "The Game and the Nation," by Wister, which appeared in the May 1900 *Harper's Monthly.*

2. Ingleneuk on the St. Lawrence River.

3. This appears to be a request for poems that would be used as captions for *Done in the Open,* a new Remington picture book.

How is little Miss Wister—she ought to be big enough to sit up and notice things by this time.

Hope to see you before Death—one is never sure often—

<div align="right">Yours
Old Pulpy Foot</div>

Thursday

Sally Farnham was a sculptor and a friend of Remington, one of the very few women with whom he corresponded. Her work was apparently also cast by the Roman Bronze Works.

☐ ***FREDERIC REMINGTON TO SALLY FARNHAM***

<div align="center">New Rochelle
[April 1900]</div>

My dear Sally—They have got me where they want me. Now I will be good, Been over a week in this bed and just to pile it on I am having the gout in the brother foot I cuss and swear enough to need a heap of praying for but it will all come right about the time early potatoes are ripe.

That 1300 lb'er slipped on a brick pavement and came down like a beef. I put out my left foot to sort of break his fall and it's some pulpy. Guess I'll ride in the red and yellow chariots which follow the wire after this.

I am awfully sorry to hear you are so out of kilter but a tough old thing like you cant go wrong long. I dont see what we have done to get this kind of a deal sawed off on us. Guess our medicine is bad. I'm going to make some new—without two eggs and two cups of flour in it.

You needn't brag about how many pains you have had—you never had the gout.

Cheer up—Sally—it may not be true—

<div align="right">Yours faithfully
Frederic Remington</div>

Forgot to say—busted me thumb also—makes my pen wabbly. Monday

☐ *FREDERIC REMINGTON TO OWEN WISTER*

New Rochelle
[Late April 1900]

My dear *Ownie* Read the Grant book[1] and think you did very well with such a dry subject. You certainly made me read it and I'm d—— if I would if it didn't catch on.

I have the splints off my tootsie but the thing is pulpy yet. I hobble around on crutches and I never could find any inanimate object in my best days—now judge of the amount of my contributions to a "swear box" which the old lady has organized on me. I say d—— the cavaliers—d—— all saddles and horse painters and— well D—— that's my sad fade-away now. But "When the devil was ѕick" I suppose.

Would like to have you drop in on me—for a night. It's a poor compliment—glad to see anything half human in my durance. Show you a mud of an Indian and a pony[2] which is burning the air—I think & hope he won't fall off as I did—he has a very teetery seat and I am nervous about even mud riders.—

I have a photo of yours "What I think McL looks like" but haven't moral energy enough to send it to you—still I wont plead statue of limitations if you come around.

I hope to go to my island on 1st June but am wobbly and my work is behind. Have a painting to do besides my illustrations.

Am never going to write any more—I have spread myself out too thin—I am going to begin to do the armadillo act or the Greek wheel—

Kind of get together.

Whitney tells me you are "doing me." It's a low down job—let me see a proof please—I may want a mandamus.

Frederic Remington

1. Wister's short biography of Gen. Ulysses S. Grant published in August 1900. *U.S. Grant and The Seven Ages of Washington*, vol. II of *The Writings of Owen Wister* (New York: Macmillan, 1982), second preface to *U.S. Grant* (unnumbered page).

2. *The Cheyenne.*

☐ *FREDERIC REMINGTON TO OWEN WISTER*

New Rochelle
[September 1900]

My dear W—"Superstition Trail"[1] is artistically the best thing you have done. I am going to do the interior of the stable Part I. I haven't Part II. yet.

As to Harpers—they are hard up and employ cheap men.[2] Also Harvey[3] wants new men. New and cheap lets you out along with all the other old men.

They dropped me out of the window over a year ago but I find a way to get printed.—

I think the pastels[4] will be all right—did they send you the portfolio? Where the shoppies put them in their windows passing fire engines will stop and hook on to the adjoining hydrant.

y——
Frederic R.

After 1900 Remington and Wister were sought by publishers other than Harper's. Their "Superstition Trail" of 1901 in The Saturday Evening Post *was followed by "The Wilderness Hunter" for the December 1901 issue of* Outing. *Wister was also to provide verses for Remington's picture book* Done in the Open, *but when Remington missed signals on a meeting between them to clarify details it appears to have caused a change in their relationship. They were equally famous, and each could now pursue his own way. This became more apparent when Remington published* John Ermine of the Yellowstone, *his own version of Wister's* The Virginian.

☐ *FREDERIC REMINGTON TO OWEN WISTER*

New Rochelle
[October 1901]

My dear Wister—Congratulations on babies[1]—you are quite a daddy by now.

1. Two-part article by Owen Wister. Part one appeared in the October 26, 1901, issue of *The Saturday Evening Post,* part two in the November 2, 1901, issue. Both were illustrated by Remington.

2. Harper's Brothers Publishers began to have financial difficulties at this time and dropped some of their former illustrators.

3. George M. Harvey, the new Harper's editor.

4. *A Bunch of Buckskins* was published by R. H. Russell, New York, 1901. This consisted of a portfolio of eight lithograph plates in full color from pastel drawings, and an Introductory Note by Owen Wister.

1. Wister's wife had twins.

Will remember the Virginian.

Am simply going to do a pastel of old time buckskin with no background for Wilderness Hunter. I can see no other way and Whitney wants something which will hold the crowd.

We illustrators are getting to be advertising adjuncts now-a-days. I dont know what Russell[2] has decided.

No paper in here

<div style="text-align: right">Frederic Remington</div>

"Whats the matter with Roosevelt—" Nothing!

☐ *FREDERIC REMINGTON TO OWEN WISTER*

<div style="text-align: center">New Rochelle
October 4　[1901]</div>

My dear Wister—Russell is re-reading your introduction to pastels thinks you talk of (Old Ramon) when you speak of Half Breed.

Old Ramon was a Mexican, which is equivalent to a half-breed—was an Indian trader from Taos—before the northern indian wars and then scouted for Miles & was quite celebrated. He was an old typical Rocky Mountain man. The half-breed is the one with the white blanket coat. While we are not going to name them, yet you may want to look again.

As for the article [1]—it is immense but when I read it Extract of Vermilion would make a blue mark on my face, I have to put on my smoked glasses.

Am going to show some paintings in New York this December[2] and hope you can run over and see them. They are a step ahead so far as paint goes.

Am on your second "Sup Trail"—going to do where the Vir—looks back at you when the man comes out of the sky.

<div style="text-align: center">Y——
Frederic R.</div>

October 4 & I am 40 years old today. Its a down hill pull from here.

2. Russell had not made final selections that would allow Wister to start the preface for Remington's *A Bunch of Buckskins.*

1. Probably refers to Wister's introduction for *A Bunch of Buckskins.*
2. An exhibition at Clausen's Gallery in New York.

☐ *FREDERIC REMINGTON TO OWEN WISTER*

New Rochelle
[October 18, 1901]

My dear Wister: Hope you are going to be able to do the little poems for my next Russell book.[1] The thing you did for the cowboy was a great help to the picture.[2] Sort of puts the d—— public under the skin.

How be ye these days any how?" I dont expect to meet you again in this incarnation but I sort of remember how you looked back in the spring of '50.

Frederic Remington

☐ *FREDERIC REMINGTON TO OWEN WISTER*

New Rochelle
[March or April 1902]

My dear Wister: Of course the whole poetry scheme was rough but I'm glad it has been patched up. Such gall is not easily understood.

I simply couldn't stop to do your story now and so told Edwards[1]—and I don't suppose they want to hold it to suit my convenience. I have done no painting since late last winter and have three pictures which must be finished since I want to get away later so I have had to suspend all illustrations for awhile. If you can get them to hold the thing I would like to do it. Think it is one of your best.

The more I think of our Brett picture book[2] the more I can't see how I am to go about it—it is such an interminable job—but it may be managed—Such a thing can't unfold itself right off the bat. We will see—

y——
Frederic Remington

1. *Done in the Open.*
2. Wister's verse for "Mounted Cowboy," used by *Collier's* for its cover on September 14, 1901. It was titled "No More He Rides."

1. George Wharton Edwards, art editor for *Collier's Magazine.*
2. It is not clear to what book Remington is referring, as the rest of the letter indicates that it was written after the publication of *The Virginian.*

☐ *FREDERIC REMINGTON TO OWEN WISTER*

New Rochelle
[1902]

My dear Wister—About the Russell book—what you say is true—
Russell has gone to Europe—the thing is in "the formes [illegible]"
and Colliers Weekly is behind it—I cannot change now. The play
will have to go as it lays and d—— the odds. Do what you can and
dismiss the things which don't appeal to you. Just pass em up.

I go to the Roman Bronze Works—275 Green Street, Green-
point—Brooklyn—leaving here every morning at 8:20 a.m. to
work out a four horse bronze[1] and I reach this above oasis at
6 p.m.—eat—smoke go to bed and day after day I am to do this
until I die or complete the bronze—and its' even up—

When that bronze is done I fly on the wings of the N.Y. Central
and if you will only come to "Cedar Island—Chippewa Bay—St.
Lawrence Co. N.Y." you will be received in any fashion which suits,
from a perfectly preserved old gentleman with a bottle of Scotch
in his left and the right all open or Madam will paddle you home
to a place where "she says no drunks are allowed"—you can have
it either way.

I don't want to make "a beef" but I am situated just as I say and
the distance is only a nights ride to Chippewa—why don't you come
and see the only place in N. America which is as still as Death—
except for us.

Yours,
Frederic R

D——this pen. It won't work

☐ *FREDERIC REMINGTON TO OWEN WISTER*

New Rochelle
[May 29, 1902]

My dear W——Say Thursday Players[1] at noon—how's that

y——
Frederic R.

1. *Coming Through the Rye.*

1. Remington sent word to Wister for Wister to meet him at the Players Club in
New York City to discuss the *Done in the Open* project. The telegram arrived after
Wister had left, so Wister did not respond.

☐ *FREDERIC REMINGTON TO OWEN WISTER*

Ingleneuk
Chippewa Bay, N.Y.
[May 1902]

My dear Wister—Telegraphed you at Philadelphia but got no reply—left N.Y. Friday night a week gone and have been settling.[1] The Missis arrived today with the trifles like paper and ink. My "injun" and I have been "burning bacon and coolin" coffee for a week. On the batch.

As for the poetry[2]—I cant say anything more than that I would like you to do it but I wouldn't stop important work to do pen edgings for you and dont expect you will for me. Tell Collier you will or you wont and pass it up—no harm done pardner.

I have worked very hard this year and now that the relaxation has come I despise labor—which is supposed to be so holy and which is in proper doses.

Are you Pennsy fellows[3] going to make us burn the trees on our lawns for fuel this winter? Be gad—the proposition looks gloomy from this rock. It may be a good year to go South.

Well—let me hear from you. The Kid says "Virginian"[4] out—will order a copy.

Yours,
Frederic R.

☐ *OWEN WISTER TO F. J. SINGLETON*

328 Chestnut Street
June 7, 1902

Dear Sir:[1] Mr. Remington departed without further answer to my letter than a telegram to dine with him, addressed here when I had asked him to communicate with me at the Players Club. I found the telegram 5 days after it had been sent. I must ask you to excuse my not telling you this at once, last Monday.

But if Mr. Russell or Mr. Remington are to lose by every day's delay after the 15 of this month that is certainly not my affair.

1. Remington had not heard from Wister and left for Ingleneuk for the summer.
2. For *Done in the Open*.
3. Pennsylvania coal miners.
4. When Wister completed the manuscript for *The Virginian* in March 1902, Remington was too busy to do the illustrations. Arthur I. Keller illustrated it. It was published by Macmillan in May 1902.

1. Wister was angry at Remington and wrote to F. J. Singleton, an assistant to R. H. Russell. Wister absolved himself of all blame for inaction on the project, having made an attempt to see Remington.

Last September Mr. Russell asked me to do this work. He showed
me the portfolio then, saying it was not quite complete, but would
be sent me soon. It now comes, eight months afterwards, with no
word during the interim, but with a request now that I hurry. I
am sorry to say that I am not free. I shall be busy for five or six
weeks more. Then I shall be more than glad to the portofolio. Let
me return it at once, or let me keep it and make the best speed I
can when I am free, but I can not consider that the delay is any
responsibility of mine.

> Yours truly,
> Owen Wister

☐ *FREDERIC REMINGTON TO OWEN WISTER*

> New Rochelle
> [August 1902]

My dear Wister—Oh gee—oh gee—here is a how do do—Now
I dont know anything about it one or the other—so fire away—
don't hit me? [1]

> Frederic R.

☐ *FREDERIC REMINGTON TO OWEN WISTER*

> New Rochelle
> [Late August 1902]

Have just been through your short story for Colliers about the
Secty. of War [1] and it nearly killed me before my time.

"The deeply religious whiskers" and he had some marsh land
which he intended to sell the Govt for a Navy Yard and "Sistah
Stone" and the Captain's moustache—

say Bill you are all right.

I sent it back because it dont need illustration—its all there—I
wouldn't care to interfere.

> y——
> Frederic R.

1. After Singleton told Remington of Wister's anger, Remington wrote to
apologize.

1. Wister's story "In the Back" for *Collier's Weekly*. It was published sometime
in 1903.

☐ *FREDERIC REMINGTON TO OWEN WISTER*

New Rochelle
[September 1902]

My dear Wist: Cawnt do it yu no—I am as busy as a cat havin a fit.[1]

Long story is my trouble[2]—but I mean to see you later.—I am going to have a Show in Dec.—have to get a "lost wax" order[3] off in ten days—do a little illustration and then I am going to see you—I have got an idea I think will interest you—it concerns a statement which must be made which will stop dead the fools who are trying to confuse the public, by their ignorance, into thinking that they too understand. I have collected material but haven't the right kind of mind to discharge it. It must be, I think, an essay, that's however—

<div align="center">y——
Frederic R.</div>

I want to consult a lawyer.

☐ *FREDERIC REMINGTON TO OWEN WISTER*

New Rochelle
[September 8, 1902]

"Done in the Open"[1] is good—My what a killing you have made—[2]

<div align="center">Y——
Frederic Remington</div>

☐ *FREDERIC·REMINGTON TO OWEN WISTER*

New Rochelle
[Late November 1902]

My dear W—— Copy of my book just at hand and I have read Intro & poems—the poems are great and I feel like this—sort of unusually puffed up

There were passages in that Intro. which sent my natural color up several octaves. A little Greek fire is good for the business.

Had a copy of "Coming through the Rye" bronze in

1. Remington still can't do "In the Back," a story that Wister requested he do.
2. Remington's forthcoming book, a novel, *John Ermine of the Yellowstone.*
3. *Coming Through the Rye.*

1. The introduction and verses Wister finally completed for him.
2. Probably refers to the outstanding financial success of Wister's *The Virginian.*

Tiffanys but it sold—have made another which I hope to have there in less than a month and you surely must see it.

My little old story[1] comes out soon but that wont interest you. However if you read it tell me what's what and spare not.

I haven't seen you since you were a young man—I'm bald-headed and one legged and the curves are more easily followed than ever. We are burning the Steinway this week—the old Virginia side board goes next week—suppose you are burning copies of the Virginian.

Did you see in N.Y. Herald that we have all got to join the Union. Amalgamated Ass. of Quillers and Daubers No. 2 affiliated with the Pants Makers and Liberty Dawners. Say wouldn't that warm your ears?

<div style="text-align:center">

yours
Frederic R.

</div>

1. *John Ermine of the Yellowstone.*

Chapter 6
Fame
1900–1907

I N 1900, THE REPUBLICAN WILLIAM MCKINLEY was elected to a
second term as president. William Jennings Bryan, who had
again been nominated by the Democrats, tried to spread the
gospel of anti-imperialism during the election, but the country was
enjoying heightened prestige abroad and widespread prosperity
at home and was not interested in Bryan's message. When McKin-
ley was assassinated in 1901, the dynamic Theodore Roosevelt
succeeded to the presidency. His wide and varied interests and
enthusiasms marked an active administration. He and Reming-
ton continued to correspond throughout the first decade of the
new century, sharing opinions on topics ranging from art to the
outdoors.

Remington was still mainly an illustrator, though other aspects of
his art were becoming increasingly important. Art historians have
made great efforts to separate illustration from art. To be "merely
an illustrator" or "only a commercial artist" is almost beneath se-
rious consideration. Yet many artists have also been illustrators and
worked under its special conditions. It is essential to know, for in-
stance, how a work will reproduce in its final form (woodcut, pho-
toengraving, or some other technique). The work must be done
quickly, with emphasis on immediate effect rather than on subtlety
of line or tone. The drawings for any single book or article must be
stylistically consistent, and thus repetitive. Within these limitations,
Remington had managed to achieve noteworthy success. Hundreds
of artists flooded the field in the 1890s to meet the growing de-
mand for drawings by the burgeoning illustrated book and maga-
zine industry. It is a credit to Remington's genuine artistic talent
and to his deep understanding of his subject that he was able to

ride the tide of popularity and yet establish a niche for himself in the world of art.

In 1900, Yale University gave him an honorary degree. When John Ferguson Weir, director of the Yale Art School and a well-known painter and sculptor, wrote afterward to thank Remington for the gift to Yale of a painting and a bronze, he said that the university would prize them as the work of its "most distinguished pupil." Certainly by 1900 the name of Remington had appeared before the American public in a variety of ways. His renderings of Western scenes for his and others' writings had memorialized an era that most recognized was gone for good. His bronzes were capturing the spirit of that era three-dimensionally. His articles were anthologized, his illustrations turned into prints, and his bronzes recast. Finally finding his war, he had managed to position himself on the front lines of the Spanish-American confrontation and to achieve a reputation in journalism as well. Yet he viewed himself as an artist struggling to achieve distinction. When he wrote to Wister in the late 1890s about his art it was the lack of color in his work that concerned him most. His concern increased as he began to see his work reproduced in color in the magazines and to view the work of the new American impressionists such as Childe Hassam and J. Alden Weir, his former instructor in painting at the Art Students League and younger brother of the Yale art professor. He had been thinking in black and white too long and often felt he just could not get it right.

Several events coalesced to change Remington's direction around the turn of the century. Some of the changes had been in motion for some time; for example, his increasing interest in and skill at working in bronze. That was to become a primary interest and source of fame, but there were also some reverses that may have helped change his course.

Around 1900, Harper's, which had published *Harper's Monthly* since 1850 and *Harper's Weekly* since 1857, experienced financial difficulties. While it is not clear whether it was an editorial or financial decision, Remington was dropped from the roster of illustrators. At about the same time, *Collier's Weekly*, under the leadership of Robert J. Collier, began to improve its illustrations, stories, and articles. It became a leader in the new era of color magazine illustration and entered into contracts with some of the leading illustrators of the day. Charles Dana Gibson was perhaps the prize catch. His "Gibson Girl" and "Gibson Man," which had appeared throughout the 1890s in the old *Life* magazine, were models for a whole generation of Americans in matters of dress, manners, and attitude. Jessie Willcox Smith drew children, E. W. Kemble did Negroes of the Old South, A. B. Frost did rural types, and Remington did Western scenes. Rudyard Kipling wrote for them; so did Wister.

Remington's relationship with Collier's was a happy one in this period, and he had a great deal of freedom. *Collier's Weekly* had been publishing his work since 1898, and they picked up the slack after the end of his association with Harper's. He was not expected to write stories. His work appeared consistently once or twice a month. On occasion, he was commissioned to do a series of paintings for the magazine that Collier's then reproduced to be sold as a folio. This was a profitable arrangement for Remington, since Collier's would then return the paintings to him to sell. A "Portfolio of Drawings" was published in 1904 followed, up to 1909, by "Six Remington Prints in Color," "Frederic Remington: Four Pictures," "Remington's Four Best Paintings," and "Remington Portfolio: Eight New Remington Prints."

Scribner's also made a splash with full-color plates after 1900. In October 1902 it published Remington's "Western Types" and made the prints available to an enthusiastic audience. *Cosmopolitan* carried many two-color illustrations in each issue for years and occasionally three-color plates by Remington and a few others. *Outing Magazine*, where Remington had gotten his start fifteen years before, had continued to prosper in the '90s. Caspar Whitney became editor in 1900 and it too began to use some color plates by Remington and N.C. Wyeth, though not as profusely as *Collier's* or *Scribner's*.

Curiosity about the man behind the drawings that were being so widely viewed was natural, and articles about Remington began to appear occasionally in the popular magazines. *Metropolitan Magazine* published "Artist Remington at Home and Afield" by C. M. Fairbanks in July 1896. On May 13, 1899, *Success Magazine* carried an article by Charles H. Garrett called "Remington and His Work." In March 1903, Edwin Wildman wrote "Frederic Remington: The Man" for *Outing*. All included photographs of either Remington or his bronzes, and the *Metropolitan* article also included three original illustrations. On March 18, 1905, *Collier's* published its "Remington Number." The entire magazine was devoted to Remington. Owen Wister's preface from *Done in the Open*, "Remington: An Appreciation," was reprinted in full. Charles B. Davis contributed "Remington: The Man and His Work" and James Barnes wrote about Remington the sculptor. There were pictures of new paintings and bronzes and a centerfold double-page spread in full color, "Evening on a Canadian Lake," which could be purchased separately. Remington himself contributed a retrospective view of his life entitled "A Few Words from Mr. Remington." It was the highlight of his year.

Two years later, in October 1907, *Pearson's Monthly* featured Remington in an article by Perriton Maxwell. The title of the article was "Frederic Remington: Most Typical of American Artists," but the appearance of the *Bronco Buster* on the cover and the letter

from President Theodore Roosevelt under the title "An Appreciation of the Art of Frederic Remington" were more indicative of his fame and status at that time.

Not much has been written about Remington the author. Altogether he produced eight books. Harper's published *Pony Tracks* (1895), *Crooked Trails* (1898), *Sundown Leflare* (1899), and *Men with the Bark On* (1900), all anthologies of articles that had appeared earlier in Harper's magazines. *A Rogers Ranger in the French and Indian War* (1897) was a reprint of an article that had appeared in the November 1897 *Harper's Monthly. Stories of Peace and War* (1899) was a reprint of three articles and two illustrations previously published in *Harper's Monthly.* The final two books were novels. *John Ermine of the Yellowstone* (1902), published by Macmillan, was well received, and the character of John Ermine was compared to Owen Wister's cowboy hero in *The Virginian.*

Louis Shipman, a playwright, believed the novel could be a success on the stage and offered to write the script for it. He and Remington corresponded frequently over the summer of 1903 about details of the production. It opened in Boston on September 14, 1903, the first presentation at the new Globe Theater. The packed house, which included the governor of Massachusetts, was enthusiastic, and the reviews were favorable. The well-known stage actor James Hackett appeared in the leading role. Two months later the play opened in New York City at the Manhattan Theater, but it was less well received there and closed in a month.

Remington wrote *The Way of an Indian,* his second novel, shortly after that but it did not appear in print until it was serialized in *Cosmopolitan* beginning in November 1905. It was published in hardcover in 1906 by Fox, Duffield and Co.

Remington had written other fiction. "The Great Medicine Horse" (*Harper's Monthly,* January 1898) had been critically well-received, with Remington as author compared favorably to Owen Wister. The character of Sundown Leflare had been introduced in "The Great Medicine Horse" and appeared again as the leading character in some subsequent stories. It was after reading one of the Sundown Leflare stories that Theodore Roosevelt was moved to write Remington that he "came closer to the real thing" than anyone else.

Despite his success as author and illustrator in this period, Remington's interests were continuing to move dramatically away from drawing and writing toward modeling. He enjoyed working in clay or plasticine and was receiving a good deal of critical attention for his tabletop bronzes. In 1905 he received the first feelers from a committee of the Fairmount Park Association in Philadelphia about the possibility of his doing a lifesize statue of a cowboy for them.

Between 1900 and 1907, Remington completed thirteen bronzes, most of them about twenty-four inches in height (two exceptions

are *The Sergeant* at ten inches and *Paleolithic Man* at fifteen inches). He worked closely with Riccardo Bertelli, owner of the Roman Bronze Works, experimenting with innovative bases, new ways of supporting sculptures on those bases, and new kinds of relationships between the sculptures and the bases. Not content with the classic approach to modeling the horse and rider, Remington was trying to capture the same drama and movement that characterized his two-dimensional paintings and illustrations. Action and realism were paramount, and in Bertelli he had found someone who was willing to be as daring as he was. Bertelli was also patient with Remington, who was never quite content with his work and who was regularly in and out of the bronze works fiddling with details on the wax models.

The following bronzes were completed in this period: *The Norther* (1900), *The Cheyenne* (1901), *The Buffalo Signal* (1901), *Coming Through the Rye* (1902), *The Mountain Man* (1903), *Polo* (1904), *The Sergeant* (1904), *The Rattlesnake* (1905), *The Dragoons—1850* (1905), *The Outlaw* (1906), *Paleolithic Man* (1906), *The Horse Thief* (1907), and *The Buffalo Horse* (1907). Remington had Bertelli cast three of his four earlier works using the lost-wax method; this also gave him an opportunity to make some changes and adjustments in them. Remington took a good deal of interest in the dealers handling his work, whether they had enough pieces available to sell, and how well the works were selling. When he was in New York, he would stop in at Tiffany's to visit with Henry W. S. Pell, who was responsible for marketing Remington's work. In Chicago it was a Mr. Spaulding. At one point a Mr. Nash was interested in getting some of the bronzes for Gorham's to carry, but Remington was reluctant. He was concerned with people copying his ideas and warned Bertelli to keep his bronzes out of sight when other artists were at the foundry. He also expressed an interest in numbering the casts of a work for accurate record-keeping.

On May 25, 1900, Remington purchased Ingleneuk, a five-acre island in Chippewa Bay on the St. Lawrence River. It was not far upriver from Ogdensburg, New York, his boyhood home. Over the years, he added to the cottage, installed a clay tennis court, and built a studio that faced Canada to catch the northern light. He also added a boathouse where he kept a "naptha launch" (one of the early motorboats), several Rushton canoes, and a pair of river skiffs. The *Island Belle,* a steamer, would bring passengers and supplies from Ogdensburg to Chippewa Bay. Both then went by launch to the various islands. He would spend part of each summer at Ingleneuk, and it replaced Cranberry Lake and the Adirondacks as his homeland country retreat.

Remington also continued to travel west and elsewhere. He went to Colorado in 1900, Mexico in 1904, Cuba the same year, and back to South Dakota in 1905.

Between 1904 and 1907 he began receiving a lot of correspondence commending him on his successful work in several fields from men who were successful in their own. Theodore Roosevelt, then president, continued to write, as did the art critic Royal Cortissoz and the artist Childe Hassam, among others. Fame had come to Remington finally in pursuits other than illustrating.

John Ferguson Weir, director of the Yale Art School and well known as a painter and sculptor, handled the correspondence related to the granting of an honorary degree to Remington.

☐ *FREDERIC REMINGTON TO JOHN F. WEIR*

New Rochelle
December 7 [1899]
My dear Prof. Weir— All right I will give you best bunch of pictures I can rake together by April. I can't tell what pictures I will have by that time. I may make some between now and then and I will probably sell some I have now so can't give you a list. The big picture is *Forsyth's Fight on the Pawnee Fork.*"[1] I am
Yours faithfully
Frederic Remington

☐ *JOHN F. WEIR TO FREDERIC REMINGTON*

Yale University
School of the Fine Arts
New Haven
April 18, 1900
My dear Mr. Remington: With reference to the details of the presentation of your name for the degree of B.F.A. next Commencement, I would say that the only detail of the receiving of the degree will be your going upon the platform at Commencement to receive the parchment from the President with a bow. You will be required to be on the campus at nine o'clock in the morning to take your assigned place in the procession, arrayed in academic gown. With respect to the latter item, if you sent your height and measure about the chest Mr. Geo H Langgettel our clerk & curator will attend to the sending you a gown for the occasion and you can communicate direct with him about it. With respect to the exhibit of your work, will you please give me a list

1. Appears in his 1897 book *Drawings*, under the title *River, 1868–The Charge of Roman Nose.*

of such things you could loan or borrow for the occasion together with such studies as are also serve to make the exhibit more complete. These should be in New Haven no later than the 20th of May—you will be on exhibition for two weeks.

A thesis on some topic relating to the Fine Arts for a beginner, and if you can prepare this it would be well or you may have inserted in addition to copies of your published writings. These should be placed on file in the Art School.

The exhibit should be as complete as you can make it.

Very truly yours,
John F. Weir

☐ *FREDERIC REMINGTON TO JOHN F. WEIR*

New Rochelle
[undated]

My dear Prof. Weir— I haven't done any water colors in years so can't show. Thank you for your consideration however—

Yours faithfully,
Frederic Remington

☐ *FREDERIC REMINGTON TO JOHN F. WEIR*

Ingleneuk
Chippewa Bay, N.Y.
[undated]

My dear Prof. Weir I shall not be home before middle of October and I have no important pictures as I told you last spring. I have been writing and sculpting for some time and have produced no paintings. Sorry—some time I hope to do better by the school.

We have had a delightful summer—cool and with the bass biting.

Yours faithfully,
Frederic Remington

☐ *JOHN F. WEIR TO FREDERIC REMINGTON*

Yale University
School of the Fine Arts
New Haven
July 15, 1900

My dear Mr. Remington Your letter is received, saying that you give to the Art School both the painting and the bronze & which

is most generous. The School will prize them as the work of its most distinguished pupil, now an alumnus of Yale "admitted to all the votes and privileges of the University"—or whatever is the wording of the document and the President's expression in handing you the parchment.

There is generally "a hot time in the old town" at Commencement, and this last was no exception to the rule. But I am glad you have a cool place in which to think it over. You have been accustomed to "hot places" before, when you were lucky to get away with a whole skin and have been under fire before the "Presidents glittering eyes" fell on you.

Thanks Frederic for the gifts. They will remain a record long after we are all "eaten of worms."

<div style="text-align: right">

Sincerely yours,
John F. Weir

</div>

When Remington applied for copyrights on his bronzes, he described them in detail. His description is given in a footnote after the first reference in a letter to a particular bronze. After that the bronze is simply identified by name.

☐ *FREDERIC REMINGTON TO JOHN F. WEIR*

<div style="text-align: center">

New Rochelle
[undated]

</div>

My dear Prof. Weir— I have taken steps to get a "Broncho Buster"[1] and a "Wicked Pony"[2] to you. "The Norther"[3] has gone to Buffalo—Glad you got the Albany pictures.

<div style="text-align: right">

Yours faithfully
Frederic Remington

</div>

Thursday

1. *The Bronco Buster* (October 1, 1895): "Equestrian statue of cowboy mounted upon and breaking in wild horse standing on hind feet. Cowboy holding onto horse's mane with left hand while right hand is extended upwards."

2. *The Wicked Pony* (December 3, 1898): "Shows a cowboy who has been thrown and is lying flat on the ground, holding onto bronco's ear with left hand. The bronco is lashing out with hind legs."

3. *The Norther* (July 2, 1900): "Cowboy on horseback in snow storm. Severe wind blowing from rear. Both man and horse almost frozen."

handling the reel—

☐ *FREDERIC REMINGTON TO JULIAN RALPH*

Ingleneuk
Chippewa Bay, N.Y.
[Summer 1900]

Telegram Chippewa, N.Y.
My dear Ralph— I am in Chippewa Bay 10 miles below Alexandria Bay. Seven miles wide here and blows like hell every minute. Got a dandy lumbered island—6 acres—good house—kitchen outside—boat house—two docks and a hospital tent. Its cool here all the while and I work summers. It was a good scheme since no one can live in New R—in the summer and work. It is cheaper than travel and anyhow summer is no time to spend on cars—mostly in upper berths being married and too weak to buy the state-room.

I am writing a series of articles all about an "injun" for the New Magazine—Hearst and R.H. Russell[1] to come in November and painting a little. I have been making bronzes—3 in *cere-perdue*[2] with good results. The H. Bonnard Bronze Co.[3] went up owing me more money than I care to say. I am a d—— unlucky fellow that way. Got caught in industrials this winter and am pretty well cleaned out but there is more where that came from.

Its getting so that a man cant invest his savings in America—these 25 or 30 plutocrats wait till every body buys a stack of chips

1. Robert Howard Russell and William Randolph Hearst had plans to launch a magazine to be called *New Magazine* that never materialized. Remington had written a novel, *The Way of the Indian*, and Russell was considering publishing it in serial form in the magazine. As it turned out, Hearst bought *Cosmopolitan* magazine in 1905, and parts of *The Way of an Indian* were published there before the novel appeared in hardcover form.

2. Cire-perdue, or the lost-wax process of bronze casting, was used by Riccardo Bertelli at the Roman Bronze Works.

3. The Henry-Bonnard Co., which had done Remington's early bronzes using a sand-casting process, was destroyed by fire in 1898.

and then they see-saw them out of it. If Bryan[4] wasn't such a dog—one who would betray the national honor I would vote the Democratic ticket. McK is but a tool of the very rich but will go along in hopes of Roosevelt or a Democrat who is not fit for an insane asylum. Bryan is a socialist and I aint. I am an *old fashioned* Democrat if there was such a party.

If the war warrants it I may do China this winter—paying particular heed to good stout mud banks while there. No more San Juan hills for Freddie. The game aint worth the candle. If anybody shoots me it will indicate that I wasn't looking.

It has been g—— d—— hot in America—the worst summer known. I am afraid France is getting ready to have a fit—she's about due. There Boys don't seem to get licked much—they hang on to beat hell—our Phillipos will come in I expect when Bryan gets licked. He is the "war Kau" for them, but he will get licked. I shall be here until the. . . .

> *In October 1900, Remington went to Colorado, where he had never been before. Arrangements were made for him to take a journey into the Rocky Mountains to Ouray and on to Ignacio and the Ute Reservation. He sketched and also added to his collection of Indian artifacts. He went on to Espanola, New Mexico, to sketch a Pueblo village and then to Santa Fe. Finally he took the Denver & Rio Grande Railroad to Taos in Mexico.*

□ ***FREDERIC REMINGTON TO EVA REMINGTON***

Auditorium, Chicago
Postcard postmarked October
1900

Got away all right—find can take c— get me Denver soon [illegible] as 5.45 came here—house full. Tripp—who runs took me to his room where I have hot bath—dine with him & Gen'l Wade.[1] If Devoe[2] didn't send my pads—telegram me Denver—so I can do something.

Fred

4. William Jennings Bryan, who had opposed McKinley and lost in the election of 1896, was renominated by the Democrats in 1900. The Republicans endorsed President William McKinley for a second term and nominated Theodore Roosevelt as the vice-presidential candidate. The main issue was imperialism, with the Republicans praising the administration for its conduct of a "righteous war" with Spain and supporting the acquisition of new territory such as the Philippines. McKinley won an overwhelming victory.

1. Gen. James Wade, former military governor of Cuba.
2. Devoe was the art supplier who provided Remington most of his equipment and materials.

☐ *FREDERIC REMINGTON TO EVA REMINGTON*

Postcard
Brown Palace, Denver
October 19, 1900

Here all right—dirty—and trunks wont show up! Bought Cliff Dweller Skull & basket—skull very fragile—take care unpacking—very valuable. Up at Denver Club—people want entertain me—fear large head—cool & pleasant here—Hope my boards come—

Y——
Fred

☐ *FREDERIC REMINGTON TO EVA REMINGTON*

The Beaumont
Ouray, Colorado
October 24 [1900]

Dear Kid— Left Denver Monday night—got here last night after long delay—freight train in the ditch somewhere in Colorado. Magnificent scenery—particularly the Marshall pass.

We are very high here—took walk this morning and it made me puff. Met our congressman—Underhill of New Rochelle and daughter at Montrose—we had good chat.

At noon a wagon is coming for me and I must sort my kit. I am going out for about four days I think—fine mountains about here. Then shall drive 9 miles & take another branch south to Ignacio Dobie and another place all indian when I will go back to Denver and if I have time go out on Plains to a ranch of a friend I cant have my mail forwarded but if you want to telegraph me badly—wire care Maj. Hooper—Genl Pass Agt. D. & Rio Grande Denver—[1]

These people have treated me better than they did Roosevelt.

Yours faithfully
Frederic

1. Maj. Shadrach K. Hooper, general passenger agent of Denver & Rio Grande Railroad Co.

☐ *FREDERIC REMINGTON TO EVA REMINGTON*

H. L. Hall
Licensed Trader
Ignacio, Colorado
October 29, 1900

My dear Kid— Got here all right—Ray Hall—trader gave me his bed—yesterday started in on chiefs portrait & did one horse study—will finish chief to day if he dont run away but the country is black with snow clouds—This is a snow country. I left over a foot on the mountains—everyone is coming out of them except miners who expect to stay all winter and are provided.

To-morrow if it does not snow Hall and I go to a ditch camp 30 miles N.E. where I may stay and paint for possibly a week. Then I am going to the Pueblos where it dont snow. The Navajos I cant reach—too far—and a great many of them are at the ditch camp working.

I have 1 hide dresser—1 lance—& beaded belt 1 Ute baby basket very fine—some Cliff dweller pottery and expect to get more. Indian stuff simply cant be bought. The dealers lodge orders for all indian stuff at any old price, not port traders. I could get a great deal of money for my collection.—

Hope you are well and everything going smoothe.

This is comparatively old country—valleys all cultivated and not much to inspire one. I hope for some stories—I have only one so far but I have some good illustrations.

<div align="center">

Y——

Fred

</div>

While he was gone, John Hay, then secretary of state, inquired after a picture.

☐ *JOHN HAY TO FREDERIC REMINGTON*

Department of State
Washington
October 28, 1900

Dear Sir I write to inquire whether the drawing by you in "Harper's Weekly" of yesterday is in your possession and whether you would be willing to part with it? I mean "The 9th Inftry Entering Peking."[1] I should like very much to purchase it, if the price is within my means.

Yours very truly
John Hay

Frederic Remington Esq.

☐ *FREDERIC REMINGTON TO EVA REMINGTON*

H. L. Hall
Licensed Trader
Ignacio, Colorado
November 4, 1900

Dear Kid— Went over to Piedras[1]—30 miles in wagon—too cold to sketch. Came back here—have 10 color studies[2] now and two or three stories—the Utes are to far on the road to civilization to be distructive.

I ship today box of Indian stuff—the best stuff you ever saw and I am going to Espanosa pueblo at noon. May stay a week if everything all right and then go Santa Fe. Hope to get home soon.

1. The double-page illustration had appeared in *Harper's Weekly* on October 27, 1900. Hay had, in 1899, enunciated his open-door policy for China, which generally came to mean support for equal commercial opportunities for all nations there. When the Boxer Rebellion occurred in 1900, members of several foreign legations in Peking were cut off from the outside, and an international expedition was sent to rescue them in August 1900. The United States, with troops close at hand in the Philippines, contributed 2,500 men to the joint enterprise, which also included British, French, German, Russian, and Japanese troops.

1. Tres Piedras, New Mexico.
2. Color sketches later made into illustrations: *A Monte Game at the Southern Ute Agency* and *On Ore Train Going into the Silver Mines, Colorado*. The latter appeared as a double-page in *Harper's Weekly*, March 2, 1901.

Have bet a hat with Hall—a very fine fellow on McK—[3]

Nothing new—it is quite cold here—Got telegram from Penfield—someone[4] wanted to buy the "Troops going in Pekin"—[5]

I am dead on to this color and trip will pay on that account alone—

<div style="text-align:center">

Yours lovingly,
Fred

</div>

☐ *FREDERIC REMINGTON TO EVA REMINGTON*

<div style="text-align:center">

The Claire Hotel
Santa Fe, New Mexico
November 6, 1900

</div>

Dear Kid: Left Ignacio—had to go up the road half way to Denver to get a nights sleep and at 6 o'c A.M. go back—stopped at Espanola and got ready to do a Pueblo village. It was cold and cloudy and I did not like pueblos—blue qui have breeches did for me—I dont want to do pueblos—too tame—so got train for Sante Fe. Have had first bath in ten days.

Going to talk to Gov. Prince[1] to-morrow and dont know what I am going to do. Have bought the biggest best piece of old crockery you every saw—also one of those pieces of blue slag which you wanted.

This is election night and the town is very much excited. Reports are favorable to McK but cant tell yet.

I am either going to do Pueblos or not and dont yet know. I think I wont. They dont appeal to me—too decorative—and too easily in reach of every tenderfoot.

Shall never come west again—It is all brick buildings—derby hats and blue overhauls—it spoils my early illusions—and they are my capital.

I have had a hard trip—eating all hours—all food—dirty and not much killing.

You come near having your second husband and the 10,000 day before yesterday. On a mountain grade our passenger car became detached and me and the brakeman stopped her otherwise.

<div style="text-align:center">

Frederic the Past

</div>

3. He is probably referring to the 1900 presidential election—McKinley vs. Bryan.

4. The "someone" was Secretary of State John Hay.

5. *The 9th U.S. Infantry Entering Peking.*

1. Territorial governor Bradford Prince, a New York Republican who had known Frederic Remington's father.

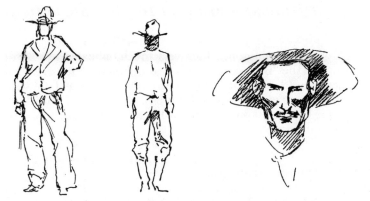

Remington continued his correspondence with Theodore Roosevelt, who became president in 1901 following the death of McKinley. The two men were kindred spirits. Remington tried to influence Roosevelt on one occasion in connection with a political appointment, an attempt that apparently backfired when the man was found to be unfit for the job.

☐ *THEODORE ROOSEVELT TO FREDERIC REMINGTON*

Oyster Bay, N.Y.
April 5, 1901

Mr. Frederic Remington,
 301 Webster Ave.,
 New Rochelle, N.Y.
My dear Mr. Remington:— I have your letter of the 3rd inst. I am sorry to say I can only give you a most general description, for I have not the material where I can lay my hands upon it. It was called broad horn simply because it was so short, wide and shallow and square at both ends. The early ones I gather were not built upon any one type, each man constructing his own scows of the size and proportions that his fancy and ability dictated. Gradually the single type of Mississippi flat boat appeared. Toward the end I gathered that the words "broad horn" were used as a term of contempt for the small flat boat built by some individual to carry down his own produce or his own family as distinguished from the larger and better constructed flat boats built for the regular trade.

It is always a pleasure to hear from you. I only wish I could see more of you.

Faithfully yours,
Theodore Roosevelt

☐ *THEODORE ROOSEVELT TO FREDERIC REMINGTON*

November 14, 1901

My dear Remington: I am very much obligated to you for send-
ing me the "Buckskins."[1] It is a compliment that I greatly appre-
ciate, and I appreciate the pictures themselves as I always do
everything of yours. Mrs. Roosevelt thanks you as much as I do. I
hope to see you on here in Washington some time in the not very
remote future.

<div align="right">

Sincerely yours,
Theodore Roosevelt

</div>

Mr. Frederic Remington,
 Care of Century Magazine,
 New York, N.Y.

☐ *FREDERIC REMINGTON TO THEODORE ROOSEVELT*

New Rochelle
February 16 [1902]

President
Theo. Roosevelt
My dear sir:—I know you have to stand and judge other people
but I think the case of Ben Daniels[1] erstwhile gambler—prisoner
of state if so—and brave soldier has many complications and I
think a lot of his critics in cold blood wouldn't do what he did in
hot blood in a disinterested way for the public good.

The man has tried to live down a past—he has managed to
your satisfaction and a whole lot of other people—now why
should a lot of old nosey women—superanimated Senators and
Democrats who are always against the government be taken into
consideration when a brave soldier is concerned.

There are two sides to the thing and here is a good chance for
your courage.—

<div align="right">

Yours faithfully,
Frederic Remington

</div>

1. Remington sent Roosevelt a presentation copy of *A Bunch of Buckskins,*
published by R. H. Russell in 1901. This picture portfolio contained eight pastels
in the impressionist mode.

1. Benjamin Franklin Daniels was an ex-sergeant in Theodore Roosevelt's
Rough Riders. Roosevelt was in the process of seeking Congressional approval to
make Daniels the United States marshal in Arizona. Daniels had not told Roosevelt
he was a prisoner in the state penitentiary at the time of the appointment.

☐ *THEODORE ROOSEVELT TO FREDERIC REMINGTON*

February 19, 1902

My dear Remington, I am in receipt of your letter of the 16th instant, concerning Daniels. If he had been frank with me I would have stood straight by him. But I had a right to demand that he should, in response to my questions, tell me of his past. He did not, and put me in an attitude of unwittingly deceiving the Senators to whom I gave my personal guarantee that Daniels was all right. If it was not for this I should, as I say, have stood perfectly straight by him.

Sincerely yours,
Theodore Roosevelt

Frederic Remington, Esq.,
301 Webster Avenue
New Rochelle, N.Y.

☐ *FRENCH DEVEREUX TO FREDERIC REMINGTON*

713 Euclid Avenue
[Cleveland, Ohio]
January 2, 1902

Dear Mr. Remington The bronze[1] is fine. It was the best present I got not counting an army saddle and a bridle. Papa told me what it was meant to represent. I was in Chicago Monday and Tuesday and stayed with Mr. Tripp. Couldn't you get it into mama's head to get me introduced to some army fellow and let me live with his troop (some cavalry officer) I want to join the army as a private when I get out of college. I would like to get to know how soldiers live etc. I lived with a German regiment of Uhlans once for a while. I have seen some of your drawings of German soldiers. Guess I will have to feed now. Hope you will have a happy year. I am

Yours very truly
French Devereux

1. *The Buffalo Signal* was copyrighted Dec. 17, 1901. The only one ever made was apparently given to this young man as a gift from his father. It is now at the National Cowboy Hall of Fame and Western Heritage Center in Oklahoma City, Oklahoma.

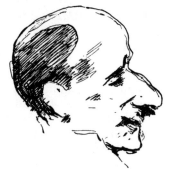

Remington worked closely with Riccardo Bertelli, owner of the Roman Bronze Works, but regularly spelled his name with an "a"—Bartelli. Remington often worked on more than one bronze at a time, beginning one while still putting finishing touches on another. References in his letters are to bronzes in any of several stages of completion.

☐ *FREDERIC REMINGTON TO RICCARDO BERTELLI*

New Rochelle
[March 1902]

My dear B—— I have reconstructed the right hand man and made it much better with a foot on the ground. So—now I have six horses feet on the ground and 10 in the air.[1]

I haven't enough wax to make the ground—don't you think we can do that over at your place with wax (proper) and save the plaster work etc?

Yours
Frederic R.

☐ *FREDERIC REMINGTON TO RICCARDO BERTELLI*

New Rochelle
[March 1902]

My dear B— Saw Pell[1] and he said he would send it up—the Cheyenne.[2] It may sell—

Am on second figure[3] now. Coming along as easy as rolling off a log.

Yours
Frederic Remington

1. *Coming Through the Rye* (October 8, 1902): "Bronze group of four cowboys on running horses. Men shooting pistols and shouting. Men represented as being on a carousal."

1. Henry W. S. Pell, salesman at Tiffany's who sold Remington's work. Tiffany's is still a leading store for jewelry and other decorative arts in New York.

2. *The Cheyenne* (November 21, 1901): "Indian on pony galloping with all four feet off the ground. Indian grasps spear in left hand and has war shield hung on his back."

3. *Coming Through the Rye.*

☐ *FREDERIC REMINGTON TO RICCARDO BERTELLI*

New Rochelle
[undated]

My dear B—— Pell tells me he hopes to sell the group[1] to a party—now if he does what will we do?

Jump Butter [illegible] him when we can have that model back

Don't do another "Mountain Man"[2] without letting me see the wax—[3]

Yours
Frederic R.

☐ *FREDERIC REMINGTON TO RICCARDO BERTELLI*

Personal
New Rochelle
[October 1902]

My dear Bartelli Sent the photos you sent me to Collier's Weekly and only hope they are published. They were excellent pictures of bronze which does not lend itself to photography.

I have an idea that we ought to do more in that way, and I think Pell is the man to do it—he is in position to through Tiffany and not directly identified with the Thing as we are. Suppose you put a flea in his ear.—

Yours
Frederic Remington

[P.S.] Noe [Thomas C., of Avery's Galleries in New York] told me that Doll and Richards of 2 Park St. Boston want the Cheyenne he has. Why not go in to that matter. Boston has the price.

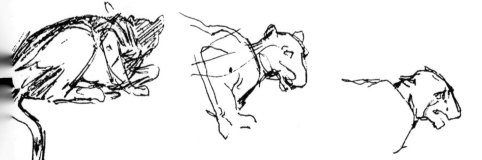

1. *Coming Through the Rye.*
2. *The Mountain Man* (July 10, 1903): "Man on horse coming down mountainside. Man fitted out with traps, knife, gun, cup, powder horn etc."
3. Note in Bertelli's hand: "Telephoned that this was in fire."

☐ *FREDERIC REMINGTON TO RICCARDO BERTELLI*

New Rochelle
January 25 [1904]
My dear B—— Am sending you a *gun & tin cup* models for my
wounded Bunkie.[1] These were taken off the statuetto by vandals at
Buffalo and tho they belongs to Mr. Collier Armstrong of Moore
& Schley 80 Broadway.

Make me duplicates of them, put a handle on the cup and a
place for the swivel to catch the carbine. Write Armstrong and he
will tell you where to send to put them on. Charge to me and
return the models.

Yours,
Frederic Remington

☐ *FREDERIC REMINGTON TO RICCARDO BERTELLI*

New Rochelle
[1904]
My dear Bartelli Enclosed find my check for Twenty Dollars—
payment for the "Seargeant"[1] sent to Mr. Cox.[2]

When you have me over to do the two figures—have a Broncho
Buster also which I want to work on by my self.
Yours faithfully
Frederic Remington
Much obliged for the St. Louis photos. The thing is pretty rotten.
Monday

1. *The Wounded Bunkie* (July 9, 1896): "Two horses in full gallop, side by
side. Each horse carries a cavalryman, one of whom has been wounded and is
supported in his saddle and kept from falling by arm of the other trooper."
(Campaigning soldiers usually carried only one blanket. At night, two men would
pool their blankets, one for the ground and one for cover; thus the term "bunky"
to describe one's best friend.)

The Wounded Bunkie, cast originally by the Henry-Bonnard Foundry, was not
recast in lost wax by the Roman Bronze Works. Bertelli was apparently willing to
do a little repair work if necessary.

1. *The Sergeant* (July 30, 1904): "Bust of Rough Rider Sergeant, height from
bottom of base to rim of hat 10 inches. Stern face, sharp nose, heavy moustache,
prominent chin, cheeks somewhat sunken, hat tilted on back of head. Handker-
chief around neck."

2. Jennings Cox, Jr., a banker who was a Remington neighbor in New Rochelle.

Remington sketched a model of Polo [1]
for Bertelli showing how the stirrup
should be positioned on the top figure.

☐ *[PART OF A LETTER TO RICCARDO BERTELLI*
FROM FREDERIC REMINGTON]

[Spring 1904]

The uppermost figure—the man on
the rearing horse—his left foot
has lost his stirrup which must
dangle behind as in the draw-
ing—with due regard paid
to the length of the
stirrup lather.
　　　Frederic Remington

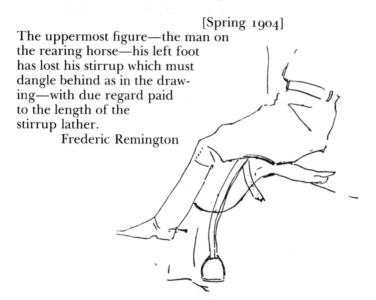

☐ *FREDERIC REMINGTON TO A MR. HUBER*

Ingleneuk,
Chippewa Bay, N.Y.
[1905]

My dear Huber [1]　Has Tiffany sold a "Scalp." [2] Do you hear of
Spaulding's doing anything.
　　Collect up from Tiffany as soon as possible and send me check

1. *Polo* (July 21, 1904): "Group of three horses and riders in game of polo.
One horse has fallen and rider is caught under him. The second horse and rider
are leaping directly over the fallen man. Third horse is standing with two hind
legs upon the belly of fallen horse."

1. Bookkeeper at Roman Bronze Works.
2. *The Scalp* (December 10, 1898): "Represents a mounted Indian reining
up his horse as he triumphantly holds aloft a scalp which he has taken from a
defeated enemy." *The Scalp* had originally been cast by the Henry-Bonnard
Foundry. Remington made some changes in it before it was cast again by the
Roman Bronze Works, probably around 1905.

when you can. "I need the money" as the fellow said who charged
50 cents for the piece of pie at the rail-road station—
<div align="center">

Yours

Frederic Remington
</div>

Tiffany wrote me a customer wanted 6 or 10 pieces of mine for
a public place and they wanted to know what reduction I would
make. I have asked for more information—if (?) I shall say
yes—I'll cut 10 percent if Bertelli will and Tiffany likewise—
How's that—
<div align="center">

Yours

Frederic R
</div>

*While Tiffany's, the prestigious New York jewelers, was one of the
dealers for Remington's sculpture in that city, Gorham & Company
tried on several occasions to persuade the artist to let them handle his
bronzes—but to no avail.*

☐ *FREDERIC REMINGTON TO RICCARDO BERTELLI*

<div align="center">

New Rochelle

[1905]
</div>

My dear Bertelli Another Gorham man Mr. Nash has been up
here and they certainly want my bronzes but we have discussed
it and I don't see my way to it.

Besides we have no bronzes to sell. What have your people been
doing. I was over Monday and found no waxes. For God sake
hurry them up. I know of two very good possible chances to sell
"Rye's." Pell could have sold a "Polo" and a Scalp has gone. Pell
has only four or five figures at present and here we are hard on
the holiday trade. I don't see how you can get out enough now to
fill the bill but if you go right at it we may manage. I am sure this
is going to be a great year for sales but if we don't have the stuff
we can do nothing.

I'll come over Monday and work and will come as fast as you
can finish the waxes for me.

Am getting along faster than I expected with the big one.[1]
<div align="center">

Yours

Frederic Remington
</div>

1. Probably refers to the large version of *The Rattlesnake*, copyrighted in 1905.

☐ *FREDERIC REMINGTON TO RICCARDO BERTELLI*

<div align="center">

New Rochelle
[1905]
</div>

My dear B—— When you do a *"mountain man"* I want to work
on the hind leg.

If possible I guess you had better not put *Dragoons*[1] in fire until
I see it again. You can have *Coming thru Rye* ready and when I
come to set that up, I can see Dragoons. Those big groups have
got to be *just so* or its a hard business for all hands.

<div align="center">

Yours
Frederic Remington
</div>

☐ *FREDERIC REMINGTON TO RICCARDO BERTELLI*

<div align="center">

New Rochelle
[1905]
</div>

My dear Bartelli Man got the "Rattlesnake"[1] all right and I will
be back from Cuba in two weeks to do the wax.—

Give James Barnes[2] all the information you can lay tongue to
on lost wax and send Collier all the photos you have of my
bronzes. I wish we could have a new one of the Broncho Buster
and the *Victory* or *The Scalp* we had better call it.

You can settle the details with Knoelder[3] or I will when I
get back—

<div align="center">

Yours faithfully
Frederic Remington
</div>

If I get yellow-fever put bear-skin *chaps* on Rattlesnake man.

1. *Dragoons—1850* (December 6, 1905): "Two Dragoons and two Indians on
horses in running fight. One single horse without rider in lead. Foremost soldier
with raised sword in right hand ready to strike foremost Indian who is protecting
himself with spear and shield."

1. *The Rattlesnake* (January 18, 1905): "Bronze group of cowboy on bronco—
twenty inches high to top of head of rider. Rattlesnake on ground ready to attack
horse. Horse shying and in a position denoting fright. Forefeet both in air, etc."

2. James Barnes wrote the article "Remington the Sculptor" for *Collier's*,
"Remington Number," March 18, 1905.

3. M. Knoedler & Co., art gallery in New York.

☐ *FREDERIC REMINGTON TO RICCARDO BERTELLI*

New Rochelle
[1905]

My dear Bartelli Colliers asked me for *photos* of my groups for the Remington number.

They have photos of the Polo—and you had better send the *one* photo of each of my groups—which *you especially* select as the best available. Do this immediately and charge to me. Address

Henry T. Clinton
Art Manager
Colliers Weekly
416 W. 13
New York

Yours faithfully
Frederic Remington

P.S. Let me know when this is done.

R.

*In 1906, Remington pro-
duced one of his finest
sculptures—*The Outlaw.
*The entire work is bal-
anced on one forefoot,
technically very difficult to
create and then cast. This
humorous sketch was prob-
ably drawn in December
1905 or 1906, and sent
to Bertelli as a Christmas
card.*

R. "Can you cast him"
B. "Do you think I am one of the wright brothers?"

☐ *FREDERIC REMINGTON TO RICCARDO BERTELLI*

New Rochelle
March 29 [1906]
My dear B—— Please send one of those Remington folders to
Miss Emma Caten
341 West Onondaga St
Syracuse
N.Y.
How did the young man "do" the second "Outlaw."[1] If you
think he has'nt got a good line on it I will come over and see it.—
Yours
Frederic Remington

☐ *FREDERIC REMINGTON TO RICCARDO BERTELLI*

New Rochelle
[1906]
My dear Bartelli This is going to be a big season for Remington
bronzes and you can BANK on that.
Pell sold two Broncho B's[1] and you want to get two more over
at once. Send two at a time as they get out and don't send for
others immediately.
He says he thinks he can sell first copy of "Rye" immediately—
so get another going at once.
I am going to have "Outlaw" which was sold sent to Tiffany and
you can send that *signed* copy when cast to place I will designate.
What is to prevent Gorham from getting those bronzes from
Spaulding?[2] Have you any provisions for preventing it. They
might not be mean enough to do it but if they do we will have
to make them stop it.
Yours
Frederic Remington
Tuesday
P.S. Don't forget to have two outside ponies in "Rye" positioned
right.

1. *The Outlaw* (May 3, 1906): "Cowboy on a pitching broncho horse, same
jumping in air and balanced on 'off' forefoot only. Cowboy leaning back with hand
down on side of horse."

1. Larger version of the *Bronco Buster* (1905).
2. An art dealer in Chicago.

☐ *FREDERIC REMINGTON TO RICCARDO BERTELLI*

New Rochelle
[Spring 1907]

RB—— . . . [illegible]—When will you have a wax for me of the
last one *The Horse Thief*?[1] I go away for the summer next month
and want to have this done.

You must look very carefully to see that *all* works leaving
foundry are *copyrighted*.

Yours trly
Frederic Remington

I saw Spaulding in Chicago and he has stuff will show but it does
not seem to go. It may in time.

*The following letter from Daniel Chester French, prominent Ameri-
can sculptor hailed as being second only to Saint-Gaudens at this
time, must have been a source of great satisfaction. The inclusion
of representative bronzes in the Metropolitan Museum collection
assured Remington status and prestige.*

☐ *DANIEL CHESTER FRENCH TO*
FREDERIC REMINGTON

Daniel Chester French
125 West Eleventh Street
New York City
March 8, 1907

Frederick Remington, Esq.
New Rochelle, N.Y.

Dear Mr. Remington: The Committee on Purchases of the Met-
ropolitan Museum yesterday approved the recommendation of
the Committee on Sculpture to purchase four of your bronzes—
"The Old Dragoons," "Bronco Buster," "Mountain Man," and
"Cheyenne."

Before this purchase is made I wish to have your assurance that
you consider that these pieces would fairly represent you. I am
sorry that our Committee had not an opportunity to confer with
you in advance, but our selection was made after careful examina-
tion of your bronzes at Tiffany's and I hope that our selection will
meet with your approval. I have to confess that it might, at this
stage, be a little awkward, to change the subjects.

1. *The Horse Thief* (May 22, 1907): "Nude Indian on horse holding buffalo skin
with right arm as a protection. Buffalo robe flying in air. Horse running with three
legs in air. Total height 30 inches, total length 27 inches."

Mr. Pell told me of your generosity in offering the pieces to the Museum at approximately cost price. Your generosity was warmly appreciated at the meeting yesterday. I wish you would accept my personal thanks for this.

With much regard believe me

Most truly yours,
Daniel C. French
Chairman
Committee on Sculpture
Metropolitan Museum

☐ FREDERIC REMINGTON TO RICCARDO BERTELLI

New Rochelle
[1907]
My dear B—— All right—go ahead and let Pell rescue the Chicago "Dragoons" and also some small ones if he will—

Yours faithfully
Frederic Remington

The Metropolitan took bronzes. I hope you were not in Wall Street [illegible] say automobiles will sell "short" for a while I am afraid—

I was in Tiffany this morning and he had nothing of mine there to speak of.

☐ FREDERIC REMINGTON TO RICCARDO BERTELLI

New Rochelle
[1907]
My dear Bartelli, Tiffany is going to be out of bronzes epecially Broncho Busters long before Xmas and it seems to me we will have to raise the price of the Broncho Buster—What do you think? I don't know as that will do.

When does big group go over? The Philadelphia Committee is coming over here Tuesday the 19th[1] and you must come up and coach me before that event.

We ought to have made 20 Broncho B—— this summer. I told you so.

Yours,
Frederic Remington

1. December 19, 1907. The Committee from the Fairmount Park Association was conferring with Remington about a lifesize cowboy sculpture for the Philadelphia park.

☐ *FREDERIC REMINGTON TO RICCARDO BERTELLI*

New Rochelle
[undated]

My dear Bartelli— Do you number every one of my bronzes which goes out?

And be careful to tell Spaulding to put their own private mark (on inner side) of every bronze they sell and to keep a record of its number. Some day we might need this to make an identification. This seems to me very important.

I will be over Monday.

Yours faithfully,
Frederic Remington

Thursday

After 1900, Harper's was in financial difficulty and published little of Remington's work. "Natchez's Pass," which appeared in Harper's Monthly *in February 1901, was the last illustrated article Remington did for them, although he provided two full-page illustrations for "Colonies and Nation" by Woodrow Wilson, which appeared in April and June 1901. His last illustration for the* Weekly *appeared on March 2, 1901, a double-page illustration titled "On Ore Train going into the Silver-Mines, Colorado."*

The Century Illustrated Monthly Magazine, under the editorship of Richard Watson Gilder, continued to publish some of Remington's work. "A Desert Romance," the last illustrated story Remington did for them, appeared in February 1902. In April 1902, "The Plains Across" by Noah Brooks, and in April 1904, "The Fights of the Fur Company" by Agnes C. Laut, appeared with Remington illustrations. That was the end of his work for Century.

☐ *R.U. JOHNSON TO FREDERIC REMINGTON*

Editorial Department
The Century Magazine
Union Square, New York
October 12, 1901

Frederic Remington Esq.,
New Rochelle, N.Y.

My dear Remington: Can you not give us a better title for your story, "Ochoa Waters," a title which will not attract a single reader. We want to get the Southwest in it somehow, though perhaps that could go into a subtitle, but we are sure you can do better than the title it now bears.

Yours sincerely,
R.U. Johnson
Associate Editor

☐ FREDERIC REMINGTON TO R.U. JOHNSON

My dear J—— I like "Ochoa Waters" but you might call it "A Desert Romance"—"The Romance of Ochoa Waters" or "The Wooing of ——" giving her name which I cant remember. "A Rough Wooing" "A Old Tale of the South West" "A wooing on horse-back"—Oh call it anything which suits your fancy.

Yours trl

Frederic Remington

[On top of letter in Johnson's hand is written:] Miss Bliss, Make it A Desert Romance A Tale of the Southwest.

Remington began to do more work for Collier's Weekly. George Wharton Edwards, who was the magazine's art editor, had a special relationship with Remington. His verses of praise and jest regarding Remington's work are very colorful.

☐ GEORGE WHARTON EDWARDS TO FREDERIC REMINGTON

COLLIER'S WEEKLY

Art Department

George Wharton Edwards, Director

521—547 W. 13th St. New York

[undated]

My dear Fred: Your trout fishing picture is "bully"![1] Keep on sending 'em—you're doing better work all the time! I want more—more!

The pictures which Fred Remington hath wrought
Are with suave and finished beauty fraught,
That proves he's mastered, 'tho' the Stipplers Scott,
The art, so little known of leaving off.
A picture is not finished till it shows
No trace of industry to mar repose.

(Eh—what?)

G. W. E.

1. "Trout Fishing in Canada," *Collier's*, August 3, 1901.

☐ *GEORGE WHARTON EDWARDS TO*
FREDERIC REMINGTON

COLLIER'S WEEKLY
Art Department
George Wharton Edwards, Director
521–547 W. 13th St. New York
[undated]

My dear Fred: No! do *not* "print" in the title—make a pen and ink heading (picture) to occupy the space. I'll put the title in type.

This is *no* parody, but 'tis good advice.
Be bold good Remington, and never fear.
The carpeting critics or their pens severe!
Your art is young, the best is yet to be,
What is to come not ever they forsee,

How comes on the D—— box—
Hast filled it yet? Say!?

Yours,
G.W.E.

☐ *GEORGE WHARTON EDWARDS TO*
FREDERIC REMINGTON

October 3, 1902

My dear Fred: I want some DRAWINGS now—wine hell cant I have some of Ewers? Hive assked U for em time and time again avent I? But!!! I dont get them. Do I? Now when do I get em???
Say Fred? When do I get em?
WHEN DO I GET 'EM!!!
SAY FRED—WHEN DO I GET EM!!!
Now Fred this is serious. This is—serious—When do I get em?
Neenon Enisdem Exendebat—
That is to say I want em bad Fred
Worse than the ink.

Thine
George

☐ GEORGE WHARTON EDWARDS TO FREDERIC REMINGTON

COLLIER'S WEEKLY
Art Department
George Wharton Edwards, Director
521–547 W 13th St. New York
[undated]
Lines
To the Happy Life of F. R.

Freddy, these things in thy possessing
Are better than the bishop's blessing.
A wife that makes preserves; a stead
That carries double where there's need;
October Ale, some good Virginny,
Roast sucking Pig, a pickaninny;
The Daily press sent gratis down and frank'd;
For which the Editor is Weekly thank'd;
A goodly point of Chaucer bound long since
When Charles *the first* was simply Prince;—

He that hath these may pass his life,
Drink with the doctor, and bless his wife;
On Sunday rest, and eat his fill;
And fast on Friday's if he will;
Toast friends or foes, argue on the news,
Or fight with the Deacon over Pews;
And after all these then are done
God Bless you Freddy Remington.

G.W.E

George M. Wright, Remington's lawyer and friend, accompanied Remington on some outdoor trips. Two samples of his admiration and humor reveal a close, personal association.

☐ GEORGE M. WRIGHT TO FREDERIC REMINGTON

Thirty-Six West Thirty-Fifth Street
December 24, 1902
To Mr. Frederic Remington
 sometime styled "Draughtsman—Historian—Poet"
Sir It may ill become one, in whose hand the pen is but a clumsy

tool, to venture to add to those titles so felicitously bestowed upon you by that master of the art of letters, Mr. Wister, and yet me thinks another can, without offense, be given by one who has shared with you the joyous life of the woods and streams, and who has heard you ponder and debate upon forrest lore, as well as the grave problems of life and human destiny, while the camp fires smouldered at ones feet and the soft voices of rippling waters and swaying boughs stirred the soul to natures harmonies, so, secure in the confidence begotten of such companionship, I shall add the title—

—"philosopher"—

and I have ventured to send you herewith my Christmas Greetings, the recorded sayings of that Prince of philosophers Sieur de Montaigne, with the hope that you will therein find much to entertain you when said, and to temper your light heartedness when it might make you prone to folly, and with all nurture and replenish those treasures of wit and wisdom from which you have been wont to draw.

 I am dear sir, your most humble and obedient servant
<div align="center">George M. Wright</div>

<div align="center">

[undated]
Hyde Park
Hudson River

To Frederic Remington
who
tramped the West hunting pictures
and who is
now pictured in the East, hunting

TRAMPS

</div>

Oh! them days on Lather's mountain,[1] when
 the skies were clear and blue
When my neighbors never bothered, and all
 were fair and true
When Scolding Anne was quiet, and
 Gus Thomas was a sport
Before the time when Kemble helped
 Wilson build the Fort

Oh! them was days as we all like, and
 hope to see some more;

1. Augustus Thomas's home was located on this mountain.

And back yards were primeval and we
 never lacked a door
But now the Playwright when, he calls
 my door bell has to ring
My mind it wanders from my work and
 this is what I sing

 I want to be a Sheriff
 and with the posse stand
 a helmet on my forehead
 and a club within my hand
 and when I am a Deputy
 with a shield upon my coat
 I'll hunt the "Weary Miller"
 and kick away the Goat

 I'll give up painting Injuns
 and cowboys and their elk
 I'll give up rye and water
 and take to soothing milk
 I'll give up drawing Cubans
 Also the Western scamp
 and glorify on canvas
 That world beyond—the tramp

 PS Kindly permit gloves
 [George M. Wright]

In November 1902, Macmillan published Remington's novel John
Ermine of the Yellowstone, *his answer to Wister's* The Virginian.
*The character Ermine is a wild man raised as an Indian who ven-
tures into an army camp, meets and falls in love with the colonel's
daughter, and is rejected by her. Wounded by her fiancé, he is later
killed by a guard on orders from her father when he returns to the
camp. Though the book was a modest success, it never achieved the
stature of* The Virginian. *Remington was, however, a remarkably
good writer for a man who achieved his major distinction in art.
Jerrold Kelley was a commander who wrote for Harper's on naval
subjects.*

☐ *J.D. JERROLD KELLEY TO FREDERIC REMINGTON*

 21 East 83rd
 New York
 Wednesday [1902]
Dear Remington/ John Ermine of the Yellowstone reached me
just before dinner last night. I read it from light until twelve
o'clock, picked it up at 6 this morning, and finished it, practically

at one reading. I couldn't & can't get away from it. Dont you worry, honey, about that book. Your friend Wister is, compared with what you have done, telling things at second hand in the Virginian. I am quite willing to go on record as saying that it is the best book on the Western country of that day that I have read & I believe honestly, it is in parts the very best book that has ever been written on that country & its people Honest injun.

The first hundred pages are a marvel & wherever you have the Indian, the soldier the four footed things & the long broken stretches of country to deal with—it is epic. I was afraid for a moment you were going to fall down on the love making, and the girl,—but it is all right and take it by & large, you have done a big thing, that should be a big success. There is vitality, an irresible adjustment so unusual that I intend to let the chapters simmer in my mind for a week & then read it again. Perhaps I should want to give you a more nicely balanced judgment, but then first impressions count for so much, that I am trying, inadequately I know but honestly & admiringly to tell you just how your Greek tragedy of the Plains struck me—

My best congratulations—and I am sure when the honest minded tell you what they think, this, trickle of good wishes will be a mighty down-pour. Thank you for the gift & the lines that convey it & always

Sincerely yours,
J. D. Jerrold Kelley

Oh but Wolf-Voice is a dandy. Do him over in another book.

☐ *GEORGE WHARTON EDWARDS TO FREDERIC REMINGTON*

COLLIER'S WEEKLY
Art Department
George Wharton Edwards, Director
521–547 W. 13th St. New York

My dear Fred: I have been on the Plains with you and John Ermine for two hours . . . You have set up a character that will

live with me as long as I have memory . . . A real man seems
Ermine so great is your art. You have hewn him in bold strokes
that remind me irresistably of the work of Rodin. In the sunlit
glare of this picture of yours the modern novel of the Boudior
seems as feeble as wax candle light—. . . Your men walk up-
right—The sun shines . . .I hear the rattle of camp life . . and
then at once I feel the wide hot waste of the Plains . . .

 Your meat is too strong for Broadway but I am sure the plains-
man will accept it as "Good Medicine"! You have soul—and your
art lieth in the hollow of your hand!

> Yale!
> George Wharton Edwards

☐ **GEORGE BRETT TO FREDERIC REMINGTON**

> The Macmillan Company
> Publishers
> 66 Fifth Avenue, New York,
> Dec. 4, 1902

Dear Mr. Remington: You will be glad to hear that we are going
to press with a second edition of "John Ermine" to-day. I trust
that this means that the book has now started on a long career of
sale and usefulness. This first edition is almost exhausted and will
be quite sold out before we shall be able to get the second edition
ready.

> Yours very truly,
> George Brett

*Louis Evan Shipman (1869–1933) was a Harvard-educated maga-
zine writer and playwright who would later serve two years as editor
of* Life Magazine *(1922–24). He thought* John Ermine *would
make a good Broadway play and offered to adapt it to the stage.
Remington, always a stickler for authenticity, made many sugges-
tions, especially in his letters to Shipman from Ingleneuk during the
summer of 1903.*

☐ **FREDERIC REMINGTON TO LOUIS SHIPMAN [?]**

> New Rochelle
> [February 1903]

[No greeting] You are now being addressed by Old Mr. Bron-
chitas—the old snow—jumped all over Fred Remington Friday
and laid him quietly down but not before he wrote Davis[1] and

1. Richard Harding Davis, journalist and fiction writer.

said that in no way must he use my name. Fact is I only answered some simple questions of fact for him in a letter marked personal so nothing can come of that and from now on I will cork up even on that with my very good plea. Ranson's Folly[2] is modern, Kackhi and he cant get indians in it without everyone west of Buffalo laughing at him—I made that plain.

Glad to see you when you come down—we will fix up. Have a pastel—fairly tough which I did of John. Do you want it?

Brett[3] made a poster of the black and white. I dont know what to make of that slob Brett except the general fact that he is a god-damn sun of a bitch like all the other publishers. Still since I dont intend a second offence it dont matter much.

 Yours
 Frederic R

P.S.
Say "John E" is getting the best kind of book-notices and it has just occurred to me that maybe somehow Wister dont want a west-ern play out while is running Virginia and if he heard of it and asked Brett to help him—Brett would & chew this.

☐ FREDERIC REMINGTON TO LOUIS SHIPMAN

 Ingleneuk
 Chippewa Bay, N.Y.
 [Summer 1903]

My dear Louis: Say—you indian—I am working like hell here on stuff which I cannot neglect so don't get me down to New York be-fore August unless you have to. Of course if it is a real necessity— I come—understand that, but don't send until you are sure the thing can't be done by correspondence. I am sorry you & Madam can't come here. But the rail road management seems never to have thought that a man would want to go from Ogdensburg to Windsor & visa-versa. I would have had to spend a day & a half; have gone to Montreal and have been dumped out at Bellows Falls at 3 a.m. and there was no information as to how I would reech Windsor. Then again we are constantly entertaining guests here but that would be merely a necessary inconvenience (to the guests).

Have tried to answer your questons—in enclosure.

Some of your indians ought to have buffalo robes on.

The "grey" shirt was the "issue" but many soldiers bought blue or buckskin shirts and all wore the big Stetson hat.

2. *Ranson's Folly* by Davis, Charles Scribner's Sons, 1902. Remington provided some illustrations.

3. George Brett was Remington's contact at the Macmillan Company, which published *John Ermine of the Yellowstone.*

This was the only Kuno holster &
some men cut that flap off.

This was the old skinning knife with
a "stub" & the scabbard to rub up the knife.

Enlisted men carried them—*In the Field.*

The soldier boot was the half boot.

Yours
Frederic R

Wednesday

☐ FREDERIC REMINGTON TO LOUIS SHIPMAN

Ingleneuk
Chippewa Bay, N.Y.
[Summer 1903]

Dear Louis—I am no champ on Civil War but the boot of cavalry
was a bootie with pantalons worn in or out as case might be. It was
sometimes called a half-boot.

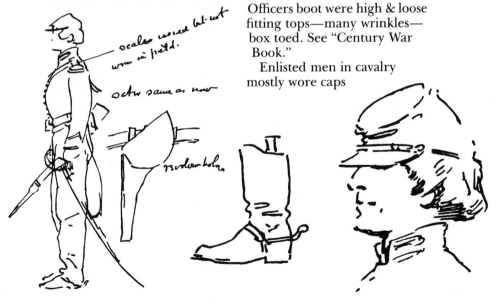

Officers boot were high & loose
fitting tops—many wrinkles—
box toed. See "Century War
Book."

Enlisted men in cavalry
mostly wore caps

but whats the use—you stage people don't care what was worn by the people of a period. You will have your cavalrymen wear boots way up to their asses.
and they wore their hair long & combed forward.

Good luck to you

Y——
Frederic Remington

☐ *FREDERIC REMINGTON TO LOUIS SHIPMAN*

Ingleneuk
Chippewa Bay, N.Y.
[undated]
Remember a Crow warrior did his hair up a'la' my sketch in book And always wore the leggin peculiar to them as per drawing "John Ermine."

Studebaker made the govt. wagons & you can get cuts from them.

The Webb Belt known as the "Mills Belt" was not issued then—The soldiers made theirs of canvas or leather.

Bannerman on Broadway can give you the Soldier clothes.
[Unsigned]

☐ *FREDERIC REMINGTON TO LOUIS SHIPMAN*

New Rochelle
[Summer 1903]
My dear Louis— Before you people come to New York you want to have grey shirts (such as I bought when you were with me in the uniform shop) or that infantry or I will denounce the play.

Why don't you tell me what is happening—I should like to see the Boston notices etc. You are such a lobster Louis—it's out of sight out of mind with
your frivilous nature

Y——
Frederic R.
Thursday I am gradually regaining my health.

This was the boot of that period—no stiffing in leg—high heel etc.

Not of this kind which came later.

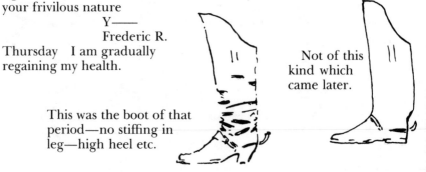

☐ *FREDERIC REMINGTON TO LOUIS SHIPMAN*

New Rochelle
[Summer 1903]

My dear Louis, I am mindful of your neat words of advice thro medam to me—concerning landscape and dialect—but it is useless—I will fail right there and you are just enough of an old grey rat to see it. But it is useless to struggle against one's loves.

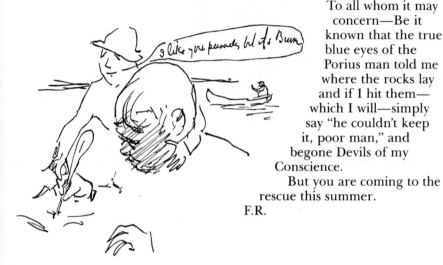

To all whom it may concern—Be it known that the true blue eyes of the Porius man told me where the rocks lay and if I hit them—which I will—simply say "he couldn't keep it, poor man," and begone Devils of my Conscience.

But you are coming to the rescue this summer.

F.R.

Remington kept in touch with wartime acquaintance Dr. Percy Crandell. Crandell was in the Philippines and Guam.

☐ *FREDERIC REMINGTON TO R. PERCY CRANDELL*

Ingleneuk,
Chippewa Bay, N.Y.
July 10 [1903]

My dear Doc— We got your beautiful letter—it was laugh—that Manilla club must have been horrible for an old weak pig skin like you—worn by the rays of many moonlights which you couldn't see bein' inside.

An "the colony of lepers"—*bueno.*

Well Doc if that height of land don't go out some high tide we expect to see your skeleton in these parts—I doubt not you will look as snakey as a medieval monk after this cruise.

Mrs. R. says she will like the baskets when they arrive and there will always be one good dinner comin' to you at 301 Webster.

We are up here—cool as cucumbers—with our nerves thickening up for the next winters campaign—a little work—a little tennis—a canooing-fishing and gassing to pass the "good old summer time" and then it will all end as every thing that I like does—God d—— it.

My book John Ermine is going to be on the stage if Hackett don't die in September but I don't guess that Mr. Man In The Street will think—I'm on to that sort of sheep-tick.

Looks like Mrs. China might get Johnnie Japan to tackle that *Man In a Sack* over East thar—What?

If you were a really intelligent person you would send me some photographs of Guam & a short article *On It* which I would give to Colliers & have them send the check to you—but Naval People who are intelligent *Dont Talk*—See there—Doc

Frederic Remington

☐ *FREDERIC REMINGTON TO R. PERCY CRANDELL*

301 Webster Avenue,
New Rochelle, N.Y.

My dear Doc— Got your photo—and by the look of your surroundings it isn't so d—— awful at Guam. I don't know who you have to talk to but I see the red stuff settin' handy on the table to make you talk and judge the other fellows on the button.

I have been having a hell of a time attending rehearsals of Ermine by Hackett. The thing opened in N.Y. and is still going but can't say for how long. This is a rotten year for the stage. P. Morgan[1] got everbodies bundle in the last break up and I guess we poor artists get a chance to reduce our flesh before Spring.

Gus Thomas[2] has gone to Paris for a year. I was yachting for a day with Henry Wolcott—my what a head. I'm no sport any more—I have dyspepsia Oh—Oh.

How long they going to keep you on that island—your sentence ought to be pretty near up—

Y——
Frederic Remington

1. John Pierpont Morgan, American financier.
2. Augustus Thomas, playwright and New York friend of Remington.

*Jack W. Summerhayes was a for-
mer U.S. Army officer. He and
his wife, Martha ("Mattie"),
became close friends of the Rem-
ingtons when they lived in New
Rochelle.*

☐ FREDERIC REMINGTON TO MARTHA SUMMERHAYES

New Rochelle
[Fall 1903]

My dear Mrs. S.,

Much obliged for your talk—it is just what we want
—proper impressions.

I fought for that long hair[1] but the management said the
audience has got to have some Hackett—why I could not see—
but he is a matinee idol and that long with the box office.

We'll dress Katherine[2] up better.

The long rehearsals at night nearly killed me—I was completely
done up and came home on train Monday in that terrific heat and
now I am in the hands of a doctor. Imagine me a week without
sleep.

Hope that fight took Jack back to his youth. For the stage I
don't think it was bad. We'll get grey shirts on their men later.

The old lady arrives to-day—she has been in Gloversville.

I think the play will go—but we may have to save Ermine. The
public is a funny old cat and won't stand for the mustard.

Well, glad you had a good time and of course you can't charge
me up with the heat.

Yours,
Frederic R.

☐ MAJOR J.W. SUMMERHAYES
TO FREDERIC REMINGTON

Nantucket, Massachusetts
September 14, 1903

Dear old man Your note received O.K. You ask for my impres-
sions as to your play. I was more than pleased—that attack on the

1. Martha Summerhayes wrote in her book *Vanished Arizona: Recollections of
the Army Life of a New England Woman* (Salem, Mass.: The Salem Press, 1911) that
when she attended the play, "The curtain went up and there sat Hackett, not with
long yellow hair (which was the salient point in the half-breed scout) but rather
well-groomed, looking more like a parlor Indian than a real live half-breed, such
as all we army people knew. I thought "this will never do."

2. Heroine in the story.

train was excellent and not over drawn. Your corral was well de-
picted—the old army wagon on the stage quite realistic—it made
my blood jump when I saw the skirmishers go out—and I wanted
to take a hand—the men should have grey flannel shirts at that
time and thimble belts were ok. In 1871 we made them of canvas
or any old thing—did not quite like the old major's way of wear-
ing his gun in the middle of his back—he could never of got at it in
a hurry—and also the captain was not respectful enough to the
major when actually on duty—off duty he was all right—and a
good hit was made in the scene where the wife went out and the
old man jumped to the side—board for the whiskey—should
have the sacks of grain hauled over of the wagon instead of back
of it. Could not the Captain make some remark on the aside in ref-
erence to the old Major's whiskey when he is gagging—40,000—
John Ermine was great but he got civilized too quick. The hero
should have stayed to the last and sorry you had to kill him—did
well enough in the book but think would have pleased the public
more if he had called up his Crow Indians and stood off the scout-
ing party awhile and simply got wounded—of course I am giving
you my impressions looking both at the stage and the effects on
the audience—another thing is it necessary for so much dusk put
on so heavy, and in spots? Your half breed can not be surpassed
and you could not have done better if you had imported one. We
had grey fatigue hats at that time and handkerchiefs for neck any
color as the men fancied. The scenery was grand and a change in
the shirts would have brightened it up. On whole I think it was a
great success and will take, as it is not a John was grand. And
I could find no fault with any of the actors. It was all true to life
and although a first night everything went through smoothly.
When I got to the ticket office I found Shipman has taken two of
my tickets. But as I insisted on getting them they made it all right.

The old major did enunciate quite plainly. But that of course
will come right—Love to "Missey" and yourself from all us—
with thanks for your kindness in sending us tickets—

 Yours,
 Jack S——
 Late of the Army

□ *FREDERIC REMINGTON TO MARTHA SUMMERHAYES*

 New Rochelle
 [December 31, 1903]
My dear Mrs. S—— Since sending my last it has occured to me
that you had trouble in getting your tickets. The last thing I did
before leaving Boston was to make sure that your tickets would be
delivered. I do not understand unless everyone was crazed with

conflict. They were my
tickets and no one should
have used them. I will
God damn everybody
I can think of about the
matter and do it good
and hard
 Yours
 Frederic R

☐ *FREDERIC REMINGTON TO JACK SUMMERHAYES*

New Rochelle
[1904]

My dear I can finally say that after all these
weary days of hopeless, helpless suffering, that I have partially
recovered from my visit to you and Mr. Wilson. I am able to
resume my less pressing affairs.

The next time I visit Nantucket I hope
you wont be there—either you or Mr.
Wilson. My foot looks like this and we only
hope it will again recover its former beauty
but only time will tell.

We are now going through our spring injun fever to be off
to Ingleneuk the canoes and the placidity of things as arranged
in that fortress of Rest. I had a letter from there which says
the water in the St. Lawrence is so high that only the flag pole is
above water but high water is good—its many years since it has
been up to the old water marks.

I go tomorrow to work my last will on my "Polo" group and I
hope the dear d—— public will like Frederic in his new costume.
The ponies and the "fellows by Jove" are slick—so smoothe that a
fly would sprain his ankle if he lit on them—but I'll soon be back
to my less curried people who are more to my mind.

I am getting so I rather live bravely at a slow pace on the water
wagon. If you go slow it dont jolt but any unusual excitement
makes one want to get back on the mud. This water w—riding
is a cultivated taste after 40.

I hope these coots have recovered their composure. They were
the most obliging things I ever knew but of course they knew how
much of that no. 12 business they could undergo.

Suppose Nantucket is waking up. Do any of those old women
dart out the back door & rush off then after piazza and otherwise
wake up. God, they sure get drowsy in the winter.

Comin' up to the island this summer? I go on big canoe trip in
September. Nippissing or Winnepeg Lake—dont know which—
birch barks & injuns for me. Do you get a detail?
She's down by the bow a
little—the injun dont eat enough.

<div align="right">Yours
Frederic</div>

After the John Ermine *stage fiasco, Remington needed to get away.
He invited his old friend John Howard of Ogdensburg to accompany
him on a trip to Mexico early in 1904. The following are letters to his
wife while on that trip.*

☐ *FREDERIC REMINGTON TO EVA REMINGTON*

<div align="center">The American Club
City of Mexico
January 5 [1904]</div>

Dear Kid We arrived here this noon after a long hot dusty ride
pretty well tired out. We stopped at the Hotel de Palacio and found
it much better than the old place Jardine. A young man friend of
John's met us and put us up at the above which is a dandy club
with everything we want. We shall live or eat here rather. We ex-
pect to stay around here doing things which our new found
friends find for us until about Tuesday and then *may* go up the
road on a private car in the Guadalahara direction but that is in
the air.

The city has changed considerably since we were here and is
much built up and more civilized. They have built a great park
out Chepultepec way and are constructing iron buildings. Prog-
ress has got this country by the tail—there are 8000 Americans
in the city and one can get along comfortably with English—but
this only in the city. It is certainly a d—— long jaunt to jam right
through from New York to Mexico but we thought best to do it
and have it over but we are both tired to death. We are going

home and do a 12 hour stint in bed and I guess we will be all
right to-morrow.

Well this is all the news and I havent got the rapa-rapa-rapa of
the car wheels out of my head yet—

If anything startling happens telegraph Maj. William Heimke—
American Legation Mexico but I hope nothing will happen.

They have a new sewer system here and bath rooms thank
God—

Good bye Kid—take care of yourself.

<div style="text-align:center">

Love

Frederic R

</div>

☐ *FREDERIC REMINGTON TO EVA REMINGTON*

<div style="text-align:center">

The American Club

City of Mexico

January 1904

</div>

My dear Kid— I got your batch of mail all right and the sketch-
ing case is just in. We go sketching tomorrow—theives market
Sunday morning—bull fight afternoon and Viga canal Monday—
then we shall probably go away from here but havent yet decided.

Am feeling rested—John has a bad cold and I a little diarahera
but nothing remarkable. I will get the opals but think mabe I can
do better in some other city. Mexico is overrun with Americans
who lift the price—

<div style="text-align:center">

Yours

Frederic

</div>

Friday

☐ *FREDERIC REMINGTON TO EVA REMINGTON*

<div style="text-align:center">

Acambaro

Monday

[January 1904]

</div>

Dear Kid— We are just arrived here—near 6—from the city of
Mex—John's friend Baldwin—Div. Sup. of this div. Mex. Na-
tional[1] came down Sunday and took us by storm—He made us
pack up after the bull fight get on board his car—sleep there and
came out this morning—This is a fine little queer towne—we are
to run around the country for a week—then Guadalajara—then
Chihuahua—then home—John quit on the bull fight and I never
want to see any part of another. Mrs. Maj. Heimke friend of the
Scotts—he was in my studio gave me a swell lunch—17 conimes

1. Mexican National Railways.

[illegible] with the ministers daughter & a bunch of sweets—it nearly bored me to death but she meant well.

Writing in an office so cant say any more. Our awful fears of terrific bills in city flatted out and were very decent—Palace & American Club and Santa Barbara not one—two-there for perpetual row—not a minute to ourselves—

John says—"he expects to see the 12 Apostles at any minute."

Yours
Frederic Remington

☐ *FREDERIC REMINGTON TO EVA REMINGTON*

Talluca
Postmarked 14 Eve 1904

Dear Kid—We left Acambro yesterday morning—over the spurs of the Mex. Nat. narrow—gauge and slept in a mountain town last night, coming here to day—we leave tonight back for Acambro and go out from there at 9 A.M. for the Northern route and by to-morrow night are free for two days. We are on a pay-car with a conductor of Mex. policemen and stop everywhere to pay section men. We are seeing more Mexico than I ever dreamed of. Big mountain country but not desert—rich and fine and surprising in its fertility.

We went up town this afternoon and were caught in a bad rain storm—quite unusual here at this time but got an untidy cab to take us back to the car—I havent had a chance to sketch yet. We are going so fast but hope to later. Am photographing and seeing things and resting up if one can call this constant jarring around resting. It is mental rest but not physical.

We go then—about Tuesday to Guadalajara—Guanajuato and Chihuahua and then home. John is in a hurry and I will be ready for home myself—so look out for us first of Feb.

Well car going—must mail this.

Lovingly
Frederic

☐ *FREDERIC REMINGTON TO EVA REMINGTON*

Compania del Furocarrel
nacionalde
Mexico
Acambro
January 18, 1904

My dear Kid— We have been a week on the road with Mr. Baldwin's private car—paying off track lands—and have gone all

over his division of the above road and have seen this section of Mexico pretty thoroughly. John thinks we must manuever to get home, so we are going to cut out Guadeljara and go tonight to Chihuahua where I must paint for a week. One cant paint and jaw around as we have been doing.

The town of Urapar[1] is one of the most interesting places I ever saw—old and semi-tropical. We got quite enough rail— roading being on the jar night and day and last night we got in here and slept 12 hours. I only hope Jack F.[2] is in Chihuahua but am afraid not—his intentions not outstanding.

This section of Mexico is rather fertile and not desert and the people are not like up north. Its a place more for Hop Smith[3] then me. John has brought all kinds of plunder but I have got nothing up to date. I intend to buy your opal in Chihuahua and if the custom house dont seize them will land them.

We ought to be home around the 1st Feb. so look out. We have had a good rest mentally if we did get a little frayed otherwise.

We cant have any washing done—since the Mexican women take it down to the river and beat it on a rock—making holes of various sizes in it. I had to throw away one shirt so its dirty for us till we strike a real sure enough laundry.

Well—Ide just as soon be home as not and will be sooner than I thought—as usual—keep your nose clean.

Yours lovingly
Fred

☐ *FREDERIC REMINGTON TO EVA REMINGTON*

The Palace Hotel
A. Labanast, Prop.
Chihuahua, Mexico
Postmarked 21 Eve 1904

My dear Kid Here we are—left Acambro and got two hours sleep—staid on a station platform from 12 at night until after 2 before a train came along Mex. Central junction—fearful dust all the way to Chihuahua—we nearly suffocated. Both of us have bad throats and I suddenly was taken with a violent diaherreha so went to bed yesterday morning had Doctor and was very weak— up this morning and am nearly all right but still a little weak. Jack met us and they promise me "punchers" to paint until further orders but Dr. wont let me work to day.

1. Urapan.
2. Jack Follansbee.
3. Francis Hopkinson Smith was a contemporary of Remington known for his watercolors and, among other things, novels depicting Southern life.

We were 10 days on a train going night and day and were thoroughly worn out. I want a few days painting if I can hold John who is getting "homeward bound" pretty fast. I think we will be home by 1st. Going out now to buy your opals. Train hands stole all John bought somewhere between here and Acambro.

Well so long—will be glad to get home—

Y——

Frederic

Remington traveled to Cuba again in late 1904, this time with Fred Gunnison, a banker friend originally from Canton, to attend a bankers convention. While there, Remington renewed his acquaintance with Jennings S. Cox, Jr., a New Rochelle neighbor and banker with John H. Davis & Company on Wall Street who handled stock and bond investments for Remington. Cox had begun to purchase Remington paintings and bronzes in 1897.

☐ *FREDERIC REMINGTON TO EVA REMINGTON*

The New York and Cuba
Mail Steamship Company
Moro Castle
off Florida Tuesday
[November 29, 1904]

Dear Kid—we have made a record run and get into Havana tonight instead of tomorrow morning. The weather has been fine and I havent been at all sea-sick. Gov. William Van Horn is aboard and I have renewed acquaintance. The boys play *Bridge* from morning until night. Jen. Cox among them.

They have a scheme to get some Cuban bonds and I am to have some—it seems a simple form of business hold up.

There is no news. I am glad I came and the rest has done us good. I sleep all night and two hours a day. It is getting hotter and hotter. I shed my heavy shirt to day and wish I had my lighter cap but suppose that may be in my trunk and I dont dare open it. Fred Gunnison says "gimmie a twenty foot ring to unpack a woman's trunk—not in this state room."

Well there is no news of course—Keep your nose clean—love—
Frederic

□ *FREDERIC REMINGTON TO EVA REMINGTON*

Hotel Louvre
Habana, Cuba
Postmarked December 1, 1904

Dear Kid We go tonight to Caballos and then to Santiago in ten days—where I sketch and then *Home for* me on the first steamer. Am having a grand time with very big financial people—which give me a new idea or two—all of which I will explain at length— am well and cant write with these g—— d—— Spanish pens which have either one or three *ribs*—

Jen Cox left last night and we go to night.

Yours,
Frederic

□ *FREDERIC REMINGTON TO LOUIS SHIPMAN*

New Rochelle
[1905]

My dear Louis: Well—let us dream about the $40. a week, but God how I hate to be awakened. I've got John[1] crossed off my books.

Would like to come up but I'm getting out a number of Colliers have a picture show in April and am now doing my masterpiece in mud with more than a million figures in it. Of course I'll never get it done but it gives me something in the trouble line. I am 10 days on the water wagon and shouldnt like to be in the same towne with Nick Biddle. He has a d—— bad influence over me. I dont like to associate with reformed drunkards—men who are living down a livid past. They are too morose.

The Corcoran[2] bought two of my bronzes and I get my brevet.

Speaking of snow—there is a little mess of it here—enough to stop a sleigh.

Do you and Hackett[3] pull double yet?

How's the missus & the kid?

Yours
Frederic R.

1. *John Ermine of the Yellowstone,* Remington's novel of 1902.
2. Corcoran Art Gallery in Washington, D.C., bought *Coming Through the Rye* and *The Mountain Man.*
3. James K. Hackett, the actor.

☐ *A.F. McGUIRE TO FREDERIC REMINGTON*

Washington, D.C.
February 2, 1905.

Mr. Frederic Remington,
 301 Webster Avenue
 New Rochelle, N.Y.

Dear Sir: I beg to thank you for your note of the 29th of January, in reference to the title for your work which we have recently acquired for the Corcoran Gallery. I think the title "Off the Range" is much more appropriate for the work than "Coming through the Rye,"[1] and I thank you for the suggestion.

We are very glad to have you represented in our Gallery by this interesting work.

Yours very truly,
A F McGuire
Director.

Cyrus Townsend Brady wrote Western stories, and some Remington illustrations appeared in his book Indian Fights and Fighters, *1904.*

☐ *CYRUS TOWNSEND BRADY TO FREDERIC REMINGTON*

455 E. 17th St.
Flatbush
Brooklyn, N.Y.
March 21, 1905

Mr. Frederick Remington
 New Rochelle, N.Y.

Dear Mr. Remington Thank you very much for your courteous letter of the 28th. The brother you mention is my only brother. I've heard from him how the correspondents went for him in Tampa and how you saved him from the consequences of their wrath.

So soon as I can get down town I will send you a copy of *Indian Fights and Fighters* which will be followed by the other three & the Lewis as soon as I get any. They are brief i.e. bound in uniform style now. I will also select some of my novels and western stories which I think you would like and have them sent to you from Scribners after signing them. You ought to get the whole "bunch"

1. Perhaps the Corcoran Gallery wanted to list *Coming Through the Rye* differently. Remington, usually a stickler on such things, seems to have permitted a change at least for the listing in this prestigious gallery.

early next week except the delayed volumes of the Am. *Fighters* Series which will come later.

You will find the illustration I referred to opposite page 316. There are two other illustrations of yours in the book.

If you find anything in your studio that you can send me will you please sign it for me as "Presented to Cyrus Townsend Brady by etc." and date it? Beggars must not be choosers I recognize, and if you have not that particular illustration which is hardly likely, I shall be most glad for anything from your brush. Still if I may be permitted to say let it be something with the Cavalry, the Cowboy, or the Indian, something of the West in it, if you can find a thing to spare.

Of couse I have seen your splendid stuff at the Noe Galleries. I saw it last Saturday. I always try to see all you do.

Here's hoping we may meet some day. Thanking you for what I have not the audacity to claim as a fair exchange.

<div style="text-align:center">Cyrus Townsend Brady</div>

I have quite a collection of originals in my house. Gibbs, Crawford, Lyendecker, Christy, Marchand, Giles, Schoonover, Thompson, Abbott, Gibson, Betts, etc. So I will hang you in good company. As the Judge said to the highwayman when he was sentenced to die at the same time with a Lord.

☐ FREDERIC REMINGTON TO JENNINGS S. COX, JR.

C/O Spanish American Im [illegible] Company, Santiago, Cuba
New Rochelle
[April 14, 1905]

Hello—you old rascal—I was just thinking of you. This is the first day I have been without an overcoat since Cuba. Suppose you are still Cuba-ing and are probably through fighting that San Juan thing over again for this season, for the want of tourists.

Had Fred Gunnison in to introduce him to the Governor the other day—I was intent on buying some thing but they told me to go back to the word press, that John Rockfeller was not needing any suckers for only just now. Its a great thing to have friends among the Frenzied.

They have put beef up again. Send me a steer or two. Money all goes to Chicago and the anthracite region. Its of little use to struggle. You are in the right country—All a fellow wants is a Panama & a salad and he can hire his "weekly."

Suppose you'll be coming up to see the Fisher palace this summer. We go to the Island just as soon as the ice goes out and I'm going on a six weeks canoe trip this Fall in Canada that will beat anything since Noah's cruise. I'm d—— tired of paint & clay and

want to see the
big river and the
moonlight and hear
Pete Smith (my man)[1]
tell how he got through
the winter.

I hit em for a few this season had a good bronze and painting
show. The Corcoran brought two groups, thus giving me a brevet
before death.

We had a good time down with you and the boys often speak of
you. I think they fully approve of you.

Hope that we receded from its grandeur. I've been watching
more [illegible] during the Spring than—that's its season for get-
ting gay—Regards to Mrs. Cox—Mrs. R—wants to be
remembered.

Yours,
Frederic Remington

Friday

1. Pete Smith handled arrangements for getting things done around the camp
at Ingleneuk.

Remington traveled to South Dakota in 1905, stopping first at Fort Robinson, Nebraska.

☐ *FREDERIC REMINGTON TO EVA REMINGTON*

> Fort Robinson
> Wednesday
> Postcard postmarked September
> 1905

Dear Kid—Here we are at Fort Robinson in Carter Johnson's quarters—leaving tonight for Hermosa—everything lovely and proposing to start Friday for Bad Lands.

> Yours
> Frederic

☐ *FREDERIC REMINGTON TO EVA REMINGTON*

> Hermosa, South Dakota
> Thursday
> September 14, 1905

Dear Kid—Got your letter here. We came right through. Had dinner with Carter Johnson at Robinson and went on to Chadron where we stayed all night. Up here this morning and outfitting today. We pull down to Cheyenne and Wyo. tomorrow morning with grub for two weeks—two teams and one of the boys is named Remington. Its fine weather here but they say it may turn cold. You can address Paul McClelland here.

I enclose some stuff from Onada We got our tent there and Westbrook gave us dinner at country club.

Henry likes the whole thing and is a good companion.

I guess our Steel will come out all right and I hope we get the Cornish thing.

Well thats all—we can get letters out I think from the Bad Lands. Keep your nose clean.

> Frederic

Royal Cortissoz, one of the foremost art critics of the day, wrote for the New York Commercial Advertiser *and the* New York Tribune. *In 1924, he was elected to the American Academy of Arts and Letters.*

☐ *ROYAL CORTISSOZ TO FREDERIC REMINGTON*

Thirty-One West Tenth Street
December 2 [1904]

My dear Remington: There are some emotions which have got to be expressed in more personal fashion than is possible in "cold type" and so I wish you would allow me to tell you here with what gusto and rejoicing I have looked at your new paintings. . . . [illegible] but they are a comfort. Will it annoy you if I take the liberty of saying as a friend what I shall presently be saying as a critic (And be hanged to you) that you have added a full cubit to your stature? So full of life they are, so chock full of interest, and oh! so rippingly painted! It fast moved my heart. I wanted to find you, to slap you all over that mighty back of yours, to congratulate you in all the languages, to tell you that you had struck twelve to ask you if it isnt great about to be alive and doing work like that. What? Well I dont know any better sensation than that of looking on while a fellow human is makng one splendid stride after another, painting good pictures and these damned good ones, and then damneder, and all the time doing it to his own beat, being himself in the fullest sense, making something beautiful that no one else could make. More power to your elbow. You make me happy.

Gratefully yours,
Royal Cortissoz

To Frederic Remington
Maestro

☐ *FREDERIC REMINGTON TO ROYAL CORTISSOZ*

New Rochelle
[1904]

My dear Cortissoz Thanks for your cheering words—don't you doubt I appreciate appreciation from fellows who are in no wise slack in the mouth and who know. This painting game is a d—— long up-hill pull and at times we are inclined to set back in the breeching if someone dont say something nice. A good word at times is a lot of comfort.

Yours faithfully
Frederic Remington

Thursday

Remington's Way of an Indian *brought more accolades from President Theodore Roosevelt. Remington sent Roosevelt a second bronze.*

☐ *THEODORE ROOSEVELT TO FREDERIC REMINGTON*

Personal

February 20, 1906

My dear Remington: It may be true that no white man ever understood an Indian, but at any rate you convey the impression of understanding him! I have done what I very rarely do—that is read a serial story—and I have followed every chapter of "The Way of an Indian" as it came out. I am very much pleased to have the inscribed volume from you now.

Is there ever any chance of your getting down to Washington? I should like to see you. You know I have appointed to office in the West, and in the case of Bat Masterson, in the East, a number of the very men whose types you have permanently preserved with pencil and pen; and curiously enough, I have also appointed a few Indians to office, and one to West Point. I have a good deal of difficulty to get the Senate to take the proper view about some of these men notably Ben Daniels, who is really a first-class fellow.

With many thanks,

Sincerely,
Theodore Roosevelt

Mr. Frederic Remington,
301 Webster Avenue
New Rochelle, N.Y.

☐ *FREDERIC REMINGTON TO THEODORE ROOSEVELT*

Ingleneuk
Chippewa Bay, N.Y.
[Summer 1906]

President Theodore Roosevelt

Am sending a small lost-wax bronze[1] with my compliments to you. He was the original inhabitant of the original Oyster Bay wherever that was—

Yours faithfully
Frederic Remington

1. *Paleolithic Man* (June 30, 1906)—"Being a representation of a human figure bordering on an ape, squatting and holding a clam in right hand and a club in left hand."

☐ *THEODORE ROOSEVELT TO FREDERIC REMINGTON*

Oyster Bay, N.Y.,
August 6, 1906

My dear Remington: We hail the coming of the original native oyster: Mrs. Roosevelt is as much pleased as I am with it. I think it is very appropriate, for undoubtedly paleolithic man feasted on oysters long before he got to the point of hunting the mammoth and the woolly rhinoceres.

Next October I do hope Mrs. Remington and you will get down to Washington and give me a chance to have two or three people meet you both at dinner.

With hearty thanks, believe me,

Sincerely yours,
Theodore Roosevelt

Mr. Frederic Remington
Ingleneuk,
Chippewa Bay, N.Y.

☐ *R.W. GILDER TO FREDERIC REMINGTON*

Editorial Department
The Century Magazine
Union Square, New York
March 24, 1906

R. W. Gilder, Editor

My dear Remington: I went the other day to see those ripping bronzes of yours. They are all thoroly alive and thoroly original. There was one that impressed me especially, as it had more beauty than some of the others, tho they all have the beauty of *life*. I mean the solitary Indian with his arm up,[1] apparently shouting defiance to the whole tribe of the paleface. What do you call that one? You seem to sum up the wildman's attitude in that one gesture; and the horse in that is especially fine.

I have received "The Way of an Indian"[2] and shall read it, I know, with great interest.

Yours faithfully,
R. W. Gilder

Mr. Frederic Remington
301 Webster Avenue
New Rochelle, N.Y.

1. "The Scalp."
2. *The Way of an Indian*, New York: Fox, Duffield & Company, 1906.

Childe Hassam (1859–1935), an American artist born in Boston, exhibited widely in the United States and in Europe. His work generally followed the methods of the French Impressionist school.

☐ **CHILDE HASSAM TO FREDERIC REMINGTON**

27 West 67th St.
December 20 [1906]

My dear Fred: I went to your show[1] and I think they are *all* the best things I've seen of yours—for sure!

You are sure to have lots of success with them too. No-body else can do them—I dont remember titles but I was interested in the coach coming down hill,[2] the only thing to say in criticism is your stars look "stuck on" and your foreground cast shadows are a bit black. Too much paint for stars perhaps too much pigment I mean and your shadows probably look lighter by daylight.

My congratulations old top!

Yours ever,
Childe Hassam

Perriton Maxwell was an art critic who reviewed magazine illustrations regularly for the Quarterly Illustrator, *a magazine founded in 1893. In October 1907,* Pearson's Magazine *featured Remington, and Maxwell wrote the article.*

1. Knoedler's December 1906 exhibition.
2. *A Taint on the Wind.*

☐ *PERRITON MAXWELL TO FREDERIC REMINGTON*

Highlands, New Jersey
July 31, 1907

Dear Mr. Remington: I appreciate to the full your prompt and courteous letter, but am keenly disappointed in finding your abode out of reach and my inquisitional mission made impossible. The editor of Pearsons wont listen to a postponement of the article and I must do it with what scout material I have at hand. As the next best thing to a talk with you I have jotted down a few pertinent queries which I will be mighty glad to have you fill in as you see fit.

I am to do a series of papers for Pearsons[1] on the really big, representative American artists. In leading off with an appreciation of your work I want to do a genuinely worth-while article and to this end anything that you send me in the way of personal data, sketch books, photos etc. will prove a great aid and tend to make my paper notable and far-reaching. I mean to have reproduced some of your earlier drawings—those over which the Colliers have no control with one or two of your best Collier drawings recently published. Can you send me a note to R.C. or Hasgood or Lee to show your cooperation with me in this Pearson undertaking? I do not anticipate any difficulty in getting the right kind of material from Century, Harpers and Scribners unless each of these magazines has returned every original you've done for them—which does not seem probable.

I think you will like what I shall say about your work and the manner of saying it. Mr. Little the editor of Pearsons has a letter from President Roosevelt saying bully things about you. You'll blush when you read it if modesty hasn't forsaken you. It is the manly kind of praise one expects from T.R.—nothing sloppy or flamboyant just a straight-from-the shoulder appreciation of big work well done.

May I hear from you at the earliest possible moment so that I can get to work and do you justice by having sufficient time to say things and say them right?

Very sincerely yours,
Perriton Maxwell

1. "Frederic Remington: Most Typical of American Artists" appeared in *Pearson's* in October 1907. In the same issue was a letter to the editor, Arthur W. Little, from President Theodore Roosevelt. The cover featured a photo of *The Bronco Buster*.

☐ *THEODORE ROOSEVELT TO ARTHUR W. LITTLE*

THE WHITE HOUSE
Washington
Oyster Bay, N.Y.
July 17, 1907.

My dear Mr. Little: I regard Frederic Remington as one of the Americans who has done real work for this country, and we all owe him a debt of gratitude. He has been granted the very un- usual gift of excelling in two entirely distinct types of artistic work; for his bronzes are as noteworthy as his pictures. His is, of course, one of the most typical American artists we have ever had, and he has portrayed a most characteristic and yet vanishing type of American life. The soldier, the cowboy and rancher, the Indian, the horses and the cattle of the plains, will live in his pictures and bronzes, I verily believe, for all time. Nor must we forget the exellent literary work he has done in such pieces as "Masai's Crooked Trail," with its peculiar insight into the character of the wildest Indians.

It is no small thing for the nation that such an artist and man of letters should arise to make permanent record of certain of the most interesting features of our national life.

Sincerely yours,
Theodore Roosevelt

Mr. Arthur W. Little,
Pearson's Magazine,
2 Astor Place,
New York.

Chapter 7
A Brief Last Hurrah
1907–1909

I N 1905, AT JUST FORTY-FOUR YEARS OF AGE, Remington could look to a remarkable range of accomplishments. He had achieved a measure of critical attention in four fields of endeavor—as a writer, illustrator, painter, and sculptor. His name was familiar to the American public, and his work was widely available. Remington paintings and bronzes were becoming expensive, but his prints could be purchased from Collier's at an easily affordable price. Noe Galleries on Fifth Avenue in New York had been having regular exhibitions of his work since 1903, when a "Special Exhibition of Recent Paintings by Frederic Remington" received a favorable review by art critic Royal Cortissoz. On January 16, 1905, the prestigious Knoedler's Gallery in New York exhibited nine of his bronzes, which had already been appearing for sale in Tiffany's window. When the March 1905 "Remington Number" of Collier's appeared on the newsstands, the five paintings reproduced on its pages were available for purchase from Noe, and the bronzes pictured in it were on sale at Knoedler's and Tiffany's.

Not long after that Remington received his first inquiry from the Fairmount Park Association in Philadelphia about the possibility of his doing a lifesize statue of a cowboy on a horse for them. The Fairmount Park Art Association was a citizens' group established in 1872 by the Commonwealth of Pennsylvania to buy statuary for outdoor display in the city of Philadelphia. Professor Leslie W. Miller was secretary of the association and chairman of its Committee on Works of Art. Charles J. Cohen served as secretary to that committee. Both served as trustees of the association. It would be the largest bronze Remington had ever done. He was excited about the project, and said to Miller, "I am not doing this thing with much in-

fluence to the money and before this thing is over I intend to give you a piece of horse-bronze which will sit up in any company. You can bet a few on that, Professor." Thus began a two-year association.

Remington was innovative in his approach to the project, developing a plinth that would blend into the rocky bluff of the selected site. He also insisted on being consulted and listened to regarding the site itself. He felt it was important for him to work on the sculpture outdoors, so he designed an elaborate track to move the statue in and out of his studio. Letters between Remington and Miller document the development of the piece. An additional packhorse was considered at one point, and an alleged rigidity in the foreleg of the horse caused a good deal of discussion between Remington and the members of the committee before it was resolved. The committee visited Remington's studio on two occasions, first in February 1907 to see the small plasticine model, and again in December 1907 to see the full-size model before Remington gave it over to the Roman Bronze Works. In March 1908, he traveled to Philadelphia to visit the site and work out problems of installation. He wrote a brief biography of himself to be used for the dedication ceremonies but went north to the St. Lawrence for the summer and did not attend, commenting that no one pays much attention to the sculptor. The unveiling of *The Cowboy* was a big event in Philadelphia on June 20, 1908, with a large crowd in attendance and a cordon of real cowboys and Indians in war paint and vivid headdresses ranged at the base of the statue. It would prove to be a lasting tribute to what even then was recognized as a vanishing breed.

Remington did not discontinue modeling small bronzes, although there are indications that he dreamed of doing another lifesize sculpture. He did, however, think on a larger scale, remodeling both *The Bronco Buster* and *The Rattlesnake* one-and-a-half times larger. He also completed *The Savage* (1908), *The Trooper of the Plains—1868* (1909), and *The Stampede,* which was cast posthumously in 1910. Remington was able to portray the horse and rider in bronze with the same dramatic tension that he achieved in his paintings. Unlike the stiff and formal sculpture of the time, his work has motion and action, which give it a timeless appeal. Casting continued under the authority of his widow until her death in 1919, when the molds were to be broken. Recasts and replicas are being produced to this day, however, and forgeries are often difficult to detect.

In 1907, Remington was still earning part of his living as an illustrator, but his work was almost exclusively for *Collier's*. His aim in the three earlier books published by R. H. Russell (*Drawings, A Bunch of Buckskins,* and *Done in the Open*) had been to get away from the limits of illustrating and produce works that would stand on their own. His agreement with *Collier's*, as outlined in an informal letter dated May 1, 1903, was that he would do at least twelve

double pages of art for them per year and that he would get all the originals back. There were also some special arrangements for portfolio reproductions.

The key ingredient was that Remington could paint what he pleased. It was the opportunity he needed to experiment with color and new materials. Between October 14, 1905, and July 14, 1906, the "Great Explorers" series appeared. Between November 10, 1906, and January 12, 1907, the "Tragedy of the Trees" series appeared. Most of the originals for these series were large oil paintings, but if Remington was not satisfied with a work he was apt to get rid of it, commonly by burning it. Diary entries for February 8, 1907, and December 1908 record that he burned seventy-five paintings on the earlier date and another twenty-three on the latter. Originals for the "Great Explorers" and "Tragedy of the Trees" have been lost except as they survive in the magazine reproductions.

Remington's work continued to appear in the magazine throughout 1907 and 1908, including some of what would become his most famous paintings, such as *Howl of the Weather, Downing the Nigh Leader,* and *Bringing Home the New Cook.* In June 1908, Collier's told Remington that they would cease purchasing his work after January 1909. They already had quite a backlog and, as it turned out, would continue to publish his work through December 1913.

At this point in his life, Remington had achieved recognition in the art world, too, but not all that he wanted. After the first exhibition of bronzes in 1905, Knoedler's Gallery in New York put on an exhibition of Remington paintings each December. Ten paintings were shown in 1906, twelve in 1907, nineteen in 1908, and twenty-three in 1909. They were well reviewed and sold well. Art critic Royal Cortissoz was to say about Remington in a 1910 issue of *Scribner's* that he (Cortissoz) had seen paintings of his that were "hard as nails. But then came a change . . . his canvases began to take on more of the aspect of nature. Incidentally, the mark of the illustrator disappeared and that of the painter took its place. . . ."

One mark of distinction eluded him, however. He was never elected an academician by the National Academy of Design, that bastion of American painters, sculptors, engravers, and architects. Established in 1826, the academy held annual exhibitions and gave prizes for outstanding work in different fields. The number of academicians was limited; the number of associates was not. Remington first entered an academy exhibition in 1887 with a watercolor. He continued to enter and was elected an associate, the academy's second highest honor, in June 1891. Altogether, between 1887 and 1899, thirteen of his paintings hung in National Academy exhibitions, but he did not seem to have a chance to be elected an academician as long as he continued to paint pictures that told a story. To the art establishment that was illustration. If symbolism and beauty were the dominant themes, then it was art. Remington never made

it despite many favorable reactions to his work by critics.

Remington continued to travel west, but he was increasingly uncomfortable, overweight, and out of shape, unable to be as versatile in his choice of accommodations and itinerary. He did return to Texas and Mexico in 1907 and to Wyoming in 1908.

Increasingly, he relied on visits to Ingleneuk to vary his viewpoint. His daily regimen usually included a dip in the chilly water and a stint around the island with a double-bladed paddle in his canoe. He loved the outdoors and seemed to work best there. Many of his best western scenes were conceived and drawn on the island. Local lore and North Country family diaries abound with tales of residents who were asked to pose as models for him by sitting on a sawhorse or paddling a canoe past his porch. These were no longer the literal, illustrative pictures of places he knew or people he had met. Instead, fact had given way to generalization. His paintings began to exhibit the historic feeling of the West as remembered in the mind's eye rather than the historic fact of the West as remembered in a photograph.

Remington had an unusual capacity for friendship, and some of his correspondence with single individuals ranges over twenty years and more. Also he began to be in touch later in life with staunch friends he had known many years before, such as John Howard and Al Brolley.

John Howard, by then president of the Hall Coal Company in Ogdensburg, served as the go-between in making arrangements for Remington's return to the island each summer. Howard's poignant verse "When Rem he quit the Bay" expressed the sentiments of many when Remington sold Ingleneuk in 1908 so that he could finance the building of his spacious new home, Lorul Place, in Ridgefield, Connecticut. He and Missie moved into their new home on May 17, 1909. Remington thought that a membership in the Pontiac Game Club in Canada would suffice to meet his outdoor needs, but it did not suit him and he soon dropped it.

It was said that Remington wanted on his tombstone the inscription *"He Knew the Horse."* Death came on December 26, 1909, from the complications of appendicitis. A raging snowstorm had blanketed the area and drifts were still high when a small group gathered for the quiet funeral services at the house in Ridgefield. Emma Caten, E. W. Kemble, Augustus Thomas, Childe Hassam, Riccardo Bertelli, Irving Bacheller, A. Barton Hepburn, and a few others were there. He was buried in Canton, New York, but the large headstone in Evergreen Cemetery is plain except for the name REMINGTON and the smaller footstone bears only his given name and the dates of birth and death. No one would deny, however, *He Knew the Horse.*

☐ *FREDERIC REMINGTON TO LESLIE MILLER*

New Rochelle
January 6, 1905

My dear Prof. Miller I am delighted to find I am to do the "puncher" for Fairmont Park and I shall go about it as soon as authorized.

You may rest assured I will make a complete success of it and I cannot thank you enough.

Yours faithfully,
Frederic Remington

☐ *FREDERIC REMINGTON TO LESLIE MILLER*

New Rochelle
March 17, 1905

Leslie W. Miller
Secry, Fairmont Park Art Ass. My dear sir: In re—yours 15 March—I should be delighted to make a horsed cow-boy for the Park.

It would be necesessary to see the place where it is to go and to consult with you generally before I can say more.

Yours faithfully
Frederic Remington

☐ *FREDERIC REMINGTON TO LESLIE MILLER*

New Rochelle
April 1 [1905]

L. W. Miller
My dear Sir: Very well—I will be in Philadelphia on April 11th at noon. I shall bring Mr. Bartelli—my bronze man with me.

Yours truly
Frederic Remington

☐ *FREDERIC REMINGTON TO LESLIE MILLER*

The Waldorf-Astoria
New York
April 12, 1905

Mr. Leslie W. Miller—Secty
Fairmont Park Art Association My dear sir: After our conversation of yesterday I shall be glad to undertake the bronze cow-boy.

Under separate cover I send a photo of one of my bronzes which

will give an idea of the plinth which will cap the rocky bluff se-
lected by us. My opinion is that the mounted figure should be
10 feet hight the details of which are not thought out yet.

I shall be glad to undertake the works and set up the figure in
the Park for the sum of $20,000.—If it were not for the consider-
able added cost of nearly 50 per cent I think the addition of a
pack horse would be desirable.

You can address me at New Rochelle, N.Y.

<div style="text-align:center">Yours faithfully,
Frederic Remington</div>

*The details of the contract with Remington were handled by three offi-
cers of the Fairmount Park Art Association: Leslie Miller, secretary;
Charles Cohen, secretary of the Committee on Works of Art; and
James W. Beck, counsel.*

☐ **LESLIE MILLER TO FREDERIC REMINGTON**

<div style="text-align:center">[May 13, 1905]</div>

Frederic Remington Esq 301 Webster Ave. New Rochelle, N.Y.
My dear Mr. Remington: When you feel like tackling the
mounted cowboy, which you told me would not be before next
winter, we, at this end of the line will be interested observers and
while, of course, we shall have to see the model before we commit
ourselves in any way, we are willing to give you five hundred
dollars ($500.) for making a study, big enough to give a fair idea
of how the thing would look. If after examining this model our
Board of Trustees approves of it and wishes to have you carry it
out in the size you have suggested (at least 10 feet high), they will
sign a contract with you on such terms as may be agreed upon
regarding price and everything else, with the understanding that
the $500. which they will already have paid you for making the
model shall be regarded as a payment on account of the contract.
If they don't like the model well enough, or are prevented by fi-
nancial or other considerations from carrying the negotiations
any further they shall be perfectly free to drop the whole matter,
without any liability on the part of the FPAA beyond the $500
before referred to.

Does this strike you as a fair proposition?

<div style="text-align:center">Yours very sincerely,
Leslie Miller</div>

☐ *FREDERIC REMINGTON TO LESLIE MILLER*

New Rochelle
May 15, 1905

Prof. Leslie W. Miller: My dear sir: I have your note of May 13. containing the suggestions concerning the cow-boy sculpture and regard the proposition to first submit a sketch as perfectly fair. That will give me all summer to think about it and I will do the sketch this winter. If I cannot satisfy your committee that will be quite reason enough for not going on with the thing.

You do not state, which is important, whether you want one to attempt the single cow-boy or the "cow-boy with a pack-horse." They are seperate propositions. Let me know regarding this.

Thanking you for your consideration I am
Yours faithfully
Frederic Remington

☐ *FREDERIC REMINGTON TO LESLIE MILLER*

New Rochelle
November 24, 1905

My dear Prof. Miller: I have been working on the cow-boy and have the statuette form nearly done in ten days I hope it will be presentable and I then hope to write your committee to run over here and see it. New Rochelle is easily reached from 42nd Street as you doubtless know.

I want to save my plasteline[1] and it is so much more satisfactory than a caste, besides if found necessary I can make changes in it.

Let me know if the committee will come etc.
Yours faithfully,
Frederic Remington

☐ *FREDERIC REMINGTON TO LESLIE MILLER*

New Rochelle
December 4 [1905]

My dear Prof. Miller The model here is of plasteline—carried pretty far and there are many trying things about a cow-boy which can never be go into plaster cast. I want to carry it into the quarter life and to put in plaster will ruin my model.

1. Plasticene, an oil-base modeling clay with a waxy consistency that remains workable.

New Rochelle is not much of an adventure—so please try and have a committee come over here and look at it. Let me know if this is not possible.

Yours faithfully
Frederic Remington

December 9, 1905

Mr. Frederic Remington
301 Webster Ave., New Rochelle, N.Y.
Dear Mr. Remington: Mr. Miller has been in correspondence with you in reference to your model, and I now write to say that our Committee has arranged to visit your studio in New Rochelle on Tuesday, December 19. We shall leave Philadelphia by the Pennsylvania R. R. 9.50 train, taking luncheon en route and making the 1.04 from the Grand Central Station, reaching New Rochelle at 1.42.

I shall be glad if you will telegraph me on receipt of this note if the arrangement be agreeable to you.

We have to thank you for the courtesy of your invitation to luncheon, but shall use the train buffet so as to avoid loss of time.

Very truly yours,
(Signed) Charles J. Cohen,

☐ *FREDERIC REMINGTON TO CHARLES COHEN*

New Rochelle
December 14, 1905

My dear Mr. Cohen Yours of 13th here—If you will let me know how many people will come as your committee I will have carraiges at station to take them to my studio which is about one mile. I will also be at station to meet the committee.

I know Prof. Miller personally but otherwise I shall have to trust to my instincts to tell the committee from the other arrivals. My detective instincts are highly developed however.

Yours truly
Frederic Remington

☐ *LESLIE MILLER TO CHARLES J. COHEN*

Fairmount Park Art Association
December 20, 1905

Charles J. Cohen Esq.
312 Chestnut Street.
Dear Mr. Cohen: The result of our trip to New Rochelle yester-
day was highly satisfactory . . .

Yours very sincerely,
Leslie M. Miller

☐ *FREDERIC REMINGTON TO EVA REMINGTON*

New Rochelle,
[January 1906]

Dear Kid I got a telegram from Burdick and had to go up
Thursday as Mr. Hiltes, Meyers son in law, gave a dinner to me.
Had a good time but it rained Friday and B & I couldnt get out
much so I came down this morning and am home here at 3.30 &
d——— glad to be here.

I dont hear from Philadelphia but it is early. I am going to start
a new small model anyway and for the most part will stay here
and write. I don't like New York and I hope you will come home
as soon as the law allows—cause naturally its d——— lonesome
around here.

Bartelli paid for Dragoons[1]

Fred Gunnison[2] has got me in $2500 or $5000 to a Long Island
Land Scheme. Burdick says he expects to make the Key West 5000
into 25000—I shall never make big money. I only hope to keep
what I have going modestly. Hope to land Hiltes for the group.

Nothing in that theater thing. Gus Thomas told me to keep out
of it.

Man & Superman[3] is the greatest thing I ever saw on the stage.
It almost makes the stage possible for me.

Well get a move on.

Yours,
Frederic

Saturday
To Eva
341 West Onondaga St.
Syracuse, N.Y.

1. *Dragoons—1850.*
2. Banker and lawyer in Brooklyn, a family friend from Canton, New York. His
father, Rev. Almon Gunnison, was president of St. Lawrence University from 1899
to 1914.
3. George Bernard Shaw's 1905 play.

☐ *FREDERIC REMINGTON TO EVA REMINGTON*

301 Webster Avenue
New Rochelle, N.Y.
[January 1906]

Dear Kid: I staid here all alone Sunday doing clerical work on my copyright blanks. Bob Emmet[1] called late and this morning I had to go down and see my brains & deposit and telephone. Bartelli & I had a treatment by Sands. I attended Gus[2] rehersal & came home.

I saw Noe[3] & have to make my catalogue tomorrow—a small drawing etc. This d——ex— ought to be good, I've had enough trouble with it.

I go I think Wednesday to Greenpoint[4] for Paleolith[5] and if I dont hear from Philadelphia I dont know what I will do—I know I wont go to New York. I simply would rather live here alone than in a hotel.

Well—come home when you can its d—— lonesome here. I don't know how much more of it I can stand.

Y——
Frederic

Monday night
To Eva
341 West Onondaga St.
Syracuse, N.Y.

1. Robert Emmet, lawyer.
2. Augustus Thomas.
3. Theodore Noe of Noe Art Galleries, New York City.
4. Home of the Roman Bronze Works in Brooklyn, New York.
5. *Paleolithic Man.*

☐ *FREDERIC REMINGTON TO LESLIE MILLER*

New Rochelle
January 16, 1906

My dear Prof. Miller I am very anxious to get ahead with the model since I want plenty of time on it before Summer. Can I go ahead now? It will be very bad to have to wait another month.

I don't care particularly about the money just now but would like $5000. down to begin with, since that will help out my expense account. That however is a detail.

I have concluded to build a new studio on the back end of my place where I can work to better advantage and I want to begin on that immediately because I will do nothing until that is ready.

Let me hear quickly

Yours faithfully
Frederic Remington

☐ *FREDERIC REMINGTON TO EVA REMINGTON*

New Rochelle
[January 16, 1906]

Dear Kid I got a notice from Miller that the trustees of F.A.A. approved report of committee but the contract will have to await another meeting next month. Have written Miller to let me go ahead waiving details and await reply.

I am going to start a small model of Kit Carson tomorrow unless Fred Gunnison telephones me he wants to see me which he wrote he did. I am in $5000 on the Shinnecock Hills and Peconic Bay Reality Co. which Fred says ought to double before transaction is complete.

Colliers man telephoned me to say that N.P.R.R. refused to pay Advertising Dept. $500 sent me so it has to be returned.

A banker in Grand Rapids wants my "Raddison"[1] picture just published. $500 I asked.

My book comes out 27 of February.[2]

Got my copyright stuff off to day—shipped two pictures and Pat is making my boxes for which we measured. The book case in your room is done and a good job. Paint it to-morrow. I dont see how I can get away up Canada way this Spring. I have a bad catas-

1. *Radisson and Groseillers*, an undated oil painting, was number four of "The Great Explorers" series for *Collier's*. It was first reproduced in the magazine in color on January 13, 1906, and shows the first white men to visit the region of present-day Minnesota. Raddison, the leader of the 1659–60 expedition, is shown standing in a birch-bark canoe, with Groseillers sitting beside him.

2. *The Way of an Indian.*

rahl cold coming on—weather nasty and I mean to stay here and work but it D—— lonesome.

I hope you'l come home Thursday.

John Malone—an old player and a protegee of Boothe[3] dropped dead in front of club yesterday while we were lunching—shocking. I suppose you saw it in papers. Doc Otis was with us and rushed out and tried to save him but no good—paralisis.

Well—the 301 yawns for you.

Frederic

☐ *FREDERIC REMINGTON TO LESLIE MILLER*

New Rochelle
January 20, 1906

My dear Prof. Miller. Yours received and I await the contract. I am only anxious to get ahead with the work—particularly a shop where I can work to advantage and I distrust the weather for building operations now.

However I shall undertake the work and the financial arrangements will be settled to the best advantage someway or somehow.

I also warn you that no matter what other sculptors have done—nothing but a physical breakdown—fire or not will keep me daudling for five years. That is tempermental with me.

Thanking you I am
Yours faithfully
Frederic Remington

☐ *JAMES M. BECK TO LESLIE MILLER*

Law Offices
Sherman & Sterling
44 Wall Street, New York
February 3, 1906.

Leslie W. Miller, Esq.,
320 South Broad Street,
Philadelphia, Pa.

Mr. dear Mr. Miller: I enclosed herewith draft of a contract between the Fairmount Park Art Association and Mr. Remington, which I trust will meet with your approval.

I do not know what the "lost wax" method is or how far successive castings are practicable, but I have tried to provide that

3. Edwin Thomas Booth, founder of the Player's Club.

Remington must cast and recast the statue until it meets with the approval of the Association.

As to fire and life insurance, it is necessary to make provision for that when Remington is required to give a bond for his compliance with all the terms of the contract? If he does not deliver and erect the statue upon the site, in a manner satisfactory to the Association, his bond becomes due. So far as the Association is concerned, this seems to protect it. It would seem therefore to be a question for Remington to determine whether to protect himself. He ought not to take out a policy of fire insurance.

As to life insurance, I presume you can take out a policy upon the life of Remington; but, as the contract contains a clause which provides that in the event of his death, you can engage another sculptor to complete it, is it necessary to insure his life?

As it is, I fear that the agreement is so drastic that Remington may hesitate to execute it, as Saint Gaudens did when we had the New England statue contract under consideration. You will remember he refused to give any security. However, he probably is more independent than other sculptors.

<div style="text-align: right">Yours very truly,
James M. Beck</div>

☐ FREDERIC REMINGTON TO LESLIE MILLER

<div style="text-align: center">February 16, 1906
301 Webster Avenue, New Rochelle N.Y.</div>

My dear Prof Miller: I return the agreement document, and it is all right in the main.

In section III. I don't seem to have any protection at any stage of the proceeding. It seems to me that after your committee approve of my "working model" of 4 ft. you ought to specify that all will go well if I "carry" the subsequent stages of the thing in accordance with it.

Section V. my heirs or assigns ought to select the sculptor and complete the work, since at that time also the friendly committee with whom I now deal might also be dead &c. and I should like you to say that I will give bonds to return all the money unless I live long enough to have your Committee approve of the working model,—because I, for the sake of my artistic reputation, wouldn't let any one complete the model in my name. After the working model has been approved it could then be carried to completion by others, I suppose.

I am going to Canada on sketching trip for a week.

<div style="text-align: right">Faithfully yours,
Frederic Remington</div>

☐ *FREDERIC REMINGTON TO LESLIE MILLER*

New Rochelle
April 30, 1906

My dear Prof. Miller Have the "Cow Boy" agreement and it is
satisfactory. I will have my lawyer attend to the Bond Business
and will then sign and send you the paper.

I am not doing this thing with much reference to the money
and before this thing is over I intend to give you people a piece of
horse-bronze which will sit up in any company. You can bet a few
on that Prof.

Many thanks—
Yours faithfully
Frederic Remington

☐ *FREDERIC REMINGTON TO LESLIE MILLER*

Ingleneuk
Chippewa Bay, N.Y.
May 19, 1906

Prof Leslie W. Miller My dear sir—The signed agreement of the
Fairmount Park Art Association came duly to my hand and now
we will proceed to do the Cow-Boy and let us hope he doesn't fall
off his horse in the process—

Yours faithfully
Frederic Remington

*In little over seven months after the final contract, Remington com-
pleted his working model. He was eager for the committee to see and
approve it.*

☐ *FREDERIC REMINGTON TO LESLIE MILLER*

New Rochelle
January 5, 1907

My dear Prof. Miller I am out of the woods with my working
model of the cow-boy. I had a lot of hard going but have finally
made the horse and rider do what I expected of them and am
now finishing and if the horse don't buck I'll be ready for your
committee in a month or so.—

Yours faithfully
Frederic Remington

☐ *FREDERIC REMINGTON TO LESLIE MILLER*

New Rochelle
January 25, 1907
My dear Prof. Miller The working model of the Fairmont *cow-puncher* is done and ready for the inspection of your committee. When may I expect them. I am anxious to get it in plaster.
Yours faithfully
Frederic Remington

☐ *CHARLES COHEN TO FREDERIC REMINGTON*

January 29, 1907
Frederick Remington
301 Webster Ave., New Rochelle, New York
The Committee will come next Tuesday, February 5th, two fifteen train from New York. Answer if agreeable to you.
Charles J. Cohen,
Secretary,
312 Chestnut Street

☐ *FREDERIC REMINGTON TO CHARLES COHEN*

New Rochelle
February 1, 1907
My dear Mr. Cohen I shall be at the station to meet you on Tuesday with transportation for however many folks you say will arrive.
 I only hope we can have good weather—or at least a bright day.
Yours faithfully,
Frederic Remington

Approval of the working model allowed Remington to receive the additional funding necessary to move into the plaster cast stage. The controversy over a change in the action of the left foreleg of the horse was resolved after Remington refused to compromise.

☐ *LESLIE MILLER TO FREDERIC REMINGTON*

February 14, 1907
Frederic Remington Esq.
301 Webster Avenue, New Rochelle, N.Y.
My dear Mr. Remington: The Committee which visited you last Monday has approved the model as inspected on that day. The for-

mal procedure is that the Committee recommends and the final approval rests with the Board of Trustees, which will not meet until the second Friday in March (the 8th) There is no question, however, regarding the formal approval of the Committee's action by the Board and you may regard this as notice of the acceptance of the working model as far as putting it in plaster and going ahead with the work is concerned.

The payment of the $3,500. due you under the contract, however, must be made by the Board's authority, but I will see that the matter is attended to as promptly as possible, and you may expect the money in a day or two at most after the date of the meeting.

I presume you were quite prepared for a certain amount of discussion over the action of the left foreleg. This discussion was continued at the meeting which followed, and to the favorable report submitted to the Board of Trustees the dissent of one member is recorded on account of the rigidity of the foreleg. With this exception the Committee was unanimous in its most cordial, even enthusiastic, approval of the model.

Yours very truly,
Leslie Miller

☐ *FREDERIC REMINGTON TO LESLIE MILLER*

New Rochelle
February 15, 1907

Prof. Leslie W. Miller My dear sir:—your note at hand and I am of course highly delighted to have your committee's approval and sorry for the dissenting opinion. That foreleg is imperative however and cannot be compromised.

I have run the plinth out to it however and think it improves the group. My final bronze will be so much better than this working model that you wont know it.

When you get ready to pay the $3500.—I will file a bond for that amount, which I suppose will be satisfactory.

The model goes in plaster next week and I hope next Fall to have a place ready to set up the big model—

Yours truly
Frederic Remington

☐ *FREDERIC REMINGTON TO LESLIE MILLER*

New Rochelle
March 15, 1907

My dear Prof. Miller I have chased around New York after a Surety bond for you folks. The people I talked to hem and haw

and want me to deposit collateral securities and do all sorts of absurd things before they will finish a bond. They do not seem to understand the whole matter—it is an unusual sort of business, so I got disgusted and threw up my hands.

Now I would suggest that you people get a Philadelphia Co. to make me a bond which shall be satisfactory to you if possible or otherwise I will let you deposit the money in a Savings bank or Trust Co. subject to a joint order from us both and let the whole thing go as it lays.

I go away last of month so let me hear what you think is best in matter.

Yours faithfully
Frederic Remington

☐ *FREDERIC REMINGTON TO LESLIE MILLER*

New Rochelle
May 2 [1907]

My dear Prof. Miller The amendment to contract is all right in so far as I can see excepting a possibility that I might need some of the money to pay my casting bill when due if there should be any considerable delay. I might then put up some satisfactory collateral and want the money—what would you do in that case. This new paper doesn't cover that contingency.

It is my intention to have the work thrown up late in the summer and to try and finish it next winter. If nothing goes wrong I ought to have it ready for the plaster man by Spring and then it wouldn't be long going through the wax and casting etc. and ought to be ready for that Autumn, and right then I would need some money.

How would it do if you simply deposit that money in the Fidelity Trust Co. of P—subject to our joint order—send me a certificate to that effect and let the matter rest?

Yours truly
Frederic Remington

[On side of the second page is written:]
As you know a "lost wax" casting bill is a good stiff institution and not to be passed over lightly.

☐ *FREDERIC REMINGTON TO LESLIE MILLER*

New Rochelle
December 12 [1907]

My dear Prof. Miller The Cow-boy goes ahead all right and I expect I shall want you to look at it about the first of the year.

I built a studio on my place here with a track to run it out on and I find the track of the greatest advantage. I think without it I could never have done the work. The hard lights of in-doors are so different from the diffused light of out-doors that it looks like *two* statues.

It is on a car and on a *turn table* and this *turn table* is so small that I do not dare take it out doors when there is any wind for fear of its overturning. Of course I want your committee to see it out doors but how we are to regulate the wind when you come here I do not know. This very thing perplexes me—what can be done? Your committee is so immobile and the wind is so persistant at this time of the year that I despair of ever making the combination.

It would give you no proper idea at all to see it in the studio—it is 12 feet × 2½ feet by 25 ft. up on car and studio is only 17 ft. by 25 ft. We work on ladders and only work from our impressions as we remember them after seeing it out doors.

Possibly you may suggest some way.

I am trying to give you a Remington broncho and am not following the well known receipt of sculptors for making a horse. I intended to do this from the first and believe I am succeeding.

I will let you know when I am ready for you but please first solve this wind question.

<div style="text-align:center">

Yours truly,
Frederic Remington

</div>

☐ *FREDERIC REMINGTON TO LESLIE MILLER*

<div style="text-align:center">

New Rochelle
[December 1907]

</div>

My dear Prof. Miller I had the bronze plaster men up today figuring on my job.

This is modeled in Italian plastaline because it is soft but Italian plastaline also shrinks rapidly and I don't want to keep it from the plaster men any longer than I have to.

Can you set a date when you can come over and see it? I am afraid we will have to waive weather conditions.

Saturday

☐ *FREDERIC REMINGTON TO LESLIE MILLER*

<div style="text-align:center">

New Rochelle
December 16 [1907]

</div>

My dear Prof. Miller Yours rec'd. That's just the *point* of this model—it has been done out of doors and that is what the track

for and that's why I am so anxious to have it seen out of doors. I dont know of any other equestrian in this country that was done out of doors.

For that matter you can come any time when the snow is not on the ground—for while there might be some fussing yet to be done it wouldn't be anything that would be noticed.

I am anxious to get the thing through the plaster stage and into the final wax where the real finish comes.

It's a dandy Professor and I am not a bit afraid of your old committee—.

Yours faithfully
Frederic Remington

☐ *FREDERIC REMINGTON TO LESLIE MILLER*

New Rochelle
December 23 [1907]
My dear Prof. Miller Got your telegram about Thursday 26th and answered "Yes" by wire.

My but this is *action*—much better than I had hoped. I suppose you will let me know time of arrival and how many people so I can get transportation from station.

Well—I am mighty glad you are coming and shall make medicine for a fine day with no wind.

Yours truly,
Frederic Remington

John T. Morris, a trustee of the Fairmount Park Art Association, had questioned the position of the left foreleg of the horse in Remington's work on February 14, 1907, and nearly a year later still objected. Remington held his ground again and no change was made.

☐ *JOHN T. MORRIS TO LESLIE MILLER*

876 Drexel Building
Philadelphia
December 24, 1907
Mr. Leslie W. Miller,
 Chairman,
 Committee on Works of Art
Dear Sir: As I shall have to attend a funeral outside the city I will be unable to inspect the Remington Statue on Thursday.

I trust the Committee will find the leg of the horse much improved for I feel strongly that we should not have a statue with such an inartistic pose as was shown on the sketch model. A good artist selects the best pose not the disagreeable one, accurate though it be.

<div align="right">
Yours truly,

John T. Morris
</div>

Once again Remington needed money to pay bills associated with the project. Once finances were resolved, he visited the exact site for the monument in Fairmount Park. Contracts for final concrete work to produce the base, a visit by Fairmount Park Commissioners to the Roman Bronze Works to see the statue, specific installation instructions for Bertelli, and plans for the unveiling complete this significant episode in Remington's life. Words of tribute marked his accomplishment, and the artist's absence at the unveiling ceremony did not detract from his great success.

☐ FREDERIC REMINGTON TO LESLIE MILLER

<div align="center">
New Rochelle

January 3, 1908
</div>

My dear Prof. Miller The plaster men are working on Cow-Boy. Will it be necessary for me to have a written approval for your Committee?

Bronze people say they want payments as thing progresses or about $3000 in all until in place. I have financed the thing up to now but will need some money about February.

I do not own many stocks or negotiable securities now but let me know how much I will have to deposit with Trust Co. to insure payment of $3500 and I will see if I cannot arrange it. The Bronze people can wait for their final payment until this Spring's $4000 is due. Some of my securities are off so much and all I have is land etc. that it is not so easy as it would have been a year ago. How will 100 shares of Copper Ranges (Boston Market) quoted at 52-3-45 now a days do as security?

<div align="center">
Yours truly

Frederic Remington
</div>

☐ *FREDERIC REMINGTON TO EVA REMINGTON*

New Rochelle
Postmarked February 1908
Dear Kid Saw plaster to day—all right. Sally F.[1] there—she has a dandy 2 figure group soldier monument.

Got after Phila. for the "Desert Prospector." 750 and said "yes"—

Dont know when I will go Phila. D———lonesome here.
Y——
Frederic Remington

To Eva
care Emma Caten[2]
610 W. Genesee St.
Syracuse, N.Y.

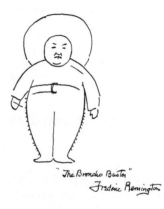

"The Broncho Buster"
Frederic Remington

☐ *FREDERIC REMINGTON TO LESLIE MILLER*

New Rochelle
[February 1908]
My dear Prof. Miller The vans took the cow-boy away this morning and I hear by telephone it has been safely delivered at the Roman Bronze work at Greenpoint a good plaster job with out a crack or mar and I am truly thankful. If it doesn't blow up in the casting I guess the worst is over.

I want to run over as soon as the snow is off the ground and see that site and contract for a concrete rock & pedestal etc. What about Art Commission and Park Commission and how do we manage about them?

Yours faithfully
Frederic Remington
Friday

1. Sally Farnham was a sculptor, Remington's friend and student. After his death she was employed by the Roman Bronze Works to complete *The Stampede*.
2. Eva Remington's sister.

☐ *FREDERIC REMINGTON TO LESLIE MILLER*

New Rochelle
[March 6, 1908]
My dear Prof. Miller No snow here and I take it there is none in
Fairmount Parks—so, unless it snows meanwhile I shall blow in to
the Bellvue Stratford some time Monday night and at 9 o'clock
Tuesday morning I shall get a sea-going cab and round-up at 320
So Broad. If this does not suit you post a letter to B. Stratford of
instructions to me.

We will look at the site all the Parks authorities and I want to see a
stone & cement man of Philadelphia—

Yours faithfully,
Frederic Remington
Sunday.
P.S. If anything prevents I will wire.

☐ *FREDERIC REMINGTON TO RICCARDO BERTELLI*

New Rochelle
[March 1908]
My dear Bartelli Went to Philadelphia and with Prof. Miller and
Superintendent Vosges of Fairmount. I marked the exact spot
where my statue is to go.—

I want a concrete base made—*one* foot higher than the ground.
The front end in the middle of a willow bush and the left side as
near the edge of the rock bluff as it can be safely put. Chief
Vosges knows exactly where and your man will have to go to him
to find out and to report etc. Will you kindly arrange with some
one to build this concrete and let me know how much he proposes
to charge me. You can furnish him with the particulars of its
detail.

It is all arranged but remember you and your men who do the
work must report to Chief Vosges—Supt. of Fairmount Park.

This matter ought to be immediately attended to, so that there
will be no delay in work when weather permits.

Yours,
Frederic Remington
Saturday

☐ *FREDERIC REMINGTON TO LESLIE MILLER*

New Rochelle
March 20 [1908]

My dear Prof. Miller: I have yours of the 19 and of course it is
for your committee to say when you will unveil the Cow-Boy but
all my arrangements with Mr. Bartelli of the Roman Bronze
works call for its immediate erection on the chosen site. This was
all entered into under the assumption that it would be unveiled in
June or sometime thereabouts. I must pay him for it when in
place and neither of us like to assume the risk of it any longer than
is necessary to get it in place.

Of course it could be left veiled until such time as you see fit to
uncover it.

We are proceeding on this basis. I today finished the lost wax—
retouching on the minor accouterments and the big thing is steam-
ing away in the melting furnaces.

Mr. B— will be over next week to attend to the details of
erection.

Yours faithfully
Frederic Remington

☐ *FREDERIC REMINGTON TO LESLIE MILLER*

New Rochelle
March 29 [1908]

My dear Prof. Miller I am assured by Roman Bronze works that
they will have my work in place by 1st of June 1908—if nothing
blows up and the train stays on the track.

I think you can safely go ahead with any arrangements you care
to make—

Yours faithfully
Frederic Remington

☐ *FREDERIC REMINGTON TO LESLIE MILLER*

New Rochelle
[1908]

My dear Prof. Sorry I can't get photograph of Cow Boy to you
by Monday. Bartelli is to set the plaster up for the Park Commis-
sioners but wont have it up before Monday.

You know we agreed not to photograph the "plastaline" when your committee was over here because you wanted to wait for the "bronze in place" to spring on the presses—otherwise I might have made one.

I hope that commission can come to Brooklyn soon to see the thing so we can get along with the base. We shall have bronze ready to ship in three weeks but of course will have to wait for the base.

The casting has been wholly successful and there is a lot more character in it than in the plaster which is what one can do with "lost wax."

In the old piece mould the plaster ends it but in wax one can go on as far as he likes. I went over every inch of the wax.

<div style="text-align:center">

Yours faithfully
Frederic Remington
</div>

Saturday

□ *FREDERIC REMINGTON TO LESLIE MILLER*

<div style="text-align:center">

New Rochelle
[1908]
</div>

My dear Prof. Miller That will be better—to have the commission see the thing than any photograph which I can supply at present.

We can set the plaster model up for them on a *day's notice* and can can even show some of the casting.

It will be necessary to go to Greenpoint Brooklyn and I will go with you if you desire.
The address is

> R. Bartelli
> Roman Bronze Works
> 275 Green Street
> Greenpoint
> Brooklyn, N.Y.

via 23rd Street Ferry. No cars run near the foundry but I will have a liveryman meet them; one McGucken (tel#11 Greenpoint Brooklyn)

Let me hear when

<div style="text-align:center">

Yours faithfully
Frederic Remington
</div>

P.S. I would like to explain to the committee my idea of not putting it away up in the air. By so doing we might compromise on something less than a baloon ascension.

<div style="text-align:center">

F.R.
</div>

☐ *FREDERIC REMINGTON TO LESLIE MILLER*

New Rochelle
[1908]

My dear Prof. Miller: All right. It is extremly unlikely that your
bunch would ever find Bartelli's without the aid of the police.

If you will tell me how many gentleman are coming I will order
a luncheon at Player's Club 16 Grammarcy Park, where you can
come immediately and then I will conduct you over to Green-
point. The 23rd St. Ferry is right handy to *The Players*. This is the
best way, so let me know if this is agreeable and I'll do the rest.

Yours faithfully,
Frederic Remington

Tuesday

☐ *FREDERIC REMINGTON TO LESLIE MILLER*

New Rochelle
[1908]

My dear Prof I have ordered *"beef and"* for eleven starving
people at 12.30 Players Club, so every minute after that grub is
spoiling—remember.

We will hurl that in and then I have carriages ordered at Green-
point—regular funeral outfit.

Yours,
Frederic Remington

☐ *FREDERIC REMINGTON TO LESLIE MILLER*

New Rochelle
[1908]

My dear Prof Miller I have copyrighted the "Cow-Boy" and shall
scratch it on in an inconspicious place. If you say nothing about
this, it will not be generally known and I don't intend to avail my-
self of its privaleges unless some one should reduce it and try to
sell them on the open market thus interfering with my business of
selling such through Tiffany & other financial bronze houses. It is
not exactly a bronze for "a statuette" but one never can tell and
outside dealers would like to get hold of a Remington bronze and
make me a world of trouble.

I suppose there is no objection—

Yours faithfully
Frederic Remington

Saturday

☐ *FREDERIC REMINGTON TO LESLIE MILLER*

New Rochelle
May 5 [1908]

My dear Prof Miller I have copyright in my name but we will fix that up at leisure since nothing will be done about it soon any way.

As to the dinner of the Park and Ass'tion Board, I am very much embarrased. I don't like to decline but I will be up on the St. Lawrence and it will be very inconvenient and for certain reasons may be next to impossible for me to come way down to Philadelphia. The reasons in brief are that Mrs. R. is not at all well at present and I have a lot of work to do before August when I am due to go West on a long trip. Also there has been a rise of 12 inches (water still going up) in St. Lawrence river putting all docks underwater and it has damaged my property in many ways—all of which I shall have to go to work on with labor which has to be overlooked in the doing and also I shall have guests.

How would it be for a scheme to put that dinner off until next Fall since many people must be going out of town by that time.

Let me hear from you on this subject.

Yours faithfully
Frederic Remington

☐ *FREDERIC REMINGTON TO LESLIE MILLER*

New Rochelle
May 15 [1908]

My dear Prof. Miller I have yours 14th and am glad the whole thing can go off without any fuss. I don't think a lot of high stepping would improve the bronze any and it would make everyone more or less uncomfortable.

I was over yesterday and saw the whole thing set up and its all right. It of course is much better than the plaster and it will never look its prettiest until "in place." I am leaving Sunday night for the St. Lawrence and my address will be

 Chippewa Bay
 St. Lawrence Co.
 N.Y.
"Ingleneuk Island"

Yours faithfully
Frederic Remington

☐ *FREDERIC REMINGTON TO LESLIE MILLER*

New Rochelle
May 17 [1908]

My dear Prof. Miller I thank you very much for the photographs. They are just what I wanted and I was quite sure you had forgotten it and didn't intend to bother you in the matter.

Yours faithfully,
Frederic Remington

P.S. I shall make as many minature models as I please—then one statuette size for your consideration in which form it is so easily altered. Then when I throw it to "quarter life" you can have another look in.

Yours
F.R.

☐ *FREDERIC REMINGTON TO LESLIE MILLER*

Ingleneuk
Chippewa Bay, N.Y.
June 4 [1908]

Telegrams
Hammond, N.Y.

My dear Prof Miller Yours rec'd—no hurry about settlement—take your time.

So you put it off until 20th—good—I suppose you will have a speech or so. I cannot be there in the flesh but will be in spirit. It won't matter; no one will know—the newspapers never mention the sculptor, you will notice, in such events.

Yours faithfully
Frederic Remington

The following statement was written in Remington's hand for use at the unveiling of The Cowboy *or in publicity about the event.*

☐ *FREDERIC REMINGTON TO LESLIE MILLER*

FREDERIC REMINGTON Born Oct. 1861 in Canton, N.Y. To school in New England—and studied art for a year in Yale Art School when his father Col. S.P. Remington died. He gave up his studies and went to Montana in '80 and followed varying fortunes in the various parts of the West until he burned to depict its picturesque features in paint and clay.

He began as a correspondent for Harpers Weekly in the Geron-

imo campaign in Arizona and gradually worked into magazine illustration—doing Pres. Roosevelt's book in cow-boy life which ran in the Century.

He was the first man to do horse action as it really is—and was the subject of great controversy at the time. He was one of the first men to do "lost wax" bronze statuettes in America. "The Broncho Buster"—"The Old Dragoons"—"The Scalp"—"The Cheyenne"—"Comin thro' the Rye" (a group of cowboys which was put up in staff at St. Louis & Seattle). "The Rattlesnake" "The Mountain Man" and others. Some of these are in the Metropolitan Museum (at New York) the Corcoran (Gallery) at Washington. The Fairmount "Cowboy" is the only sculpture which was made in an out-of-door size and represents a good type of the old Texas cow-boys who came up over the trails with cattle in the early eighties on a small Spanish horse—the saddle, hat & other accouterments are of that day and must not be confused with later things. These were the Plainsmen who traveled by the stars.

As an author Mr. Remington produced such works as "Pony Tracks" "Crooked Trails" "Men with the Bark On"—"Sun Down Leflare" and others and as a painter [he is clearly known]

"and if you want any more "you can sing it yourself [Miller crossed out from "as a painter" on and added "as a painter he has made the whole field of the wild free life of the plains and foothills his own. No man of this generation, in any country"— the rest is not included.]

☐ *LESLIE MILLER TO FREDERIC REMINGTON*

Fairmount Park Art Association
Office of The Secretary, 320 Broad Street Philadelphia
June 22, 1908

Frederic Remington Esq.,
 Ingleneuk,
 Chippewa Bay, N.Y.
My dear Mr. Remington The Cowboy was unveiled Saturday afternoon before a large crowd, and looks splendidly. I enclose the best newspaper account of the exercises (from yesterday's "North American.")

I also enclose, what is more substantial, the warrant for the payment of $4,000. due you this year, and a cheque (which requires your signature beneath my own, as it is to close out the joint account of yourself and the Association) for $3,614.19, the amount of last year's payment, deposited to our joint a/c until the work should be completed, with interest to date. Will you kindly sign and return to me (at Box 261, Oak Bluffs, Mass) the enclosed two receipts for my files?

Now that the work is in position, I feel more strongly than ever that it is a magnificent thing, and that it will reflect great credit upon yourself and upon this Association. Congratulating you very cordially, I am, with best wishes for a pleasant summer,

Very sincerely yours,
Leslie W. Miller

Enclosures.

☐ *FREDERIC REMINGTON TO LESLIE MILLER*

Ingleneuk
Chippewa Bay, N.Y.
June 25 [1908]

My dear Prof. Miller Enclosed are the two receipts for $4000— & $3,614.19 for bronze "cow-boy" of Fairmount Park Art Association.

Your words of praise for the work are very gratifying to me. To have tried so hard to meet the measure of such an opportunity and meet with your response is what I hoped to win. I have some excellent photographs of it and it looks exactly as I had it pictured in my minds eye when "in place."

That model I knew would never look right until in place. Some more solemn & reposeful thing might defend itself in a foundry but that cow boy had to be on the bluff he was intended for.

The ceremonies of unveiling were unique and creditable to your people who conceived the enterprise.

I hope now some one will let me do an indian and a Plains cavalryman and then I will be ready for Glory.

Hoping you have a fine summer I am

Yours faithfully
Frederic Remington

Owen Wister and Remington continued their correspondence even after their professional association lapsed.

☐ *FREDERIC REMINGTON TO OWEN WISTER*

New Rochelle
[April 1908]

My dear Wister Lunched today with Mr. Worth the mining engineer and we are proposing to go into his deserts in October and he has hopes you might go and I think it would be a good scheme— we would have a good time and might uncover some new color.

I am doing a big cow-boy for Fairmount Park and I thought I would scratch on the base.

"He rides the earth with hoop of might"
Did you do that or was it George Warton Edwards?—
Yours
Frederic Remington
Tuesday

☐ *OWEN WISTER TO FREDERIC REMINGTON*

[June 1908]
My dear Remington: If you mean this—
No more he rides, yon waif of might,
 His was the song the eagle sings.
Strong as the eagle's his delight,
 For like his rope, his heart had wings—
I wrote it to accompany a cover-illustration you have in Collier's
Sept. 14, 1900.
 I am glad we are going to have a cowboy from you in Fairmount
Park & should be proud if any verse of mine went underneath.
 There's no chance for me to go with Worth. I wish I could merely
for the pleasure. I am sure some new color is there, but I rather
think it is pictorial and yours, & not narrative and mine. It is likely
to furnish more specimens of the same kind of thing one has met.
But I am sure the figures & the landscape are well worth seeking.
Yours faithfully,
Owen Wister

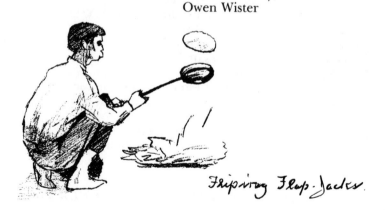

Flipping Flap-Jacks.

☐ *FREDERIC REMINGTON TO OWEN WISTER*

New Rochelle
[1908]
My dear Dan I have worked myself right to a standstill and have
lots more to do before I get my tail in a canoe again. I know it is
childish but I go to bed by candle light and I find that sitting up

nights doesn't improve the stuff above the signature F.R.

I cant plead age exactly but I did most d——— faithfully burn the candle at both ends in the days of my youth and I got the high sign to slow down some little time since therefore I have cut out the "boys"—God bless 'em for I find them just as irristable as ever despite all I know. I always loose my bridle and when I get going I never know when to stop. If there is anything in the world I love it is to sit 'round the mahogany with a bunch of good fellows and talk through my hat—I like it a lot better than it likes me and I greatly fear it will take more than a year of training to make a calen eyed philosopher out of me.

Yet your appeal goes to my heart (my head bids me harden [illegible] but I must say I will try to line up for present or accomodate [illegible] just figger I'll be there and if I am feeling strong about Dec. whatever's the date I'll go. Of course you know I cant make a speech. I couldnt make a decent talk for my life so I cant help that way.

Mark me down on your dinner list. Here's how you bully old Dan.

Frederic Remington

☐ *FREDERIC REMINGTON TO RICCARDO BERTELLI*

Ingleneuk,
Chippewa Bay, N.Y.
June 25, 1908

My dear Bartelli Enclosed find my check for 2185^{59}/_{100}$ with bill and the deduction for royalties of $410.—which please receipt (add on $410) and return.

This closes that matter and I want to thank you for the good work done and the helpful way you treated me at all times, but you know this.

Yours faithfully
Frederic Remington

☐ *A. G. HETHERINGTON TO FREDERIC REMINGTON*

Office of the Civil Service Commission
Philadelphia

A.G. Hetherington

July 2, 1908

My dear Mr. Remington I appreciated very much your letter. I have been a member of the Fairmount Park Art Association from the beginning and one of its Trustees—I came to New Rochelle to

see the sketch model. I was convinced then what the finished
work would be—the promise is more than fulfilled.

It was a great pleasure to me to have charge of the details and
was most fortunate in getting the Cowboys and Indians. No statue
was seen unveiled with more appropriate ceremonies. I wish you
could have seen the picture—it was much like one of your own.
He Dog the Chief who pulled the rope has been ever since the
proudest Indian possible

When I saw your modest letter on Mr. Miller's desk saying you
"would not be here but it made no difference as no one paid
much attention to the sculptor" I resolved that all the praise should
be given you in our newspapers and set to work. I send you today
the clippings. You may want them for your scrapbook—the In-
quirer has my brief address almost in full. It is to tell the million
and one half inhabitants of Philadelphia—"*Remington's* Mounted
Cowboy" and thousands have gone to see it and all are moved. I
consider it one of the great statues of the world.

God knows there are few enough of them.

When you come to Phila. let me know before hand. I want to
put you up at the Clubs—I see some colored prints of some of
your paintings. I want to get one and get you to autograph it for
me—which do you consider the best—please let me know so I can
get it. You have done a great thing in our mounted Cowboy—I
hope you may long be here to [illegible] pass by your genius to
other cities great works—I took one of the greatest surgeons in
the country to see it—he says it is the greatest anatomical work in
the world—I hope you are having a nice summer. Wish I was out
in God's woods and water—it is hotter than Hades here.

> Yours sincerely
> A.G. Hetherington

To Frederick Remington Esq.

☐ *FREDERIC REMINGTON TO LESLIE MILLER*

> New Rochelle
> November 11, 1908

My dear Prof. Miller I am about to build a house and have to
borrow some money in the process and I was wondering if you
knew of any financial juggelry whereby I could get the money
owing me by Fairmount Park Art Asstion.

Would a bank over there advance it—if I assigned it at a dis-
count etc. I dont like to bother you but you might be able to
throw a little light on the situation.

> Yours faithfully
> Frederic Remington

☐ *FREDERIC REMINGTON TO RICCARDO BERTELLI*

New Rochelle
November 23 [1908]
My dear B Send one more—middle view—of the Fairmount
Cowboy—I want to use it to drum some business—
 I *think* I have add a *Mountain Man*—one of these I did last—to
go west before Xmas—

Yours faithfully
Frederic Remington

☐ *FREDERIC REMINGTON TO LESLIE MILLER*

New Rochelle
December 2, 1908
My dear Prof. Miller As for a proposition for settlement of the
Cow Boy statue account a proper discount would be on Jan. 1,
1909.

Pay due May 19 1909	$ 3908.
Pay due May 19 1910	3668.
Pay due May 19 1911	3428.
total	$11004.

This would be an ordinary business discount at a bank and would
entail no hardship on your Association if you could negotiate it
without too much trouble but if it is trouble I should be willing to
consider that in connection.

Let me hear further
Yours faithfully
Frederic Remington

☐ *FREDERIC REMINGTON TO LESLIE MILLER*

New Rochelle
December 20, 1908
My dear Prof Miller How long do you think it will be before your
Board passes on my proposition? My affairs demand that I know
pretty soon what I can expect from your people or I shall have to
arrange matters some other way to meet my payments.
 I don't suppose the thing can be hurried any but if you can tell
me when next the Board sits I can figure a little that way.

Yours faithfully,
Frederic Remington

☐ *FREDERIC REMINGTON TO LESLIE MILLER*

New Rochelle
December 22 [1908]

My dear Prof. Miller Very good—I can come over any day if it is
necessary but say we make it after New Years—you can set a day.

I very much appreciate the consideration of your Committee in
the matter.

Yours faithfully,
Frederic Remington

*Remington made two more trips west in the last years of his life. The
first was to Texas and New Mexico in 1907. He took Henry Smith, a
New York lawyer, with him. The letters are to his wife, Eva.*

☐ *FREDERIC REMINGTON TO EVA REMINGTON*

St. Regis Hotel
B. J. Brun, Prop.
El Paso, Texas
[April 7, 1907]

Dear Kid We got to Chicago all right and met Keygatt [illegible]
who lunched us, then drove us all over Chicago in an auto until
6.30 when we were given a dinner at Chicago club with Genl Car-
ter, Joe Lester, and other notables and got a 9.30 train on Rock
Island almost dead.

We came through to Tucumcari—a dismal little plains town with
no hotel but a rooming place and had to lay over all day Friday &
night. The country was uninteresting and green as a tick with big
rains the night before—a blanket of clouds over the sky. I am
almost discouraged. Got in here last night and nearly didn't get a
room—the town is crowded. It is grey with clouds and I have a
d——— good notion to come right back home.

We are going to buy and arrange for a place to stay at Cloud-
croft which is high up in Superstition Mountains reached by
cog—rail road Alamogordo north of here. I think it will be inter-
esting if we can get a place to stay.

We are going to try and change over tickets and come back
Santa Fe Road in hopes Colorado wont be so green but I am
afraid. There has been lots of snow & rain in the West. I was
afraid of this but I have never seen the West so *green*. The country
is sitting up at an astonishing rate. El Paso grows like a weed.

Henry is going over to Juarez to a bull fight this afternoon but I
dont think I want to see one.

We have slept every minute and both of us have recovered our nerves which is all we can say for the enterprise. Still this trip gives me a renewal of my impressions and I hope for the best.

Yours lovingly
Fred

☐ *FREDERIC REMINGTON TO EVA REMINGTON*

St. Regis Hotel
B. J. Brun, Prop.
El Paso, Texas
[April 8, 1907]

Dear Kid Everything promises well—some R.R. people here are sending a man with us 80 miles up R.I. to Alamogordo and to-morrow morning we go 8000 feet up Superstition Mountain to Cloudcroft and we are promised a 40 mile trip to Mescalero Apache reservation. I expect to get something (d——— this old pen). I have been discouraged until now but I guess I'll make it worthwhile. Keep your nose clean. I wired you just now—

Y——
Fred

We may be gone a week.

Buffalo cow. —

☐ *FREDERIC REMINGTON TO EVA REMINGTON*

St. Regis Hotel
B. J. Brun, Prop.
El Paso, Texas
[April 13, 1907]

Dear Kid We are back from Cloudcroft and go to Grand Canen Arizona tonight. We ought to leave there Thursday and be home Sunday. I will keep you advised.

I made 7 sketches at Cloudcroft & 2 sunsets at Alamogordo and we are to drive up the river here to day to sketch the water.

We are both feeling bully. I sent you some spoons & a jug. Those spoons are Moki[1]—I am not stuck on travelling & wish I was home again. Its so d———long between places out here.

Met Terry here last night and lunch with him to day and sent you telegram last night because I forgot Littles address—Its 3 hours difference between here & there.

Yours
Frederic

Cloudcroft was 9000 ft. and too high for both Smith & I. We puffed & our heart's beat and blood got us heads!

☐ *FREDERIC REMINGTON TO EVA REMINGTON*

The Alvarado
Albuquerque, New Mexico
[April 14, 1907]

Dear Kid Here we are—and about to pull out for Grand Canon. We leave there Wednesday and are due 6. o.c. p.m. N.Y. Saturday.

Henry brought the finest Navajoe blanket I ever saw $275.

I bought a few things and had expressed and sent you a Navajo's buckle by mail—

Yours
Fred

1. An early name for the Hopi Indians, a tribe of Pueblo Indians.

In September 1908, Remington went West again to travel some of the same routes he had as a younger man. He went alone, which was unusual for him, but met James W. Beck, a lawyer friend from Phila-delphia, in Cody, Wyoming. Beck had been the counsel for the Fair-mount Park Association during negotiations with Remington for the Fairmount cowboy sculpture.

☐ FREDERIC REMINGTON TO EVA REMINGTON

The Sheridan Inn
Sheridan, Wyoming
[Septembr 13, 1908]

Dear Kid Here I am for Saturday night because no trains run or branch in from Toluca to Cody. I shall run up to Toluca to-morrow night sleep in the station to get a train out early Monday.

I bought a horn spoon here—had it shipped on with bill some seven dollars etc.

I never had such a grilling as this trip. It was the hot spell of 1908 and I got it all. Even now my baggage has gone and I am back in the dirty clothes I took off at Chicago but I am going to laundry them tonight in the wash bowl. Such is the life of an artist in search of the beautiful

There is a wind off the Big Horn to night—the first cool time I have had. I expect it will snow—everyone thinks so and I hope it does—I want to get cool once. I would not have come now if I had know what a streak of weather I was tackling. The minute I leave that Island it is bound to get Hellish.

I got a Collier chek & deposited it Special. Bobbie liked my stuff and promised it November but I think he doesn't pay much atten-tion to anything.

Sherman Caufield is away in Miles City—getting right of way for a Railroad down Tongue river. Sheridan is 10,000 inhab now and this whole country is setting up.

Keep your nose clean
Fred

☐ FREDERIC REMINGTON TO EVA REMINGTON

The Irma
Col. W. F. Cody, Prop.
Cody, Wyoming
[September 15, 1908]

Dear Kid Got here at last—and am cool for once. I have nearly died of the heat. Beck met me and has insisted that I go out on a regular hunting trip with him and as it is the last time I will have

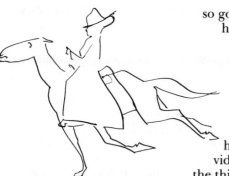

so good a chance I'm going. He has everything, horses, tents and pots, saddles etc. and they are hard to pay for out here.

We are going to Irma Lodge to-morrow and I am going to paint slowly up the valley because before he boosts me over the main divide he wants me to get used to the thin air. It is quite an undertaking for one legged man but I'm in for it. Mail & tel's addressed care Beck will be forwarded if important.

Of course if I do this I will come right home when I get through and it will be a month without doubt. We going to Jacksons Lake and are to carry a collapsible boat and go into Yellowstone Lake in the Park. Moose bear. elk—geese—fish.

Cody is a nice town. This hotel is a dandy—as good as one could want. Bobbie Collier is going into Jackson's Hole only 40 mules 20 of us.

A fellow who was going to cook for us didn't come in and so we have to get a new one which delays us a day. It will be just a week from New R——— before I get really out on the grass.

I suppose you will be home by the time this is.

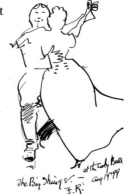

Yours lovingly
Fred

Tuesday

The Big Things! — F.R. at the Cody Ball aug 1899

Some of Remington's most interesting correspondence in this later period of his life was with old friends, people with whom he had kept in touch over the years and with whom he shared a love of the outdoors. The years had made their relationships comfortable. Many of them were at the top of their own fields. The Remingtons and Summer-hayes had spent time together at Davids Island, near New Rochelle. Gus Thomas, E. W. Kemble, Rufus Zogbaum, and Francis Wilson also joined them.

☐ *FREDERIC REMINGTON TO MARTHA SUMMERHAYES*

New Rochelle
[1907]

My dear Mrs. S. Very grateful that you and the Maj. like my book—it is doing better than I had any right to expect.

As for your diary—will say—dont be sanguine—it is hard to find a good publisher—be slow—think it out—rewrite it & recast it and make it tell a story—dont lay down on your facts—no one has time to ask whether you ate dinner before breakfast on a hot day in June—'74—Savvy?

Dont be personal in a Diary—think of other people and things & events around you—dont be prolix—dont string things out— but do put local color in & do take note of the little things which make pictures in the mind of the reader and dont seem (only dont seem—you may if you are clever) to have any purpose. Also pardon me for saying these things which you doubtless know

When it has been written and lain awhile on your desk—say six months at the least (you must sleep with it) let me see it and then I will tell you what I think if you care to know.

Y——
Frederic R

☐ *FREDERIC REMINGTON TO MARTHA SUMMERHAYES*

Ingleneuk
Chippewa Bay. N.Y.
[1908]

My dear Mattie Read your book[1]—in fact when I got started I forgot my bed time (and you know how ridgid that is) and sat it through.

It has a bully note of the old army—it was all worth while—they had color, those days—and of course to me knowing you & old Jack it was good as apple-pie. I say—now suppose you had married a man who kept a drug-store—see what you would have missed.

Do you know—it made me realize that time flies and the old west is a 1000 years ago.—

Yours
Frederic Remington

1. Martha Summerhayes's diary was first published in Philadelphia in 1908 (*Vanished Arizona: Recollections of My Army Life*) and was so well received that she revised it somewhat, added a bit of new material, and printed it privately at Salem, Massachusetts, in 1911. A third edition that reproduces the first (1908) edition was published in 1939 by the Lakeside Press (R.R. Donnelly and Sons) in Chicago.

☐ *FREDERIC REMINGTON TO JACK SUMMERHAYES*

Ingleneuk
Chippewa Bay, N.Y.
[undated]

My dear Jack So there you are[1]—and I'm d———glad you are
so nicely fixed. It's the least they could do for you and you ought
to be able to enjoy it for ten years before they find any spavins on
you if you will behave yourself, but I guess you will drift into that
Army and Navy Club and round up with a lot of those old alka-
lied prairie-dogs whom neither Indians nor whiskey could kill and
Mr. Gout will take you over his route to Arlington.

I'm on the water wagon and I feel like a young mule. I am
never going to get down again to try the walking. If I lose my
whip I am going to drive right on and leave it.

We are having a fine summer and I may run over to Washington
this winter and throw my eye over you to see how you go. We
made a trio down to New Foundland but saw nothing worth while.
I guess I am getting to be an old swat—I can't see anything that
didn't happen twenty years ago,

Y——
Frederic R.

*Irving Bacheller was a novelist born in Pierrepont, New York, near
Canton, Remington's birthplace. His early novels* Eben Holden *and*
Dr'i and I, *which were about pioneer life in northern New York State,
had won him much acclaim.*

☐ *IRVING BACHELLER TO FREDERIC REMINGTON*

Thrushwood
Riverside, Connecticut
December 5, 1908

Dear Remington —I had a delightful hour with your pictures
the other day. That Eye of the Mind hit me very hard—something
terribly true in the lift of those hands, in the turn of those heads.
I thought Shotgun Hospitality a wonderful picture and Chippewa
Bay and the wood scenes moved me north in a jiffy. If I ever get
rich I'll have a Remington room here to help me to be content
with life and old age. By the way I'm making a Christmas book

1. Summerhayes accepted a detail in active service in Washington at the
Soldiers' Home after his retirement.

for our friend Hepburn.[1] If you get time to put anything you please on one of the sheets I am sending herewith I should like to bind it in with a lot of things I have got from other artists and writers. I know it would please him very much—something from *you*. Couldn't you and the Mrs. come up for a quiet Sunday with us soon. I'll show you a pretty bit of country and a pleasant fireside and you shall choose your own time. With best wishes,

Yours sincerely,
Irving Bacheller

A. Barton Hepburn was a northern New York native who became president of Chase National Bank in New York and an important economist on the national scene. Hepburn owned a summer home near the site where Remington was building his new home in Ridgefield, Connecticut. The two enjoyed a number of outings together during the few months between the completion of Remington's home in the spring of 1909 and Remington's death on December 26, 1909. The letter from Hepburn on December 17, 1909, would have been one of the last received by Remington.

☐ *A. BARTON HEPBURN TO FREDERIC REMINGTON*

The Chase National Bank
New York
May 6, 1908.

Frederic Remington, Esq.,
 No. 301 Webster Avenue,
 New Rochelle.

My dear Remington Delighted with your note just received. A little disappointed that you are not going to build in Ridgefield this season. Had expected you were and understood that your plans were in the hands of the builders. I have "shuttlecocked" around the world here on the bell end of a wire pretty much all my life, and it seems as though we should have some place somewhere where we could sit down and light a cigar, accompanied by friends, and have a real feeling of homelike proprietorship. The Madam's characteristic strenuousity has had sufficient run, so she has attained the same frame of mind, and we hope, withal, to soak up a good degree of comfort. That is only possible when surrounded by congenial people whom we know and like, and nothing had more to do with settling my mind as to the desirability of Ridgefield for a permanent location than what you said of it, after

1. A.B. Hepburn, president of Chase National Bank, New York City.

your visit and expeditious purchase; all that occurred before I "took root" as it were.

I am very sorry you are going to the islands so soon, but we hope to have you and the Madam for a week's end sometime during the summer. Something must develop to your building programme and should this transpire, just wire the Hotel de Hepburn to reserve rooms for you and we shall be delighted.

With kind regards to the Madam as well as yourself, in which Mrs. Hepburn joins,

Very truly yours,
A. B. Hepburn

☐ *A. BARTON HEPBURN TO FREDERIC REMINGTON*

The Chase National Bank
December 3, 1908.

Frederic Remington, Esq.,
No. 301 Webster Ave.,
New Rochelle, N.Y.

My dear Remington Your letter received. The golf club does own in fee simple the grounds it occupies, so Finn will have a good, orderly neighbor, at least on one side of him.

Very glad to know your place is getting on so well. I imagine that the temperature this morning will interfere with laying mortar somewhat. Delighted with the progress you are making up there and feel sure of a good neighbor for next year.

The Madam has seen your pictures[1] and is very enthusiastic over them. I shall run in to see them this afternoon or in the morning.

With kind regards to the "Missus,"

Very truly yours,
A. B. Hepburn

☐ *A. BARTON HEPBURN TO FREDERIC REMINGTON*

The Chase National Bank
New York December 17, 1909

Mr. Frederic Remington,
Ridgefield, Conn.

My dear Remington I have been expecting to see you any day for a long time but understand that your excuse is good as an excuse but most uncomfortable as a fact. Sorry you have to be laid up in this way. I saw the Madam a moment in passing the other

1. Knoedler held an exhibition of Remington paintings in December 1908.

day and she expected to be in town with you last week. Everything that has happened to me for the last three months has happened on Saturday and I have not been to Ridgefield in over two months, much to my disappointment.

I like your picture exhibit[1] very much indeed and have taken a great many people to see the pictures. You are certainly "coming." What do you think of the picture I purchased—"The War Bridle"—I preferred the moonlight camp scene, with men and horses about the fire but somehow the one I selected seemed a bit more characteristic and then too it portrayed scenes which were quite familiar to me. I regretted afterwards that I did not take the "Blanket Signal."[2] The number of pictures sold and the rapidity with which they went was most gratifying and the best part of it is the character of the people who bought them. I congratulate you.

Take a brace and come to town and let us look you over. You will need a letter of introduction if you put it off much longer.

With kind regards to the "missus."

Very truly yours,
A. B. Hepburn

John Howard was an old childhood friend who became president of the George Hall Coal Company in Ogdensburg, New York, and spent his life there. Remington relied on him over the years to take care of the details of maintaining Ingleneuk, his camp on the St. Lawrence River. Correspondence with John Howard dating back to the purchase of Ingleneuk is included here to convey the nature of the relationship.

☐ *FREDERIC REMINGTON TO JOHN HOWARD*

New Rochelle
December 1 [1898]

My dear John Impossible—I couldn't do a job of your boy—the nearest I come to portraiture is once in a while a stray soldier.

There are lots of artists who could *do* the boy and for very much less money than I would have to charge.

Never buy a picture, old man, unless it is in the *narrowest vein* and *best mood* of any artist. That a great tip on art.

Yours faithfully,
Frederic Remington

1. Knoedler's held an exhibit of Remington works again in December 1909.
2. *The Smoke Signal.*

☐ *FREDERIC REMINGTON TO JOHN HOWARD*

New Rochelle
[undated]

My dear John While I cant forgive you for not coming out yet I make due allowance for your intemperate habits and the high vibration of New York on a countryman's nerves.

Article by Lt. Johnson absolutely true. I have often talked this to you. I used to write about it from patriotic impulses but long since quit, having clearly saw that nothing will be done until we get the licking which is coming to us sooner or later (as sure as anything can be sure on this Earth). This is perfectly recognized by military men all over the Earth.

We have concluded to rely on our first and only line of defense, the Navy—if that is ever licked we are helpless—all of which is due to *Quick Modern Transportation,* which you so well understand, and to a European fear of *awakening us to that future.*

In a military sense we are absolutely *unprepared* for even a *minor* campaign. We lack artillery ammunition—field transport—newest equipment and staffs—not to speak of *trained* soldiers and proper bases or depots. The reason is that the people dont understand and therefore dont care—and that our average Congressman is d—— mutton as ignorant as a horse about everything outside of the pestiferous details of his own backyard.

But it is useless to agitate—we will get the licking—and you boy will probably die of the belly ache in a camp.

Yours,
Frederic R——

☐ *FREDERIC REMINGTON TO JOHN HOWARD*

New Rochelle
May 10 [no year]

My dear Howard I have ordered launch shipped care of you alert 1st June. I hope to be there.

You must know all the loose kids around Ogd—Do you think you can cut out an eighteen year old boy to run errands & pose for me at islands from June 1st. If you do put my brand on him. Get him for what is right pay.

Yours,
Frederic Remington

☐ *FREDERIC REMINGTON TO JOHN HOWARD*

New Rochelle
[undated]
My dear John In the devils' rush which I am going I forgot to
write you that I have hired that Denner[1] boy of Chippewa Bay so
wont need your fellow unless he dies and they dont do that at
Chippewa I believe.

I am through my troubles mostly I hope and am only waiting
for the 1st of June but expect to die before then. Guess I am
getting old—and they put up a harder game every year but if I
can crawl up to that Island that will fix me for another year. Be
gad—we made an error in not living back in the 3oties. When
men were not antiques at 40 years.

So long—much obliged. Well—as to your father, I have thought
much of him and he only did what we all expected. It couldnt be
otherwise you ought to read Montaignes essay on Death.

Yours Faithfully,
Frederic Remington

☐ *FREDERIC REMINGTON TO JOHN HOWARD*

New Rochelle
[1904]
Well John I was thinking of you—I have been all day over in
Greenpoint working on bronzes. Things are looking up. One or
two pictures have gone and I think we are going to have a good
year of it. As for guessing an election why of course Mr. Roosevelt
will be President and Mr. Herrick (who is no saint) will be Gover-
nor and Mr. Hall will be Comptroller and that is all pretty much
as it should be and is another attestation of the fact that the Ameri-
can people are sane. I got your letter about "Overbrook" and
wrote a reply which I found under a heap on my desk insert. It
was a good letter, touching and kindly but out of date so I
"wasted" it.

Do I get a ride in the swellest yakacht on the river? Oh I dont
know me and Pete Smith[1] will be shooting around in our small
craft with our mouths watering.

If my health will stand it I intend to do Canada in January—40

1. Henry Denner. The Denners owned a store at Chippewa Bay. Many
Remington neighbors on the St. Lawrence River served as models for the artist
during his summer visits.

1. Remington's caretaker at Ingleneuk and often his fishing partner. He also
served as a model for Remington.

degrees below and 4 ft of snow and if you feel the spirit of adventure well up in your veins I might bring you. Speak up Monsieur and buy flannels. Our idea is across the C.P.R.[2] out with the Spring preslito or make so the San. Maurice river to lumber camps with Dr. Dormound as guide. We want a hearty crowd who appreciate "snow effects." Its the antipods of Mexico—but you dont feel the cold so much in Canada.

<div style="text-align:center">Yours,
Frederic</div>

When do you dine with us?

☐ FREDERIC REMINGTON TO JOHN HOWARD

<div style="text-align:center">New Rochelle
[undated]</div>

My dear John Hand this letter of instruction enclosed to my young man.

We expect to land in on you about Wednesday the 15th. Dont turn on the cold water.

You may get a bill for a dozen tennis balls. Don't cry! We may need them for bobs if the fishin's good this summer. I wrote Pete Smith to take soundings on my tennis court, I think it will be a good place for pickerel.

I'm crazy to see neighbor Inglis' yacht.[1] I have figgered out that our friend Howard will have to run up the river with four of five jack screws and get busy with his boat house. I told Allen carefully to build my dock considerably lower than the old one. It will be all right for low water years and in high water years we don't want to see the d—— thing anyway.

I suppose the Massena[2] will have to lighter us this season. Well—. . . and the cut of things generally is height and the St. Lawrence is sure fashionable.

<div style="text-align:center">Yours
Frederic R.</div>

2. Canadian Pacific Railroad.

1. Could refer to C. M. Englis's yacht, since he was a former commodore of the Chippewa Yacht Club.
2. A river steamer that carried passengers, mail, etc., on the St. Lawrence River primarily from Clayton to Ogdensburg. Remington used this and the steamer *The Island Belle* in his travels to Ingleneuk. Some called them morning boats due to their schedule of stops at the dock.

☐ *FREDERIC REMINGTON TO JOHN HOWARD*

Ingleneuk
Chippewa Bay, N.Y.
[undated]

Dear John You might bring up an odd dozen swift water minnies next week for I have it that E.L. Strong[1] positively swears that some six or seven years ago he knew a man who had heard another man—a friend of his—swear that he saw the biggest string of bass he ever saw which had been caught over by Pooles Resort—they were caught by the man that the man saw who told the friend of E.L. Strongs and Strong told me, so if you have anything on Pools Resort[2] trot her out and we'll throw an eye over it.

Y——
F.R.

☐ *FREDERIC REMINGTON TO JOHN HOWARD*

New Rochelle
[1906 or 1907]

My dear John I have given the matter careful thought but I guess you'll have to count me out on dinner. I have refused all dinners this winter including one with the President (and thats going some). I find my stomach very delicate. It has given me no end of trouble—no matter how careful I am with my diet. I am working very hard and have a lot which I must get through with. I may yet have to go South for a vacation and I can't spare the time. I want to arrange to spend *one* easy summer at the Island and not have too much to do.

I sold 8 pictures out of 11 I showed at Knodelers and I guess Remingtons will have to be marked up a little.

I have not had such easy sledding with the *working model* of the cowboy as I hoped, but g—— d—— him I'll *do* him yet.

Another year I hope to be husky enough to set in—

Yours faithfully
Frederic Remington

1. Edward L. Strong, a fellow resident along the river who owned Snug Island near Remington's Ingleneuk.

2. Pools Island was in Canadian waters not far from Remington's home.

place where reef used to be — Canada.

formerly a dock.

formerly a dock.

Suds — who has no home —

Area Map of Cedar group as remembered by Louisa Howard White; daughter of John C. Howard & Charlotte (Strong) Howard; secretary of C.Y.C. around 1910.

Log cabin built by John C. Howard

Remington's house — he called it island Inglenook — house & island later owned by Margo (Strong) & Tony Mankell — then Aunt Ella Harder.

Remington studio.

Thomas Five Strong built here. Island called Timagimi.

State Park

hotel run by a Mrs Phillips

House built by John C. Howard. Island called Ponemah (from Hiawatha islands of the blessed. This house later lived in by Margo & Louie Benton — house burnt & rebuilt by Cy & Sam Covant.

"Suds Point" — Named after Mr. & Mrs Suds who lived here about 1910 – 1912

☐ *FREDERIC REMINGTON TO JOHN HOWARD*

New Rochelle
[February 16, 1907]

My dear John Oh I am itching to get up on that Island but its three long months yet. I look forward to it like a school boy. I want to get out on those rocks by my studio in a bath robe in the early morning when the birds are singing and the sun a shining and hop in among the bass. When I die my Heaven is going to be something like that. Every fellows imagination taxes up a Heaven to suit his tastes and I'de be mighty good and play this earthly game according to the rules if I could get a thousand eons of something just like that.

Got letter from Allen[1] saying ice house filled and dirt drawn for my lawn out where tennis court used to be. I am going to get big "medicine ball" and we are goint to pass that for a sweat Sundays.

I wouldn't sell that Island for $4,750,000,000. We only go through here once and money won't buy that plant: Its to near all right.

Yours,
Frederic Remington

[Note on side of second page:]
The Phila. committee have approved my model of cow-puncher.

☐ *FREDERIC REMINGTON TO JOHN HOWARD*

New Rochelle
[March, 1907]

My dear John I was up at Canton Tuesday to Bill Remington's[1] funeral and Tuesday night to surprise they ran a sleeper over to Ogdensburg where we lay five or ten minutes.

I should have been tempted to send for you but it would not have been worth while and I was tempted to get off only I had paid $7 for the sleeper. It was a case of "so near and yet so far"

Yours
Frederic R.

1. Local merchant in Ogdensburg.

1. Bill Remington, Remington's uncle, died March 7, 1907.

☐ *FREDERIC REMINGTON TO JOHN HOWARD*

New Rochelle
[1908]

Dear John That treasureship clears up a great mystery. That's
where Pete Smith got his money. He used to fish for sturgeon just
there, one mile S.E. by N—from Bounders Island. You know Pete
never worked and yet he has a great deal of money and the air of
one who has plenty and no worry and that sturgeon fishing every
other rainy Thursday morning in the Spring and Fall when no
one was about was a bluff.—It's dead easy. I'll bet you dont see
Pete out there in the canoe now. He is in the Phillips[1] boat house
chuckling to himself.

Y——
Fred R.

☐ *FREDERIC REMINGTON TO JOHN HOWARD*

New Rochelle
[1908]

My dear John I am afraid you won't see me at your Knicker-
bocker[1] dinner.

It would be d—— hard to explain why except that I have confi-
dence in your "savy."

I am working myself harder than I ever did and I dont go out
nights. I am all right so long as I observe strict hours and diet and
when I dont I'm as tender as a burnt boot. I have a great hope
that about a year of this will put me back in my old form for mid-
night enterprises but Ide be dead one at a dinner now. I would
simply sit around glare at you fellows—choking with envy at your
youthful abandon—and probably end up with a temperance lec-
ture most highly insulting to all present. We converts play our
game wide open you know, it hurts our eyes to look sideways. You
can tell the fellers that Remington is having his teeth filed.

Yours—
Frederic R.

1. Martin Phillips built the Cedar Island Hotel in 1890 and a dock in 1898 so
that steamers could land. In 1903 he built a store, and it became a meeting place
for local gentry. Ingleneuk was one of the Cedar islands and Remington had
frequent contact with Phillips during the summer. Martin Phillips was known as
"Jimminetty" Phillips because he prefaced each remark "By Jimminetty." He posed
for Remington.

1. The Knickerbocker Club in New York was formed in 1871 with a restricted
membership. One had to prove colonial ancestry to join.

☐ *FREDERIC REMINGTON TO JOHN HOWARD*

New Rochelle
January 19 [no year]

My dear John Sorry I can't be with you fellows at your annual
eat but I have made my explanations to you as the honorable chair-
man and hope you have explained it all to the boys.

In the long course of years in which I have banged around the
world I have never asked nor given quarter to my enemy the flow-
ing bowl—we have engaged early and often on every occassion
and fought to a finish. I of late years found myself rarely vic-
torious in these contests and hard as it comes to one "who puts his
hat on his sword point" I have been overcome by numbers and
forced to yield.

It has been some considerable time since the battle ended and I
find myself still weak from my wounds—wherefore I abide in soli-
tude after 6 p.m. and view the contests of the younger and stronger
men from afar.

I will not obtrude any philosophy which this state of things has
taught me for I know that a good red stomach cannot understand
the ladylike reserve of a light pink gastritis such as I enjoy, so I say
go it.

God bless you—force the demon down and we will discuss the
fray later in the calm sunny days as we sit on the dock up at
Chippewa.

Yours faithfully,
The Injun on Ingleneuk

☐ *FREDERIC REMINGTON TO JOHN HOWARD*

New Rochelle
[undated]

My dear John That bulletin is just what I want—give me some
more. "The Red Gods have called on me and I must go." We have
selected Sunday night the 17th to answer the call.

As a weather bulletin, your last would answer very well for
down here except the buds have got as far as little leaves. I figger
we can fight the chills with our little fires up there as well as here
and when we get a few hunks of Chippewa air into our systems,
we can stand some grief if they have it coming for us.

Tom Strong's boat house is no criterion—it was underwater
during the Big Rise of five years ago. Pete writes he cut my lawn
so it cant be so d—— high but Pete admits that a pair of rubber
boots help out in a down river wind.

Will you tell the Merchant Dispatch feller to send anything up
on Riverside[1] which comes to me.

Will Wheelock dines with me here on Saturday night. There is the g—— d—— East wind howling in here you ever heard of—if the house holds I'll be satisfied.

The Mulfords told me they heard the water was over Phillips Flag pole but you can hear anything down here and d—— little from up there. Now if I was living in Ogdensburg I could tell just how high the St. Lawrence was. I should not exaggerate or set down ought in malice I shouldn't try, jolly or dope out any hopes but I would state the exact truth that on Howard's boat house dock at Ponemah it was so high on May 9th at noon (wind so and so).

<div style="text-align:center">Yours,
Frederic R—</div>

Tell Hall[2] I broke the moulds of his "Coming thro the Rye" which makes a limited edition of eight groups.

☐ *FREDERIC REMINGTON TO JOHN HOWARD*

<div style="text-align:center">New Rochelle
[undated]</div>

My dear John: The Ingleneuk Indians will pull down their tepee-pack their travois and pull out Thursday for the summer hunting grounds. They will make their smoke on Ingleneuk Friday when the sun is so high. The dog is going too.

The sun is full in the heavens here—the leaves are out and the game animals on which we live have gone to the North. Gallagher for us.

Tell Al. H.[1] to put shoemakers wax on the seat of his pants and

1. A steamer referred to as a "morning boat."
2. George Hall, president of Hall Coal Company in Ogdensburg.

1. Alric R. Herriman, an Ogdensburg friend and St. Lawrence County Surrogate Judge.

then he can stay on the wagon unless Howard comes up the isle and pulls him off.

If suddenly a blizzard should come on the Esquinoix drop down throw me a telegram and we will unpack.

 Frederic R.
Saturday
 [On side of first page is written:]
Telephone freight people at Depot to forward any stuff they have by Riverside immediately.

☐ *FREDERIC REMINGTON TO JOHN HOWARD*

 New Rochelle
 [undated]
My dear John Have given your case some study and it only confirms my previous idea that you ought to be painted.

 I was talking with Smedley[1] in the club today and he said he would do you for $1500.—but I think I can get that down some. He is a rising man, a d—— good one and his stuff will be worth owning. He would dignify you and you are going to be the proginater of a large family who would like to point with pride to the old oak and not have it a nasty 90 cent photograph. Smedley could do you so you would look fierce, friendly, popular, meek, poetic, well dressed, debonnair (excuse spelling) and in a year after you had it on your walls you wouldnt part with it for $9000000 in cash.

 Will I arrange it?
 Yours Frederic Remington
[In Eva's hand at end:]
 Someday you are going to be Pres. of the Century Club and youl have to have it up there.

☐ *FREDERIC REMINGTON TO JOHN HOWARD*

 New Rochelle
 [undated]
My dear John I ordered my framer to ship you that picture. We will make the trade later when we are sitting on the dock in the moonlight—

 Yours,
 Frederic R.

1. W.T. Smedley, American artist.

☐ *FREDERIC REMINGTON TO JOHN HOWARD*

New Rochelle
[undated]
My dear John Came d—— near bringing you a picture. A little
gem in the Eastman Johnson sale—I thought the crowd would
overlook it and told my man at Am. Art Ass. to go them $100.—
but he said there was a large rich person who saw it first and he
wouldnt be denied so it has gone from us. Maybe so I wouldn't
have given it to you anyway even if I had got it—so I dont think
you stood to win.

I got some dandy coppers in Drake sale—would have bid on
some for you if I thought you would have stood for them. I got in
first for later they went out of sight. My friend Fred Gunnison left
a bid of $150 for a Spanish brazier—he thought he would be gen-
erous and make it stick. It went for a little less than $400 and
Fred's unbelieving didnt even inhibit the auctioneers.

Yours,
Frederic R.

☐ *FREDERIC REMINGTON TO JOHN HOWARD*

New Rochelle
[undated]
My dear John Glad you saw the pictures done up properly—
they do look better than in Ingleneuk studio—fine feathers make
fine birds:

When the show is over I will talk with you about the *Harding
Ponies*—I dont expect to sell anything—no one sells pictures this
year—they give them away with a half a pound of tea.

Yours
Frederic R—

☐ *FREDERIC REMINGTON TO JOHN HOWARD*

New Rochelle
September 18 [1908]
My dear John A man asks me what I will take for my Island and
I am going to tell him $10,000 flat if you say so. Will I do it? Now
that I want to sell I suppose I had better consider possible purchas-
ers. You wanted a say but I don't imagine you want to give $10,000.

Yours faithfully,
Frederic R—
Answer immediately

☐ *FREDERIC REMINGTON TO JOHN HOWARD*

New Rochelle
October 24 [1908]
My dear John I see by the paper that the Hall Coal Co's boats are taking to the woods; it is shocking.

When are you coming down? Want you to run out here—
Yours
Frederic R.

☐ *FREDERIC REMINGTON TO JOHN HOWARD*

New Rochelle,
[Fall 1908]
My dear John You are going to vote for that phonograph of a thousand political tunes from Nebraska[1]—in short you are to do your little to aid in the election of a man who will be surely superceded by Roosevelt in four years.

John you need me right at your elbow—you don't seem to grasp grand political tactics but of course I can only be with you four months in the summer and it would need about 13 months hard work to keep you straight.
Y——
Frederic R.

☐ *FREDERIC REMINGTON TO JOHN HOWARD*

New Rochelle
[After election of 1908]
My dear John Ah—ahem—I want to be polite but excuse my smile.

Still I think Bryan will run well next time. His issues were not quite right—he has considerable experience and maybe he can get a better set next time. Anyway he has got Nebraska trained so it will stand still.

Democrats are hard to find about here. I see a few heads out in the tall grass but we are compelled to write to most of them. They come in after dark to get their mail.
Yours warmly,
Frederic R.

1. William Jennings Bryan.

☐ *FREDERIC REMINGTON TO JOHN HOWARD*

New Rochelle
January 21 [1909]

My dear John You dont know any fellow up there who wants to make an offer for my Island do you. I thought there might be a great popular excitement to buy it.

Haven't heard about California yet—pretty d—— fine country!

My house in R[1]—is going along nicely expect to be in by middle of May.

My show made a great hit this winter and I did pretty well. I am no longer an illustrator.

I hear rumors that Al[2] is in very bad way. I hope it is not so but fear. If he is bound to go to hell I suppose the best way is to go cross lots.

Yours,
Frederic R.

We are out of regular paper.

☐ *FREDERIC REMINGTON TO JOHN HOWARD*

New Rochelle
February 5 [1909]

My dear John Just back—have yours—bully for you for interesting yourself in my affairs. You needn't worry about my writing Tom Strong.

Of course the reason I am anxious to sell the Island is because I want money. I don't want a lot of money owning me—I would, just as soon not do anything—Gad, I may be rich in a year.

There is no use of Strong's making anything but a cash offer. He can float the mortgage up there. Get him to make a cash offer for the whole business, (bar my canoes and personal effects) "put Missie"[1] whole or any part of the establishment and do it before ice cutting is over. Then we will talk business—otherwise I shall do what I can elsewhere or wait as the case may needs.

Yours,
Frederic R.

1. Ridgefield, Connecticut.
2. Alric R. Herriman.

1. Motorboat.

☐ *FREDERIC REMINGTON TO JOHN HOWARD*

New Rochelle
February 18 [1909]

My dear John Enclosed is a receipt etc. I am going to Ridgefield
tomorrow if it is fine and Friday I will go down to my safe deposit
and get out deed—make new deed to Strong and send on insur-
ance papers properly made over. Mch 15 is all right. I don't remem-
ber insurance but it is ample. Smith KS. can tell.

Since I will not come up there may I ask if you won't see that
the canoes are taken down to Ogd. and stored in your loft until
such time as I can send for them. The easel can be sent to Ridge-
field sometime this spring and I will have to get you to look up the
minor things and bundle them down.

Pete Smith has keys and gets $20. a year 1st of Jan. (paid to then)
for looking after Island and I am now writing him that Tom
Strong owns island. Strong had better communicate with him and
either tell him to go ahead and look after it or not as he sees fit.
Some one must cut that lawn when the spring opens.

Much obliged—you are sure good goods.

My house in Ridgefield is lathed and ready for plaster. I am in
a low way to sell this place.

Yours faithfully,
Frederic Remington

☐ *FREDERIC REMINGTON TO JOHN HOWARD*

New Rochelle
February 18, 1909

Received payment $500.00 (Five Hundred Dollars) on
account of $6000. (Six Thousand) purchase money for
island "Ingleneuk"—Chippewa Bay St. Lawrence
River, N.Y. from J.C. Howard of Ogdensburg, N.Y.

Frederic Remington

John Howard wrote the following poem to Remington on the occasion
of the sale of Ingleneuk in 1909.

☐ JOHN HOWARD TO FREDERIC REMINGTON

Ogdensburg, New York
February 19, 1909

When "Rem" he quit the Bay

There was mournin on the river
 When Rem he quit the Bay
There was bile on Howard's liver
 When Rem he quit the Bay
Fer it seemed like Death had took him
That never more we'd look him
In the eye, that ne'er forsook him
 When Rem he quit the Bay

The laughter died in Faithful Pete
 When Rem he quit the Bay;
There was silence in the "put-put" fleet
 When Rem he quit the Bay
Not a blessed sound of gladness,
Just a great big sob a 'sadness'
Fer the world seemed gone to badness
 When Rem he quit the Bay

Old "Jimininently" Phillips cried
 When Rem he quit the Bay;
The black bass curled their tails
 and died
 When Rem he quit the Bay;
And "Al" way down in Burgtown said,
 "I wish to hell that I was dead
Fer what's the use, since
 we've lost Fred?"
When Rem he quit the Bay.

 John C. Howard

☐ *FREDERIC REMINGTON TO JOHN HOWARD*

New Rochelle
[1909]

O Bully Old John I greatly appreciate your sentiments so grace-
fully hidden behind the guard of a poem but I'll tell you that there
are other places besides Chippewa and we'll manage to meet in
some of them often enough to keep up the association of 40 years
and dont you forget it.

Poem is filed in the archives of No. 1 Remingtoniania.

As for that deed I find it has to go to White Plains for a C.C.
cert. of notary public—which you will understand.

It begins to look as tho' that Westchester R.R. electric 6 trac was
coming next door and if it does I'll be rich on what would be rich
if I lived up on the Wind Fall instead of in this hell deviled muck
of plutocracy.

I just brought the finest d—— big farm hoss you ever saw.
Bought him out of the shaves of a coal Co's wagon and he'll spend
his days on the cool hills instead of jacking anthracite into peoples
back yards. We hope to move 1 of May and you must run up to
Ridgefield and revel in my folly.

Of course I have to tell you that I have the d——est swellest
colonial cottage—up to date and built to outlast the granite hills—
with a cute little man's cottage—a fine stable—a high art cow barn
and the worst is yet to come since you have to go through a swamp
and up a steep hill to get to it.

Road—make land set up—new palace—big shed—ice house
and Gods knows not to do. Time and a cheerful optomistic nature
will get through that—

Yours
Frederic R.

☐ *FREDERIC REMINGTON TO JOHN HOWARD*

New Rochelle
February 25, 1909

My dear John Enclosed is a deed to Strong of Ingleneuk to-
gether with all the papers relating to it—our taxes were paid this
winter.

Geo. Shepard[1] is dead and I will not want to dig any sand in the
chanell. That was a dream of his and there is *rope on ozone* as you
will see.

You can pass the deed and receive a *certified check* for me in good

1. Remington had purchased the island from George Shephard's estate.

old real estate style. Also make it plain about the small things I retain and I will have to get you to look after those. Dont send them here as I will only have to move them to Ridgefield when I go.

I fortified my wood house this Fall so that no one but an experienced yegg could get into it. The key is in one of my mail bags and the lock belongs to a mail bag. If you dont remember this you will have to tear the house down. There is a cord or so of wood in it with kindling.

Hope everything is regular as old Geo. Wright drew paper.

Yours faithfully
Frederic Remington

☐ *FREDERIC REMINGTON TO JOHN HOWARD*

New Rochelle
March 6 [1909]

My dear John The great treck begins on the 17th. It is a piece business trucking all my plunder—19 years of damage settled on top of itself and when you break it out hundreds of things come up which we had grown not to notice.

If you want to ship my Island effects—fire ahead.

I had to build 700 ft. of stone road—hows that for hell—it shows that one only procures isolation at expense.

Yours
Frederic Remington

☐ *FREDERIC REMINGTON TO JOHN HOWARD*

New Rochelle
March 15 [1909]

My dear John Enclosed is check for 2.00 insurance papers— check for $5500 received and thus passes Chippewa into the vista of remembrance along with much else. I shall never forget that I passed that way.

I am much obliged to you for your interest in my affairs and it is d—— strange that at this critical juncture I have two other parties who would buy it if we could set the clock back.

Yours,
Frederic Remington

☐ *FREDERIC REMINGTON TO JOHN HOWARD*

New Rochelle
[undated]

My dear John When Strong wants to take possession of the house on Ingleneuk you can have my stuff put over in your boat house or have it all taken down to Ogd. and shipped after I get to Ridge-field. For that matter you can ship it anytime to me care J.W. Hebbard Ridgefield, Conn.

There is a small drawing[1] of Mis and I by Lea Kemble pinned on wall which we want—also the books. Mrs. R's sewing machine—my fishing tackle which is in hall closet—med. ball look the drawers of desk and bureaus over and if you find any intimate personal effects of ours, gather them up. We forget what might be there. I dont think much. There is some plated silver ware—my easel (not the old spraddelday thing but the heavy one). Some bad canvasses ought to be burned up for my own protection. My mail bags (lock of one on wood shed and key in bag). There is a lot of ammunition which *dont* send.

My three canoes—paddles and yoke which I exempted. Pete Smith will furnish the motor power if you ask him and will take the put down to Leyares when you get ready to have it go.

Yours
Frederic Remington

1. Maybe the drawing above:

☐ *FREDERIC REMINGTON TO JOHN HOWARD*

New Rochelle
[1909]

My dear John Send the easel and the fishing tackle here and store the canoes in your loft—I shall send them to Pontiac later.

Al—and the cuspidors—certainly emotional and picturesque. These are the sort of episodes that make history glow.

We are having the great sorrow of our lives—we are trying to exhist in a house loaded with carpenters, paper hangers, painters and plummers and it is a cross section of Hell. War is a summer holiday compared with it. Dont come here. I say this as a friend—I wish you no such harm.

If the clovas clear —— via South Norwalk —— Branchville

Yours,
Frederic R

☐ *FREDERIC REMINGTON TO JOHN HOWARD*

Lorul Place
Ridgefield, Connecticut
[1909]

My dear John When you comin' down here to see this wonderful foolishness of mine? You act just as though there were other places just as important as this, but a severe jolt awaits you.

Ive' discharged herusef the other day but there seems to be plenty of others who are willing to assume his borders.

I am poor—happy & hopeful. When we have any money which we formally spent in the gay Metrop.—we build some antique stone wall.

Everytime we raise a new bunch of chickens I have to build a new hen house. Lorul begins already to resemble the State Fair grounds at Syracuse.

Yours,
Frederic R.—

☐ *FREDERIC REMINGTON TO JOHN HOWARD*

Lorul Place
Ridgefield
[undated]

Dear John Come along—we can put you up.

After the most thrilling experience of my life we are nearly settled. Only got furnace working last Saturday lights this Friday and telephone yesterday.

Its a pretty smoothe place and I am going to like it. Beautiful country—nice people—quiet—Four p.m. out of Lex. ave 42nd gets you here just before 6.—

I have only 2 guest chambers so you had better be sure they are not full—you are too old to sleep on a sofa but even then I could swing a cot in the library.

When do you expect to be down

Yours
Frederic Remington

John Howard had been a member of the Pontiac Game Club in Sheesboro, Quebec, Canada. After the completion of Remington's Ridgefield home and sale of his beloved Ingleneuk, his desire to return to the solitude of the woods surfaced. In August of 1909 he and Eva planned a month's trip to Pontiac, but he found the environment unappealing after one visit. Howard once again was asked to help handle his affairs by canceling his membership.

☐ *FREDERIC REMINGTON TO JOHN HOWARD*

Lorul Place
Ridgefield
[undated]

Dear John Long photo of Pontiac came. They give you a perfect idea of the place and it suits me perfectly.

A bunch of log houses in an ocean of trees with water going out into the unknown. It's likely that is the most intelligent enterprise you ever engaged in. If Peace is not found there, cease the search except in your dreams. It sure is a long way from the firing line.

Yours,
Frederic R—

☐ *FREDERIC REMINGTON TO JOHN HOWARD*

Lorul Place
Ridgefield
[undated]

My dear John O Hell—"The Red Gods have called on me and I
must go."

Ship my two cedar canoes to Pontiac Club immediately.

When are you going? I will meet you on train out of Montreal.
Full particulars d—— farming Kid going to

Y——
Frederic Remington

☐ *FREDERIC REMINGTON TO JOHN HOWARD*

Lorul Place
Ridgefield
[undated]

My dear John Now listen—sit down and write me how I get to
this *Pontiac* place—all particulars. Do I have to be introduced?

Don't neglect to describe me to those camp keepers.

I intend to spend some time there in September but I have fits;
I am subject to sudden abberrations and once in a while I go places
before I'm set. So don't forget to send me a "blaze."

Hell has overtaken this country. We have Arizona looking like a
fish pond. My poor farming is on its last legs. This whole lower
country is in a fearful condition. I don't know how you are af-
fected up there. I see it rained frogs in Gouverneur. I wouldn't if
it rained aligators if it would only rain here.

I never want to see Ingleneuk again. I want to keep the mem-
ory of it as it was in the old canoe before the "putts" and the
Broadway boys.

You can gamble I would like to be squaddling around on that
sand beach. If they dont have a sand beach in Heaven I shant like
the place.

You must organize yourself for Pontiac in September.

Y——
Frederic

☐ *FREDERIC REMINGTON TO JOHN HOWARD*

Lorul Place
Ridgefield
[1909]

My dear John Ship those canoes to Pontiac—

Tell the camp keepers I'm coming and to buy grub and get ready. I going to have a tent and a kit and if I dont like the camp I'll make one. I do like pretty d—— I

Y——

Frederic R—

☐ *FREDERIC REMINGTON TO JOHN HOWARD*

Lorul Place
Ridgefield
[1909]

My dear John Now listen. Go to Irving and get a complete detail of how I get to Pontiac Club via Montreal.

Dont you bother about me. Kid and I are going to start just as soon as we can get around to it and go to that club with the intention of staying the month of August—instead of September.

We wont bother your party and of course expect the place is big enough for us all or it won't do as a place of retreat for me.

Who do I wire for team to meet us and all that? Where do I get off train and what do I do then etc. *Are their accomodations limited* and is transportation *limited*. This last is important.

Yours,
Frederic Remington

Monday

We will arrange to go in as your party come out and may meet you if you can be deffinate.

☐ *FREDERIC REMINGTON TO JOHN HOWARD*

Lorul Place
Ridgefield
[1909]

My dear John We hope to show up at that landing Monday and will if the fish plates hold—and you know me well enough to know that it will be rather before than after.

I am bringing my knitting—I may take out King George papers and stay the rest of my life.

I dont see how you can stand it to stay so long in Pontiac. I should think you would come out Sunday morning.

I am going to take a cooking kit across the border but I expect stay in the custom house.

Till we meet—I salute you—

It is raining—I have been standing out in it.

<div align="center">

Y——

Frederic R

</div>

☐ *FREDERIC REMINGTON TO JOHN HOWARD*

<div align="center">

Lorul Place

Ridgefield

[1909]

</div>

My dear John I have received notice that $60 dues on Pontiac are wanted—Irving.

Now I am hard up as the result of all this enterprise and the season of art sales is yet a few months off and I dont want to pay.

Also I shall not go to Pontiac soon again—if ever. It dont appeal to me and I want to resign. I dont want hurt Irving's feelings in the process and I do want to talk to you as to how to go about it and had hoped and expected you would drop in here long before this.

I'll let the initiation fee go to cover my sins if it will and turn the canoes over to you and if you can arrange it so Irving wont hate me go ahead.

The fact is I have got to travel in my capacity as a painter and shall not soon again confine myself to one spot—other than here. The whole thing hinges on this necessity and not on my inclinations for I like Pontiac as a pure and simple "sit down and rest up" proposition but it dont call to me to paint.

We had Bartelli—Childe Hassam and wife and Poultney Bigelow here to dinner last night and had a grand howl. I wish you had been here.

<div align="center">

Yours,

Frederic Remington

</div>

You are getting to be a regular Bill Taft[1] for ironing out difficult situations.

1. President William H. Taft.

☐ *FREDERIC REMINGTON TO JOHN HOWARD*

Lorul Place
Ridgefield
December 18, 1909

My dear John The Hunters supper[1] made a great hit—the boys
at K —— told me they could have sold that over and over again.

At last all the N.Y. critics came off the grass. They hated to do it
but they all took the bridle off and said I was the "goods." It was a
long time coming but it "came". It marks a triumph for

Y——
Frederic R.

*Al Brolley had been a boxer and Remington had boxed with him early
in his career when he was a clerk in Albany. Brolley later became a
judge for the State of New York. He was interested in finding a pub-
lisher for his writing and in purchasing some of Remington's work.
Remington sent him assorted catalogs and advertisements. As in the
case of Howard, earlier correspondence is included here.*

☐ *FREDERIC REMINGTON TO AL BROLLEY*

New Rochelle
[undated]

My dear Brolley Very interesting—I had no idea Buddism &
Christianity was so near—

You are certainly a wonderful old lamp-burner. I dont think it
will ever hurt you if you take enough out—do exercise and eat
roast beef.

Just been in Canada hunting—no luck—

Yours faithfully
Frederic Remington

☐ *FREDERIC REMINGTON TO AL BROLLEY*

Endion
New Rochelle
[undated]

My dear Brolley Send this to Nelson[1] of the Weekly—keep
pounding and you will either get arrested for malicious persecu-
tion or something taken of yours to print.

1. *The Hunters' Supper,* a 1909 painting of men around a campfire with white
tent in background.

1. Henry Loomis Nelson, editor of *Harper's Weekly.*

I cant illustrate anything until it's accepted for publication. You got the thing in on me before you got my letter. I will look at it next time I go down towne.

Yours faithfully
Frederic Remington

☐ *FREDERIC REMINGTON TO AL BROLLEY*

No. 2—Enclosure
[undated]

Dear Al I have been thinking about your article—since I enclosed the last—and I think I would think all you do if I had time—I only have time to be a bad artist and I have to hunt the time "like hell"—one cant be everything—If you are going to be a *scholar* why dont you "lay down on the job"—you are fit. If you have the *big* (that's our American idea) force to do anything like converting idiots (and that seems to me to be your job) why dont you ambush them—storm them—beseige them—parley by chance—die for it—that's the way to do things

Frederic

☐ *FREDERIC REMINGTON TO AL BROLLEY*

New Rochelle ·
[undated]

Dear Al I have read the poem—it comes d—— near being great—it's a little rough in places but if you had kept it and scoured and cleaned it a little—The "big thing" as we artists say is all right. You should not let things go so easily to those d—— Bashi Bazouks[1]—the Daily Press of the Provinces "except for bread—and you eat too much already. So much for the poem

The long article is very profound—It has started me thinking—if I could *think* which I cannot—all I want to do is to *look*—However it stamps you as a scholar—I wonder how big a library you will find in Los Ojos—Southern California where you propose to settle.

I return the papers—since I fear you do not have any more

Yours
Frederic R—

1. A mercenary soldier belonging to skirmishing or irregular troops of the Turkish army, notorious for their lawlessness, plundering, and savage brutality.

☐ *FREDERIC REMINGTON TO AL BROLLEY*

New Rochelle
[undated]
My dear Brolley No—that dont need—polishing. Why dont you
get it published—send it to Henry Louis Nelson—Editor Harpers
Franklin Square—tell him I told you to.
Yours
Frederic Remington

☐ *FREDERIC REMINGTON TO AL BROLLEY*

New Rochelle
[undated]
Dear Brolley Sorry Nelson "threw ye down" but I can't help his
bad taste.
Fact of the matter is—literature and art have to be *followed* like
politics racing—card sharping or anything which is worth ones
while to do. It's a long story but you know enough about it to know
that you have got to "lie daytimes and steal nights" to get along in
any of them, so peace to you
Yours faithfully
Frederic Remington
P.S.
No great harm however—2 stamps and I expect the State paid
for them.
R.

☐ *FREDERIC REMINGTON TO AL BROLLEY*

New Rochelle
Dec. 19 [no year]
My dear Brolley I am sending you a Scribner's Catalogue—
thought you might want to know how to spend money. The thing
makes your mouth water. First editions have ruined more "good"
men than rum and women.
I only have two firsts "Catlin colored prints"[1] and "Tanner's Nar-
rative"[2]—I stumbled on them and the book shop had seen so few
in his life time that he wasn't on. Bye the way I think the "Tan-
ner's Narrative" was stolen from the State Library.

1. George Catlin (1797–1872), famous artist of Indian life. Illustrations in *The
Manner, Customs and Conditions of the North American Indian* (London: Henry
Bolen, 1846).
2. Henry Ossawa Tanner, American painter (1859–1937).

How *are* you anyway. I stopped with Burdick for a night not long since but had no time to hunt you up.

I am on the water wagon now a days—dont like it but the Doctor scared me nearly to death and the cogs began to grind so I am a monk. You feel better mornings and worse nights—that's about all I can say to recommend it.

Yours faithfully
Frederic Remington

☐ *FREDERIC REMINGTON TO AL BROLLEY*

New Rochelle
[undated]

My dear Al Glad you saw my paintings—it gives you an idea of what I am doing.

Sorry I haven't any rough horse pictures as yet which fills your requirements.

You ought to have gone into Tiffanys and seen my bronzes. One of those might have come near to filling your bill and they don't cost as much. I could give you some discount on one if it had suited.

Yours
Frederic Remington

☐ *AL BROLLEY TO FREDERIC REMINGTON*

State of New York
Court of Appeals
Judges Chambers
Albany
March 8, 1909

My dear Fred I received the current copy of The Craftsman[1] marked, and have read Edgerton's appreciation with intense interest. Once, advised by a newspaper man, I aspired to do something of the kind. Maturity has tempered my confident smugness and I long know the banal ineptness of my sweetest essay. Your recorder has done well; but in the telling of your tale, a story that to me seems truly grand, I would he had the gift of telling things in flaming, lambent words, to shower upon his theme an atmosphere starred with electric sparkle.

Perhaps I wander from the field; not knowing art. But I am sure

1. The March 1909 *Craftsman* ran the article "Frederic Remington—Painter and Sculptor: A Pioneer in Distinctive American Art" by Giles Edgerton. Ten illustrations by Remington from *Collier's* were included.

you'll feel what I would say. The things I've read from Huneker[2] pleased me, and if enthused might justice give to you a pen like his.

While dawdling through those belogged halls in France I often thought how fresh and sweet twould be if even once in every mile of stall-fed figures, a swooning pilgrim could but chance upon one of your Western scenes. Nothing of yours was there that I could find, but sure's the sun you'll get there yet and shed some rays of glory round about poor basking exiles.

I thank you very much for the pleasures of reading the article and I have "filed it for future reference."

I hope to be able to see and talk with you. But things grow more difficult and more confining as I grow older and excepting summer vacation I'm glued to the desk chair. What a bum fate! I started early but I'm poor and the Albany fellows who come in my biz about that time & since range from $400,000 to $150,000. How about Loeb?[3] Of course they saved; which I can't do. I've hit up the market a time or two; and its hit me. If it gets up again I'll buy that Prairie River; you bet! That's magic!

May God bless you, my boy, and may a constantly happy life fulfil the promise of your youth.

<div style="text-align:right">

Ever your friend and admirer
A. S. Brolley

</div>

☐ *FREDERIC REMINGTON TO AL BROLLEY*

<div style="text-align:center">

Lorul Place
Ridgefield
December 8 [1909]

</div>

My dear Al Mighty glad you saw my work and think so well of it. I am a *plain air* man by instinct and am getting at things better I think.

I am living here (above) now—one mile outside a beautiful little hill village—on a farm. I have built my own house and a group of animal barns and a cottage and I love it. No more city for me. In a few generations posterity will marvel at our worship of cities when their true status is more perfectly understood—they are the firing line of industrialism and d—— impressive as such.

As for your determination to buy a picture for your friend—I only regret that I cannot give you one but I can't because they are my "time"—my way of living. I will make you the interest of a commission, relying on your silence in the matter since I do not

2. James Gibbons Huneker (1860–1921), American essayist and music critic.
3. James Loeb (1867–1933), American banker and philanthropist.

like to cut my prices but "whats the constitution between friends etc."

I can't do anything with "Lostwarrior" or "Sun Dance" or "Buffalo Gun" until I have them back from K's hands but if not sold I will cut them for you: so wait a week and I'll let you know.

Evan bought a picture for the National Gallery and the Corcoran of Washington one. I am the bone in a big art war down here and bones don't have a good time. I stand for the proposition of "subjects"—painting something worth while as against painting *nothing* well—merely paint. I am right—otherwise I should as soon do tit tatting, high-art hair pins or recerchia ruffles on women's pants.

Did you like my portrait of Gen'l Wood. That was experimental—and done out of doors with only two sittings.

Some time you must come out here—I have a nice place—raw as rattlesnakes at present but in the making which is what I like. It's only another way of painting a picture. I saw this old hard luck hill and said ten years—manure & many men can make that sit up.

adios
Frederic Remington

☐ *FREDERIC REMINGTON TO AL BROLLEY*

Lorul Place
Ridgefield
December 8 [1909]
My dear Al I have just heard that "Lostwarrior" has been sold
Y——
Frederic Remington
I have a picture called "The Show Down"[1]—cow-boy quarrel around a grub wagon—a good picture and one which promises to be sanguary in about ⅛ of a second—27×40 inches. If this will suit your friend I'll give it to you for $500—framed.

☐ *FREDERIC REMINGTON TO AL BROLLEY*

Lorul Place
Ridgefield
[1909]
My dear Al There is no indian in "Show Down" and there couldn't be one any more than a sugar-cured ham. I'll send it up if you say so first time I go to N.Y.

1. Also called *The Quarrel*.

I suppose the P.O. people will have a hard time finding Cambridge Ct. There "aint" no C.C.
<div align="right">Yours</div>
<div align="right">Frederic Remington</div>

Injuns & Texas cow-boys didn't mix socially.

☐ *FREDERIC REMINGTON TO AL BROLLEY*

<div align="right">Lorul Place</div>
<div align="right">Ridgefield</div>
<div align="right">December 20, 1909</div>

My dear Al If you want me to I'll send *"The Show Down"* up for inspection. Only give me a shipping address since you probably dont want it sent to the Court of Appeals.

The "Sun Dance" did not sell—so you see I consecrate my horrors to the academic—no one wants horrors in the house.

The "Show Down" is merely a hair-trigger study of human nature in a frying pan civilization and not properly a horror.
<div align="right">Yours faithfully</div>
<div align="right">Frederic Remington</div>

☐ *FREDERIC REMINGTON TO AL BROLLEY*

<div align="right">Lorul Place</div>
<div align="right">Ridgefield</div>
<div align="right">[1909]</div>

My dear Brolley I have your 500. and will send The Show Down on for inspection as soon as it can be boxed to.
<div align="right">Yours</div>
<div align="right">Frederic Remington</div>

Monday

☐ *FREDERIC REMINGTON TO AL BROLLEY*

<div align="right">Lorul Place</div>
<div align="right">Ridgefield</div>
<div align="right">[December 20, 1909]</div>

My dear Brolley I hurt myself Saturday and am so stiff and sore I can't get to New York before to-morrow Wednesday when I will ship painting.

This painting has never been varnished so you had better take it down to Annesleys[1] and have it done.

I never varnish paintings (except a spirit varnish) until as long after wards as possible which gives the paint time to harden. If

varnished too soon they crack (the varnish *shatters*) It is somewhat dead in consequence but the varnish will revive it. I used in my youth to varnish early with the result that some of my early things are cracked.

Tell Annesley to keep the picture in a very warm (hot) place until the varnish sets.

I would have it varnished down here but I take it you are in a hurry for it and this will save time. *Tell Annesley to send me the bill.*

Yours
Frederic Remington

Tuesday

Remington's early interest in Custer and the Battle of Little Big Horn has been documented. Less well known is the fact that he established a professional relationship with Mrs. Custer (Elizabeth Bacon Custer), who devoted much of her life to upholding Custer's memory. Mrs. Custer published three books: Boots and Saddles *(1885), describing her life with Custer;* Tenting on the Plains *(1887), describing their life and campaigns in Texas and Kansas; and* Following the Guidon *(1890). Eleven Remington illustrations appear in* Tenting on the Plains *and two in* Following the Guidon. *Mrs. Custer had a wardrobe of Custer's clothing that she would lend to artists for the purpose of authenticity.*

☐ *ELIZABETH CUSTER TO FREDERIC REMINGTON*

Bronxville, N.Y.
April 1, 1908.

My dear Mr. Remington I was intensely interested in your letter, and think it was so good of you to write me in such detail of the very things that are of vital interest to me. I want you to think up ways in which I can be of service to you.

I will gladly come to New Rochelle to see Mrs. Remington and you, though I fear I cannot do so this spring. I am exhausted with the winter's work. The six months of responsibility and anxiety in trying to be of assistance to the Committee from Michigan, has worn me to a "frazzle," and just now, when Mr. Potter needs me very much, I am about to sail for Europe, to motor with some dear old friends of my childhood, who live here; the Lawrences and the Wellingtons. Mr. Lawrence expects to go through the Italia Lake District, the Austrian Tyrol, and Germany. I shall stay longer than they if Mr. Potter does not need me. In the autumn, whatever I can do with photographs and anything I have that per-

1. Annesley & Co. was a framing and art supply store in Albany. They also had an art gallery where Remington sent items to be sold.

tains to the General, I shall be so glad to offer you. Just now Mr. Potter has almost everything that would be of use to you. I suppose when you do the General, it will be in his buckskins. I have the jacket and the breeches, the top-boots and soft hat and the red necktie. There is an old Sergeant of the 7th Cavalry, now a policeman at West Newton, Mass, Sergeant John Ryan, who served in the Regiment ten years. I write him occasionally and do not lose my chance of keeping in touch with him. He might be of service to you. He has all the pictures of the 7th Cavalry officers, newspaper clippings, pictures of the scouts, an account of the interview with "Sitting Bull," pictures of the Indian Chiefs and between six and seven hundred pages of typewritten matter pertaining to his life up to the time he left the Army. As you say, he is a man that one might wish to put under glass.

I wish that I could see the Jack Hayes of the 5th Cavalry if he is living. Did you read the articles in the Atlantic Monthly last year, by Colonel Morris Schaff on "Old Westpoint"?

With kindest regards to Mrs. Remington, whom I remember with pleasure, I am,

<div style="text-align:center;">
Sincerely yours,

Elizabeth B. Custer
</div>

I hope that you will pardon my type written letter. I try to do all my letters but those about the General increase so I cannot always master them without help.

<div style="text-align:center;">
Most Sincerely

EBC
</div>

☐ CASPAR WHITNEY TO FREDERIC REMINGTON

<div style="text-align:center;">
The Outing Magazine

Edited by

Caspar Whitney
</div>

<div style="text-align:center;">
35 and 37 W. 31st Street

New York

December 2 [1908]
</div>

Dear Fred Remington Good work! The strongest exhibition you have ever made—there all good—My choice was Night Halt of Cavalry[1]—first—Water Hole[2]—second. It pleases me greatly to see you getting there—I keep track of you even if I dont see you.

<div style="text-align:center;">
yours,

Caspar Whitney
</div>

1. *Night Halt of the Cavalry,* oil on canvas, 1908.
2. *The Fight for the Water Hole,* oil on canvas, 1903.

Remington himself was quite pleased with his own work around Christmas of 1908, as is evidenced by this letter to Robert Sackrider.

☐ *FREDERIC REMINGTON TO ROBERT SACKRIDER*

New Rochelle
[December, 1908]

My dear Rob Merry Xmas. Yes—you are all right—don't fail to make your will as you conceive it and get your affairs straightened out and then tell Emma all your business and how it stands so she wont run against snags if she has to settle it. Every man ought to do this. I do.

I am building a house—cow barn stable and main house on my property in Ridgefield and it is my intention to make it my home for life. I hope I shall never have to move again. If I can't live on a farm I will have to go to the poor house and have done with it but I guess I can make riffle

I scored a great triumph in my art show at Knoedlers this winter. Am doing good work—feelin frail—dont drink a drop and altogether getting the most out of life. I put up for Mrs. Levis [1] and suppose I'll have to do that till she dies.

Things are beginning to straighten up financially down here tho' this was an awful hard year.

Don't make any joint exector with Emma—let her be the whole thing—

Yours,
Frederic

The Remington–Roosevelt correspondence continued into 1908 and 1909.

☐ *THEODORE ROOSEVELT TO FREDERIC REMINGTON*

Oyster Bay, New York
June 29, 1908

My dear Remington I am mighty glad to get those three photographs. By George, that is a corking bronze [1] but do you know, I do not think that any bronze you will ever make will appeal to me

1. Mrs. O. Levis, Remington's mother, who had remarried.

1. Probably refers to *The Cowboy*, which was unveiled in Fairmount Park, Philadelphia, on June 20, 1908.

more than the one of the bronco-buster, which you know my regiment gave me. I am mighty proud of it. I prize also the man on the stone edge[2] which you sent me which, by the way, has a comic likeness to a certain high personage whose name I won't venture to put in writing, but will tell you when I next see you.

<div style="text-align: right">
Faithfully yours,

Theodore Roosevelt
</div>

Mr. Frederic Remington
New Rochelle, N.Y.

☐ *THEODORE ROOSEVELT TO FREDERIC REMINGTON*

<div style="text-align: center">
Oyster Bay, New York

October 28, 1908
</div>

My dear Remington It was good of you to write me and I appreciate it. You are one of the men whose friendship I value. Do you know I am rather ashamed to say that I can not accept your condolence?[1] I am still looking forward and not back. I do not know any man who has had as happy a fifty years as I have had. I have had about as good a run for my money as any human being possibly could have; and whatever happens now I am ahead of the game. Besides, I hope still to be able to do some good work now and then; and I am looking forward to my African trip with just as much eagerness as if I was a boy, and when I come back there are lots of things in our social, industrial and political life in which I shall take an absorbed interest. I have never sympathized in the least with the kind of man who feels that because he has been fortunate enough to hold a big position, he can not be expected to enjoy himself afterward in a less prominent position. In fact, I do not in the least care for a position because of its title, so to speak—I want to try to do good work whereever I am, and I am far more concerned with that than with the question of what position it is in which I am to do the good work. Cushing,[2] who sunk

2. *Paleolithic Man.*

1. This may refer to the fact that Roosevelt chose not to run again for president in 1908 but instead directed his support to William H. Taft, secretary of war, who was elected on the Republican ticket.

2. William Barker Cushing (1842–1874) was noted for daredevil exploits, particularly the sinking of the Confederate ram *Albemarle* at Plymouth, North Carolina, in October 1864.

the Albemarle, was only a lieutenant, but there are mighty few admirals with whom, if I had been in his shoes, I should have thought it worth while to change positions.

With warm regards to Mrs. Remington, believe me,

Faithfully yours,
Theodore Roosevelt

Mr. Frederic Remington
301 Webster Avenue
New Rochelle, N.Y.

☐ THEODORE ROOSEVELT TO FREDERIC REMINGTON

Personal

Oyster Bay, New York
February 7, 1909

My dear Remington I entirely agree that the Asiatic must be kept out.[1] I am keeping him out. What I object to is action which does not keep him out but which irritates him extremely at the same time that it lets him in, and which goes hand in hand with a failure to prepare for a fight on our principles. For instance the present California legislature has reelected a Senator, Mr. Perkins,[2] a spineless creature who, in his feeble way, has done what he could to defeat the unbuilding of the navy, and who is at present also freely doing what he can to irritate the Japs into a war. I am trying to combine a maximum of efficiency in keeping out the Japs with a maximum of courtesy so as to make the arrangement one that can be entered into by the Japs and ourselves with mutual selfrespect. My opponents seek to combine the maximum of insult with minimum of efficiency.

Ever yours,
Theodore Roosevelt

Mr. Frederic Remington
301 Webster Avenue
New Rochelle, N.Y.

1. Roosevelt is referring to what became known as the "Japanese School-boy Crisis." In 1906, the San Francisco Board of Education, concerned about an influx of Japanese children into its schools, passed an order requiring all Oriental pupils to attend a public school specially set aside for them. This insulted and angered the Japanese government. Roosevelt, in an attempt to mediate the situation, first invited the entire school board to Washington and convinced them to change the policy, then worked out a series of Gentlemen's Agreements (1907–08) with Japan which limited the number of passports issued to laborers headed for the United States.

2. George Clement Perkins (1839–1923).

☐ *FREDERIC REMINGTON TO LOUIS SHIPMAN*

301 Webster Avenue[1]
New Rochelle
March 18, 1909

Dear Louis My new shack in Ridgefield is the finest building
what ever was—but why boast—Oh I am not boasting—but only
enjoying the sublimation of a creator—a woman with her first kid
or a man who has built a house—I havent had a real sensation
in years—not since the Espangnols were mausering me down
Cuba way.

I have some dandy out buildings and an appalling proposition
to make a poor old Stony Lonesome Rubbed out hill in Connecti-
cut sit up and bleed like Kansas but never mind I believe all I
read in the Fertilizer advertisements. The world is mine—if some
of those men who have spent their lives tilling the soil only knew
that $3 worth of black sand colored with lime would bring 4000
tons to the acre of clover and that after clover the corn will push
the hard-hack over the fence they would also enjoy their winters in
Havanna. Coffins for the Pessimists only the Opps. growing strong.

It is summer down here—it was a week or two earlier this year.
The lillies are up—the peaches blooming—the drowsy hum of
bees—the birds shriller than arrows and the fire spits on the
stove—I froze my ear this morning.

I'll bet Mittie hit em up—he's a plain good one—one of the few

When the plow strikes a rock.

1. Remington used stationery from Webster Avenue days.

men who have more than one convulation in the brains in this business.

Love to Mrs. Nell from both

Yours

Frederic R

P.S. Did you hear what Mort Scheyler said about Sarolla,[2] "He's a painter but not artist—he sees nothing above the eyes."

Work with Bertelli on the large Bronco Buster *and* The Stampede *continued in 1909.*

☐ *RICCARDO BERTELLI TO FREDERIC REMINGTON*

R. Bertelli, Prop.

Roman Bronze Works

275-289 Greene St., Brooklyn

Greenpoint New York

March 8, 1909

My dear Remington I received your copy of the March number of Craftsman. I wish to thank you very much for the honorable mention there is made of my connection with your work and I want to tell you how much I appreciate your kindness. =Too bad there is only one like you in America=

With kindest regards to Mrs. and yourself.

Yours

R Bertelli

☐ *FREDERIC REMINGTON TO RICCARDO BERTELLI*

Lorul Place

Ridgefield

July 7 [1909]

My dear Bartelli I have had a most awful time getting settled in my new home and think another week will see the mechanics off the place. Being in a shop with dozens of men is one thing but when they come to live with you it is another. You cant look out a window but what you see a painter on the other side of the glass. Will ask you out later to see things.

Has Pell sold any bronzes—keep him stocked up—

Yours

Frederic Remington

2. Joaquin Sorolla (1863–1923), Spanish painter known for his bold, sunlit scenes in a late impressionist style.

☐ *FREDERIC REMINGTON TO RICCARDO BERTELLI*

Lorul Place
Ridgefield
[1909]

Say Bartelli You ought to see the 1½ Broncho Buster—It will
make your eyes hang out on your shirt-front.

Get ready to retire the small one—mind you

Y——
Frederic Remington

☐ *FREDERIC REMINGTON TO RICCARDO BERTELLI*

Lorul Place
Ridgefield
[1909]

My dear Bartelli I dont see what good can come of my calling
at the Foundry because the 1½ B. Buster model must be redone
in my studio here—I could never do it at the Foundry, so one way
or another it *must* be sent here and also I must have a little model
I think.

Fix it up—recast—do anything but here it must come.

I did not understand it was to be a *plastaline* model but a *plaster
one* How was this? I think next week I will be ready for Contini[1]—
I will let you know. Send plaster & get him ready

Y——
Frederic Remington

Sunday

☐ *FREDERIC REMINGTON TO RICCARDO BERTELLI*

Lorul Place
Ridgefield
[1909]

My dear Bertelli I have the Broncho Buster done—and you can
have Contini come Tuesday (I hope to go to New York Monday).

We want to get this out as soon as possible. I would even give
it presidence of the last group.

This size lends itself to my hand much better than the smaller—

Y——
Frederic Remington

Friday

1. Workman at the Roman Bronze Works.

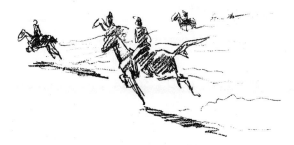

☐ *FREDERIC REMINGTON TO RICCARDO BERTELLI*

Lorul Place
Ridgefield
[1909]

My dear Bartelli I have started a group[1] which I hope will be
a good one.

I want about ½ bushel of modeling clay (green) for a *plinth*
but don't know where to order. Will you order some for me *very
pronto* and greatly oblige.

Why dont you break up the Fairmount Cow Boy. It is a nui-
sance and serves no purpose.

Y——
Frederic Remington

(on side of page)
How goes the waxes?

Monday

☐ *FREDERIC REMINGTON TO RICCARDO BERTELLI*

Lorul Place
Ridgefield
[1909]

My dear Bartelli Get Contini ready and ship plaster here.

I shall be ready very soon now with the group. *One* cowboy &
four steers & a big plinth.[1] It will be quite a job and tell him to
put in his *time* on it. If this isn't a killer I'll quit clay.

Yours faithfully
Frederic Remington

Are you making any new ones for Xmas?

How comes the new B.B.?

Monday

1. *The Stampede* (April 13, 1910, posthumously): "Bronze groups of
stampeding cattle with mounted cowboy in their midst."

1. *The Stampede.*

Sally Farnham was a friend and student.

☐ *FREDERIC REMINGTON TO SALLY FARNHAM*

Lorul Place
Ridgefield
[undated]

My dear Sally I think Col. Sargt. wore this in Civil War. I think later the chevrons were placed the other side up, with the change of '69—He had his sling for the flag pole and wore a Sargt's sword. You had better ask someone else but be sure you find out which side up the chevrons went—they changed—

Yours
Frederic Remington

☐ *FREDERIC REMINGTON TO SALLY FARNHAM*

Lorul Place
Ridgefield
[undated]

My dear Sally F I keep a scrap book in which I paste photos of sculpture and it yawns for one of the Sergeant & Bugle Boy—if you have one but I suppose a photo of the bronze will be much better than the plaster.

However remember me when the distribution comes.

Yours
Frederic Remington

Saturday

☐ *FREDERIC REMINGTON TO SALLY FARNHAM*

Lorul Place
Ridgefield
[undated]

My dear Sally *Missie* was talking about your *Sentinel* on monument. First—his gun must not be on the ground if you want the sentinel idea.

The only good Civil War art material is *Forbes Etchings* and *Winslow Homers* illustrations in war numbers of Harpers Weekly. All else is misleading.

Why dont you put him in marching order—blanket roll— haversack canteen etc? Tuck his breeches in his socks, and dont make him slick. Give him long hair—curled forward over the ears. Dont have much in his haversack—pantaloons very full &

wrinkled—fix his bayonet—Springfield muzzle loader, and above all never mind what old soldiers tell you because this one had that and this issue without end but the things they describe were not general—uniform or typical *ofttimes*. There were all kinds of things issued but which did not survive. The last of the war was fought with merely a poncho (rubber) and no blanket. Go to *Bravermans* on B'way for your stuff—and get a *civil war haversack*—they were unlike the new ones in use now.

I enclose a rough sketch—which may help you a little.

If you don't have that soldier so he suits me I will slander your d—— old monument.

> Yours
> Frederic Remington

☐ *FREDERIC REMINGTON TO SALLY FARNHAM*

> Lorul Place
> Ridgefield
> [undated]

My dear Sally The Mohawks roached their hair and wore in war a quilted mail of bark. Of course in Champlain's time we know little about them—only be sure they did not wear the war bonnet of feathers of the Northern Plains. Every idiot artist lugs that in and it immediately yells "he knows nothing of Indians." Eastern indians used a long bow like the archers of England while the horse back indians used a short one.

Ancient prints are useless since they were done by men in Europe who followed the ancient Greek idea—here and there are short snatches of description by contemporary writers & explorers but they do not carry far.

You are at liberty to do pretty much what you want to so it says Eastern & not Sioux of course not a shred of White-trade goods.

We are settled and like this place much—we both send love—

> Y——
> Frederic R

Scribner's was interested in doing a major story on Remington's career. "Frederic Remington: A Painter of American Life" by Royal Cortissoz appeared in February 1910, two months after the artist's death.

☐ J.H. CHAPIN TO FREDERIC REMINGTON

Scribner's Magazine Charles Scribner's Sons
Art Department 153—157 Fifth Avenue
 New York, October 18, 1909.
Dear Mr. Remington: I wired you today because of the delay in
answering your letter which was duly received.

Our Editors feel that an article considering the totality of your
work as a painter, sculptor and illustrator would be most desir-
able, and from my point of view nothing could be better than to
have a number of reproductions of your paintings. The article
our Editors have in mind would emphasize the work of the painter
and sculptor without altogether ignoring the place you have oc-
cupied as an illustrator. If written, however, not in the manner of
the average article on artists, but by such a man for example as
Stewart Edward White, who is in sympathy with all phases of
western life (which you so faithfully portray in your canvases), it
seems to us that it would be a very happy combination. How does
this strike you?

In any event we can probably hit upon the right way of han-
dling the article before we have finished with it. In the meantime
I should be glad to undertake the making of photographic copies
of the paintings at your place.

I suppose you have no rough photographs from which we
could make a selection. Have you any preference as to photogra-
phers? I want to send a man who is satisfactory to you, if possible.
If there are any further details which we ought to consider before
proceeding, perhaps you will be coming into town some day soon
and we can meet and talk the matter over.
 Yours Sincerely,
 J.H. Chapin

Mr. Frederic Remington
Lorul Place,
Ridgefield, Conn.

☐ FREDERIC REMINGTON TO RICCARDO BERTELLI

 Lorul Place
 Ridgefield
 October 6 [1909]
My dear Bartelli Thanks for the cut—it doesn't throw much
light on the question. I believe I won't bother with a cast.

Will you have a photo "side view" of that Fairmount Cowboy
sent to

J.H. Chapin
Art Manager
Scribners Magazine
157 Fifth Ave.
and write on back what d is & bye me—they will publish it I think
in an article—bill to me

Yours
Frederic Remington

☐ *NELSON A. MILES TO FREDERIC REMINGTON*

1233 17th St.
Washington, D.C.
November 5, 1909
My Dear old friend I have not seen you for an age. Why don't
you ever come to Washington?

My son Sherman is sending out cards for his wedding on No-
vember 24. I fear he sent the ones for you and Mrs. Remington
to the old address in New Rochelle. I hope you may receive the
invitation and that you and Mrs. R can come down at that time.
I want to see you very much.

With best wishes
I remain
Very truly yours,
Nelson A. Miles

☐ *FREDERIC REMINGTON TO NELSON A. MILES*

Lorul Place
Ridgefield
[November 1909]
My dear General I am sorry I cannot get over to Washington to
the Sherman M. wedding but my annual show of paintings opens
at Knoedlers on 29th[1] and that is altogether the important event
for me in the year so I have to "be on the job" you see. I should
like to come and see & talk with you and be present when the
young man does the very natural thing—get married, my how
important a thing that is too in our lives and one we never take
any advice concerning very properly. I have concluded that it is
not good for old men to advise young men at all—did you ever
think of it that way.

1. Knoedler's had an exhibition of Remington paintings that actually opened
December 4, 1909, not November 29 as Remington anticipated.

We are settled up here—have a nice place and are very happy and working hard making a home. It is no small job to make a hard back & rattlesnake farm into a country place but its mighty interesting. Hope you can come out some day & see us.—I feel sure you would not be disappointed.

Give my regards Sherman (my what a little scoundrel he was 19 years ago and I have seen him but once since—a long cadet at West Point) and tell him we will let this marrying go this time but dont let it occur again.

> Both send love to you,
> Yours
> Frederic Remington

Sunday

□ *T. GERRITY TO FREDERIC REMINGTON*

> November, 1909
> M. Knoedler and Co.
> 355 Fifth Ave
> New York

Mr. Frederic Remington
Lorul Place
Ridgefield, Conn.
Dear Sir We are in receipt of your favor of the 10th instant, and our letter re frames crossed yours. You know by this time the frames will be ready on Friday for your inspection.

We take this opportunity of informing you that Mr. William T. Evans has purchased your painting, "Fired On" for the National Museum in Washington for $1,000, and we will have to put on a new frame which he selected. He asked if you were an Academician.

When in our store please ask for our Mr. Roland F. Knoedler, who wants to see you especially.

> Very truly yours,
> M. Knoedler and Co.
> T. Gerrity

Remington seemed to be holding his own after his emergency appendectomy, as his wife's telegram of December 24, 1909, notes. Unfortunately his condition deteriorated, and on December 26 his life ended.

☐ **EVA REMINGTON TO MRS R. B. ELLSWORTH**

The Western Union Telegraph Co.
Received 10:30 AM December 24, 1909
[From] Ridgefield, Conn
To Mrs. R. B. Ellsworth
Canton, NY
 Frederic operated on last night for appendicitis so far doing well—

Eva A. Remington

Tributes to Remington poured in from a variety of sources. New York newspapers and notable figures of the day spoke in glowing terms about his many contributions to American art. Among all his testimonials, the following by fellow Western artist Fernand Harvey Lungren and President Almon Gunnison of St. Lawrence University are among the best summaries.

☐ **FERNAND LUNGREN TO OWEN WISTER**

[undated]

Dear Mr. Wister This is a few rambling thoughts in appreciation of Remington which I meant to elaborate later but did not, I am sorry to say. Of Frederic Remington the man, I cannot speak with knowledge, not having the good fortune to know him beyond a slight acquaintanceship Although our work lay in much the same territory but of Remington the illustrator and painter, of his work and its value I have perhaps the right to speak with some authority. But I wish now to simply record my appreciation of it very sincerely and admiringly. No critic or band of critics can pass upon Remington's work, can make or unmake his reputation as a truthful and sympathetic delineator of western life and character, because for them to do so it would be necessary to know his field as he did and that they cannot do. Leaving quite aside the countless charming and stirring drawings and pictures he has delighted us with, his work has had a constructive value difficult to associate

with any other American artist. His contribution to what may eventually become known as American art has been large and he has proven, contrary to some opinion, that the west is capable of furnishing material for art impulses other than sensational. To multitudes he made the west known in a comprehensive & selective manner they could never hope to do for themselves, and in so doing he put the fear of God and self respect into some western men who needed it. Whatever honors or reward he won he deserved, and some day it will be realized how hard he worked and at what hard work. It is not altogether childs play to gather materials and work on the range and on the desert. It is difficult at this time to estimate his loss. Rather will the absence of his work grow upon us and it will be known that we have had taken away one whose worth and ability will loom the larger as we realize there is no one to fill his place.

<div style="text-align:center">Fernand Lungren</div>

<div style="text-align:center">January 4, 1910.
GLOWING TRIBUTE</div>

<div style="text-align:center">Words Spoken at Funeral of Frederic Remington by His Old
Friend, President Almon Gunnison.</div>

How true that in the midst of life we are in death, and how true also it is, that no one can predict the hour when the black messenger will leave his message at our doors. Physical strength comes to be prophetic of length of days, but the strong equally with the weak receive the sentence from which there is no appeal. Youth has hardly less immunity than age and death chooses all seasons for his own.

It is fitting today, when the hands of friendship have borne the body of their comrade to give it Christian burial beside its kindred, that they should rest their burden here for a little while, that the offices of consolation should be performed and that someone, however inadequately, should voice the sorrow that is in our hearts. In all the annals of this town there are few names of larger distinction than that of Frederic Remington. A prophet's honor is seldom magnified at home, he walks the streets like other men; he grows up among his fellows giving little prophecy of greatness. They remember his foibles. He comes back among them, leaving his work behind to take up the comradeships, to be a common man among common men. But the judgement of the world long ago put the seal of greatness on this man, and the lengthening years will increase his fame and give him enduring place in the foremost ranks of the elect guild of American artists. His outward personality was familiar to us all. The boy of robust vitality de-

veloped into a man of strength, simple minded, ingenuous, impulsive, carrying into manhood the heart of youth, keeping the old friendships, caring nothing of caste or rank, scorning the shams of conventionalities of life, more ready to companion with humble men than with those of rank and power, generous hearted to the unfortunate but abashed and embarassed at any words of praise or gratitude. There were faint glimmerings of his future in the days of his youth and he became a student in the Art School at Yale, but his physical nature dominated his artistic nature, and he was less industrious in the studio than on the field, and this perhaps was fortunate, because his great virility gave him the force of energy to endure the privations of his long years of hardship and toil in the great west, where he unconsciously gathered the materials of his life, and beyond this, no greater calamity could have happened than to have put the limits of conventional artistic training upon one whose art was great because it grew out of an original power, working unhampered by limitations. He was vital with all primeval instincts. He loved the woods and the fields and felt the lure of mother nature calling him to the soil, and when by the death of his father he received his patrimony he hastened to the west, to enter upon that primitive life of the plains which is so rapidly passing away. The quotations of the cattle market interested him less than the wild dash upon the broncho's back, the herding of cattle, the swish of the lariat, the comradeship of the camp fire and the long night on the lonely vigils of the plains. Here he found nature and humanity stripped of all conventions, "life with the bark on" as he used to call it, and he learned life at its original source and felt the strange enchantment of that land of mystery and power. He had a love of martial pursuits and became the friend of the army which was in that border land of semi-civilization, and the great officers saw in his unique personality, his intense enthusiasm, his graphic power of quaint speech, a comrade of resistless fascination. He was a welcome comrade at the soldiers' mess, galloped with them on their raids in the mimic Indian wars, and learned to know and love the Indians as no artist ever knew them. Beneath the grimy filth of their camps, their cruelty and sordidness, he saw a stalwart race battling with fate, despairing, resolute, unconquered, living a life of barbaric force but having their legends, their songs, their myths and mysteries, the pathetic tragedy of a great race slowly but with the certainty of fate vanishing into oblivion.

His barbaric life of the Indians and the hardly less primitive life of the cowboy, which was destined to submerge it, appealed to his own unwasted primitive virility, and tho he afterwards visited the old world and became acquainted with all the phases of its life, his heart turned ever to the plains. This to him was the land of enchantment, and with a love like that of the Arab for the desert

and the sailor for the sea, like the Tartar's arrow from his bow he
flew to it, and fed his artistic sense with the mystery and charm of
nature and life, rough, uncouth, but, as yet unspoiled.

But all this was only one phase of his life. Had it no other mean-
ing for him, his early death would not today be a cause of such
lamentation.

In all this drama of western life he saw what no other men saw,
the heroic age of American life and age passing swiftly away, leav-
ing few vestiges and with the haste and passion of a patriot as well
as an artist he made it not his work but his mission to put into
imperishable art the life, the habits, the myths and customs of
these races, ere they vanished completely into oblivion.

And so he returned to the east and set to work. His work was
crude for he was self taught and he lacked the finer touch which
comes with the apprenticeship and martyrdom of arts.

And artists who had studied nature in the studios of Paris and
painted men from their lay figure, cried out against him and said,
he lacked technique and the finer touches of a trained art. But the
few who had the finer vision, saw that an original man had come,
and that a king was groping his way to his throne of power. And
the years went on and he perfected his art and taught himself to
draw and paint with skill, losing nothing of his power, but by as-
siduous toil changing his weapon of iron into one of tempered
and polished steel. And he became a great artist, great in the de-
tails of expression, great in conception, greater in his unvarying
adherence to the absolute truth of the scenes and life which he
preserved, and they who scoffed, learned to admire and praise,
and unchallenged gave him his place at the head of the long line
of imitators and admirers who are following in the trail which
he blazed.

His creative power was phenomenal, his industry intense. It was
said of Michael Angelo that when he was in the ecstasy of his
creative work he was wont to rush out into the campagna to cool
his fevered brain and then return with almost demonic fury to
resume his work and so this man worked with an impulsiveness
which had behind it the unwasted energy of a masterful virility
as tho he had some prophecy that the days of his apostleship
were to be brief.

His versatility was surprising. He made his pen almost equally
skillful with his brush, he learned the sculptor's art, and created
works which rivalled those of an age which was thought to have
passed away, and his last work was his best, and he built his new
home away from the distracting throngs, that he might do the
largest, finest work he ever did, because he believed that his past
achievements had only taught him how to give expression to the
finer visions which had hitherto eluded him. And then the end
came. But his place in American art had been fixed. He was the

acknowledged historian in pictorial form of the most precious age from an artistic and patriotic standpoint in our American life, its revelator and its interpreter, and that place will forever be secure to him.

The words of the orator, the song of the singer go out into the viewless air, they thrill and are forgotten; great industrial creators do their work and pass on, but the artist, who has the skill to put beauty or truth upon the canvass or in the grace of form, has endurance of fame, a double immortality, the immortality of heaven and an immortality on earth. His work becomes the heirloom of families and men buy it with the dowery of princes.

And so we come to speak the final word. Can it be possible that life, consecrated to high ideals, that visions not yet embodied in expression, must end through the breaking of a nerve, a blood clot on the brain, the fevered muscle or duct that is unseen, and that when man has fitted himself to do his work, he must end it all, and pass into annihilation? It is an unthinkable and impossible travesty of truth. In larger, freer studios in this many manshioned house we call life, there must be a continuance of vision and a going on of life and thought and deed to nobler issues.

Selected Bibliography

☐ BOOKS

Allen, Douglas. *Frederic Remington's Own Outdoors*. New York: Dial Press, 1964.

―――. *Frederic Remington and the Spanish-American War*. New York: Crown Publishers, 1971.

Baigell, Matthew. *A History of American Painting*. New York: Praeger Publishers, 1971.

―――. *The Western Art of Frederic Remington*. New York: Ballantine Books, 1976.

Bailey, Thomas A. *A Diplomatic History of the American People*. New York: Appleton-Century-Crofts, 1958.

Baskett, Sam S., and Theodore B. Strandness. *The American Identity*. Boston: D. C. Heath and Co., 1962.

Bassett, John Spencer. *Expansion and Reform 1889–1926*. New York: Longmans, Green and Co., 1926.

Bigelow, Poultney. *Seventy Summers*. New York: Longmans, Green and Co., 1925.

Boorstin, Daniel J. *The Americans: The National Experience*. New York: Random House, 1965.

Brady, Cyrus Townsend. *Indian Fights and Fighters*. Lincoln, Neb.: University of Nebraska Press, 1971.

Brown, Charles H. *The Correspondents' War*. New York: Charles Scribner's Sons, 1967.

Canby, Henry Seidel. *American Memoir.* Boston: Houghton Mifflin Co., 1947.

Commager, Henry Steele. *The American Mind.* New Haven: Yale University Press, 1950.

Cortissoz, Royal. *American Artists.* New York: Charles Scribner's Sons, 1923.

Dary, David. "Frederic Remington in Kansas." In *The Prairie Scout,* edited by Joseph W. Snell. Abilene, Kansas: The Kansas Corral of the Westerners, 1973.

Davis, Richard Harding. *Cuba in War Time.* New York: R. H. Russell, 1898.

Downey, Fairfax. *Richard Harding Davis: His Day.* New York: Charles Scribner's Sons, 1933.

Dykes, Jeff. *Fifty Great Western Illustrators: A Bibliographic Checklist.* Flagstaff, Ariz.: Northland Press, 1975.

Faulk, Odie B. *The Geronimo Campaign.* New York: Oxford University Press, 1969.

Fiske, Turbese Lummis, and Keith Lummis. *Charles F. Lummis, The Man and His West.* Norman, Okla.: University of Oklahoma Press, 1975.

Forbis, William H. *The Cowboys.* The Old West Series. Alexandria, Va.: Time-Life Books, 1973.

Fowler, Albert, ed. *Cranberry Lake from Wilderness to Adirondack Park.* Syracuse, N.Y.: Syracuse University Press, 1968.

Gard, Wayne. *Frontier Justice.* Norman, Okla.: University of Oklahoma Press, 1949.

Hassrick, Peter. *Frederic Remington.* New York: Harry N. Abrams, 1973.

———. *The Way West: Art of Frontier America.* New York: Harry N. Abrams, 1977.

Hassrick, Royal B. *Cowboys and Indians, An Illustrated History.* New York: Promontory Press, 1976.

Jackson, Marta, ed. *The Illustrations of Frederic Remington.* New York: Bounty Books, 1970.

Johnson, Virginia W. *The Unregimented General: A Biography of Nelson A. Miles.* Boston: Houghton Mifflin Co., 1962.

Jussim, Estelle. *Frederic Remington, The Camera and the Old West.* Fort Worth: Amon Carter Museum, 1983.

Krakel, Dean, ed. *Frederic Remington. Persimmon Hill.* Vol. 10, no. 3. Oklahoma City: National Cowboy Hall of Fame, 1980.

Leech, Margaret. *In the Days of McKinley.* New York: Harper and Brothers, 1959.

Link, Arthur. *American Epoch: A History of the United States since the 1890s.* New York: Alfred A. Knopf, 1967.

Lord, Walter. *The Good Years: From 1900 to the First World War.* New York: Harper and Brothers, 1960.

Manley, Atwood. *Frederic Remington: In the Land of His Youth.* Ogdensburg, N.Y.: Northern New York Publishing Co., 1961.

Marden, Orison Swett, ed. *Little Visits with Great Americans.* Vol. 2. New York: The Success Co., 1905.

McCracken, Harold. *The American Cowboy.* Garden City, N.Y.: Doubleday and Co., 1973.

———. *Frederic Remington: Artist of the Old West.* Philadelphia: J. B. Lippincott Co., 1947.

———. *Frederic Remington's Own West.* New York: Dial Press, 1960.

———. *Portrait of the Old West.* New York: McGraw-Hill Book Co., 1952.

Miles, Nelson A. *Personal Recollections and Observations of General Nelson A. Miles.* Chicago: The Werner Co., 1896.

Morison, Samuel Eliot. *The Oxford History of the American People.* New York: Oxford University Press, 1965.

Mott, Frank Luther. *American Journalism, A History. 1690–1960.* New York: Macmillan Co., 1962.

————. *A History of American Magazines*. Vol. 3, 1865–1885. Cambridge, Mass.: Harvard University Press, 1938.

————. *A History of American Magazines*. Vol. 4, 1885–1905. Cambridge, Mass.: Harvard University Press, 1957.

Oppel, Frank, comp. *Frederic Remington: Selected Writings*. Secaucus, N.J.: Castle, 1981.

Rodenbough, Theodore F., and William L. Haskin, eds. *The Army of the United States*. New York: Maynard, Merrill and Co., 1896.

Russell, Don. *The Wild West*. Fort Worth: Amon Carter Museum of Western Art, 1970.

Russell, Henry B. *An Illustrated History of Our War with Spain*. Hartford, Conn.: Hartford Publishing Co., 1899.

St. Clair, Philip R., ed. *Frederic Remington: The American West*. New York: Bonanza Books, 1981.

Samuels, Peggy, and Harold Samuels, eds. *The Collected Writings of Frederic Remington*. Garden City, N.Y.: Doubleday and Co., 1979.

————. *Frederic Remington: A Biography*. Garden City, N.Y.: Doubleday and Co., 1982.

————. *The Illustrated Biographical Encyclopedia of Artists of the American West*. Garden City, N.Y.: Doubleday and Co., 1976.

Shapiro, Michael. *Cast and Recast: The Sculpture of Frederic Remington*. Washington, D.C.: Smithsonian Institution Press, 1981.

Stewart, John. *Frederic Remington: Artist of the Western Frontier*. New York: Lothrop, Lee and Shepard, 1971.

Sullivan, Mark. *Our Times: The United States 1900–1925*. Vol. 1. New York: Charles Scribner's Sons, 1926.

Summerhayes, Martha. *Vanished Arizona: Recollections of the Army Life of a New England Woman*. Salem, Mass.: Salem Press, 1911.

Taft, Robert. *Artists and Illustrators of the Old West 1850–1900*. New York: Charles Scribner's Sons, 1953.

Ten Cate, Adrian G., ed. *Pictorial History of the Thousand Islands*. Brockville, Ontario: Besancourt Publishers, 1977.

Thayer, William Roscoe. *Theodore Roosevelt, An Intimate Biography*. New York: Houghton Mifflin Co., 1919.

U.S. Department of the Army. *American Military History, 1607–1953*. ROTC Manual No. 145-20. Washington, D.C., 1956.

Vorpahl, Ben Merchant. *Frederic Remington and the West: With the Eye of the Mind*. Austin: University of Texas Press, 1978.

———. *My Dear Wister: The Frederic Remington–Owen Wister Letters*. Palo Alto, Calif.: American West Publishing Co., 1972.

Wear, Bruce. *The Bronze World of Frederic Remington*. Tulsa, Okla.: Gaylord, 1966.

White, G. Edward. *The Eastern Establishment and the Western Experience*. New Haven: Yale University Press, 1968.

Williams, T. Harry. *Americans at War: The Development of the American Military System*. Baton Rouge: Louisiana State University Press, 1960.

Wister, Fanny Kemble, ed. *Owen Wister Out West: His Journals and Letters*. Chicago: University of Chicago Press, 1958.

☐ ARTICLES AND UNPUBLISHED MATERIAL

Bigelow, Poultney. "Frederic Remington: With Extracts from Unpublished Letters." *New York State Historical Association Quarterly* 10 (1929): 46–48.

———. "Frederic Remington." Speech delivered in Canton, New York, November 1909.

Cortissoz, Royal. "Frederic Remington, A Painter of American Life." *Scribner's* 47 (February 1910): 187.

Dary, David. "Frederic Remington in Kansas." *Persimmon Hill* 6, no. 1 (1976): 28–35.

Dippie, Brian. "Frederic Remington's Wild West." *American Heritage* 26, no. 3 (April 1975): 7–23.

Manes, Susan. "Who's Up?" Mimeo, 1981.

Sellin, David. "Frederic Remington, 'Cowboy.'" Unpublished manuscript in Fairmont Park Art Association archives, no date.

Splete, Allen P. "Frederic Remington Letters at St. Lawrence: A Closer Look at the Many Sides of Frederic Remington." *Bulletin of the Friends of the Owen D. Young Library* 11, no. 1 (February 1981): 2–20.

Thomas, Augustus. "Recollections of Frederic Remington." *Century* 86 (July 1913): 354.

Letter Collections Concerning Frederic Remington

(Dates in brackets are conjectural)

Owen D. Young Library
St. Lawrence University
Canton, N.Y.

Frederic Remington to Poultney Bigelow:
 1/5/92, 1/8/[92], 1/11/92, 1/21/92, 2/10/92, 3/8/92, 3/16/92,
 3/23/92, 3/27/92, 6/27/92, 6/[92], 7/1/92, 7/12/92, 7/19/92,
 7/26/[92], 8/24/92, 9/27/92, 10/18/92, 10/31/92, 11/4/92,
 11/16/[92], 11/24/92, [92], [92], [92], [1/4/93], 1/9/93,
 1/29/[93], 4/10/[93], 4/18/93, [5/93], 7/15/[93], 7/18/[93],
 7/28/93, 8/13/93, 8/19/93, 11/12/93, 11/25/[93], 12/22/93,
 93, [93], 3/2/94, 4/13/94, 4/16/94, 5/15/94, 5/21/94, 6/14/94,
 7/27/94, 8/4/94, 8/19/[94], 9/94, 10/23/94, 5/18/95, [6/10/95],
 7/[95], 8/16/95, 8/17/[95], [95], [95], 1/28/97, 8/9/97, [97],
 12/11/99, [undated]
Poultney Bigelow to Frederic Remington:
 [3/92]

Frederic Remington to Joel Burdick:
 [4/15/96], 11/15/98
Frederic Remington to John Howard:
 6/13/[75], [75], [76], 4/14/78, 12/1/98, 5/10[99], [04], [06],
 [2/16/07], [3/07], 9/18/[08], 10/24/[08], [after 11/4/08], [fall/
 08], [08], [08], [08], 1/21/[09], 2/5/[09], 2/18/09, 2/18/[09],
 2/25/09, 3/6/[09], 3/15/[09], 12/09, [09], [09], [09], [09], [09],
 [09], [09], [09], [09], 1/19/?, [undated], [undated], [undated],

[undated], [undated], [undated], [undated], [undated], [un-
dated], [undated], [undated], [undated], [undated]
Frederic Remington to Alvin H. Sydenham:
 10/31/[90], 4/24/[92], 8/15/[92], 8/31/[92], 9/12/[92], 4/12/[93],
 7/14/[93], [8/15/93], 9/24/[93], 10/31/[93], [undated]
Frederic Remington to Arthur F. Merkley:
 12/29/83
Frederic Remington to Clara Remington:
 [78]
Frederic Remington to Fred B. Schell:
 2/15/[90], [11/90]
Frederic Remington to Harper Bros.:
 [summer/98]
Frederic Remington to Horace Sackrider:
 5/27/78, 10/18/[81], 5/16/83, 8/23/83
Frederic Remington to Howard Pyle:
 11/5/[99]
Frederic Remington to Huber:
 [09]
Frederic Remington to J. Henry Harper:
 12/17/[90]
Frederic Remington to Julian Ralph:
 summer/[00], [undated], [undated]
Frederic Remington to Louis Shipman:
 [undated]
Frederic Remington to Maj. Jack Summerhayes:
 9/14/03
Frederic Remington to Marcia Sackrider:
 12/12/[79], [80], [80], [80], [80], [82]
Frederic Remington to Mr. McCormack:
 12/10/[90]
Frederic Remington to Riccardo Bertelli:
 [3/02], 1/25/04, [05], [3/08], 11/23/[08], [09]
Frederic Remington to Robert Sackrider:
 11/13/[77], [7/88], [spring/99], 12/[08]
Frederic Remington to Henry Sackrider:
 [94]
Frederic Remington to William A. Poste:
 [87], 11/11/[88], [88], [89]
William A. Poste to Frederic Remington:
 1/8/89
Frederic Remington to Eva Remington:
 [6/6/88], [6/8/88], [6/10/88], [6/14/88], 6/25/88, [7/1/88],
 6/29/[98], 11/4/00, 11/6/00, 1/04, 1/18/04, [11/29]/04, 9/14/05,
 [1/16/06]

Frederic Remington Art Museum
Ogdensburg, N.Y.

Frederic Remington to Eva Remington:
 [88], 6/22/[88], 12/25/[96], [12/26/96], 10/19/[00], 10/24/[00],
 10/29/00, 10/[00], 1/5/[04], [1/04], [11]/04, [04], [04], 9/05,
 [1/06], [1/06], [4/07], [4/07], [4/13/07], [4/14/07], 2/08,
 [9/15/08]
Eva Remington to Mrs. R. B. Ellsworth (telegram):
 12/24/09
Frederic Remington to Jennings S. Cox, Jr.:
 [4/14/05]
Frederic Remington to Lawton Caten:
 8/25/80
A. Barton Hepburn to Frederic Remington:
 5/6/08, 12/3/08, 12/17/09
Caspar Whitney to Frederic Remington:
 12/7/95, 6/2/96, 12/2/[08]
George Wharton Edwards to Frederic Remington:
 10/3/02, [02], [Lines to Happy Life of FR—undated],
 [undated], [undated]
Nelson A. Miles to Frederic Remington:
 7/25/93, 6/25/95, 1/16/99, 11/5/09
Nelson A. Miles to Department Commanders:
 12/31/95
Powhatan Clarke to Frederic Remington:
 9/13/90, 10/24/[90], [undated]
Powhatan Clarke to Eva Remington:
 8/31/[90]
John Fox, Jr. to Frederic Remington:
 7/28/98, 8/15/98
Howard Pyle to Frederic Remington:
 3/29/99, 12/23/99
Theodore Roosevelt to Frederic Remington:
 11/20/95, 9/19/98
Theodore Roosevelt to Arthur Little:
 7/17/07
John F. Weir to Frederic Remington:
 4/18/00, 7/15/00
A. F. McGuire to Frederic Remington:
 2/2/05
A. W. Heatherington to Frederic Remington:
 7/2/08
Albert S. Brolley to Frederic Remington:
 3/8/09
C. C. Buel to Frederic Remington:
 10/28/98

Casey Bunyan to Frederic Remington:
 9/15/[98]
Childe Hassam to Frederic Remington:
 12/20/06
Cyrus Townsend Brady to Frederic Remington:
 3/21/[05]
Daniel C. French to Frederic Remington:
 3/8/07
Daniel Lamont to Frederic Remington:
 5/5/95
Elizabeth B. Custer to Frederic Remington:
 4/1/08
Francis Parkman to Frederic Remington:
 1/7/92
Frank D. Millet to Frederic Remington:
 4/7/[90]
French Devereux to Frederic Remington:
 1/2/02
George Brett to Frederic Remington:
 12/4/02
Irving Bacheller to Frederic Remington:
 12/5/08
J. D. Jerrold Kelley to Frederic Remington:
 [02]
J. H. Chapin to Frederic Remington:
 10/18/09
John Hay to Frederic Remington:
 10/28/00
John Howard to Frederic Remington ("When 'Rem' he quit
the Bay"):
 2/19/09
Leslie W. Miller to Frederic Remington:
 6/22/08
Perriton Maxwell to Frederic Remington:
 7/31/07
Poultney Bigelow to Frederic Remington:
 1/30/93
R. Percy Crandell to Frederic Remington:
 5/16/98
R. D. Evans to Frederic Remington:
 1/31/99
R. W. Gilder to Frederic Remington:
 3/24/06
Riccardo Bertelli to Frederic Remington:
 3/8/09
Royal Cortissoz to Frederic Remington:
 12/2/[04]

Rudyard Kipling to Frederic Remington:
 [95]
S. C. Robertson to Frederic Remington:
 12/31/[90]
Seth Remington to Frederic Remington:
 3/9/71
T. Gerrity to Frederic Remington:
 11/09
W. D. Howells to Frederic Remington:
 12/22/95
George M. Wright to Frederic Remington:
 12/24/02
[George M. Wright] to Frederic Remington ("Tramps"):
 [undated]

Missouri Historical Society
St. Louis, Missouri

Frederic Remington to Powhatan Clarke:
 8/6/87, [11/3/87], [fall/87], [87], 1/3/88, 3/13/88, 4/3/88,
 4/11/88, 5/18/[88], 9/11/88, 10/25/88, 10/31/88, [12/27/88],
 3/14/89, 4/2/89, 4/15/[89], 12/1/89, 1/9/90, 1/30/90, [3/90],
 3/25/90, 4/9/90, 6/5/[90], 8/7/90, 9/1/90, 9/13/90, 10/1/90,
 11/12/[90], 1/27/91, 6/3/91, 6/20/[91], 9/8/91, 10/14/[91],
 10/27/91, 11/2/91, 11/20/91, 12/10/91, [91], 3/19/92, 7/19/[92],
 10/14/92, 12/7/[92], [92], 1/12/[93], 1/18/[93], 1/24/[93],
 3/21/[93], 4/10/93, 4/13/[93], 4/22/[93], 4/29/[93], 5/17/[93],
 6/12/93, 6/27/[93]
Eva Remington to Powhatan Clarke:
 5/24/90, 1/20/91, 6/1/91
Frederic Remington to Mrs. Clarke (Powhatan's widow):
 8/4/[94], 8/21/[94]
Frederic Remington to Dr. Clarke (Powhatan's father):
 10/3/93
Frederic Remington to Mrs. Clarke (Powhatan's mother):
 7/24/[93]
Frederic Remington to Francis Parkman:
 1/5/92
Frederic Remington to Riccardo Bertelli:
 7/[09]

Fairmont Park Art Association
Philadelphia, Pennsylvania

Frederic Remington to Leslie W. Miller:
 1/6/05, 3/17/05, 4/1/[05], 4/12/05, 5/15/05, 11/24/05, 12/4/[05],

1/16/06, 1/20/06, 2/16/06, 4/30/06, 5/19/06, 1/5/07, 1/25/07,
2/15/07, 3/15/07, 5/2/[07], 12/12/[07], 12/[07], 12/16/[07],
12/23/[07], 1/3/08, 2/08, [3/08], 3/20/[08], 3/29/[08], 5/5/08,
5/15/08, 5/17/[08], 6/4/[08], 6/25/[08], 11/11/08, 12/2/08,
12/20/08, 12/22/08, [08], [08], [08], [08], [08]
Leslie W. Miller to Frederic Remington:
 [5/13/05], 2/14/07
James M. Beck to Leslie W. Miller:
 2/3/06
John T. Morris to Leslie W. Miller:
 12/24/07
Leslie W. Miller to Charles J. Cohen:
 12/20/05
Frederic Remington to Charles J. Cohen:
 12/14/05, 2/1/07
Charles J. Cohen to Frederic Remington:
 12/9/05, 1/29/07
Frederic Remington to Mr. Sparhawk:
 11/26/[90]
Frederic Remington to Owen Wister:
 [02]
Frederic Remington autobiographical sketch:
 [undated]

Library of Congress
Washington, D.C.

Frederic Remington to Owen Wister:
 1/31/[94], [1/94] or [2/94], 2/8/[94], 2/21/94, [2/94], 4/1/94,
 4/12/[94], before [5/94], before [6/94], before [6/94], before
 [6/94], before [7/94], before [9/94], 9/94, early [10/94],
 10/24/[95], before [2/1/96], [97], [4/00], [4/00], 3/02 or 4/02,
 5/29/02, [08], [undated]
Fernand Lungren to Owen Wister:
 [undated]
Owen Wister to F. J. Singleton:
 6/7/02
Frederic Remington to Theodore Roosevelt:
 12/25/97, [9/98], 2/16/[02], [06]
Theodore Roosevelt to Frederic Remington:
 8/18/97, 8/26/97, 9/15/97, 10/26/97, 11/11/97, 12/28/97,
 12/31/97, 4/5/01, 11/14/01, 2/19/02, 2/20/06, 8/6/06, 6/29/08,
 10/28/08, 2/7/09

The R. W. Norton Art Gallery
Shreveport, Louisiana

Frederic Remington to Riccardo Bertelli:
 [3/02], [10/02], [spring/04], [04], [05], [05], [05], [06], [06],
 [spring/07], [07], [late 07], 6/25/[08], 10/6/[09], [fall/09], [09],
 [09], [09], [undated], [undated]
Frederic Remington to Louis Shipman:
 [summer/03], [summer/03], [summer/03], [summer/03]
Frederic Remington to Percy Crandell:
 7/10/[03], [03]
Frederic Remington to J. Henry Harper:
 9/2/[99]
Frederic Remington to Huber:
 [05]

Buffalo Bill Historical Center
Cody, Wyoming

Frederic Remington to Sally Farnham:
 [4/00], [undated], [undated], [undated], [undated]
Frederic Remington to Martha Summerhayes:
 [fall/03], [03], [07], [summer/08]
Frederic Remington to Maj. Jack Summerhayes:
 [04]

Denver Public Library
Denver, Colorado

Frederic Remington to J. Henry Harper:
 1/21/90, 10/30/93, 5/18/98, 2/3/[99]
Frederic Remington to Julian Ralph:
 5/22/91, 6/11/92
Frederic Remington to G. W. Baird:
 6/2/90
Frederic Remington to Fred B. Schell:
 12/10/[90]
Frederic Remington to Robert Howard Russell:
 [97]
Frederic Remington to Harper Bros.:
 1/19/00

The New-York Historical Society
New York, New York

Frederic Remington to Fred B. Schell:
 1/8/90, 10/11/90, 2/20/91
Frederic Remington to Frank Squires:
 1/30/90, 2/1/90
Frederic Remington to William Carey:
 10/3/88
Frederic Remington to Richard Watson Gilder:
 4/6/89
Frederic Remington to Nelson A. Miles:
 [11/09]

Yale University Library
New Haven, Connecticut

Frederic Remington to John F. Weir:
 12/7/[99], [undated], [undated], [undated]
Frederic Remington to Julian Ralph:
 4/6/96

Beinecke Rare Book and Manuscript Library
Yale University
New Haven, Connecticut

Frederic Remington to Louis Shipman:
 [2/03], [05], [3/18/09]
Frederic Remington to Royal Cortissoz:
 [04]

National Archives, Kansas City Branch
Kansas City, Missouri

Frederic Remington to Capt. Chas. G. Penny:
 6/13/91

New York Public Library
New York, New York

R. U. Johnson to Frederic Remington:
 10/21/01

Kansas State Historical Society
Topeka, Kansas

Unknown to Ella Remington Mills:
 [undated]

Private collection
Owner anonymous

Frederic Remington to Albert S. Brolley:
 12/8/[09], 12/8/[09], 12/20/09, 12/20/[09], [09], [undated],
 [undated], [undated], [undated], [undated], [undated],
 [undated], [undated]

Previously Published

Frederic Remington to Owen Wister:
 8/9/[94], 8/10/94, 9/94, 9/94, 9/94, [9/94] or [10/94], between
 [10/13/94] and [10/18/94], between [10/20/94] and [10/30/94],
 between [11/1/94] and [11/10/94], early [12/94], between
 [12/20/94] and [12/30/94], [12/29/94], [1/95], [2/95], [2/95],
 between [2/25/95] and [2/28/95], [3/9/95], [3/11/95], [3/31/95],
 [3/95], [4/95], between [4/21/95] and [4/27/95], between
 [8/18/95] and [8/22/95], late [10/95], late [10/95], 10/26/95,
 early [11/95], [12/95], 3/6/[96], early [4/96], [6/96], [6/96] or
 [7/96], [5/29/97], [7]/29/[97], [97], [6/98], 9/1/99, [3/00], late
 [4/00], [9/00], 10/4/01, [10/18/01], [10/01], [5/02], [8/02], late
 [8/02], [9/02], [9/8/02], late [11/02], [4/08]
Owen Wister to Frederic Remington:
 [4/08]
Frederic Remington to Scott Turner:
 3/3/77, [77], [77], [77]
Frederic Remington to Jack Summerhayes:
 [undated]
Montague Stevens to Frederic Remington:
 11/29/94
Alvin H. Sydenham description of Frederic Remington:
 [undated]

Illustration Credits

Frederic Remington Art Museum
Ogdensburg, New York

Pages 10 (right), 12, 18, 19, 24 (top and bottom), 32, 54, 56 (top and middle), 57 (top, middle left, middle right, lower left, and lower right), 58 (left and right), 70 (all), 71 (all), 85 (top), 86 (middle and bottom), 97, 109, 129, 134 (all), 137, 138, 139 (all), 140, 142, 144 (all), 145 (all), 166, 204, 215, 225 (all), 226, 228, 241 (top), 242, 243, 246, 254, 260, 277, 278, 281, 285, 295, 296, 298, 313, 316, 319, 322, 323 (all), 335, 345, 356 (top and bottom), 361, 363 (all), 373, 393, 398, 399, 406, 424 (left and right), 431, 445.

Missouri Historical Society
St. Louis, Missouri

Pages 41, 43, 46 (both), 47, 63 (all), 64, 65 (all), 67 (all), 72, 74, 75, 89 (all), 90, 91 (all), 93, 96, 98, 99, 100 (all), 101, 103, 105, 106, 112, 115, 117, 118, 121, 122, 123, 127, 150 (top and bottom), 151 (all), 160 (all), 161, 169 (all), 170 (all), 173, 175 (all), 241 (bottom).

Owen D. Young Library
St. Lawrence University
Canton, New York

Pages 16, 17, 20, 22 (top and bottom), 85 (bottom), 86 (top two), 130, 131, 133, 136, 152, 154, 157, 178, 200, 205, 209, 255, 268 (all), 270 (top), 270 (bottom), 272, 274, 290, 338, 343, 411 (top), 415, 425.

Library of Congress
Washington, D.C.

Pages 206, 214, 217 (all), 248, 250, 251, 252, 253 (top), 253 (bottom), 256, 257 (all), 258 (all), 259, 262, 263 (all), 264, 280, 282, 283, 303.

The R. W. Norton Art Gallery
Shreveport, Louisiana

Pages 111, 222 (left), 325, 328, 341 (all), 342 (all).

Buffalo Bill Historical Center
Cody, Wyoming

Pages 347 (all), 348, 401 (all).

Mrs. Harold McCracken
Private collection

Pages 29, 30, 31 (all), 33 (all).

Yale University Archives
New Haven, Connecticut

Page 23.

Yale University Library
New Haven, Connecticut

Page 216 (all).

Beinecke Rare Book and Manuscript Library
Yale University
New Haven, Connecticut

Page 442.

Susan H. Manes
Private collection

Page 411 (bottom).

Atwood Manley
Private collection

Page 10 (left).

Southwest Museum
Los Angeles, California

Page 384.

Index

About the Authors

ALLEN PETERJOHN SPLETE spent most of his life in the North Country of New York and is a native of Carthage. He received his B.A. from St. Lawrence University, an M.A. with distinction from Colgate University, and a Ph.D. from Syracuse University. His roots in upstate New York and acquaintance with the Adirondacks and the St. Lawrence River helped to stimulate his scholarly interest in Frederic Remington. Conversations with G. Atwood Manley, longtime resident of Canton, New York, and authority on the Remington family, led to research on Frederic Remington that has spanned a period of ten years. In 1981, he was awarded a grant by the John Ben Snow Foundation to proceed with work leading to the publication of this book. Dr. Splete has published a number of articles and books in higher education and about the Adirondacks and Canadian-American relations. He was vice president for academic planning at St. Lawrence University from 1970 to 1982, president of Westminster College in New Wilmington, Pennsylvania, from 1982 to 1985, and currently is the president of the Council of Independent Colleges in Washington, D.C. His name has appeared in *Who's Who in America* since 1984.

MARILYN DETWEILER SPLETE was born in Abington, Pennsylvania. She received her B.A. from Dickinson College in Carlisle, Pennsylvania, and an M.S. from Syracuse University. Her interest in history began as a college major and has continued to this day. Presently she teaches in the public schools of Howard County, Maryland. She initially joined her husband as a research assistant and editor for this book but became a full partner in shaping and crafting the final manuscript. Both she and her husband are often consulted in regard to the life and work of Frederic Remington.